Affinities of Form

Indiana University Art Museum

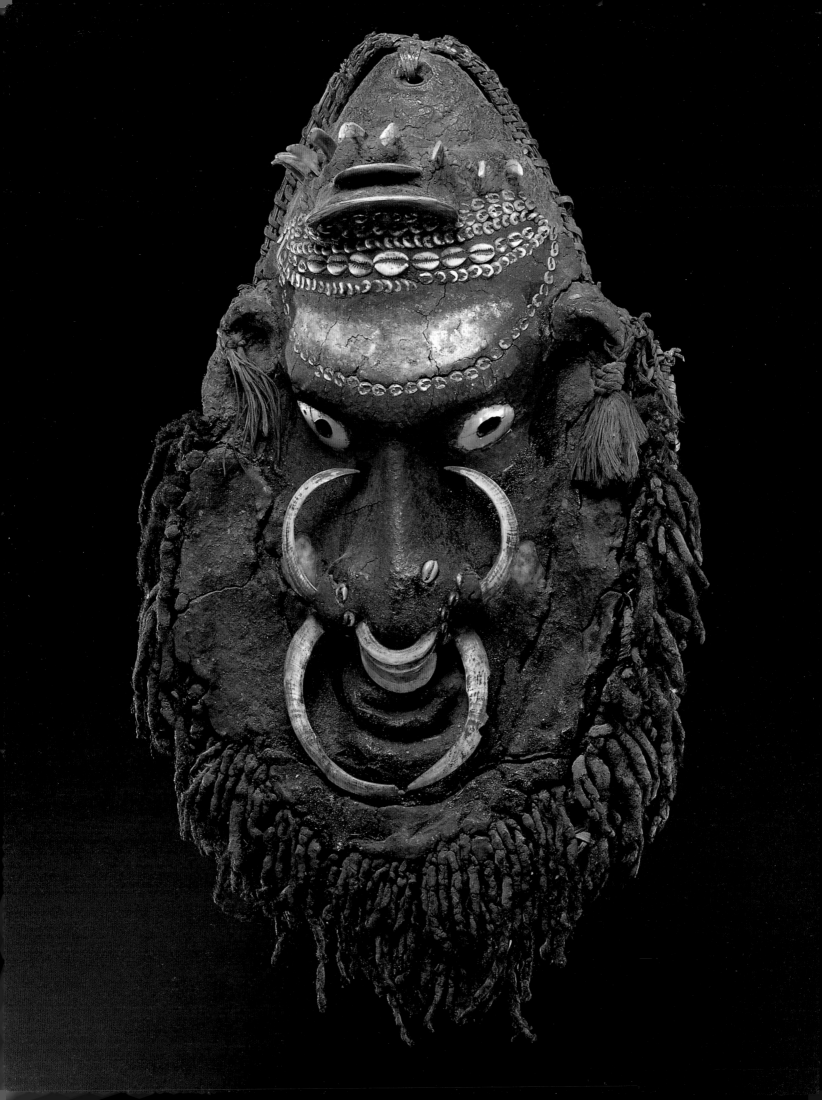

Affinities of Form

Arts of Africa, Oceania, and the Americas
from the Raymond and Laura Wielgus Collection

Diane M. Pelrine

With an introduction by Roy Sieber

Photographs by Michael Cavanagh and Kevin Montague

Prestel

Munich · New York

Indiana University Art Museum

This book has been published in conjunction with the exhibition
"Affinities of Form: Arts of Africa, Oceania, and the Americas from
the Raymond and Laura Wielgus Collection", held at Portland Museum
of Art, Maine (April 13–June 9, 1996); Kimbell Art Museum, Fort
Worth, Texas (July 14–October 13, 1996); Tampa Museum of Art,
Florida (November 8, 1996–January 5, 1997); and Norton Museum of
Art, West Palm Beach, Florida (September 19–November 16, 1997).
The exhibition was organized by Indiana University Art Museum and
circulated by the American Federation of Arts.

Front jacket illustrations (from left to right):
Reliquary Figure (cat. no. 11, pages 46–47); *Female Figure* (cat. no. 23,
pages 70–71); *Vessel in the Form of an Old Woman* (cat. no. 68, pages 156–57)
Spine: *Luba Amulet* (cat. no. 20, pages 60–61)
Back jacket illustration: *Urn in the Form of a Seated Figure*
(cat. no. 71, pages 162–63)
Frontispiece: *Kambot Mask* (cat. no. 53, pages 126–27)

Editor: Andrea P. A. Belloli, London

© 1996 by Prestel-Verlag, Munich · New York
and Indiana University Art Museum, Bloomington, Indiana
© Photographs: Indiana University Art Museum,
(except on page 34: Dan Ben-Amos, courtesy Paula Girshick);
Drawing on page 152: redrawn by Brian Garvey from *The Jaguar's Children*,
Museum of Primitive Art, 1965, p. 28;
Drawing on page 177: courtesy Raymond Wielgus;
Watercolor on page 180: Claude Bentley;
Cartographic design: Brian Garvey

Die Deutsche Bibliothek – CIP-Einheitsaufnahme:
Affinities of form : Arts of Africa, Oceania, and the Americas from the
Raymond and Laura Wielgus Collection ; in conjunction with the exhibition
"Affinities of Form: Arts of Africa, Oceania, and the Americas from the
Raymond and Laura Wielgus Collection", held at Portland Museum of Art,
Maine (April 13–June 9, 1996)... Norton Museum of Art, West Palm Beach,
Florida (September 19–November 16, 1997) / Diane M. Pelrine. With an
introd. by Roy Sieber. [Organized by Indiana University Art Museum]. –
Munich ; New York : Prestel, 1996
NE: Pelrine, Diane M.; Exhibition Affinities of Form: Arts of Africa, Oceania,
and the Americas from the Raymond and Laura Wielgus Collection
<1996–1997, Portland, Me. u. a.>; Portland Museum of Art; Art Museum
<Bloomington, Ind.>

Prestel-Verlag · Mandlstrasse 26 · D-80802 Munich, Germany
Tel.: (89) 38 17 09-0; Fax.: (89) 38 17 09-35
and 16 West 22nd Street, New York, NY 10010, USA
Tel. (212) 6 27 81 99; Fax (212) 6 27 98 66

Prestel books are available worldwide. Please contact your
nearest bookseller or write to either of the above addresses for
information concerning your local distributor.

Color lithography by Fischer Reprotechnik GmbH., Frankfurt am Main
Typeset by Reinhard Amann, Aichstetten · (Type face: Sabon)
Printed by Passavia Druckerei GmbH., Passau
Bound by R. Oldenbourg GmbH., Kirchheim/Munich

Printed in Germany

ISBN 3-7913-1669-9

Contents

Foreword

The circumstances that bring a museum and its collections into being are always unique and form part of the intricate net of friendships and legacies that make up every institution's history. The story of the Raymond and Laura Wielgus Collection and how it came to Indiana University Art Museum is one of the happiest in our museum's evolution. Ray and Laura are collectors and friends of the art historian Roy Sieber, Rudy Professor of Fine Arts at the Henry Radford Hope School of Fine Arts at Indiana University and one of the most distinguished scholars in the field of African art. His friendship with the Wielguses is surely one of the greatest of the many extraordinary gifts Roy Sieber has shared with the museum. Through their long years of friendship, the Wielguses' interest in Indiana University and its Art Museum grew. Finally, they felt comfortable enough to give their important collection a home there. It is a vital part of the ongoing teaching and educational environment of the university.

With a particularly keen eye for excellence in artistry and technique, Raymond Wielgus refined his collection over a lifetime. The Wielgus Collection is widely regarded by scholars as one of the finest of its kind in the world, and it is gratifying that the exquisite masterpieces it contains have begun to receive the public attention they so richly deserve. This catalogue is intended to provide a wider audience with the opportunity to experience the visual delights and fascination these objects present, each on its own and as a totality. The traveling exhibition which this volume accompanies will offer visitors the rare chance to view firsthand some of the best African, Oceanic, and Pre-Columbian works of art in the world.

Our most heartfelt thanks and acknowledgments for this exhibition and catalogue go first to Ray and Laura Wielgus, dear and wonderful friends that they are. Thanks also to Roy Sieber for his sustaining dedication to teaching, to Indiana University, to his department, and to the Art Museum. His commitment to objects as the greatest resource for teaching is one we believe in and whose potential we continually strive to fulfill.

This project marks the first collaboration between the Indiana University Art Museum and the American Federation of Arts and Prestel-Verlag. We are indebted to The American Federation of Arts staff, particularly Serena Rattazzi and Marie-Thérèse Brincard, for their tireless efforts on behalf of the exhibition.

Deepest thanks also must go to Diane M. Pelrine, associate director for curatorial affairs and curator of the arts of Africa, Oceania, and the Americas, for her years of effort in bringing this exhibition and catalogue to fruition. She is a superb scholar and a wonderful colleague. Our pride in Diane's work is matched by the pleasure we take in the wonderful photographs by Michael Cavanagh and Kevin Montague, who have put their talents and taste to the task of photographing our museum collections for over 11 years. Finally, thanks for supporting this whole enterprise must go to Kenneth R.R. Gros Louis and the Office of the Chancellor of Indiana University; the Annenberg Foundation; and Steven and Elaine Fess.

Adelheid M. Gealt

Director
Indiana University Art Museum

7

Preface

We at the American Federation of Arts are proud to have organized the national tour of this exhibition drawn from the superb collection of Laura and Raymond Wielgus and first presented in October 1993 at the Indiana University Art Museum. The tour will enable a wide audience to view extraordinary objects from the rich and diverse cultures of Oceania, sub-Saharan Africa, and the Americas — objects whose astounding forms, as Baudelaire wrote, "beckon us to transform our ravishment into knowledge."

The one hundred objects in the collection span a three-thousand-year period, ranging from a unique small clay bowl and figure of 1200-900 B.C. from the Olmec culture, to a powerful early twentieth-century lifesize figure from the Angoram peoples in Papua New Guinea. The works reveal the unrelenting commitment of the Wielguses to seeking objects that embody the greatest formal qualities within their respective cultures. We are deeply grateful to Laura and Raymond Wielgus for their generosity in making their extraordinary collection available to museum audiences.

We also wish to acknowledge the Indiana University Art Museum and, in particular, Adelheid M. Gealt, director, and Diane M. Pelrine, associate director for curatorial affairs, for their close cooperation with the AFA on this exhibition.

At the AFA, this project has called upon the skills of Marie-Thérèse Brincard, senior curator of exhibitions, who carried out the project with great dedication; Gabriela M. Mizcs, registrar; Jennifer Rittner, assistant curator of education; Jillian Slonim, director of public information; Sara Rosenfeld, exhibitions coordinator; and Tom Padon, director of exhibitions.

We also recognize with thanks the participation of the presenting museums: Portland Museum of Art, Maine; Kimbell Art Museum, Fort Worth, Texas; Tampa Museum of Art, Florida; and Norton Museum of Art, West Palm Beach, Florida.

Special thanks go to Jane Katcher for her generous support toward the educational materials that accompany the exhibition, to Allen Wardwell for his help in developing the national tour, and to Roy Sieber, who as an advisory member of the AFA's exhibitions committee lent his support to the project.

Serena Rattazzi

Director
The American Federation of Arts

Acknowledgments

To the many people who contributed to the realization of this catalogue and the exhibition that accompanies it, I extend heartfelt thanks. Though space and an imperfect memory preclude the listing of everyone by name, the assistance and encouragement I have received over the past several years has been remarkable.

Wielgus objects have been examined by many experts and scholars whose information and insights are reflected in this catalogue. In particular, Roy Sieber and Allen Wardwell, longtime Wielgus friends with a knowledge of the collection surpassed only by the Wielguses themselves, have been very generous in sharing that knowledge with me. I am also grateful to Allan Frumkin and Alan Brandt for discussions about the Wielgus Collection and to the many private collectors and museums that helped locate ex-Wielgus Collection objects.

Indiana University Art Museum staff have played important roles in this project. The creative skills of photographers Michael Cavanagh and Kevin Montague are evident from the most casual perusal of this catalogue, and, once again, they have exquisitely illustrated the adage that a picture is worth a thousand words. The museum's graphic designer, Brian Garvey, drew the maps and assisted in various design considerations. Linda Baden, the museum's associate director for editorial services, not only did some preliminary editing of the catalogue but also offered many suggestions and encouragement. Lois Baker and Susan Reed provided clerical assistance at strategic points. Jerry Bastin, Dennis Deckard, and Dan Deckard made photography mounts, installed the collection in Bloomington, and packed objects for safe travel between Bloomington and Tucson. In the registrar's office, Frances Huber and Debra Garland oversaw records and shipping arrangements. To all of these people, and to the museum's director, Adelheid M. Gealt, who has shown unflagging support for this project, I am extremely grateful.

The organizational and research skills of Indiana University art history graduate students Kathleen Bickford, Teri Sowell, Tavy Aherne, Amanda Carlson, Rebecca Green, Gilbert Amegatcher, Caelan Mys, John Jacob, Vicki Rovine, and John Frazier have been much appreciated. In addition to the museum's graduate assistant program, special funding that made some of this student support possible was provided by the Indiana University African Studies Program.

I also thank Marie-Thérèse Brincard of the AFA, who facilitated the traveling exhibition, and Andrea P.A. Belloli, who was a sensitive and thorough editor of this volume.

Affinities of Form stretched from the museum to my home for extended periods of time, and therefore these acknowledgments would not be complete without thanks to my strongest supporters, my husband, Patrick McNaughton, and children, Nicholas and Meredith, whose patience and encouragement have been Herculean.

Finally, of course, I am most grateful to Raymond and Laura Wielgus, for their generosity to the Indiana University Art Museum, for entrusting me with this project, for sharing their records and expertise in countless conversations, and for their friendship. This catalogue is offered to them with respect and affection.

Diane M. Pelrine

Curator, Arts of Africa, Oceania, and the Americas
Indiana University Art Museum

Introduction

I intend this note to be a personal rather than a scholarly introduction to Raymond and Laura Wielgus and their remarkable collection. Early in 1956, I was asked to curate a summer loan exhibition of African sculpture for the 18th Annual Fine Arts Festival at what was then the State University of Iowa. In my necessarily hurried search for works, William Fagg of the British Museum suggested I contact a New York dealer, J.J. Klejman. He responded that there was a new, young, active collector living practically next door in Chicago: Raymond Wielgus. Ray and Laura generously lent a number of sculptures to that exhibition.

Of far greater importance than that fleeting exhibition was the lasting friendship that developed. Chicago became a scheduled stopover whenever I flew anywhere. At that time, Ray was in the business of making product models, creating three-dimensional prototypes using blueprints and designers' sketches. These prototypes ranged from radios to bathtubs in materials ranging from wood and metal to plastics. Although Ray managed all media, he also had a working staff of specialist artisans.

During my visits, Ray and I would discuss and compare the respective aesthetic merits of works in his collection. Which were aesthetically the weakest, which the strongest? Comparisons ranged over works of the same type or origin or works from widely separated cultures. Were they really comparable or too different, too much apples and oranges? Argument became heated at times, and although Laura held firm opinions, she also served as moderator.

We hovered over illustrations from their extensive library, searching for *the* finest example of a given type, be it an Ijo mask, a Sepik ancestor image, a central Polynesian ivory figure, or an Olmec vase. We were constantly sharpening our eyes, endlessly comparing, always disputing.

In that process, I learned a great deal. I learned that Ray has a most discerning eye and nearly impeccable taste, "nearly" only because I still reserve the right to disagree with him now and again. I learned that nothing substitutes for the process of looking: in books; in museums; at dealers; in private collections. However, I also learned that observing must not be passive but critical, comparative, judgmental. Thus is connoisseurship born and developed.

My life has been enriched by my friendship with Ray and Laura Wielgus. The physical echo of that friendship, their generosity, and, above all, their connoisseurship, is the collection that is the subject of this publication. In it and in the accompanying exhibition, each reader or viewer will discover the richness and variety of the Wielgus Collection. Robert Goldwater, then director of the Museum of Primitive Art in New York, wrote in his foreword to the 1960 exhibition catalogue of the collection that it did not need an introduction: "The objects speak for themselves ... each of these works is excellent and bespeaks an exceptional and consistent taste." In his introduction, Ray added, "The collection is in a process of continual modification, I do not feel irrevocably committed to any particular piece. Each work is open to re-evaluation, it must constantly prove itself and be proved." He described three criteria, all intangible, all expressions of personal taste. First, the work must be outstanding as art irrespective of type or time; second, it must be ethnographically or archaeologically important (in this criterion, Ray acknowledged his debt to specialists); and third, the work must be "right"; that is, it be traditional in style and content, the product of the mainstream of a culture.

Recent revisionist scholarship has tried to shame us for judging the art of other societies, imposing, as it were, our taste. I refuse to be embarrassed. It is clear that I can apply no judgments except those rooted in my past, my culture, my experience. All judgments are based on comparisons, and I can never share the comparisons, the cultural bases of the judgments made by other peoples and other times. I am as trapped in my time and place as they are or were in theirs.

In a larger sense, however, we do have a significant advantage over the original creators. We have available to us far more works from far more places and over a far longer time span than they. Would it not be self-defeating, indeed stupid, not to use that knowledge? To be consistent, one would of necessity refuse to make aesthetic judgments (or, indeed, any other judgments) of any object, act, or belief except those of one's immediate experience; that is, to ignore all of world art, music, literature, religion, philosophy except that produced not only during one's life-time

but also within one's immediate and necessarily limited experience.

Both the cultural choices and the aesthetic judgments of the parent culture that gave rise to a particular work of art are to be discerned in the form and style of that work. In contrast, our cultural and aesthetic choices are to be made from among the many forms and styles that have survived and become available to us. Those choices reflect and define the taste of our time. Thus connoisseurship as defined by Ray and Laura Wielgus and embodied in their collection has become a part of the history of the taste of our time, just as the works individually are illustrative of the taste of theirs.

Roy Sieber

Collectors, Museums, and
Ethnographic Arts in the United States

Primitive art, ethnographic art, folk art, non-Western art, and *arts of indigenous peoples* are just a few of the terms that have been applied to the arts of Africa, Oceania, and the Americas. As Adrian Gerbrands (1957) pointed out over 30 years ago in relation to African art, each term has its drawbacks and none is truly satisfactory. Indeed, why should we expect the arts from three such divergent places, spanning over three thousand years, to fit neatly in a single category?

Today, each area has its own specialists, who clearly see the differences. That many other people still think in terms of a single grouping can be ascribed to several factors, both historical and attitudinal. First, African, Oceanic, and certain American cultures have been linked on the basis of their "tool kit"; that is, their separation from the scientific revolution in Europe and the technological developments that succeeded it. It has also been convenient to group these arts together under a single umbrella, as if among the great world traditions there was Western art, Asian art — and everything else. Perhaps most significant, however, has been the fact that recognition by European and Euro-American societies of objects from these areas as works of art occurred around the same time.

Early Collections and Exhibitions

In the United States, as in Europe, ethnographic objects were rarely collected or exhibited as art during the 1800s. Instead, they were acquired primarily by missionaries, traders, and other visitors as curiosities, souvenirs, and examples of exotic beliefs and ways of life. The early collections of what was to become the Peabody Essex Museum in Salem, Massachusetts, for example, were the result of such acquisitions (Grimes 1984, 6-7). The East India Marine Society, founded in 1799 by whalers and sea merchants, included among its chartered goals the establishment of a "cabinet of natural and artificial curiosities." By 1837, the society's collections included around five thousand natural history specimens and ethnological objects from Asia, Oceania, Africa, and the Americas. The later purchase of the society's museum by George Peabody

led to a merging of its collections with the nearby Essex Institute, which included a number of objects acquired from diplomats and missionaries who had served in Africa. Thus began the Peabody Academy of Science, which was renamed the Peabody Museum of Salem in 1915 and, later, the Peabody Essex Museum.

Likewise, the ethnographic collections of Virginia's Hampton University (formerly the Hampton Normal and Agricultural Institute), which was established in 1868, were acquired for their uses as teaching aids rather than as works of art. These collections, among the earliest shown in the United States, began with a core of Oceanic materials acquired from the missionary parents of Hampton's founder and first president, General Samuel Chapman Armstrong. While his parents were working in Hawaii, Armstrong asked his mother to send "specimens of coral, lava and curiosities of all kinds found in the Pacific" for use in teaching world geography, cultures, and history (Zeidler and Hultgren 1988, 97).

Although such objects were often admired for their skillful and beautiful manufacture, nineteenth-century collectors and museums continued, for the most part, to regard them as the purviews of natural history and anthropological collections, not those specifically dedicated to art. For example, Louis Ayme, a civil engineer who collected Monte Albán funerary urns while laying a railway through Oaxaca, Mexico, gave his collection to the Smithsonian Institution in Washington, D.C., in 1885. A notable exception was the Cincinnati Art Museum, where central African objects from the collection of Carl Steckelmann, a trading agent for a British company, were exhibited in 1889, just three years after the museum opened. Steckelmann, who had collected over 1,200 objects in the area of the Zaire River between 1885 and 1888, sold the collection to the Cincinnati museum, making it "one of the first, if not the first, art museums in the United States to purchase and display African art" (Mount 1980, 40). Though Steckelmann's collection includes figures, masks, and other carved objects (such as over a hundred Loango ivory tusks), the majority consists of baskets and other personal and household objects. Though other art museums followed Cincinnati's lead in the acquisition of

African figural sculpture (primarily masks and figures), it was well into the twentieth century before many art collectors or art museums began to emphasize nonfigural objects in their collections.

In 1914, Alfred Stieglitz showed African objects belonging to the influential French dealer and collector Paul Guillaume at his gallery, 291, in New York. Though his was the second New York showing of African art that year, it was the one that received national publicity and was effectively the first widely recognized exhibition of African — or any ethnographic — objects as art in the United States. For most of the first half of the twentieth century, much of America's perception of African and Oceanic art was influenced by French dealers such as Guillaume and, later, Charles Ratton, who, beginning with this exhibition, regularly loaned objects to shows and found a clientele for their wares in America. Though a few private collectors were active earlier in the century, such as the painter Frank Burty Haviland, who collected ethnographic art before World War I, the 1920s marked the beginning of the formation of major collections in America, such as those of Alfred Barnes and Frank Crowninshield.

Many of these early collectors contributed to a growing number of special exhibitions in museums and galleries. The most widely recognized museum exhibitions of arts from Africa, Oceania, and the Americas during the first half of the twentieth century were at the Museum of Modern Art in New York. *African Negro Art*, shown there in 1935, consisted of over six hundred objects, most of which were from western and central Africa. Over five hundred were from private collections, with the remainder coming from fifteen European and four United States museums. While most of the 52 individual and gallery lenders were also European, 15 private lenders were from the United States, primarily New York. In 1946, the Museum of Modern Art organized *Arts of the South Seas*, another ambitious undertaking, which examined the arts of Polynesia, Micronesia, Melanesia, and Australia. Though Oceanic exhibitions had been held in the United States before, this was the first major art exhibition in America. Unlike the African exhibition, in which privately owned objects dominated, more than half of the thirty-one lenders to this exhibition were museums, and all but two of those were from the United States.

The selection of lenders to any exhibition is determined by many factors, including the knowledge of the organizer, the willingness of the owner to lend, the accessibility of the desired objects, and the costs of such items as shipping and insurance. Therefore, any analysis involving comparisons of numbers and kinds of lenders can be misleading. For these two exhibitions, two points are worth noting, however. First, the African exhibition's heavy dependence on European loans was surely a reflection of Europe's important role in the development of a Western appreciation for African art, and the large number from France indicated the source to which many Americans looked as they began collecting. (As early as the 1920s, many French dealers favored African objects, perhaps reflecting Paul Guillaume's belief that Oceanic forms were less varied than African ones [Peltier 1984, 107, 109].) Second, the larger ratio of private to museum lenders for the African exhibition and the smaller ratio for the Oceanic one is indicative of general collecting patterns that have held through the twentieth century.

By the first half of the 1900s, when art collectors began acquiring ethnographic arts, many South Pacific populations had been decimated; Christian conversions had resulted in the widespread destruction of objects connected with traditional ways of life; and, at least in Polynesia, most objects still being made were pale imitations of earlier objects, now being created specifically for sale to Westerners. Many objects that had been made prior to or during the early stages of Western contact had been acquired by missionaries or seafarers and had become part of institutional collections such as the Peabody Museum of Salem.

Furthermore, the available numbers of certain types of objects, even at the time of Western exploration, were never very large. This was due partly to the relatively small populations on the islands and partly to the fact that in many areas, such as Polynesia, exceptional objects were the prerogative of the even smaller numbers of people in the highest echelons of society. Additionally, in Polynesia, premiums were placed on old, heirloom objects, which were believed to gain *mana*, a kind of sacred power, from each succeeding owner (see cat. nos. 34, 42); therefore, many objects were not made with the frequency that a demand for new, pristine objects would require. Objects could still be acquired in parts of Melanesia, especially New Guinea, and most expeditions were organized in Germany, to which country objects were brought back. Many of the French sources from whom American collectors acquired their objects preferred the refinement of Polynesian pieces to the expressionism of ones from Melanesia.

For African art, the situation was — and is — very different. Of course, the size of Africa and its population in comparison to the islands of the South Pacific suggests a greater number of artworks being made. Though Christianity and Islam have many adherents on the continent, this has not brought about a wholesale rejection of traditional ways of life everywhere, so that in some areas traditional arts can still be found. And while in some areas objects were traditionally believed to grow more powerful with age, most were made under the assumption that they would be replaced when the climate, insects, or ordinary use caused their deterioration.

Additionally, in Africa new discoveries by dealers (or, more often, the sudden availability of numbers of objects from previously little-known areas) fueled collecting fires throughout the twentieth century. Dogon sculpture, for example, became popular with collectors in the 1950s and 1960s, when large numbers of objects became available; collectors turned their attention to previously little-known eastern Nigerian objects that appeared during the Biafran war, and only in the 1980s and 1990s have the sculptures of Tanzania come to the attention of the art world in the West. Finally, the collecting of African art may also have been encouraged by the development of the field of African art studies in the United States during the second half of the twentieth century. This resulted in extensive research by art historians and anthropologists, which could — and still does — often provide the expert validation that many collectors consider advantageous, particularly as prices for ethnographic art have risen dramatically. Far fewer people have entered the field of Oceanic art studies, producing fewer experts and publications for consultation.

Though major exhibitions of Oceanic and African arts took place in the United States before 1950, a comparable exhibition focusing solely on Pre-Columbian arts did not take place until the Museum of Modern Art's *Ancient Art of the Andes* in 1954. While this was not the first Pre-Columbian exhibition — one organized by the Maya expert A.M. Tozzer at the Rhode Island School of Design may have that distinction — it was the one that received national publicity. Even earlier, the Museum of Modern Art in New York had included Pre-Columbian objects in its 1933 *American Sources of Modern Art*, and they figured prominently in *Twenty Centuries of Mexican Art*, a 1940 exhibition of five thousand works loaned by the Mexican government.

Since the middle of the twentieth century, private collections have influenced the study of ethnographic arts,

helping to shape taste and, perhaps most importantly, having a significant impact on museums. American art museums for the most part did not begin assembling collections of ethnographic art until the middle of this century, and in many cases private collectors have shaped these collections. In fact, many American art museums with small, sometimes not even regularly exhibited ethnographic collections received those collections as gifts from one or more donors.

Certainly, the most prominent example of a collector's influence on the development of a public collection is Nelson Rockefeller. Rockefeller's mother had been among the few American art collectors acquiring African art during the early decades of the twentieth century. Beginning with a Hawaiian bowl, Rockefeller himself began collecting ethnographic art in 1930, amassing a collection of African, Oceanic, and Pre-Columbian art unsurpassed in scope and quality. Using this collection as a core, he founded the Museum of Primitive Art in New York in 1954 and then arranged in 1969 for that collection, which had grown in the interim, to become part of the Metropolitan Museum of Art. Though Rockefeller was a knowledgeable collector, advice from René d'Harnoncourt on Pre-Columbian arts and, later, Robert Goldwater on African and Oceanic objects influenced acquisitions he made for himself and for his museum. Similarly, the collections of people such as Maxwell and Betty Stanley, Harrison Eiteljorg, Katherine White, John Friede, and Raymond and Laura Wielgus have formed the cores of major collections at the University of Iowa Museum of Art, the Indianapolis Museum of Art, the Seattle Art Museum, the Brooklyn Museum, and the Indiana University Art Museum.

The influence of private collectors has not always been for the best, however. Pre-Columbian arts are probably the most obvious example. Archaeologists and other scholars maintain that the willingness of many collectors to acquire objects of unknown provenance has encouraged the pillaging and looting of sites before proper excavations could be done, thus causing the irretrievable loss of information about the cultural contexts in which the objects were created. Until recently, this has not been a major issue in Oceania and Africa, where archaeological material has never been as abundant and fieldwork has been possible for more contemporary forms. However, widespread unauthorized excavations in areas in the vicinity of Jenne-Jeno in Mali and a ready market for the hundreds of clay and metal figures taken from there have prompted African-

ist archaeologists to echo the sentiments of their Pre-Columbian colleagues.

On a more positive note, private collections have helped to advance knowledge through museum exhibitions and their accompanying publications. This is particularly true for African art, where the greatest number of private collections have been published in exhibition catalogue form. In *Sculpture of Black Africa: The Paul Tishman Collection*, the catalogue of an exhibition by the same name, for example, authors Roy Sieber and Arnold Rubin (1968) suggested a new system for the stylistic analysis of African art based on historical and linguistic relationships. For a later exhibition of the same collection at the Metropolitan Museum of Art, curator Susan Vogel (1981) engaged 71 researchers to write about objects in their areas of specialization, resulting in a catalogue containing much information published for the first time. Likewise, in *African Art in Motion: Icon and Act*, the catalogue of an exhibition of the Katherine White Collection, Robert Farris Thompson (1974) offered far more than observations about a particular assemblage of objects, instead developing a theory of African aesthetics that has had continuing influence.

Raymond Wielgus

It is into this tradition of collecting that the Raymond and Laura Wielgus Collection of the Arts of Africa, Oceania, and the Americas must be placed. Raymond and Laura Wielgus are Chicago natives now living in Tucson, Arizona. While Laura shares her husband's appreciation for the sculpture they have collected, Raymond has been the driving force behind the acquisitions. From his personal and professional interests and training, he had an intimate knowledge of materials and techniques and an eye for detail. By combining these qualities with an interest in the relevant literature and looking at as many objects as possible, Wielgus developed a connoisseur's eye.

Most of the collection was formed between 1955 and 1975, and Wielgus no longer collects actively — he feels that the collection has matured, and, he adds, prices are now too high. In Tucson, he has pursued a new interest: the embellishment of firearms. Through painstaking processes involving the intricate inlay of gold and silver, the carving of grips out of ivory or precious wood, and often the reshaping of weapons themselves, he has created, according to Leonid Tarassuk, a prominent authority on arms and armor, "a new and original page in the history of arms decoration." Nonetheless, Wielgus is regularly called on by both museums and individual collectors for his opinion about an object's authenticity and aesthetic qualities. In addition, his acknowledged skill in displaying pieces to their best advantage has resulted in regular requests to do restoration work and make mounts.

Born in 1920, Raymond Wielgus grew up with an interest and skill in art and fine craftsmanship. Trained in making furniture patterns in his father's shop, he attended the School of Fine Arts at the University of Illinois, where his special interest was sculpture. After college, he joined a Chicago design and engineering firm as manager of its prototype model department, and, in 1949, he founded Wielgus Product Models. This small, guildlike business that emphasized quality produced prototype models for design organizations and industry.

One story that Wielgus relates about his company indicates the type of work for which it became known and also offers a telling clue about his own aesthetic sensibilities. A contact for one of the manufacturers for whom he made models told him that generally when a new prototype was presented to the board, it was identified as only a prototype, and the board was told that the production model would look much better. With a Wielgus model, however, executives had to explain that the board was being shown a one-of-a-kind item; those made in production would not look quite as good. Wielgus Product Models worked for a variety of businesses, sometimes making full working models, sometimes making only the shells to indicate what a product would look like. As a result, Wielgus acquired direct experience with many different materials and manufacturing techniques.

In 1955, he says, he was looking for a hobby. Claude Bentley, an artist friend who regularly visited Mexico, had Pre-Columbian objects in his studio that the Wielguses admired. They bought their first piece, a Mexican urn, from Bentley, partly, Wielgus says, because he "liked the idea of having something old." They acquired the urn without knowing anything about it; Wielgus then proceeded to do research that led him to conclude that the object was a fake. This made him realize the folly of buying without knowledge, but it did not destroy his enthusiasm for his newly acquired hobby.

Indeed, a few months later, his interest was piqued while watching a television program that included an interview with the dealer/collector Ladislas Segy, who showed examples of African and Oceanic art. This was not Wielgus's first encounter with African art; earlier,

some African figures illustrated in a book had interested him, and around 1946 he had carved a perfume bottle inspired by what he had seen. The television program, though, was a catalyst as far as collecting was concerned. It prompted Wielgus to contact Segy, thus beginning approximately 20 years of active collecting in the area of what at that time was called "primitive" art.

Wielgus's collecting was guided by certain principles, which are best summarized in his introduction to the 1960 catalogue of an exhibition of his collection held at the Museum of Primitive Art:

> My aim in collecting is not to amass a great number of pieces, but to acquire a small group of objects that combine three admittedly intangible characteristics: esthetic excellence, ethnographic or archaeological importance and that quality perhaps best described by the adjective "right."
> Esthetic excellence means for me that the piece is outstanding as art irrespective of type or time. Naturally this is an expression of personal taste and, as such, is bound up with the taste of one's time.
> I do not profess to scholarship and acknowledge my debt to specialists who, personally and through their publications, have educated me to estimate the cultural importance of a work.
> For a piece to be right it should, except in rare instances, be unimproved by cleaning, restoration or techniques of preservation. Further it should be traditional in style and content, a product of the mainstream of a culture uninfluenced by alien civilizations. Perhaps this quality is most easily recognized in its absence, for whenever the arts have become the battleground of cultural values in conflict there is a resultant indecisiveness of character, a loss of esthetic strength, a weakening of artistic purpose.
> The collection is in a process of continual modification; I do not feel irrevocably committed to any particular piece. Each work is open to reevaluation; it must constantly prove itself and be proved [Museum of Primitive Art 1960, 7].

It is important to remember that this was written in 1960. Raymond Wielgus's notions about what it takes for a piece to be "right" seem dated to scholars now, although even today some collectors would echo the same sentiments. On the other hand, his acknowledgment that aesthetic excellence is a subjective opinion and "bound up with the taste of one's time" sounds very contemporary.

The highest accolade that Wielgus gives an object is that it evokes within him an intense emotional response.

Recognizing that different people often respond differently to the same object, he says that a collector is lucky to find even a couple of objects to which he or she responds in that way over a lifetime of collecting. For him, the Angoram figure from the Sepik River area of Papua New Guinea (cat. no. 52) and the kneeling female figure (cat. no. 68), a product of Mexico's Olmec culture, are two such objects.

While most objects do not have such a powerful emotional effect on Wielgus, he appreciates them for other reasons, such as rarity or historical importance. In this group he places the figure from Teotihuacan (cat. no. 73), the first major urban center in the New World, and the nineteenth-century Edo mask (cat. no. 5). Much of the Polynesian material (cat. nos. 23-42) also fits into this category. However, Wielgus also feels a special affinity for many Polynesian objects. The great ones, he says, have a unique quality to their carving that separates them from much other ethnographic art. Usually small, they express their carvers' extraordinary sensitivity and have a softly worked quality that Wielgus particularly admires.

Wielgus's concern was never to amass a huge number of objects; in fact, he purposefully kept the size of the collection to approximately a hundred objects at any one time, a number he feels allowed him to appreciate individual objects without having the collection overwhelm him or his home. These objects were carefully displayed, usually on mounts of Wielgus's own design and fabrication. Some might even be packed away, offering opportunities for later reappraisals and allowing full attention to be devoted to those that were on view. Unlike such people as Paul Tishman, who collected with the aim of acquiring a group of sculptures representative of Africa's major styles (Sieber 1971, 135), Wielgus considered each object on its own merits as a work of art.

This emphasis on appreciating objects one at a time has meant that they have always been available for loans to special exhibitions; indeed, the exhibition record of Wielgus pieces extends from coast to coast and abroad, and includes such seminal exhibitions as the Museum of Primitive Art's *Bambara Sculpture from the Western Sudan* (1960), *Senufo Sculpture from West Africa* (1963), and *The Jaguar's Children* (1965), as well as *Art of the Pacific Islands* (1979) at the National Gallery of Art in Washington, D.C.; *Teotihuacan: City of the Gods* (1993) at the M.H. de Young Museum in San Francisco; and the Museum of Modern Art's *"Primitivism" in 20th Century Art* (1984).

As Wielgus's emphasis on selectivity might suggest, many objects have entered and left the collection. At one time or another, nearly four hundred African, Oceanic, Pre-Columbian, and Native American objects have been owned by him. While they were his, he constantly reevaluated each of them, not hesitating to eliminate those that he felt did not live up to his standards over time. A few were like his first Pre-Columbian acquisitions, about which he developed questions regarding their authenticity; most, however, were objects that he decided did not measure up to his first criterion, aesthetic excellence as an expression of his personal taste. Some of these are objects that most scholars would agree are not outstanding, but others are items that most experts would consider fine examples. Wielgus owned four or five Dogon figures, for example, before buying one (cat. no. 1) that completely satisfied him. Likewise, he disposed of a memorial figure from New Ireland that he had owned for several years when he was able to acquire one that he considered better (cat. no. 47). A Dogon figure of a musician was eliminated because Wielgus found himself thinking too much about what the music might sound like, which distracted from his appreciation of the piece as a work of art.

Objects were acquired from several sources. Most were bought or traded from established dealers, several of whom Wielgus dealt with extensively. In very few instances does he refer to the source of an object as "some runner whose name I don't know," even for objects that were relatively quickly eliminated from the collection. Many of the same dealers sold both Oceanic and African objects; few specialized in one or the other. For the most part, a different group of people dealt in objects from the Americas.

Most notable among the dealers with whom Wielgus did business were Allan Frumkin and J.J. Klejman; nearly half the objects in the current collection were acquired from one or the other. Primarily a dealer in contemporary art, Frumkin also sold Oceanic and African art in Chicago during the 1950s and 1960s. During biannual buying trips to Europe for prints, drawings, and paintings, Frumkin also looked for objects that might appeal to Wielgus and a handful of other ethnographic collectors, most of whom also collected modern art (personal communication, December 1994). Frumkin's personal interest was objects from the Pacific (ibid.), and some of the Wielguses' most remarkable Oceanic objects were acquired from him, such as the Austral Islands drum (cat. no. 27), the New Ireland memorial figure (cat. no. 47), and the Biwat flute figure

(cat. no. 54). But he sold Wielgus some outstanding African objects, too, including the Dogon and Lulua figures (cat. nos. 1, 18) and the Bamana antelope headdress (cat. no. 2).

John J. Klejman came to New York from Europe prior to World War II. After the war, he began dealing in ethnographic arts and became known for the quality of the objects he sold. Like Frumkin, he acquired many of them from Europe. He and Julius Carlebach, another New York dealer who had left Europe under similar circumstances, are the only dealers who are represented in each of the three regions making up the current Wielgus collection. Most of the Klejman pieces are Oceanic, such as the Tonga figure (cat. no. 23) and the Marquesan fan (cat. no. 34), but the Senufo and Hongwe figures from Africa (cat. nos. 3, 11) and the Columbia River valley adze from the Americas (cat. no. 95) indicate the breadth of his offerings.

Wielgus also made significant acquisitions from museums and from individuals who were primarily collectors. This was, of course, at a time when many museums did not hesitate to deaccession objects to individuals, particularly in trade. The most important object acquired from a museum in this way is the masterful Angoram figure from the Sepik River area of Papua New Guinea (cat. no. 52). Wielgus obtained it in 1959 in trade from the Field Museum of Natural History in Chicago for a rare Solomon Island shield, which he had acquired the year before. From individuals, perhaps the best example would be a mask from the Ijo peoples of eastern Nigeria (cat. no. 9), which was collected by the British colonial officer and ethnographer P. Amaury Talbot around 1916 and which Wielgus acquired from the Chicago collector James Alsdorf in trade for some West Mexican ceramics.

As with many collectors, Wielgus was never interested in collecting in the field. He has traveled to Mexico and New Zealand, areas represented in his collection, but these trips were "to see the sights," as he puts it. While there, he acquired a few souvenirs, most of which he no longer owns.

Wielgus's statement in the Museum of Primitive Art's 1960 catalogue acknowledges the importance of specialists in educating him about objects, but he never developed the kind of relationships some collectors do, whereby specialists seriously advise them on purchases. In fact, during the 1950s and 1960s, when most of the collection was formed, most specialists were searching for information as avidly as he was. For example, Allen Wardwell

(1990), former curator of primitive art at the Art Institute of Chicago and now senior consultant for ethnographic art at Christie's in New York, has acknowledged that he learned a great deal from weekly conversations with Wielgus when both were in Chicago. Roy Sieber, who received the first Ph.D. in African art history in the United States (in 1955 from the University of Iowa) and who has known the Wielguses for 40 years, mentions in the introduction to this catalogue that during his visits with Wielgus both would sharpen their eyes by comparing, evaluating, and judging objects in the Wielgus Collection and in book illustrations.

In addition, of course, Wielgus feels that forming a collection is — or should be — a very personal statement. He believed it important to draw his own conclusions about objects and sees that activity as part of the intellectual and emotional involvement required to make a great collection. "If you want to buy something simply to be admired by your friends and peers, you might as well buy a big car," he says.

During the course of his collecting, Wielgus also developed significant relationships with several museums. Close to home, the Art Institute of Chicago exhibited the Wielgus African collection in 1957. Wielgus objects were significant components in several important special exhibitions organized at that museum, particularly during Allen Wardwell's tenure as curator, such as the 1967 show *Sculpture of Polynesia*, which traveled to the Museum of Primitive Art, and *Art of the Sepik River* (1971). Since 1957, the Wielguses have made a number of gifts and loans to the Art Institute, and Raymond Wielgus still serves on one of its advisory committees. Additional gifts and loans were made to the Field Museum. Wielgus also became personally involved there, first as a volunteer specializing in restoration in the anthropology department. After selling his business in 1967, he held a full-time position as restorer of artifacts until he and his wife moved to Tucson in 1970.

It is not surprising that Wielgus also became involved with the Museum of Primitive Art. In 1960, the Wielguses' became the second private collection exhibited there. Later, Raymond Wielgus became the only lay person named a consulting fellow of the museum, joining such luminaries such as Africanist William Fagg and Pre-Columbianist Junius Bird. Wielgus admired the Museum of Primitive Art and what they were doing, an admiration that led him seriously to consider leaving the collection there. However, the 1969 agreement between Nelson Rockefeller and the Metropolitan Museum of Art was, in Wielgus's words, "the beginning of the end." While others noted with satisfaction that so-called "primitive" art was finally being acknowledged as on a par with the world's other great artistic traditions, Wielgus saw it — and his collection, if he gave it to a large museum — as being consumed and subsumed by the size and bureaucracy of such an institution.

Around this time, another potentially more attractive option appeared. Roy Sieber moved from the University of Iowa to Indiana University in 1962, and, as he had done when his friend was at Iowa, Wielgus began giving the university's art museum objects for its growing collection of the arts of Africa, Oceania, and the Americas. The foundation for Indiana's ethnographic collection had been laid under the museum's first director, Henry Hope, with gifts in 1959 from Frederick Stafford, but the collection was expanded dramatically during the 1970s by the museum's second director, Thomas T. Solley. Solley, though a collector of ancient and modern art, shared Wielgus's appreciation for fine craftsmanship and sculptural form. Through his and Roy Sieber's efforts, the Wielguses committed their collection and library to the Indiana University Art Museum. As a result, the arts of Africa, Oceania, and the Americas have become a major strength of the museum's collections. For the Wielguses, this has been an assurance that their objects will be displayed and given the prominence they so richly deserve.

References cited

Gerbrands, A.A. 1957. *Art as an Element of Culture, Especially in Negro-Africa*. Mededelingen van het Rijksmuseum voor Volkenkunde, no. 12. Leiden: E.J. Brill.

Grimes, John R. 1984. *The Tribal Style: Selections from the African Collection at the Peabody Museum of Salem*. Salem, Mass.: Peabody Museum of Salem.

Mount, Sigrid Docken. 1980. "African Art at the Cincinnati Art Museum." *African Arts* 13, no. 4 (August): 40-46, 88.
Museum of Primitive Art. 1960. *The Raymond Wielgus Collection*. Foreword by Robert Goldwater. Introduction by Raymond Wielgus. Exhibition catalogue. New York.

Peltier, Philippe. 1984. "[The Arrival of Tribal Objects in the West] from Oceania." In *"Primitivism" in 20th Century Art: Affinity of the Tribal and the Modern*, 1: 99-122. Edited by William Rubin. Exhibition catalogue. New York: Museum of Modern Art.

Sieber, Roy, and Arnold Rubin. 1968. *Sculpture of Black Africa: The Paul Tishman Collection*. Exhibition catalogue. Los Angeles: Los Angeles County Museum of Art.

Thompson, Robert Farris. 1974. *African Art in Motion: Icon and Act*. Exhibition catalogue. Berkeley and Los Angeles: University of California Press.

Vogel, Susan, ed. 1981. *For Spirits and Kings: African Art from the Paul and Ruth Tishman Collection*. Exhibition catalogue. New York: Metropolitan Museum of Art.

Wardwell, Allen. 1990. "Proven Objects: The Raymond and Laura Wielgus Collection." Lecture presented at Indiana University, April 4, 1990.

Zeidler, Jeanne, and Mary Lou Hultgren. 1988. "'Things African Prove to be the Favorite Theme:' The African Collection at Hampton University." In *Art/Artifact: African Art in Anthroplogy Collections*, 97-111. Exhibition catalogue. New York and Munich: Center for African Art and Prestel.

Note to the Reader

Within each world area, catalogue entries are arranged geographically.

For Africa, they are organized roughly west to east and north to south, beginning in Mali and ending in South Africa. Oceania is divided into Polynesia and Melanesia, with Polynesian entries beginning in central Polynesia and those from Melanesia beginning with Vanuatu and moving west to New Guinea. For the Americas, Pre-Columbian material is arranged from Mexico south; within each geographical area, objects are also subdivided chronologically from earliest to latest. The index on page 231 is intended to facilitate the finding of objects by particular ethnic groups or cultures.

All measurements are of the largest dimension (H., height; L., length; W., width; Diam., diameter).

Indiana University Art Museum accession numbers are listed for all objects now owned by the museum. In addition, Wielgus Collection numbers, designated by the prefix "RW," are indicated for all objects to which such a number was assigned.

Complete bibliographic citations listed at the end of each entry under "References cited" are to the books and articles mentioned in the text of that entry. In each instance, the "References cited" section is followed by relevant data about the object. Under "Published," each short reference corresponds to a complete citation in the Bibliography on pages 225-30. This bibliography contains only specific references to Wielgus objects.

An explanation of the abbreviations that appear under "Exhibited" can be found in the List of Exhibition Abbreviations on page 223-4.

Plates

Africa

Although the number of objects from Africa is the smallest of the three world areas represented in the Wielgus Collection, they clearly demonstrate the range and consistent discernment of Raymond Wielgus's taste, from the geometric simplicity of a Bamana antelope headdress (cat. no. 2) to a multimedia, heavily encrusted power figure from the Songye people of Zaire (cat. no. 19).

While no attempt was made to acquire a geographically representative selection from sub-Saharan Africa, the Wielgus objects are typical of most Western collections in that the largest number by far are from west and central Africa, the areas where figural traditions are the most prevalent. Also typical is the fact that most of the objects are figures and masks and are carved out of wood, often with other materials added and surfaces richly patinated from use. Unlike many other collections, however, the Wielguses' includes few objects with surfaces enlivened by polychromy. The lack of such pieces among ex-collection objects (see pp. 215-22) as well suggests that this is an expression of personal taste, an observation confirmed by Raymond Wielgus, who says that he generally prefers "sculptural" works.

Like much African art, the objects in the Wielgus African collection were meant to function in spiritual contexts or to emphasize the status or position of their owners. While it is convenient for outsiders to label and categorize them, African art objects, like great art worldwide, functioned on more than one level in their original contexts. Objects such as catalogue number 14, connected with the Lega Bwami association, an organization dedicated to the well-being of individuals and communities, for instance, serve not only as emblems of Bwami status but also as teaching devices for instruction in the moral and ethical principles that Bwami embodies.

When discussing African art, the term *spiritual contexts* is broadly intended not only to include situations meant to honor or appeal to deities but also to encompass many aspects of life and the supernatural which Westerners are less likely to see as directly related to the world of the sacred. These include, for example, contexts involving divination, the process whereby contact is established with the supernatural world in order to interpret the past and present and to foretell the future. The Montol figure (cat. no. 8), for instance, was used to help determine the causes of illnesses; the Pende oracle object (cat. no. 15) could determine who was guilty of a crime.

In most Western collections, the individual artists who made these objects are unknown, not because they were anonymous within their own communities or to their own patrons and clients, but rather because the people who collected their work most often did not inquire as to their identities. The idea that African artists were untrained fit very well with the Western myth of the "noble savage," as did the belief that Africans did not make or judge their objects according to aesthetic principles. Both of these notions are now recognized to be untrue, of course. Most African objects that are considered art in the West were made by people who were trained in their crafts, even if, as was most often the case, these crafts were only practiced part-time. Furthermore, aesthetic considerations are important for many Africans, though the principles by which they judge objects are not necessarily the same as those used in

the West. Comments made by Baule individuals about figures such as catalogue number 4 clearly demonstrate this point; admiration is consistently shown for figures with features that Westerners might tend to disregard, such as long necks and heavy calves.

Because of use patterns (most objects were not intended to last indefinitely) and environmental conditions (humidity and insects hasten the destruction of wood), most African wooden objects are presumed to have been made in the twentieth century, unless provenance information or technical analysis clearly indicates an earlier date. Information of the latter sort allows several Wielgus African objects to be assigned pre-twentieth-century dates with certainty.

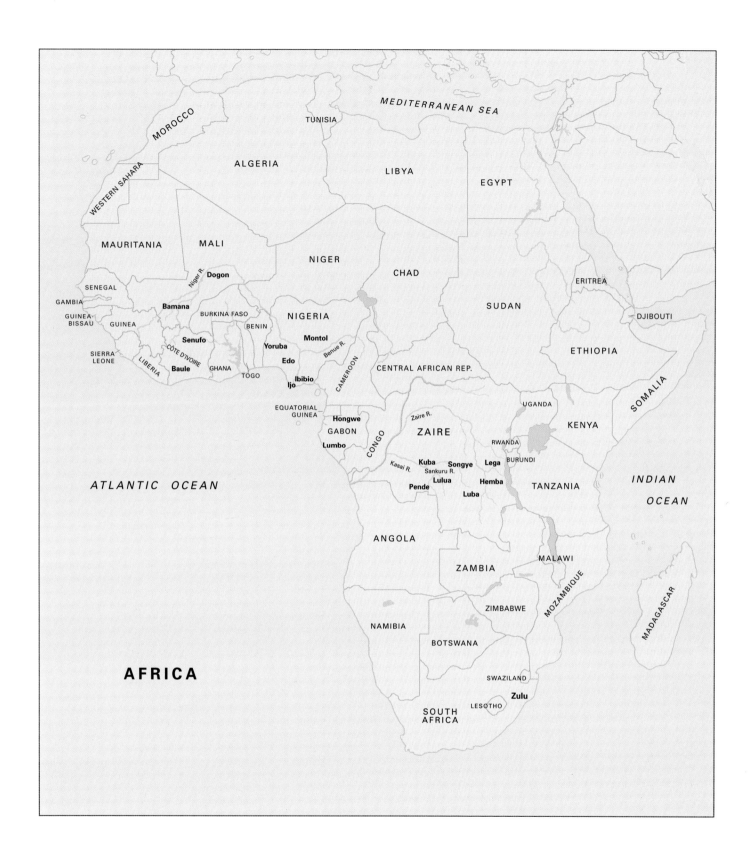

MEDITERRANEAN SEA

MOROCCO

TUNISIA

ALGERIA

LIBYA

EGYPT

WESTERN SAHARA

MAURITANIA

MALI

NIGER

CHAD

ERITREA

SUDAN

DJIBOUTI

SENEGAL

Niger R.

Dogon

GAMBIA

Bamana

GUINEA-
BISSAU

GUINEA

BURKINA FASO

NIGERIA

ETHIOPIA

BENIN

Senufo

Yoruba

Montol

Benue R.

CENTRAL AFRICAN REP.

SIERRA
LEONE

CÔTE D'IVOIRE

Edo

LIBERIA

Baule

GHANA

TOGO

Ibibio

Ijo

CAMEROON

SOMALIA

EQUATORIAL
GUINEA

Hongwe

Zaire R.

UGANDA

KENYA

GABON

ZAIRE

Lumbo

RWANDA

BURUNDI

ATLANTIC OCEAN

CONGO

Kasai R.

Kuba

Songye

Lega

Sankuru R.

INDIAN

OCEAN

Pende

Lulua

Hemba

Luba

TANZANIA

ANGOLA

MALAWI

ZAMBIA

MADAGASCAR

MOZAMBIQUE

ZIMBABWE

NAMIBIA

BOTSWANA

AFRICA

SWAZILAND

Zulu

LESOTHO

SOUTH
AFRICA

Dogon peoples, Mali

Male Figure

Sixteenth century (?)
Wood
H. 44 in. (111.8 cm)
IUAM 87.12 (RW 59-153)

Living in the dry, rugged Bandiagara cliffs of northeastern Mali, the Dogon have been among the most studied African peoples. Though some of their work has been controversial, the research of the French ethnographer Marcel Griaule and his colleagues, which was begun in 1931 and has continued to the present, has revealed a rich, complex culture based on an elaborate mythology (see Ezra 1988, 17 for a summary of criticisms and van Beek 1991 for a recent reevaluation of Griaule's work). In spite of extensive publications about the Dogon, however, a clear understanding of their sculpted figures remains elusive.

Dogon figures have been described primarily in relation to altars. They have been associated with lineage altars, dedicated to the founders of lineages and later members who have died; with altars dedicated to the spirits of women who have died in childbirth; with those dedicated to *binu*, mythic ancestors who lived before death came to humankind; with altars dedicated to increasing and strengthening an individual's personal force; and with rain-making altars (Ezra 1988, 21-22). While pointing out that the Dogon assume a great flexibility in the creation and maintenance of altars, Walter van Beek (1988, 58, 61-62), an anthropologist who worked among these peoples during the 1970s and 1980s, emphasizes the importance of individual and household altars, noting that in his experience those types, some lineage altars, and the *binu* altars are where figures are generally used.

Interpretations of Dogon figures by Griaule and his colleagues have identified them with Nommo, the first living being created by Amma (the Dogon creator), or with ancestors in general, but van Beek (ibid., 58, 60) asserts that they are representations of the people who commissioned them. In more general terms, the sculptures depict people who have problems for which supplications to Amma are made. In this way, the figures act as ever-vigilant intermediaries between Amma and people making supplications, always calling attention to the problems at hand.

Interpretations of the raised arms, one of the most common gestures among Dogon figures, vary. The gesture has most frequently been said to be an appeal for rain, which van Beek (ibid., 63) indicates is one possible explanation; a figure with raised arms, he observes, "generally ... indicates either a specific demand (often rain) or protection against danger and evil (e.g., spirits or sorcery)." The absence of all clothing, except for a belt, supports an explanation that the figure is praying, for that is the traditional manner in which Dogon religious leaders address the spiritual world (Leloup 1994, pl. 101).

Hélène Leloup (1988, 50), an African art dealer who has researched Dogon figures extensively, designates this figure as belonging to the Tintam style, named after a village in the northern Dogon region of Tombo. Figures in this style, she says, usually range from just over 31 inches to just over 39 inches in height, though some are almost 79 inches high and are "characterized by a full-bodied realism." This figure's lack of clothing, few ornaments (only bracelets are indicated), simplified hair, and scarification patterns on the torso are features consistent with the Tintam style.

The tentative sixteenth-century attribution is based on a carbon-14 test that was performed on a sample from this figure during the 1960s by Beta Analytic Laboratory (Raymond Wielgus, personal communication, March 1994). That test yielded a date of 1520 +/- 100.

References cited

Beek, Walter E.A. van. 1988. "Functions of Sculpture in Dogon Religion." *African Arts* 21, no. 4 (August): 58-65, 91.
————. 1991. "Dogon Restudied: A Field Evaluation of the Work of Marcel Griaule." *Current Anthropology* 32, no. 2 (April): 139-58, 165-67. (Responses to this article may be found on pp. 158-65 of the same issue and in 32, no. 4 [August-October]: 434-37; 32, no. 5 [December]: 575-77.)
Ezra, Kate. 1988. *Art of the Dogon: Selections from the Lester Wunderman Collection.* Exhibition catalogue. New York: Metropolitan Museum of Art.
Leloup, Hélène. 1988. "Dogon Figure Style." *African Arts* 22, no. 1 (November): 44-51.
————. 1994. *Dogon Statuary.* Translated by Brunhilde Biebuyck. Strasbourg: Daniele Amez.

Provenance: Acquired from Allan Frumkin (Chicago) in 1959

Published: Allan Frumkin Gallery [1959], cat. no. 1 (ill.); MPA 1960b, cat. no. 3; Arts Club 1966, cat. no. 1 (ill.); *African Arts* 1973, 54 (ill.); IUAM 1986, cat. no. 98 (ill.); Leloup 1988, fig. 8; Robbins and Nooter 1989, fig. 18; IUAM 1990a, 3 (ill.); Leloup 1994, pl. 103; Musée Dapper 1994, 26 (ill.)

Exhibited: Frumkin 1960, MPA 1960b, Arts Club 1966, Tucson 1976, IUAM 1993

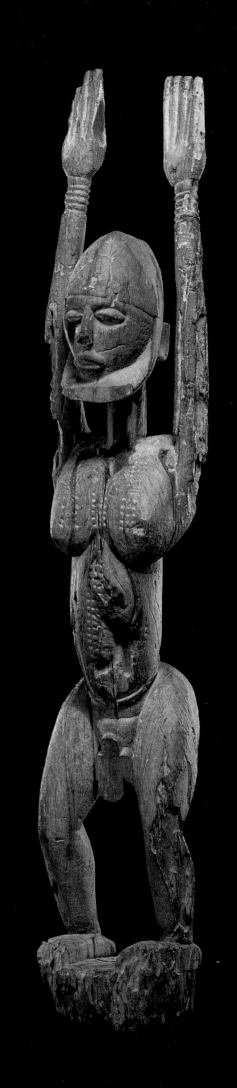

2

Bamana peoples, Mali

Antelope Headdress,
Ci Wara or Sogoni Kun

Wood
H. 20 in. (50.8 cm)
IUAM 87.24.3 (RW 56-36)

This antelope headdress, which was originally affixed to a basketry cap, is known as *ci wara* (also written *chi wara* or *tyi wara*), "farming beast," or *sogoni kun*, "little animal head." It was worn by a dancer during performances affirming the importance of agriculture for the Bamana people. As both James Brink (1981) and Pascal James Imperato (1970), researchers who have worked many years with the Bamana, have explained in detail, many levels of meaning, all revolving around the importance of agriculture, are associated with the words *ci wara*. For example, the term can refer to the Bamana cult concerned with agricultural fecundity; to the mythic figure who brought farming to the Bamana people; to a particularly proficient farmer or farming tool; to the primarily secular dance performances held today in celebration of successful agriculture; or to the songs, dances, and costumes — including headdresses such as this — that are parts of such performances. Like the *ci wara* headdress, *sogoni kun* also appears at agricultural festivals, though originally it was borrowed from the neighboring Wasulunke of southwestern Mali.

Both *ci wara* and *sogoni kun* appear in many southwestern Bamana villages (Imperato 1974, 19), and it is likely that the Wielgus antelope headdress is from the south. Based on a stylistic comparison with another collected and published by F.-H. Lem (1949, pl. 29), the Wielgus piece has been attributed to the Kinian area of the Kenedougou region in southern Mali (Museum of Primitive Art 1960, 40). A further comparison with one collected by Carl Kjersmeier ([1935-38] 1967, 1: pl. 6) in Dougoukolobougou, another southern village, strengthens the attribution. Finally, the combination of verticality, associated with headdresses from the eastern Bamana area, and simplified abstraction, a characteristic of southern *ci wara*, suggest that this headdress is likely to have originated in an area where both styles come together, perhaps a southeastern village.

Antelope headdresses are made by blacksmiths, who are also the Bamana carvers. Like all Bamana sculpture, they convey important ideas about Bamana aesthetics. Patrick McNaughton (1988, 107-9), an art historian who has worked with Bamana blacksmiths, has described several aesthetic concepts that apply to the Wielgus antelope. The elegant simplicity of the carving, which Westerners find so appealing, is embodied in the term *jayan*, which "connotes a quest for abstraction and reduction, in search of the real meaning of things" (ibid., 108). This form is enhanced by the addition of *nyègèn* (design), the incised decoration on this sculpture, and *jago* (added decoration), here indicated by the holes in the nose and ears for the attachment of red thread or metal rings.

References cited

Brink, James T. 1981. "Antelope Headdress (Chi Wara)." In *For Spirits and Kings: African Art from the Paul and Ruth Tishman Collection*, 24-25. Edited by Susan Vogel. New York: Metropolitan Museum of Art.
Imperato, Pascal James. 1970. "The Dance of the Tyi Wara." *African Arts* 4, no. 1 (Autumn): 8-13, 71-80.
————. 1974. *The Cultural Heritage of Africa*. Chanute, Kansas: Safari Museum Press.
Kjersmeier, Carl. [1935-38] 1967. *Centres de style de la sculpture nègre africaine*. Translated by France Gleizal. 4 vols. Paris: A. Morance; reprint ed., 4 vols. in 1, New York; Hacker Books.
Lem, F.-H. 1949. *Sudanese Sculpture*. Paris: Arts et Métiers Graphiques.
McNaughton, Patrick R. 1988. *The Mande Blacksmiths: Knowledge, Power, and Art in West Africa*. Bloomington: Indiana University Press.
Museum of Primitive Art, New York. 1960. *Bambara Sculpture from the Western Sudan*. Introduction by Robert Goldwater. Exhibition catalogue. New York: Museum of Primitive Art.

Provenance: Acquired from Allan Frumkin (Chicago) in 1956

Published: Layton 1957, cat. no. 13; AIC 1957a, cat. no. 16; MPA 1960a, fig. 60; MPA 1960b, cat. no. 5; Arts Club 1966, cat. no. 2; *African Arts* 1973, 51 (ill.); Zahan 1980, pl. 43, IM150; IUAM 1986, cat. no. 100 (ill.); McNaughton 1987, fig. 8; Robbins and Nooter 1989, fig. 57; Pelrine 1993, ill. 2

Exhibited: Layton 1957, AIC 1957a, MPA 1960a, MPA 1960b, Arts Club 1966, AIC 1969, IUAM 1989a, IUAM 1993

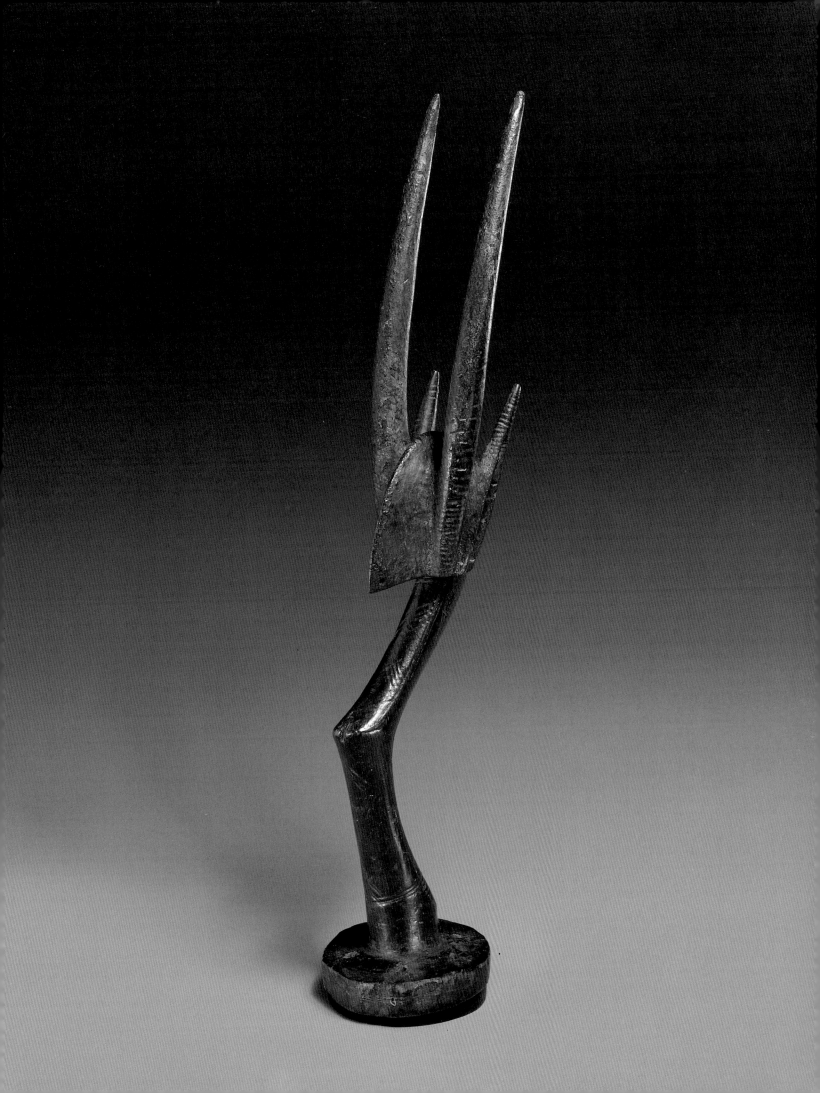

3

Senufo peoples,
Côte d'Ivoire / Mali / Burkina Faso

Female Figure

Wood, incrustation
H. 6 3/4 in. (17.1 cm)
IUAM 100.4.5.79 (RW 56-30)

Small in size but monumental in expressive power, this figure affirms a Western idea that great sculpture can withstand extensive damage without losing its power. Here, both legs are missing — destroyed in a fire, whether by accident or intentionally. In spite of this damage, the stylized features, use of basic geometric forms, and interaction of positive and negative space created by the position of the arms give the figure an architectonic presence.

We do not know precisely where in Senufo country the figure originated. However, Robert Goldwater (Museum of Primitive Art 1964, 25, caption to pls. 118, 118a) used stylistic comparisons to place it in the northern Senufo area, noting that squareness of face and shoulders, pointed breasts, short legs, and a conical belly with lines radiating from the apex are features shared by sculpture from this area. Anita Glaze (personals communication, February 1995), who has studied the Senufo for nearly thirty years, concurs, suggesting it is from an area she calls the "three-corners region," where Côte d'Ivoire, Mali, and Burkina Faso meet. Though the scarification marks in front of the figure's ears recall the Mossi of Burkina Faso, the pattern around the navel is an old Senufo one, as is the hairstyle. Furthermore, Senufo figures tend to be less naturalistic toward the north, and Glaze associates round ears, found on this example, with the three-corners region.

Senufo figures of similar size are generally part of male / female pairs used in Sandogo, a powerful women's divination society. Such figures, which average six to eight inches in height, are considered the physical representatives of the bush spirits (*madebele*) that are believed to be the chief source of a diviner's power, as well as the source of both success and misfortune for Senufo individuals. A male / female pair of figures is an essential part of a diviner's equipment (Glaze 1981, 62, 67). However, we cannot say conclusively that the Wielgus figure was for Sandogo, because lack of research in the three-corners region makes it unclear whether Sandogo is found that far north (Glaze, personal communication).

Further study of this region will not only shed light on the arts of the northern Senufo but will also have implications for understanding the history of Senufo art to the south. As Dolores Richter (1980, 81-87), an anthropologist working among the Senufo, has pointed out, the Kulebele, traditional carvers among the Senufo in Côte d'Ivoire, originated in Mali and migrated south to take advantage of markets for their products. Research currently being carried out by Boureima Diamitani in the Burkina Faso portion of the three-corners region may begin to offer a fuller understanding of the arts of the northern Senufo.

References cited

Glaze, Anita J. 1981. *Art and Death in a Senufo Village*. Bloomington: Indiana University Press.
Museum of Primitive Art. 1964. *Senufo Sculpture from West Africa*. Text by Robert Goldwater. Exhibition catalogue. New York: Museum of Primitive Art.
Richter, Dolores. 1980. *Art, Economics and Change: The Kulebele of Northern Ivory Coast*. La Jolla, Calif.: Psych/Graphic Publishers.

Provenance: Acquired from J.J. Klejman (New York) in 1956

Published: Layton 1957, cat. no. 17 (ill.); Think 1957, 18 (ill.); AIC 1957a, cat. no. 19 (ill.); MPA 1960b, cat. no. 6; MPA 1964b, pls. 118, 118a; Arts Club 1966, cat. no. 3; *African Arts* 1973, 52 (ill.)

Exhibited: Layton 1957, AIC 1957a, MPA 1960b, MPA 1963, Arts Club 1966, IUAM 1993

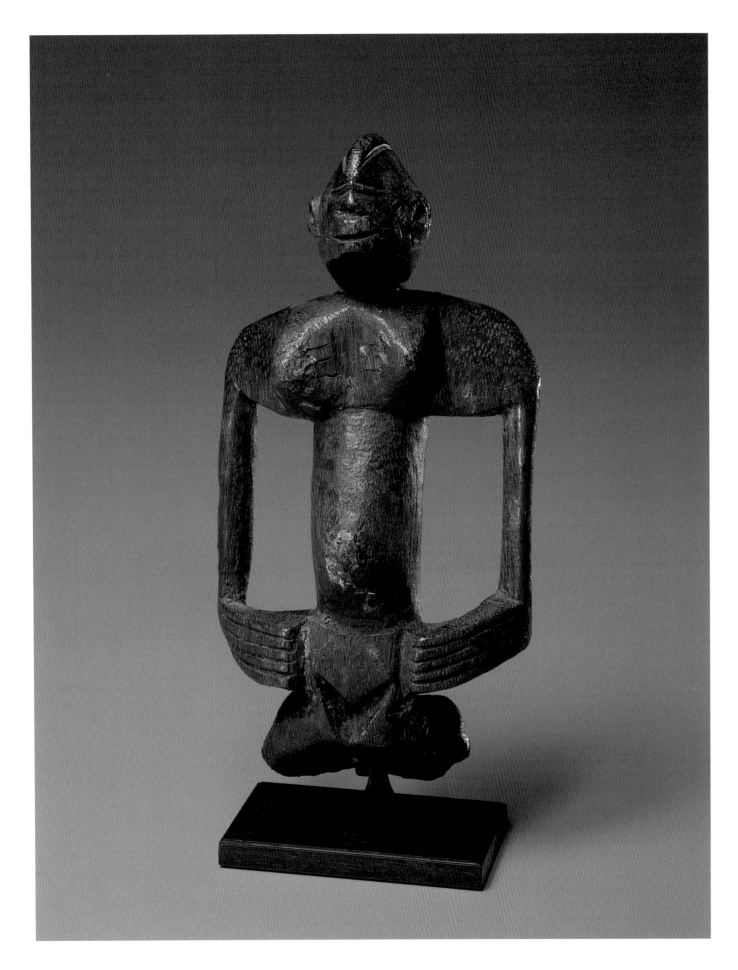

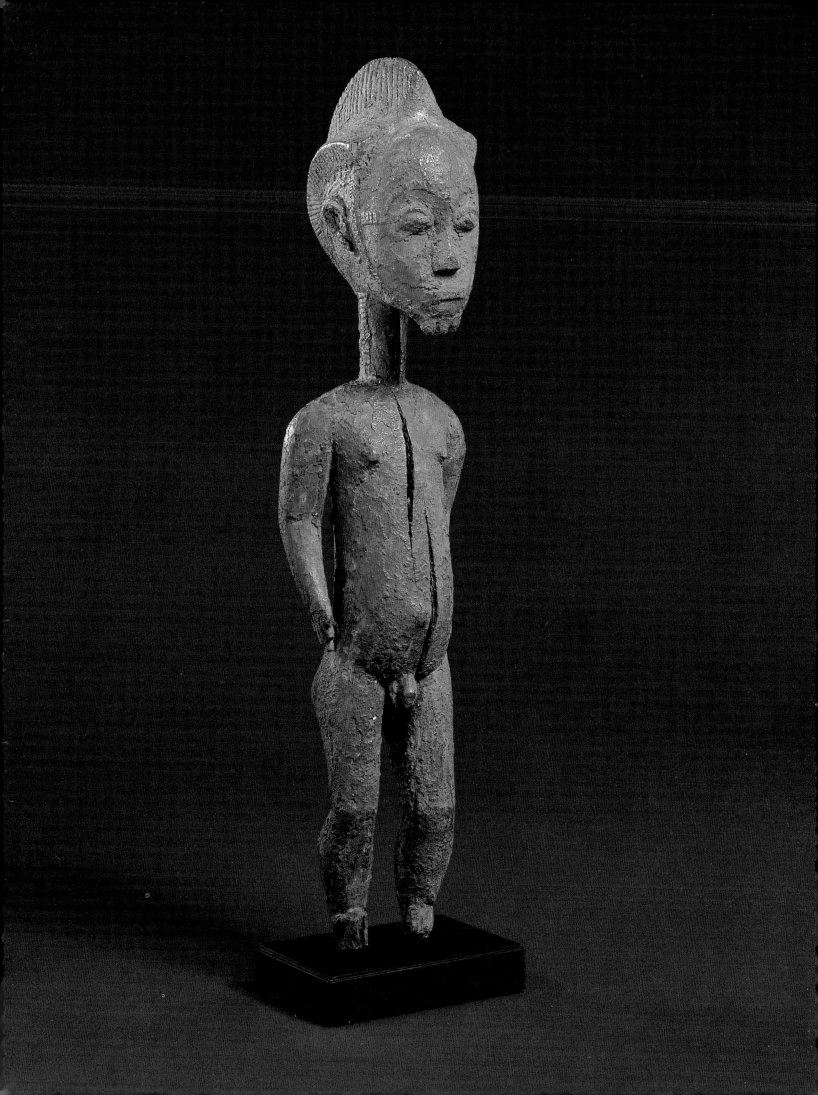

4

Baule peoples, Côte d'Ivoire

Male Figure, *Asie Usu (?)*

Wood, incrustation
H. 17 in. (44.1 cm)
IUAM 100.5.5.79 (RW 56-22)

Among the Baule, male and female figures under two feet in height act as intermediaries between people and two very different supernatural entities. Figures of spirit lovers (*blolo bian*, male, and *blolo bla*, female) serve as tangible points of contact between a man or a woman and his or her spirit mate of the opposite sex who resides in what the Baule call the "Other World" (Vogel 1977, 155-57; Ravenhill 1994, 9, 25-28). Earth spirits (*asie usu*), who are believed to reside in trees, streams, mountains, and other natural settings, are represented by similar figures, which are physical manifestations of alliances between the spirits and individuals. As a result of these alliances, those individuals may gain extraordinary powers, which may lead to their becoming professional clairvoyants who divine while in a trance (*komien*). Diviners may either keep their figures in private shrines or display them during divination (Vogel 1977, 163-68; 1980, 2-3; Ravenhill 1994, 23-24).

Though a *blolo bian / bla* and an *asie usu* may look identical when carved, differences in use patterns usually result in different appearances later on. The figures of spirit lovers are carefully tended; they are fed, washed, and given gifts of cloth and beads (Vogel 1973, 25; 1977, 153). Nature-spirit figures, on the other hand, receive sacrifices of eggs, animal blood, and other organic materials, which may be applied directly to them. While some *asie usu* figures, particularly those displayed to the public, may be kept relatively clean, others, especially ones kept hidden from public view, show the results of these offerings in the form of heavily encrusted surfaces, as in this example (Vogel 1973, 25; 1980, 3).

Like spirit lovers, nature-spirit figures are carved to reflect Baule ideals of beauty, since the Baule believe that a figure that is not beautiful may offend the spirit. Several characteristics make figures pleasing to the Baule. These include above all a sense of moderation or balance — no part should be over- or underdone. Specific features are also important: a neck that appears long by Western standards is admired as an indication of someone who can carry heavy loads on the head and is thereby able to perform his or her share of work; large calves also indicate physical strength (Vogel 1980, 3-18).

Carefully coiffed hair and scarification are also appreciated, for they place a figure within the Baule civilized world, being indications of human order imposed on nature. The high-crested hairstyle depicted on this figure is one that men stopped wearing around the 1930s, though it is still admired on sculpture today (Vogel 1988, 97, 99-101). The marks on the temples, though found among several different peoples, probably represent the oldest scarification pattern used by the Baule, who believe that scarification makes a person more beautiful; it apparently never established ethnic identity, nor did it indicate affiliation with a particular subgroup or area.

References cited

Ravenhill, Philip L. 1994. *The Self and the Other: Personhood and Images among the Baule, Côte d'Ivoire*. Exhibition catalogue. Los Angeles: Fowler Museum of Cultural History.
Vogel, Susan Mullin. 1973. "People of Wood: Baule Figure Sculpture." *Art Journal* 23, no. 1 (Fall): 23-26.
———. 1980. *Beauty in the Eyes of the Baule: Aesthetics and Cultural Values*. Working Papers in the Traditional Arts, 6. Philadelphia: Institute for the Study of Human Issues.
———. 1988. "Baule Scarification: The Mark of Civilization." In *Marks of Civilization*, 97-105. Edited by Arnold Rubin. Los Angeles: UCLA Museum of Cultural History.

Provenance: Acquired from Julius Carlebach (New York) in 1956

Published: Layton 1957, cat. no. 25 (ill.); AIC 1957a, cat. no. 22; MPA 1960b, cat. no. 9; Arts Club 1966, cat. no. 4; IUAM 1986, cat. no. 113 (ill.)

Exhibited: Layton 1957, AIC 1957a, MPA 1960b, Arts Club 1966, IUAM 1993

5

Edo peoples, Nigeria

Mask, *Ighodo*

Before 1897
Wood, incrustation, pigment, fiber
L. 24 in. (62.2 cm)
IUAM 78.11.2 (RW 57-71)

This very rare mask is for Igbile, a cult devoted to a water spirit, which, among the Edo, seems to be found only in Ughoton, the traditional river port for the kingdom of Benin. Igbile is said to have come to Ughoton from the Ijo via the Ilaje Yoruba (Fagg 1969, 122), and, indeed, the abstract quality of the face, its popping eyes and long nose, and the manner in which the mask was worn — horizontally as a cap on top of the head — relate it visually to the masks of the Ijo's Ekine society (see cat. no. 9).

Igbile is one of several Edo village cults; that is, it is not associated directly with the king and his court in the capital city of Benin. These village cults are dedicated to the health and well-being of community members and include annual ceremonies that involve the purification of the village and its protection from evil. They honor hero deities who came into serious conflict

with the Benin king, and so it is not surprising that they, as well as objects associated with them, including masks, are banned from the capital city (Ben-Amos 1980, 52-57; Bradbury [1957] 1970, 56).

This mask is one of seven or eight confiscated in 1897 at Ughoton (Gwatto), a village that was the major point of European trade with the Benin kingdom. In February of that year, the British Punitive Expedition began its march toward the city of Benin in retaliation for the murders of Englishmen who had, against the Benin king's wishes, attempted to visit him during a time devoted to certain ancestral rites. When the British landed in Ughoton, villagers brought out the masks with the hope of enlisting supernatural powers to drive away the expedition that was later to sack the kingdom's capital and take the king prisoner (Fagg 1969, 122).

William Fagg (ibid.), who visited Ughoton in 1958, reported that replacements based on the old masks had been made and noted that the name given to this one's newer version was *ighodo*, which he interpreted as "lizard." In 1976, Paula Girshick, an anthropologist who has worked for many years in Benin, visited the port and saw yet another group in use (personal communication, September 1993). Though brightly painted, the version of this mask that she documented (see illustration) shows the same distinctive features as this nineteenth-century example.

Igbile masquerader at Ughoton, 1976.
Photo: Dan Ben-Amos, courtesy Paula Girshick.

References cited
Ben-Amos, Paula Girshick. 1980. *The Art of Benin*. London: Thames and Hudson.
Bradbury, R.E. [1957] 1970. *The Benin Kingdom and the Edo-Speaking Peoples of South-Western Nigeria*. Ethnographic Survey of Africa: Western Africa, pt. 13. London: International African Institute.
Fagg, William B. 1969. *African Sculpture*. Exhibition catalogue. Washington, D.C.: International Exhibition Foundation.

Provenance: Collected in Ughoton, Nigeria, in 1897; ex-coll. Charles Ratton (Paris); acquired from Allan Frumkin (Chicago) in 1957

Published: Toledo 1959, fig. 97; MPA 1960b, cat. no. 12, pl. 5; Fagg 1961, pl. 40; Fagg 1963, pl. 106; Arts Club 1966, cat. no. 7; Fagg 1969, cat. no. 143 (ill.); *African Arts* 1973, 50 (ill.); IUAM 1980, 215 (ill.); Gillon 1984, fig. 178; Robbins and Nooter 1989, fig. 582

Exhibited: AIC 1957a, Toledo 1959, MPA 1960b, Munich 1961, Arts Club 1966, IEF 1970, IUAM 1993

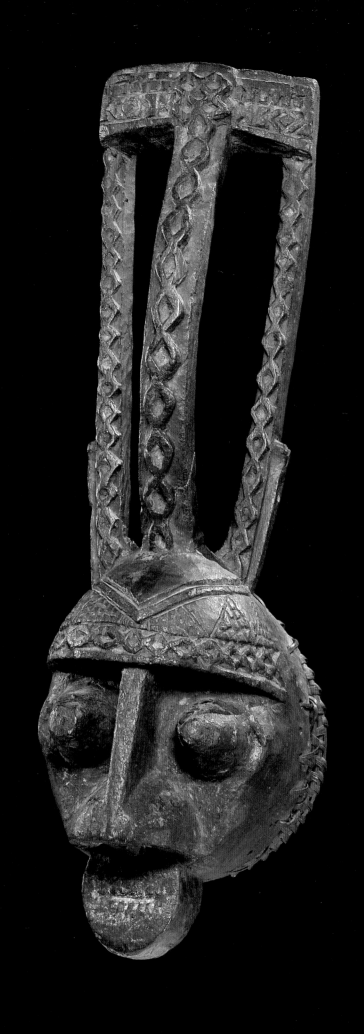

6

Edo peoples, Kingdom of Benin,
Nigeria

**Box in the Form of an Antelope
or Cow Head**

Wood, brass
L. 13 1/2 in. (34.9 cm)
IUAM 75.99.4 (RW 59-172)

This box was made to hold kola nuts,
the bitter, caffeine-containing seeds of
the kola tree. In many parts of Africa,
kola nuts serve as sacrifices in the spir-
itual realm and as hospitable gifts to
guests and dignitaries. Among the Edo,
such presentations often called for
elaborate containers for the nuts. Paula
Girshick Ben-Amos (1980, 78) has
noted that Edo chiefs present kola nuts
to the king in carved boxes such as this.
Although we do not know the precise
age of this example, the tradition is an
old one. The kingdom of Benin, which
flourished from the fourteenth century
until 1897, when its capital was sacked
by the British (see cat. no. 5), is known
for its elaborate court arts. Similar
boxes are depicted on metal plaques
that once decorated the king's palace
and that are believed to date to the six-
teenth and seventeenth centuries, and
examples in wood and ivory were taken
from Benin City during the Punitive
Expedition of 1897.

The head is either an antelope's or a
cow's. According to Ben-Amos (1976,
245), Edo people today disagree about
the animal's identity, perhaps because
they may never have seen such boxes.
However, she notes that, for the Edo,
both animals share traits that make
them appropriate for a kola-nut box:
they are beautiful, docile, of significant
value to people (as food), and used in
sacrifices to the gods. Two hands clutch
the animal's horns. For the Edo, as for
several other peoples of southern Ni-
geria, the hand symbolizes a man's
skill, strength, and power (Bradbury
1973, 261-66, 272).

The box was once covered with
brass, a material associated with royal-
ty. Much of it is now missing, however,
and that which remains has a patin-
ation that closely resembles the color
of the wood. Edo preference, however,
is for the metal to be kept brightly
polished, as it is then considered both
beautiful and able to drive away evil
forces (Ben-Amos 1980, 64).

References cited

Ben-Amos, Paula Girshick. 1976. "Men and
Animals in Benin Art." *Man* n.s. 11, no. 2
(June): 243-52.
————. 1980. *The Art of Benin*. London: Tha-
mes and Hudson.
Bradbury, R.E. 1973. *Benin Studies*. Edited by
Peter Morton-Williams. London: Oxford Uni-
versity Press.

Provenance: Ex-coll. Spink (London); acquired
from Allan Frumkin (Chicago) in 1959

Published: MPA 1960b, cat. no. 13; Arts Club
1966, cat. no. 8 (ill.); *African Arts* 1973, 50
(ill.); Sieber 1980, 192 (ill.); IUAM 1986, cat.
no. 119 (ill.)

Exhibited: MPA 1960b, Arts Club 1966, AFA
1980, IUAM 1993

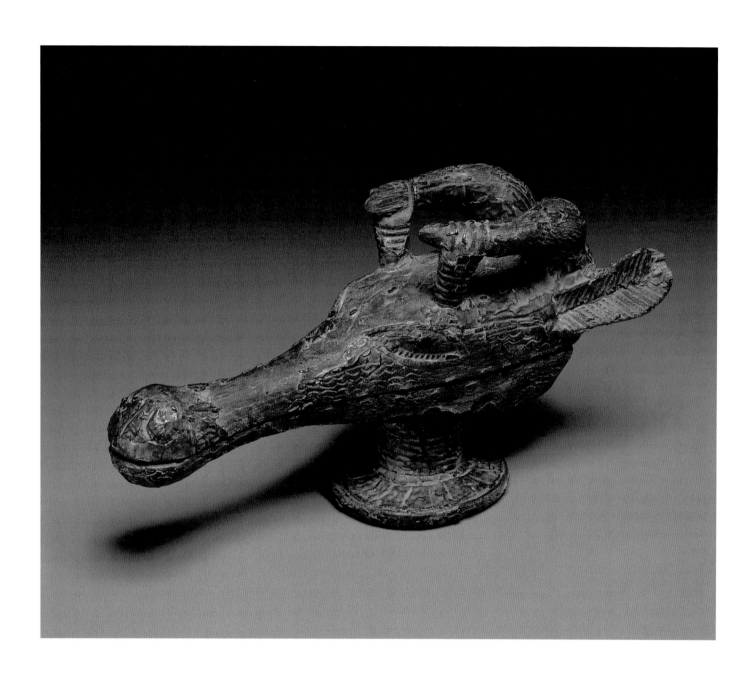

7

Yoruba peoples (Oyo subgroup),
Nigeria

Staff for Esu/Elegba Cult, *Ogo Elegba*

Before 1930s (?)
Wood, leather, cowrie shells, brass, bone, iron
H. 19 1/4 in. (50.7 cm)
IUAM 87.24.2 (RW 59-184)

One of the most prolific sculpture-
producing groups in Africa is the
Yoruba, a large ethnic group straddling
the border of southwestern Nigeria
and the Republic of Benin. Hundreds, if
not thousands, of deities (*orisa*) inhabit
their pantheon, but Esu (also written
Eshu), trickster and messenger, is one of
the few that is associated with sculpture
of prescribed forms recognized all over
Yorubaland (Wescott 1962, 337). One
of several types of figural sculpture
dedicated to Esu, this staff would have
been kept with other paraphernalia in
an Esu shrine. During celebrations
honoring the deity, however, it would
have been hooked over the right shoul-
der of a male devotee as he danced
(Thompson 1971, 4/2).

Esu is a deity of contrasts and contra-
dictions. As messenger of the gods,
he conveys sacrifices from the human
world. As a trickster, he frequently
makes them necessary, by tricking
people into offending the deities and
quarreling among themselves (Wescott
1962, 337). He is generally associated
with unrestrained sexuality, aggression,
and power. Shrines dedicated to Esu are
found at places of potential conflict —
crossroads, markets, and the entrances
to homes.

Esu's position as an *orisa* of contrasts
is visually expressed in this staff by the
white cowrie shells that contrast with
the darkened sculpture; black and white
are emblematic of this deity. In addition,
the cowrie shells, valued by peoples all
over Africa, at one time were used as
currency and thus serve as a reminder
of Esu's involvement with economic
affairs and the conflicts they often
engender.

The figure's distinctive long-tailed
hairdo also immediately associates it
with Esu. A similar hairstyle is worn
by Esu's priests, and among the Yoruba,
as among many peoples throughout the
world, long hair is associated with
sexual license and aggressive behavior.
The small bone comb that is attached to
a cowrie strand emphasizes Esu's vanity
and the importance of this hairdo to
him. The small calabashes carved along
the top of the hair represent containers
for herbal medicines, a reference to the
deity's supernatural powers.

The figure blows a whistle similar
to ones used to summon Esu during
festivals. Associated with masculinity,
the whistle also refers to the contrary
aspect of the deity's personality. Though
children are told not to whistle for fear
of provoking evil spirits, and whistling
is forbidden in palaces because of
sexual associations (ibid., 347), Esu the
provocateur is perfectly happy to do so.

In correspondence with a private
Parisian collector who owns a similar
figure apparently by the same hand,
Roy Sieber (personal communication,
June 1993) suggests that this figure
dates no later than the 1930s and is
likely earlier.

References cited

Thompson, Robert Farris. 1971. *Black Gods
and Kings: Yoruba Art at UCLA*. Exhibition
catalogue. Los Angeles: University of Califor-
nia Museum and Laboratories of Ethnic Arts
and Technology.
Wescott, Joan. 1962. "The Sculpture and
Myths of Eshu-Elegba, the Yoruba Trickster:
Definition and Interpretation in Yoruba Icono-
graphy." *Africa* 32, no. 4 (October): 336-54.

Provenance: Purchased by Roy Sieber (Bloom-
ington, Indiana) from a dealer in Oyo, Nigeria,
1958; acquired from Sieber in 1959

Published: Toledo 1959, cat. no. 83 (ill.); MPA
1960b, cat. no. 14; Fagg 1961, pl. 48; Dräyer
and Lommel 1962, pl. 26; Fagg 1963, pl. 97;
Arts Club 1966, cat. no. 5; *African Arts* 1973,
55 (ill.); IUAM 1986, cat. no. 122 (ill.); Zimmer-
man 1990, 14 (ill.); McNaughton and Pelrine
1995, pl. 58

Exhibited: Iowa 1959, Toledo 1959, MPA
1960b, Munich 1961, Arts Club 1966, Lowie
1967, Tucson 1976, IUAM 1993

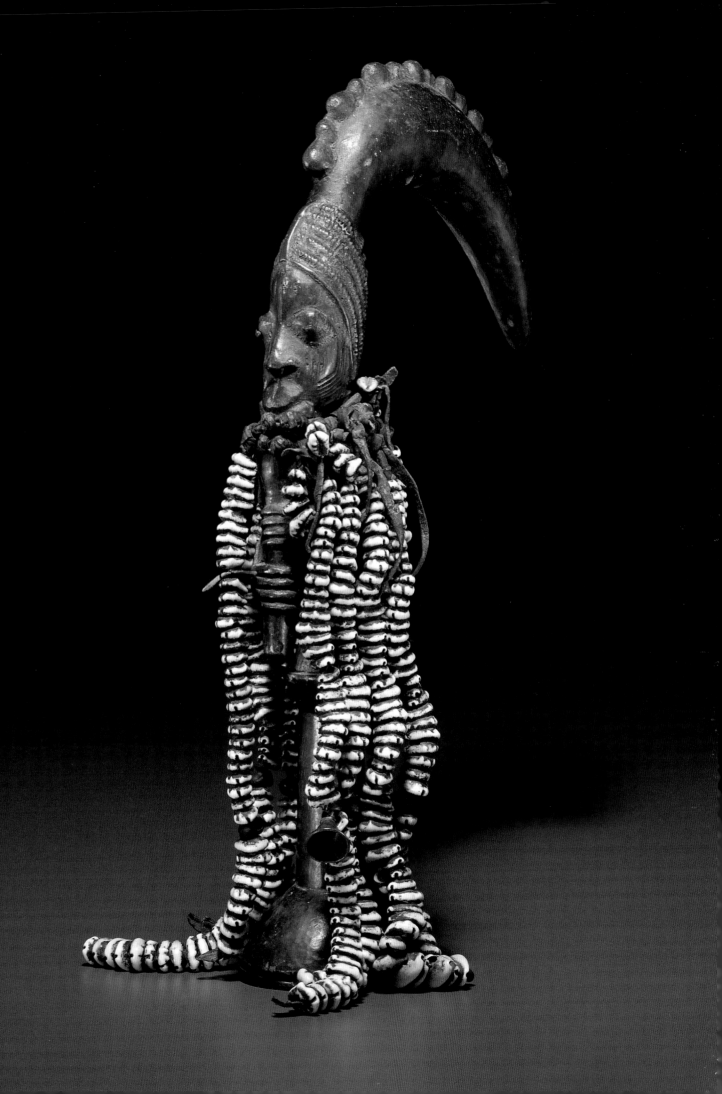

8

Montol peoples, Baltip village,
Nigeria

Female Figure

1950
Wood, pigment
H. 15 in. (38.1 cm)
IUAM 100.10.5.79 (RW 60-206)

One of the most widely published Wiel-
gus African objects, this figure became
in the 1960s the most frequently illus-
trated example of sculpture by the Mon-
tol, who live in eastern Nigeria, north
of the Benue River. However, while the
simplicity of the carving is characteristic
of Montol figures, the monumental
presence and powerful expressiveness
of this sculpture, evoked by the arched
posture and sharply angled arms, set it
apart from others from this area.

The Montol remain to this day a
group about which little is known, and
Roy Sieber's groundbreaking *Sculpture
of Northern Nigeria* (1961) is still the
primary source for information about
their art. According to Sieber (10, 12),
most figures are made for Komtin, a
men's association concerned with
healing and herbalism. Members use
figures such as this in divining the
causes of illnesses, a practice that is
shared with a number of neighboring
peoples, such as the Goemai.

We do not know why this figure is
female (some are male, others are of
indeterminate sex) or why it has been
rubbed with a reddish-orange powdery
pigment (some figures are dark and
shiny). Nor can we explain the signifi-
cance, if any, of the small patch of or-
ganic mastic near the left shoulder,
which apparently once had several abrus
seeds stuck to it. Aside from a predilec-
tion for simple forms, many aspects of
Montol carving seem to be left to the
preferences of individual carvers, and
therefore it is difficult to associate
specific features with an identifiable
Montol style (Roy Sieber, personal com-
munication, February 1994).

Sieber collected this figure in Lalin,
but its owner told him that it had been
carved by an artist in nearby Baltip.
Sieber (1961, 12) cites other instances
in which figures' carvers and owners
were from different villages or ethnic
groups, and, indeed, this is a fairly
common occurrence throughout the
continent, as artists' reputations spread
and people travel or move about.

Reference cited

Sieber, Roy. 1961. *Sculpture of Northern Nige-
ria*. Exhibition catalogue. New York: Museum
of Primitive Art.

Provenance: Collected by Roy Sieber (Bloom-
ington, Indiana) in Lalin, Nigeria, 1958; ac-
quired from Sieber in 1960

Published: Toledo 1959, fig. 103 (ill.); MPA
1960b, cat. no. 16; Fagg 1961, pl. 68; Dräyer
and Lommel 1962, pl. 44; Fagg 1964, pl. 37;
Fagg and Plass 1964, 58 (ill.); Fagg 1965, 45
(ill.); Arts Club 1966, cat. no. 11; Leiris and
Delange 1967, pl. 359; Trowell and Never-
mann 1968, 18 (ill.); Fagg 1969, cat. no. 53
(ill.); *African Arts* 1973, 53; *Primitive Art*
1979, 268 (ill.); Rubin 1984, I: 37 (ill.); IUAM
1986, cat. no. 128 (ill.); Sieber and Walker
1987, cat. no. 34 (ill.); Pelrine 1993, ill. 1

Exhibited: Iowa 1959, Toledo 1959, MPA
1960b, Munich 1961, Berlin 1964, Arts Club
1966, IEF1970, MOMA 1984, NMAA 1987,
IUAM 1993

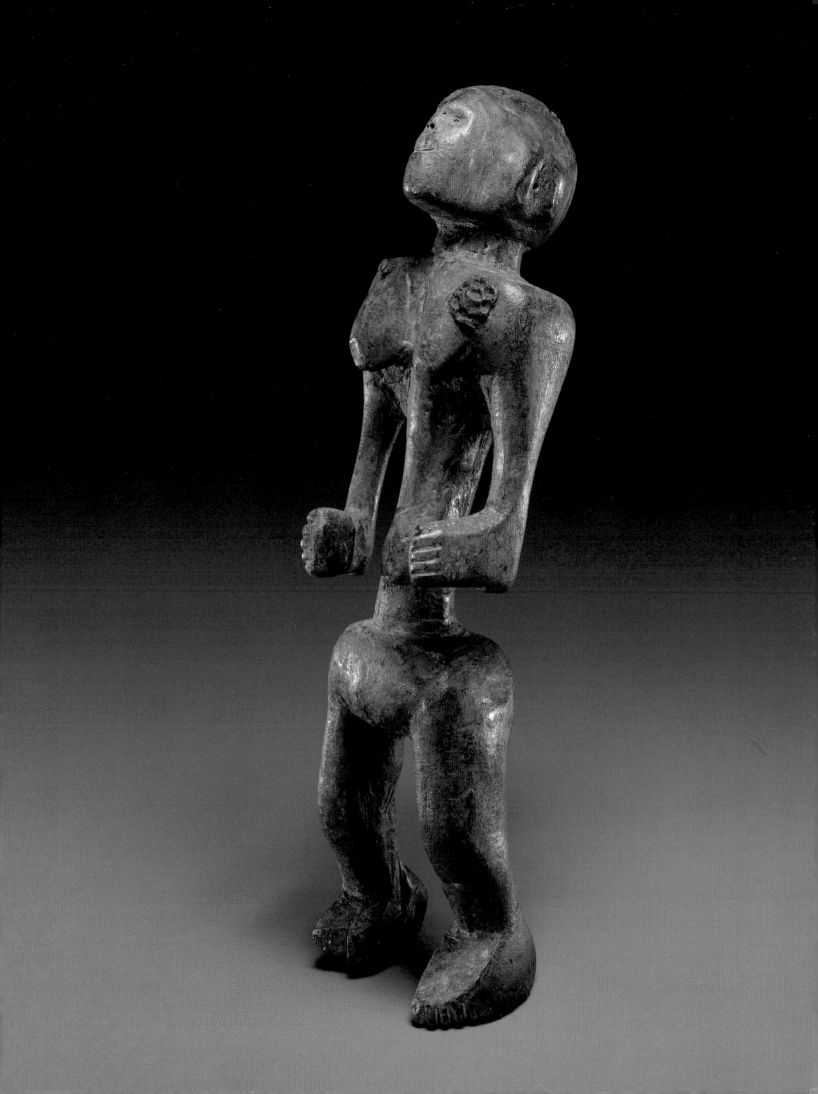

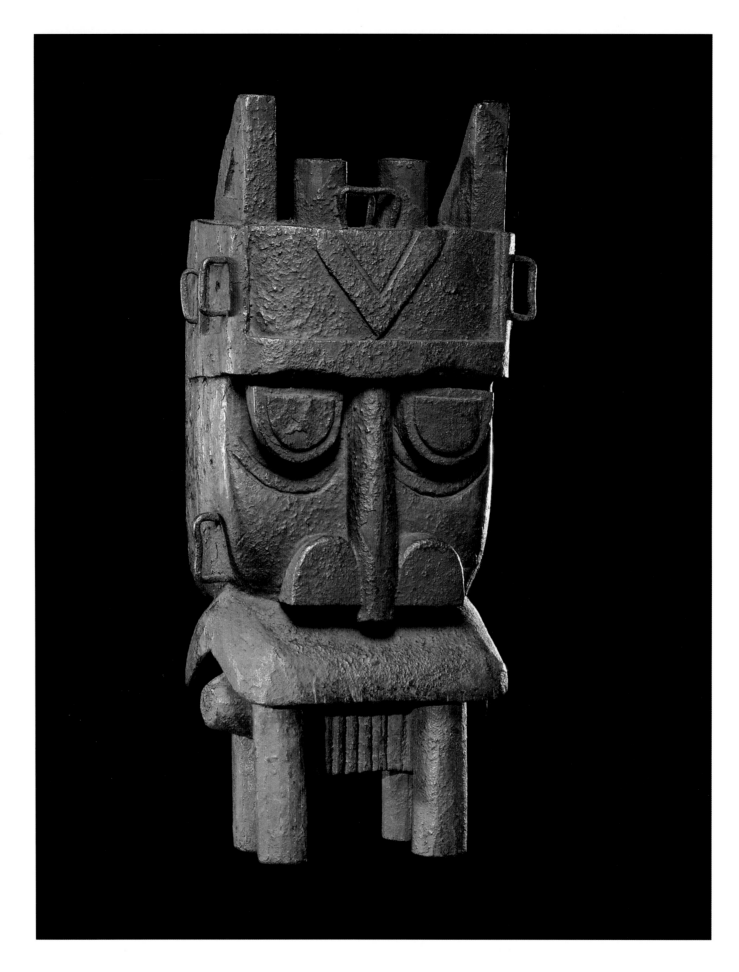

9

Ijo peoples (Kalabari subgroup), Degama area, Nigeria

Hippopotamus Mask, *Otobo*

Collected ca. 1916
Wood, incrustation, pigment
H. 18 1/2 in. (47 cm)
Raymond and Laura Wielgus Collection
(RW 57-56)

The Kalabari Ijo peoples, who live in the delta of the lower Niger River, follow a two-part belief system, consisting of aloof supernatural forces concerned with creation and a more accessible group of forces consisting of ancestors, deceased village heroes, and water spirits. Sculpture is an important component in rituals connected to the supernatural world, and it is not surprising that water-related imagery appears frequently.

Ceremonial life includes important rituals related to honoring and appeasing water spirits *(owu)*, who were believed responsible for ensuring the Ijo's food supply and their fertility. The dancing of masquerades representing water spirits is the prerogative of the men's Ekine (or Sakapu) association (Horton 1965, 2). These masquerades appear as part of a multiyear ritual cycle, which consists first of ceremonies honoring ancestors and deceased village heroes. P. Amaury Talbot (1930, 307-20), an early twentieth-century British colonial officer and ethnographer, described a series of thirty-six masquerade plays, of which *otobo* is the fourth. These plays "hold up a mirror to everyday life and allow men to stand back and contemplate the experiences they are normally most deeply involved in," according to Robin Horton (1965, 2), an anthropologist who has done extensive work among the Kalabari.

All water spirits are believed to be similar, and all are thought to conform to Kalabari cultural ideals by being outgoing, ambitious, and generous (Anderson 1983, 97). While a mask is not believed to house the spiritual aspect

(teme) of a spirit, as a Ijo shrine figure does, masks are said to represent particular water spirits.

Although this mask's name, *otobo*, means "hippopotamus," its appearance combines features of that powerful aquatic mammal with those of a human. This reflects a Kalabari belief that water spirits have both human and animal elements and can materialize in either form (Horton 1965, 35). When worn, the mask was positioned on top of the head and decorated with feathers and cloth.

Between 1914 and 1918, in response to a Christian revivalist, some Kalabari destroyed their masks and figures. A few were saved by Talbot (Jones 1984, 164); this mask may have been among those. Raymond Wielgus acquired it in 1957 from James Alsdorf, a Chicago collector, in a trade for three West Mexican Pre-Columbian ceramic figurines. The mask's right tusks have been damaged by insects and restored.

References cited

Anderson, Martha. 1983. "Central Ijo Art: Shrines and Spirit Images." Ph.D. dissertation, Indiana University.
Horton, Robin. 1960. *The Gods as Guests: An Aspect of Kalabari Religious Life*. Lagos: Nigeria Magazine.
———. 1965. *Kalabari Sculpture*. Lagos: Department of Antiquities.
Jones, G.I. 1984. *The Art of Eastern Nigeria*. Cambridge: Cambridge University Press.
Talbot, P. Amaury. 1932. *The Tribes of the Niger Delta*. London: Sheldon Press.

Provenance: Collected by P.A. Talbot ca. 1916; ex-colls. British Museum (London), Webster Plass (London); acquired from James Alsdorf (Chicago) in 1957

Published: Royal Anthropological Institute 1949, cat. no. 43; Fagg 1953, cat. no. 87; Allen Memorial Art Museum 1955, cat. no. 40 (ill.); Munro 1956, 28 (ill.); Paulme 1956, pl. 16; Plass 1956, cat. no. 17-A (ill.); Sotheby 1956, cat. no. 121, pl. 9; AIC 1957a, cat. no. 26; Elisofon 1958, fig. 177; MPA 1960b, cat. no. 10; Fagg 1961, pl. 56; Dräyer and Lommel 1962, pl. 35; Paulme 1962, pl. 16; Fagg 1963, pl. 109; Arts Club 1966, cat. no. 6; University Prints [1970], N80; Willett [1971] 1991, fig. 168; *African Arts* 1973, 55; Bascom 1973, pl. 60; Rubin 1984, 1: 124 (ill.); Sieber and Walker 1987, cat. no. 33 (ill.); Kerchache, Paudrat, and

Stéphan 1988, pl. 102; Robbins and Nooter 1989, fig. 691

Exhibited: London 1948, London 1949, London 1951, London 1953, Brooklyn 1954, Allen 1956, Pennsylvania 1956, AIC 1957a, MPA 1960b, Munich 1961, Arts Club 1966, Lowie 1967, Tucson 1976, MOMA 1984, NMAA 1987, IUAM 1992, IUAM 1993

10

Ibibio peoples (Anang subgroup), Nigeria

Mask for Ekpo Society

Wood, pigment, incrustation, fiber
H. 11 1/2 in. (31.9 cm)
IUAM 87.24.1 (RW 61-231)

Two types of masks, depicting the beautiful and the fierce or ugly, are worn by a number of peoples living in southeastern Nigeria, including the Ibibio, as well as the Igbo, Ijaw, Ogoni, Idoma, Igala, and Ejagham. Among the Ibibio, these masks are the prerogative of the Ekpo ("Ghost") society, a men's association dedicated to propitiating ancestors for the good of the community, upholding the powers of the elders, and maintaining social order (Murray 1949, nos. 30-48). During annual celebrations, members perform masquerades representing a village's ancestors.

The two mask types are a study in contrasts. The fierce or ugly type, such as this example, are called *idiok ekpo* and represent people who were immoral and evil and who therefore were transformed at death into ghosts and forced to wander the world for eternity. The masks have coarse, misshapen, or diseased features and are painted black or dark colors. The masquerader's body is blackened with charcoal, and black raffia covers much of his torso. He moves aggressively and may seem out of control, shaking and speaking unintelligibly; he usually appears at night. According to G.I. Jones (1984, 183), a British ethnographer, most Ekpo society masks are of this fierce or ugly type. Beautiful masks (*mfon ekpo*), on the other hand, have delicate features, are painted white or light colors, and represent ancestors who led moral, upright lives. Such a masquerader, who wears undyed raffia and long, colored cloths, moves slowly and gracefully and appears during the day (Murray 1949, nos. 30-48; Messenger [1973] 1989, 120-21).

In addition to its black color and coarse features, the Wielgus mask has several other characteristics often found on fierce masks. The open mouth suggests the threat of aggression (Nicklin 1988, 165), which is reinforced by the spikiness of the beard. Scarification marks at the temples and between the eyes are not indicative of the *idiok ekpo* type, but are found on many of these masks. This is also true of the ring around the top of the head, which has been interpreted on other masks as an insignia of membership in Idiong, a diviners' cult (ibid.).

Masks made today are most often painted with enamel, and the absence of such pigment is an indication that this one is old. Instead, locally made paint was used. Messenger ([1973] 1989, 111, 112) reports that before imported paints became available, black was obtained from mixing charcoal with the sap of a particular tree, while red came from the sap of another kind of tree. He further notes that a mask might last 20 years if repainted and oiled annually and stored away from termites. The uneven surface of the Wielgus example suggests that it was repainted many times.

This mask is from the Anang, a group renowned as carvers, who also made masks for other Ibibio subgroups as well as for the neighboring Igbo. Jones (1984, 174) has pointed out that "the style which is usually called Ibibio was concentrated in a single local area, that of the Anang, who were probably the most gifted artistically of all Eastern Nigerian people."

References cited

Jones, G.I. 1984. *The Art of Eastern Nigeria.* Cambridge: Cambridge University Press.
Messenger, John C. [1973] 1989. "The Carver in Anang Society." In *The Traditional Artist in African Societies*, 101-27. Edited by Warren L. d'Azevedo. Midland Book edition. Bloomington: Indiana University Press.
Murray, Kenneth C. 1949. *Masks and Head-dresses of Nigeria.* Exhibition catalogue. London: Zwemmer Gallery.
Nicklin, Keith. 1988. "Face Mask." In *African Art from the Barbier-Müller Collection*, 165. Edited by Werner Schmalenbach. Munich: Prestel.

Provenance: Acquired from Allan Frumkin (Chicago) in 1961

Published: Arts Club 1966, cat. no. 9; Fagg 1969, cat. no. 157 (ill.); Butler 1970, 159 (ill.); *Time* 1970, 46 (ill.); *African Arts* 1973, 53 (ill.); IUAM 1986, cat. no. 126 (ill.); Robbins and Nooter 1989, fig. 699

Exhibited: Arts Club 1966, IEF 1970, IUAM 1993

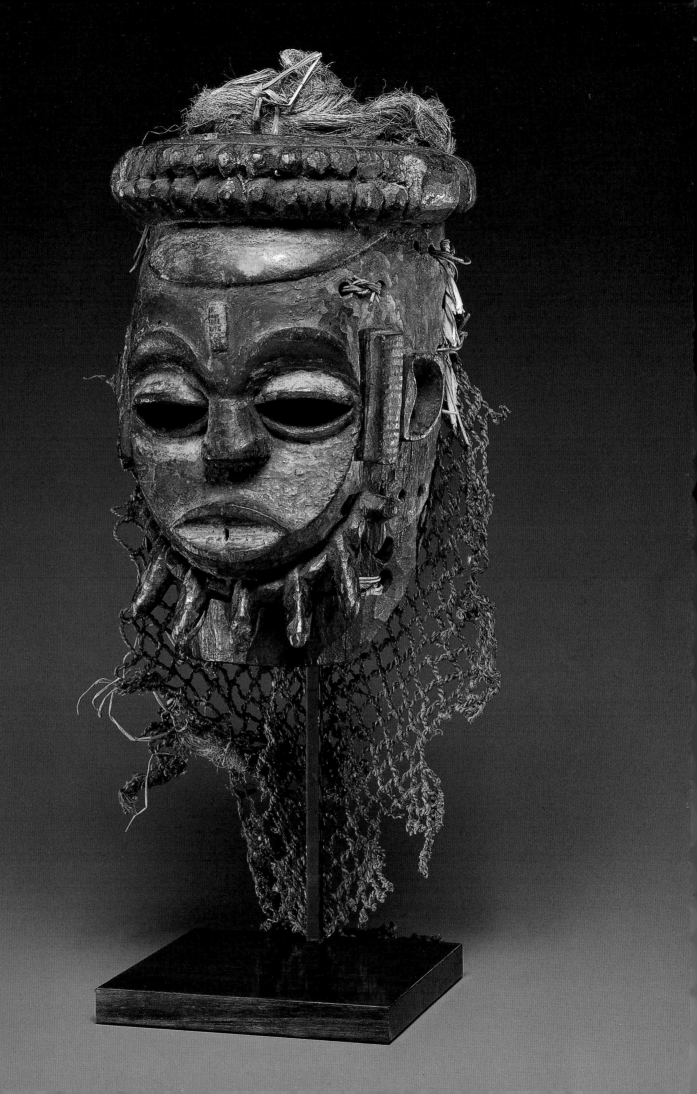

11

Hongwe peoples, Mekambo area, Gabon

Reliquary Figure, *Bwiiti*

Wood, brass
H. 23 in. (55.9 cm)
Raymond and Laura Wielgus Collection
(RW 55-19)

A variety of reliquary figures used in cults devoted to ancestors are perhaps the best-known sculptures from Gabon and are among those African objects clearly admired by Raymond Wielgus, as a list of his ex-collection objects (see pp. 215-22) indicates. Although first taken to Europe in 1875, figures such as this one remained little discussed until they were brought to the fore in 1967, when more than 20 recently collected examples were exhibited in Paris. Since then, publications by Leon Siroto (1968), Louis Perrois (1976), and Alain and Françoise Chaffin (1979) have examined the figures from stylistic, historical, and cultural perspectives. The ethnic group among whom these objects originated remains unclear, however; indeed, they are said to have been used by several different peoples, though Westerners seem now consistently to attribute all figures of this type to the Hongwe, who some researchers regard as a subgroup of the Kota.

This figure was part of a cult called *bwiiti* (also written *bwete*), which is also the term by which the figures are known. Like many African peoples, the Hongwe traditionally believed that death did not destroy the powers that important people held. Though transferred to the spiritual world, those powers could continue to help or harm the living, and *bwiiti* ensured, through sacrifices and prayers, that they had positive effects.

To this end, skulls, certain bones, and other relics of important family members, such as religious specialists, heads of families, artists, and women who had given birth to many children, were preserved (Siroto 1968, 27). These objects were placed in bark containers or baskets with figures such as this one. The figures were intended both to honor the ancestral spirits and to protect the relics from physical and supernatural harm.

Reliquary containers were usually kept in the houses of the heads of families or in special shelters and were appealed to by the individual families that owned them. They also were brought out and displayed to a wider audience on certain important occasions, such as the initiations of young men or the death of a village chief. At those times, men may have taken the figures from their containers and danced with them (ibid., 27, 88; Perrois 1976, 24). Perrois (1976, 25) notes that sometimes a reliquary container might hold a larger figure with one or two smaller ones. He also says that the larger ones (more than 12 inches in height), of which this is an example, represent clan founders, and the smaller ones are descendants.

Except for size, the figures show little variation. All heads have narrow horizontal strips of copper or brass covering a wooden base in a blade or foliate form, which might be a reference to the display weapons that were owned by leaders and that were a symbol of their status (Siroto 1968, 86). The distinctive knob at the top of the large figures depicts a hairstyle common in the nineteenth century. The small raised patterns above the eyes resemble scarification practiced in the area, while the thin strips placed on each side of the narrow nose may refer to scarification, a beard, or, possibly, elephant hairs that men wore through the nasal septum (ibid., 87). The figures have no mouths. Patterns on the handles vary, and whether they have significance beyond decoration is uncertain.

It is entirely fitting that objects intended to honor ancestors should be covered with brass or copper, precious metals in much of central Africa. These metals were imported into Gabon from European sources as early as the sixteenth century, in the form of bars, rolls of wire, and the neptune, a wide basin that was made in several sizes (ibid., 86; Perrois 1976, 34). In addition to its value as a prestige material, the brass's bright color may have been thought to have been especially effective in combatting witchcraft, which is believed to be most powerful at night (Siroto 1968, 87).

References cited

Chaffin, Alain, and Françoise Chaffin. 1979. *L'Art kota: Les Figures de reliquaire*. English translation by Carlos E. Garcia. Meudon, France: Alain and Françoise Chaffin.
Perrois, Louis. 1976. "L'Art kota-mahongwe: Les Figures funéraires des populations du bassin de l'Ivindo (Gabon-Congo)." *Arts d'Afrique noire*, no. 20: 15-37.
Siroto, Leon. 1968. "The Face of the *Bwiiti*." *African Arts* 1, no. 3 (Spring): 22-27, 86-87, 96.

Provenance: Ex-coll. Pierre Vérité (Paris); acquired from J.J. Klejman (New York) in 1955

Published: Rousseau and Diop 1948, fig. 5; *African Folktales and Sculpture* 1952, pl. 142; *Chefs-d'œuvre* 1952, cat. no. 88 (ill.); Sieber 1956, cat. no. 102 (ill.); Layton 1957, cat. no. 38; *Think* 1957, 18 (ill.); AIC 1957a, cat. no. 35; MPA 1960b, cat. no. 17, pl. 1; Huet 1963, 97 (ill.); Arts Club 1966, cat. no. 12; Balandier 1966, fig. 37; Bolz 1966, pl. XLIIIA; Fröhlich 1966, pl. XLIII, 4; Bascom 1967, cat. no. 127; Siroto 1968, fig. 35; Fagg 1969, cat. no. 70 (ill.); *New Bulletin* 1969, 8 (ill.); Kan 1970, 36 (ill.); Sieber and Walker 1987, cat. no. 78 (ill.); Robbins and Nooter 1989, fig. 894

Exhibited: Leleu 1952, Reattu 1954, Volney 1955, Iowa 1956, Layton 1957, AIC 1957a, MPA 1960b, Arts Club 1966, Lowie 1967, IEF 1970, Tucson 1975, NMAA 1987, IUAM 1993

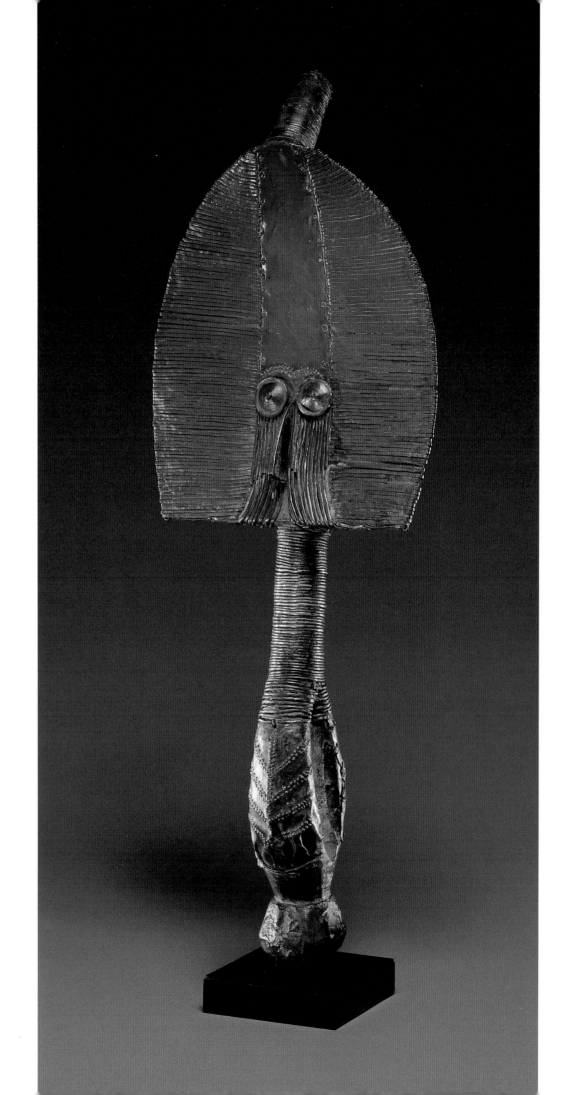

12

Lumbo peoples, Gabon

Amulet

Wood
H. 4 3/8 in. (11.1 cm)
IUAM 87.24.5 (RW 63-248)

13

Lumbo peoples, Gabon

Spoon Handle in the Form of a Mother and Child

Wood
H. 5 1/2 in. (13.6 cm)
IUAM 75.99.5 (RW 63-249)

Living in southern Gabon in the area of the Nyanga River, the Lumbo are one of several groups, including the Punu and Shira, that are best known for elegant white-faced masks. Though these masks have been much admired in the West, the complexity of this area and the dearth of published in-depth field research have contributed to a lack of understanding about the meaning and significance of the arts from this vicinity. (Recent research among the Punu by Alisa LaGamma will certainly help remedy this situation.)

The Wielgus figures exemplify the same delicacy, elegance, and refined carving that are so appreciated in the white-faced masks. The figures' faces and the masks share certain features: carefully delineated coiffures, rounded foreheads, broad noses, protruding lips, coffee-bean-shaped eyes, and thin, arching eyebrows. Scarification, usually indicated on the masks, is absent from the faces of the figures, though it is depicted on the shoulders and chest of the amulet. Perhaps most attractive to Western viewers are the smooth surfaces and deep, rich patination, which suggest much handling and attention.

Louis Perrois (1986, 90), an ethnologist who has published extensively on the art of Gabon, says that small figures (just over three inches to approximately four and three-quarter inches), usually

female, were carved to protect their owners from sorcery. Some of these figures were apparently worn (ibid., 90, 199) and were therefore pierced for hanging. Others, including the Wielgus amulet, are pierced at the bottom and may have been attached to other objects, such as whistles (*Ouvertures* 1986, cat. no. 9). Alisa LaGamma (personal communication, January 1995) confirms that kneeling figures such as the Wielgus piece did indeed serve a protective function. She notes that though wooden protective figures are no longer made, figures in a similar style are carved from soft stone for sale.

The bottom of the spoon handle indicates that it, unlike the amulet, was cut from a larger object. The Lumbo and others in the area carved spoons with handles topped by figures of approximately the same size as this one (Roosens 1967, pl. 84; Perrois 1986, 91, 197; Siroto 1991, 130-31), suggesting a likely original form. The asymmetry of the sculpture sets it apart from much African art and creates a sense of informality, even playfulness, which is reinforced by the way the child hangs on to his mother's head. Like most depictions of children in African art, this one is shown as a miniature adult. The mother, who balances him on one shoulder, presumably reached up with her left arm, now broken (as are his legs); she holds a calabash in her right hand. We do not know the significance of the calabash; however, they are commonly used as containers for palm wine, as well as holders for herbal medicines, throughout sub-Saharan Africa.

References cited

Ouvertures sur l'art africain. 1986. Exhibition catalogue. Paris: Editions Dapper.
Perrois, Louis. 1985. *Ancestral Art of Gabon from the Collections of the Barbier-Müller Museum.* Translated by Francine Farr. Geneva: Barbier-Müller Museum.
Roosens, Eugeen. 1967. *Images africaines de la mère et l'enfant.* Publications de l'Université Lovanium de Kinshasa, 21. Louvain and Paris: Editions Nauwelaerts and Béatrice-Nauwelaerts.
Siroto, Leon. 1991. "Cuillers de l'ouest africain équatorial." Translated by Jeanne Bouniort. In *Cuillers sculptures*, 107-40. Exhibition catalogue. Paris: Museé Dapper.

Provenance: Acquired from J.J. Klejman (New York) in 1963
Published: Arts Club 1966, cat. nos. 13, 14; IUAM 1986, cat. nos. 136, 137 (ill.)
Exhibited: Arts Club 1966, IUAM 1993

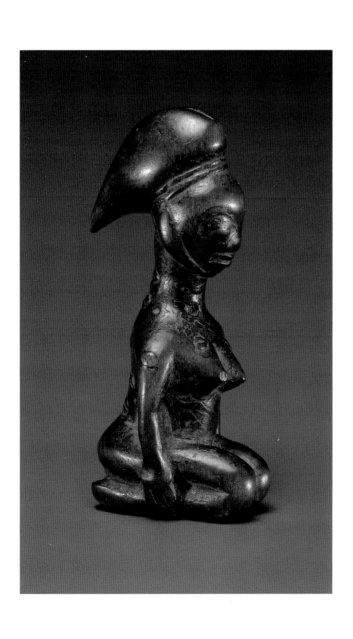

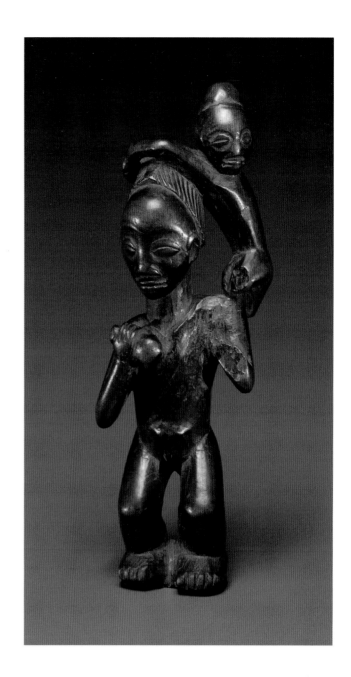

Lega peoples, Zaire

Figure for the Bwami Association,
Kakulu Kamwenne Kumasengo (?)

Wood, shells, wax or resin
H. 11 1/2 in. (29.2 cm)
Raymond and Laura Wielgus Collection
(RW 60-208)

This figure served as an initiation teach-
ing device for the highest level in the
Bwami association, a Lega organization
that provides political and social struc-
ture and stability for a community and
that offers spiritual and moral ideals
toward which individual members
strive. Bwami is composed of several
levels — the exact number varies from
area to area — and initiation into each
one requires fees; presents; distributions
of food; certain activities such as hunt-
ing, preparing salt, and house building;
certain sequences of songs and dances;
and the display and manipulation of
certain objects. Although Bwami is
open to all circumcised Lega men and
their wives, only a few reach its highest
levels, positions that carry status, privi-
lege, authority, and fame, as well as
many duties.

This sculpture belongs to a category
of human figures over four and a half
inches tall called *iginga* (pl., *maginga*),
meaning "that which sustains." Men of
the highest Bwami grade, called *kindi*,
own at least one *iginga*, which is usually
inherited. Most large wooden figures
such as this one, however, are owned
not by individuals but collectively, by
members of various subgroups within
a Bwami level. Daniel Biebuyck (1973,
161), who has studied the Lega for over
40 years, notes that *maginga*, whether
collectively or individually held, are
considered the "heart" of *kindi*.

All Bwami objects remind members
of proverbs and axioms related to living
moral, exemplary lives. Biebuyck (ibid.,
220) points out that most often mean-
ings associated with Bwami objects
depend on specific circumstances, and
therefore one can only be sure of a fi-

gure's meaning if it was collected from
the owner; however, he also explains
that certain forms do seem to be asso-
ciated generally with certain names and
meanings. Ones with bent back and
knees, such as this figure, may be called
Kakulu kamwenne kumasengo, which
Biebuyck (1986, 77) translates as "Big-
One who has seen [i.e., who is in pos-
session of] the initiation objects is bent
[or bends himself] under them [i.e.,
under their weight]." Biebuyck (ibid.;
1973, pl. 64 caption) explains that the
figure refers to an old Bwami member
who not only has his own initiation
objects but who also, because of his po-
sition, holds in trust objects that be-
longed to members who have died and
that will be passed on to appropriate
individuals when they reach certain
Bwami levels. Therefore, though this
man is old, he should be taken care of,
because he is very powerful.

As with many Bwami figures, this
one depicts several features admired by
the Lega. Its smooth, shiny surface
reflects ideas about male beauty: skin
should be blemishless and regularly
oiled. The head is depicted without
hair, just as a proper Bwami member
keeps his head shaved; the cowrie on
the figure represents the skullcap that
should be worn by a member at all
times. The large feet, though not neces-
sarily thought to be attractive in reality,
refer to the strength and power asso-
ciated with Bwami members.

References cited

Biebuyck, Daniel. 1973. *Lega Culture*. Berke-
ley: University of California Press.
————. 1986. *The Arts of Zaire. Volume 2:
Eastern Zaire*. Berkeley: University of Califor-
nia Press.

Provenance: Acquired from Julius Carlebach
(New York) in 1960

Published: MPA 1960b, cat. no. 21 (as 60-207);
Arts Club 1966, cat. no. 21 (ill.); Sieber and
Walker 1987, cat. no. 50 (ill.); Horn 1987, 67
(ill.); Robbins and Nooter 1989, fig. 1239;
McNaughton and Pelrine 1995, pl. 66

Exhibited: MPA 1960b, Arts Club 1966, Tucson
1975, NMAA 1987, IUAM 1993

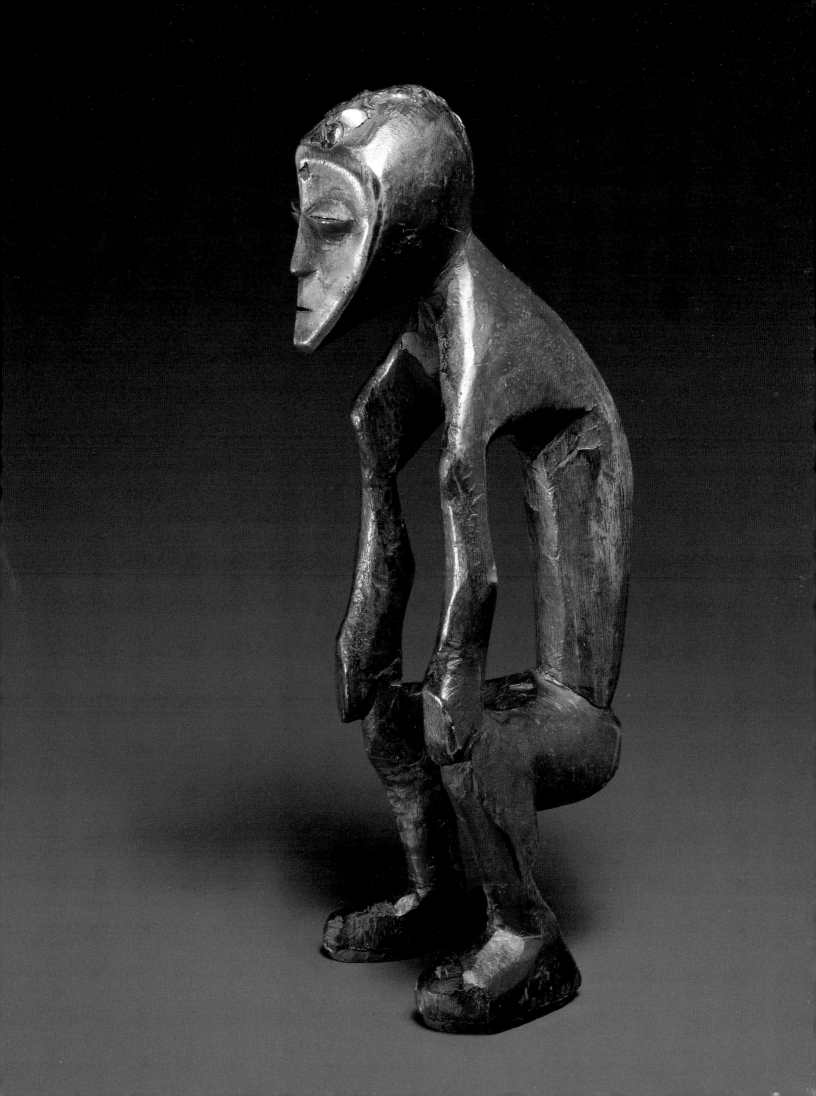

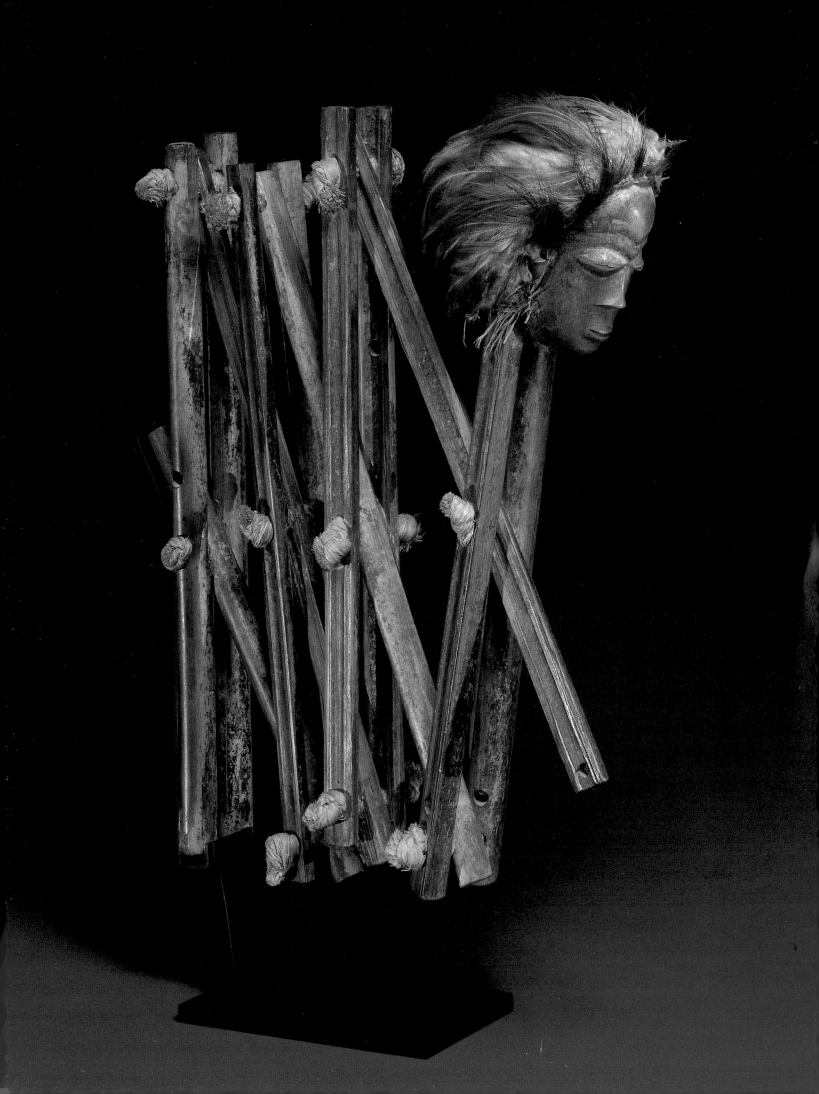

15

Pende peoples, Zaire

Divination Instrument, *Galukoshi*

Wood, fiber, feathers
H. approx. 9 in. (22.9 cm);
h. of face 3 1/2 in. (8.9 cm)
Promised Gift to the Indiana University Art
Museum by Mr. and Mrs. Kelley Rollings in
Honor of Raymond and Laura Wielgus
(RW 60-209)

Many people in sub-Saharan Africa, including Pende of southwestern Zaire, believe that certain individuals have the ability to communicate with supernatural forces that determine the course of events in the lives of people on earth. Through these communications, generally known as divination, people feel they are able to uncover the invisible forces affecting their lives and ascertain the best course of action to take under those circumstances. In addition, divination enables people to identify individuals who have harnessed supernatural energies for antisocial purposes and who have committed crimes.

The process of divination involves a specialist who follows standardized practices and draws from an extensive body of knowledge (Peek 1991, 2). Often he or she uses an object or objects through which the communication occurs. Bones, stones, or shells may be thrown, for example, and the patterns in which they fall have certain meanings. In central Africa, one of the best-known forms of divination is the rubbing or friction oracle, in which a diviner rubs one object across another while praying or reciting names or other appropriate formulas. An interpretation of the question or problem at hand is based on the point at which the object sticks or stops as it is being rubbed.

Rubbing oracles are found among the Pende, but Léon de Sousberghe (1958), who has written the standard monograph on Pende art, has noted that, at least among the western Pende (those between the Kwilu and Loange rivers), another type of object, the *galukoshi*, is much more common. As this

example illustrates, it is composed of a wooden face at the end of a series of crossbars that are tied together in such a way that they can be compressed or extended. The face, usually two and three-quarters to four inches high, is adorned with a headdress made of rooster or guinea-fowl feathers. According to de Sousberghe (ibid., 81), a diviner held the instrument on his lap with the head at the top and inserted a finger between the crossbars. A person's guilt would be indicated when, at the mention of his or her name, the head of the *galukoshi* would move up toward the face of the diviner.

The face on this *galukoshi*, as on most, is in the clearly identifiable Gatundo (also written "Katundu" or "Gatundu") style. Although this style originated in the western Pende chiefdom of the same name, it became extremely popular, particularly in this century, and spread to other Pende areas. It is characterized by a rounded forehead, unbroken eyebrow line, delicate up-turned nose, heavily lidded eyes, and prominent cheekbones. Among Westerners, the Gatundo style is most frequently associated with wooden *mbuya* masks, which appear for entertainment and at ceremonies connected with boys' initiations. However, as the Wielgus Collection demonstrates with this object and with catalogue number 16 (a cup), Gatundo faces also appear on a variety of other types of objects.

References cited

Peek, Philip M. 1991. "Introduction: The Study of Divination, Present and Past." In *African Divination Systems: Ways of Knowing*, 1-22. Edited by Philip M. Peek. Bloomington: Indiana University Press.
Sousberghe, Léon de. 1958. *L'Art pende*. Brussels: Académie Royale de Belgique.

Provenance: Acquired from Henri Kamer (Paris/New York) in 1960; Wielgus traded to Claire Zeisler (Chicago); sold from Zeisler estate at Christie's auction to Mr. and Mrs. Kelley Rollings (Tucson)

Published: Christie's 1994, no. 143 (ill.)

16

Pende peoples, Zaire

Cup

Wood, pigment
H. 5 3/8 in. (13.7 cm)
IUAM 87.24.7 (RW 61-228)

17

Kuba peoples, Zaire

Cup

Wood, cowrie shells, copper
W. 7 in. (17.8 cm)
IUAM 87.24.6 (RW 55-8)

Palm wine, a mildly intoxicating beverage fermented from the sap of certain palm trees, is a favored drink on ritual and social occasions for men and women in many parts of sub-Saharan Africa. Among a number of peoples of central Africa, men, and sometimes women, traditionally drink this beverage from elaborately carved cups that serve as symbols of their owners' wealth and importance. Jan Vansina (1992, 74), a historian who has studied the Kuba for over 40 years, notes that among the Kuba, for example, prestige was made visible by the possession of works of art, especially those that were richly decorated or had been created by the most reputed experts. The decorations showed how much labour had been lavished on the object, and hence how powerful the patron was. The reputation of the artist testified both to the wealth and to the competitive success of the patron who owned work from his hand over rivals who were not able to commission such a reputed artist.

Though the Pende cup is clearly in the Gatundo style (see cat. no. 15), Léon de Sousberghe (1958, 140), the primary source for Pende art, maintained that examples such as this are the work of Wongo and Lele artists, neighbors to the northeast; cups made by the Pende, according to him, are much more likely to have relief carving

than to be sculptural in form. Joseph Cornet (1978, 240), the former director of the Institut des Musées Nationaux in Zaire, points out that the Wongo combine Lele and Pende art forms, illustrating a Wongo cup similar to this one but cruder, which, he says, shows a Lele form in a Pende style. Be that as it may, most authors continue to attribute cups such as this one to the Pende.

While the Pende cup is sculptural, the Kuba cup shows a greater interest in surface patterning and contrasts, features found consistently on Kuba arts in all media. The interlace pattern on the body of the cup is a common Kuba motif. Vansina (1978, 221) points out that about two hundred such geometric motifs are known, and men and women who invent new patterns are admired. Though patterns have names, these vary from place to place; Cornet (1982, 168), however, notes that a basic interlace pattern such as this goes under the general name *nnaam*, which recalls lianas, tropical creepers that often grow in crisscrossed fashion on the forest floor. Cowrie shells, which are inlaid among the interlaces, not only offer a contrasting color and texture but also indicate the high status of the cup's owner. First traded in Zaire in the eighteenth century, they were used as currency during most of the 1800s (Vansina 1978, 172). In addition to the elaborate carving and the cowrie shells, the copper on the face on the handle indicates prestige. Copper and its alloy brass are prestige metals in many parts of the African continent (see, for example, cat. nos. 6, 11), and Vansina (ibid., 65, 191) mentions that copper-based metal was the prerogative of the Kuba king.

Both cups have remarkable surfaces that bespeak much handling and use. This handling has softened the relief carving and given the wood a deep luster, which, combined with the refined skill of the carving, makes the cups particularly appealing to Westerners.

References cited

Cornet, Joseph. 1978. *A Survey of Zairian Art: The Bronson Collection*. Exhibition catalogue. Raleigh: North Carolina Museum of Art.
————. 1982. *Art royal kuba*. Milan: Edizioni Sipiel.
De Sousberghe, Léon. 1958. *L'Art pende*. Brussels: Académie Royale de Belgique.
Vansina, Jan. 1978. *The Children of Woot: A History of the Kuba People*. Madison: University of Wisconsin Press.
————. 1992. "The Kuba Kingdom (Zaire)." In *Kings of Africa: Art and Authority in Central Africa*, 71-78. Edited by Erna Beumers and Hans-Joachim Koloss. Exhibition catalogue. Maastricht: Foundation Kings of Africa.

Cat. no. 16

Provenance: Ex-coll. H. Elias (Aalst, Belgium); acquired from Allan Frumkin (Chicago) in 1961

Published: Brussels 1958, fig. 20; Verly 1959, 145 (ill.); Arts Club 1966, cat. no. 17 (ill.); *African Arts* 1973, 51 (ill.); IUAM [1989c], 3

Exhibited: Brussels 1958, Arts Club 1966, IUAM 1993

Cat. no. 17

Provenance: Ex-coll. Dehount (Belgium); acquired from Ladislas Segy (New York) in 1955

Published: Segy 1951, fig. 30; MPA 1960b, cat. no. 25; Arts Club 1966, cat. no. 18; IUAM [1989c], 3

Exhibited: New York 1939, Layton 1957, AIC 1957a, MPA 1960b, Arts Club 1966, IUAM 1989a; IUAM 1993

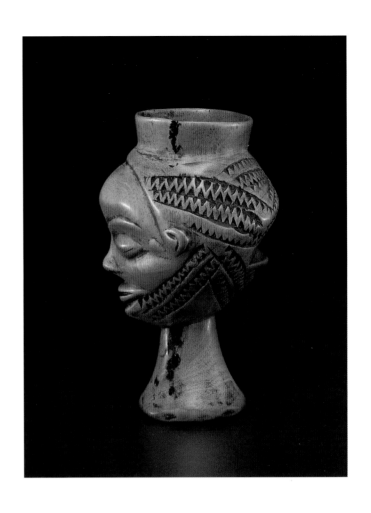

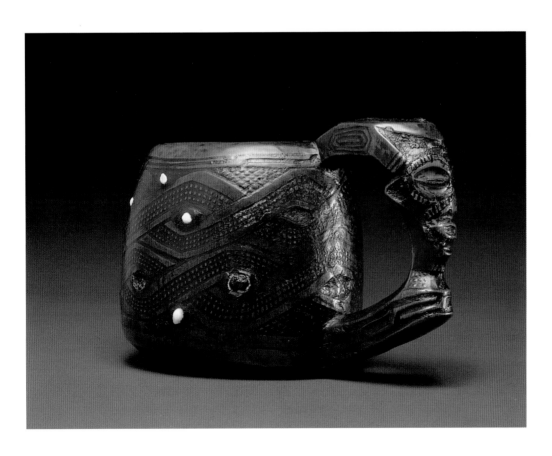

18

Lulua peoples, Zaire

Female Figure, *Lupinga lua Luimpe*

Nineteenth century
Wood, incrustation
H. 17 in. (43.2 cm)
IUAM 75.91 (RW 60-199)

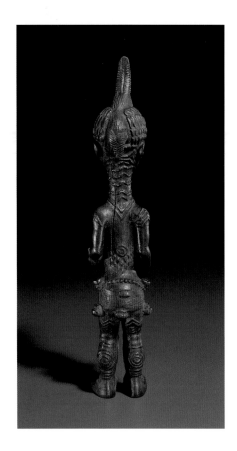

References cited

Timmermans, P. 1966. "Essai de typologie de la sculpture des Bena Luluwa du Kasai." *Africa-Tervuren* 12, no. 1: 17-27.
Walker Art Center. *Art of the Congo.* 1967. Essays by Martin Friedman, Clark Stillman, and Albert Maesen. Exhibition catalogue. Minneapolis.

Provenance: Collected by Sergeant Joseph Henri Lassaux at Luluabourg before 1896; ex-coll. Edmond Perée (Brussels); acquired from Allan Frumkin (Chicago) in 1960

Published: MPA 1960b, cat. no. 22, pl. 20; Arts Club 1966, cat. no. 19 (ill.); Bascom 1967, fig. 167; Fagg 1969, cat. no. 92 (ill.); Kan 1970, 38 (ill.); *African Arts* 1973, 52 (ill.); IUAM 1979, 57 (ill.); IUAM 1980, 227 (ill.); IUAM 1986, cat. 152 (ill.); Darish 1987, fig. 13; Robbins and Nooter 1989, fig. 1126; Zimmerman 1990, 17 (ill.); Pelrine 1993, ill. 3; Hubbard 1993b, 65 (ill.); McNaughton and Pelrine 1995, pl. 43

Exhibited: MPA 1960b, Arts Club 1966, Lowie 1967, IEF 1970, Tucson 1975, IUAM 1993

Most often called *Bena Lulua* ("people of Lulua") in earlier literature, the Lulua (also written "Luluwa") are a group of relatively independent chiefdoms located near the Lulua River in south-central Zaire. Though Lulua history is intertwined with the Kuba, Luba, and Chokwe peoples, their sculpture is among the most distinctive in Africa. Carvers sculpt a variety of objects, including masks, male warrior figures, neckrests, and snuff containers, but they are best known for their female figures, which range in size from four to eighteen inches.

This figure was placed among the most beautiful examples of its type by the late William Fagg, one of the world's premier connoisseurs of African art. The piece clearly shows that Lulua sculpture at its best demonstrates a complex harmony of form and surface effects from every viewpoint. Characteristic are the large head and feet, elongated neck, powerful calves, intricate scarification patterns, and elaborate skirt and pointed coiffure. The prominent navel, emphasized by concentric scarification, not only serves as a visual reminder of the link between mother and child but also is considered a mark of beauty in many African societies.

Female figures such as this one are associated with *bwanga bwa cibola* (or *shibola*), a cult devoted to bringing good fortune to newborns and their mothers in several ways (Timmermans 1966, 19-23). A woman who had lost several children might use such a figure in a ritual to ensure safe childbirth for her and a new baby. After birth, the figure might be kept close to the newborn, in the belief that ancestral spirits, present in the sculpture, would protect

the baby from illness. These same spirits, invoked through the figure, could also aid in curing a child of a skin disease, infection, or eye problem.

Documentation indicates that this figure was collected by a Belgian colonial officer in the late nineteenth century in Luluabourg (now Kananga). It appears likely that it was made before the 1880s, for during that decade the Lulua leader Kalemba Mukenge forbade scarification and its depiction on sculpture and tried to abolish traditional religious practices, including the sculpture associated with them (Walker Art Center 1967, 40). The richly patinated surface suggests that the figure was much used. Its crusty and reddish areas reflect the custom of rubbing the newborn, mother, and figure with red earth or powdered tree bark, palm oil, and water. The cup held by the figure contains kaolin, a white chalk also ritually rubbed on the mother and child, and sometimes on the figure.

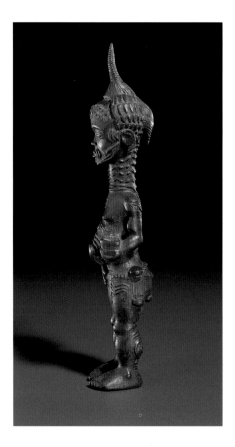

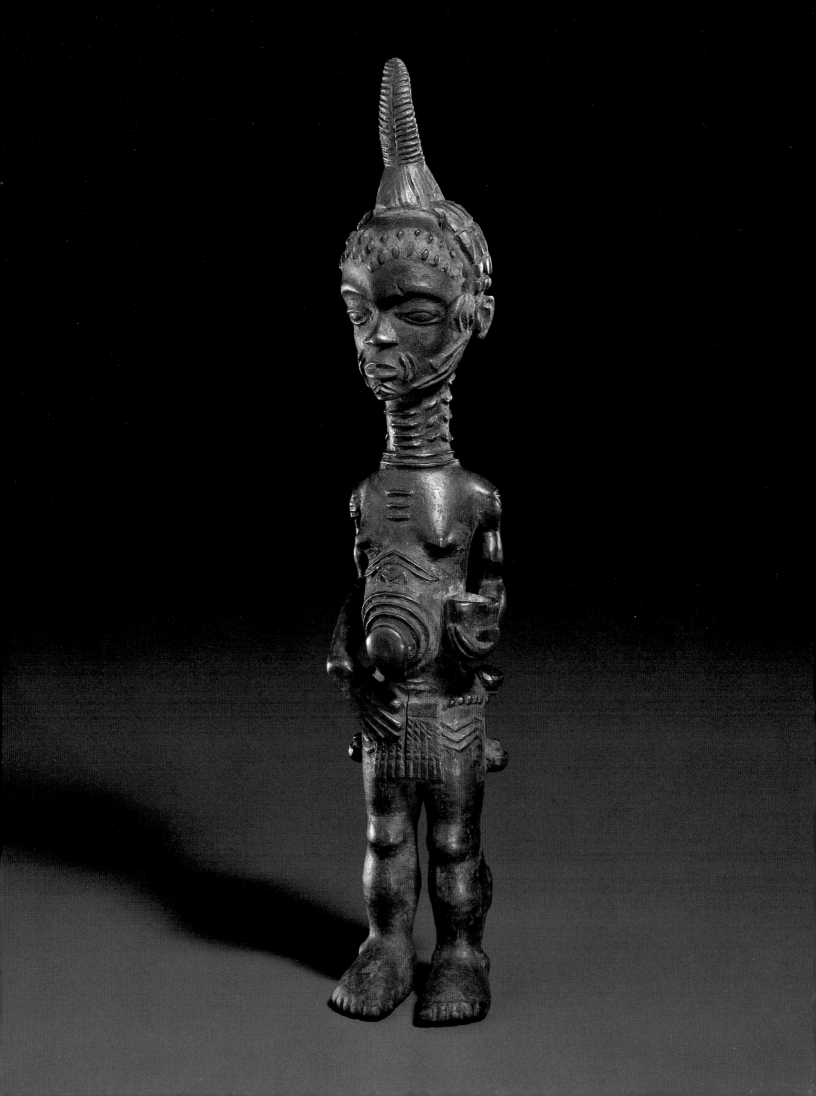

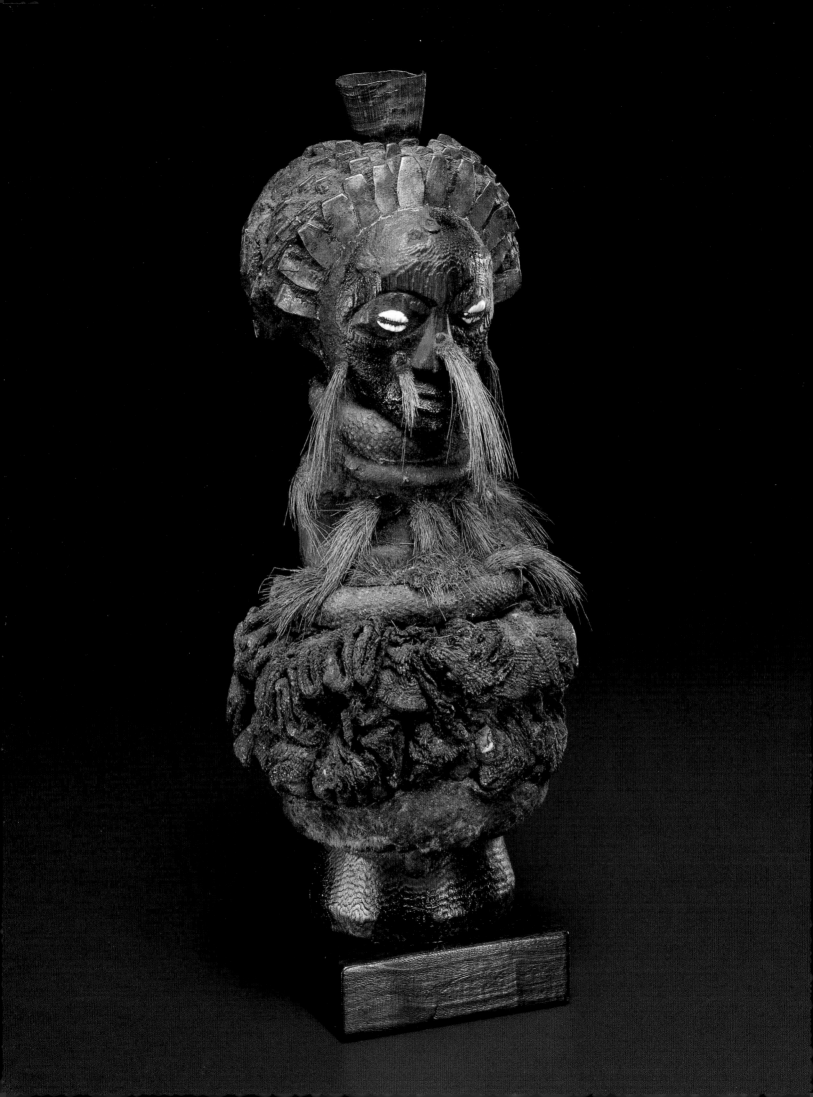

19

Songye peoples, Zaire

Power Figure, *Nkishi*

Wood, iron, horn, fiber, cowrie shells,
snakeskin, hair, incrustation
H. 12 1/2 in. (32 cm)
IUAM 74.55.3 (RW 60-198)

Power figures, *mankishi* (sing., *nkishi*),
of the Songye join those of other Zair-
ian groups, such as the Kongo, as some
of the most visually complex and enig-
matic sculptures in Africa. Though the
general principles by which such figures
are made and used have been discussed
at length (see, for example, Rubin 1974,
Hersak 1986, MacGaffey 1993), specific
interpretations of individual objects
depend on information acquired from
the figures' original owners.

Like other Zairian power figures,
those of the Songye are used to benefit
an individual, a family, or even an entire
community (Hersak 1986, 118). *Man-
kishi* owned by individuals serve a vari-
ety of purposes, depending on the
specific needs of the owners and their
families. Dunja Hersak (1986, 120),
who carried out fieldwork among the
Songye in 1977-78, notes that those
owned by communities are associated
with ancestors and generally "serve a
more limited range of social needs such
as procreation, protection against
illness, sorcery, witchcraft, war, and
the preservation of territorial
claims."

All *mankishi* contain *bishimba*, parts
of plants, animals, and nonorganic
materials that are believed to give the
figures their supernatural powers.
Bishimba must be added by an *nganga*,
an occult practitioner, who chooses the
particular combination of ingredients
that are required for the purpose a
particular *nkishi* is to serve. These ma-
terials are inserted directly into cavities
in the stomach and/or head of the
figure or added to one or more small
horns that are placed on the head, as in
this example. Without *bishimba*, the
figures are ineffective.

In addition to *bishimba*, assorted
other substances and objects may be
added to the figure to augment its
power and to add to its visual and sym-
bolic impact (ibid.). Many of these
materials relate to ideas about strength
and dominance and are often connected
with individuals in positions of author-
ity. On this figure, for example, the
cowrie shells in the eyes may remind
people not only of the wealth associated
with cowries in general but also of
myths of the origin of leaders in which
such shells play a role. The metal pieces
in the head recall the blacksmith who
plays a significant role in the same
myths. Their particular form may also
refer to the tools that are necessary for
an individual or community to prosper
(ibid., 12, 131).

Animal parts, which are frequent
additions, are chosen for physical or
behavioral characteristics of the living
creature or for symbolic associations.
Snakeskin, seen on this figure, is usually
that of a poisonous reptile. The bits of
hair that hang from the face and upper
torso resemble the "nasal hair" that
sometimes hangs from Songye *kifwebe*
masks. On the masks, this hair is sup-
posed to prevent the entry of evil spirits
(Mestach 1985, 152).

Two features usually differentiate
personal and community *mankishi*: size
of the figure and quantity of attached
materials (Hersak 1986, 120, 140, 154).
The relatively small size of this figure
suggests that it might have belonged to
an individual, as most community-
owned figures are larger, sometimes
reaching a height of over three feet. Per-
sonal figures, though, usually do not
have as much attached to the figure as
this one does: little more than the face
and pedestal of the carving is visible.
Furthermore, the prominent additions
of materials such as cowries and metal
that can be related to ancestral leaders
support the conjecture that this may
have been a community-owned figure.

References cited

Hersak, Dunja. 1986. *Songye Masks and Fig-
ure Sculpture*. London: Ethnographica.
MacGaffey, Wyatt. 1993. "The Eyes of Under-
standing: Kongo Minkisi." In *Astonishment
and Power*, 21-103. By Wyatt MacGaffey and
Michael D. Harris. Exhibition catalogue.
Washington, D.C.: Smithsonian Institution
Press.
Mestach, Jean Willy. 1985. *Etudes Songye:
Formes et symbolique; essai d'analyse/Songye
Studien: Formen und Symbolik; ein analytischer
Essay/Songye Studies: Form and Symbolism;
An Analytical Essay*. Munich: Galerie Jahn.
Rubin, Arnold G. 1974. *African Accumulative
Sculpture: Power and Display*. Exhibition cata-
logue. New York: Pace Gallery.

Provenance: Acquired from Allan Frumkin
(Chicago) in 1960; sold to Milton Hirsch (Chi-
cago); purchased by IUAM from Torshen, Fortes
and Eiger, Ltd.

Published: MPA 1960b, cat. no. 23, pl. 18; IUAM
1986, cat. no. 161 (ill.); McNaughton and
Pelrine 1995, pl. 44

Exhibited: MPA 1960b, IUAM 1993

20

Luba peoples, Zaire

Amulet

Ivory
H. 7 1/16 in. (18.1 cm)
IUAM 79.79.2 (RW 76-291)

Among the most delicate African sculptures are Luba amulets, which take the form of heads, busts, and figures. Though the Luba are perhaps better known for their wooden figures, headrests, and stools depicting the female form, amulets show the same sensitivity and clarity of form which have made Luba sculpture famous.

Carved from ivory, a prestige material of the highest order in most of sub-Saharan Africa, as well as from hippopotamus and wart-hog teeth, such amulets are worn bandolier-style, suspended from the neck or waist, or attached to the arms. In addition, leaders might sometimes attach them to the tops of their staffs of office. They are said to commemorate deceased relatives and may be given the names of those ancestors (Colle 1913, 435). The amulets are believed to protect their wearers and may be rubbed with palm oil, which people often also rub on themselves and which gives the ivory an orange patina.

The Wielgus example illustrates the simplest amulet form, consisting of a head carved at the end of a piece of ivory. The patterns of circle-and-dot motifs which have been incised on the ivory may refer to scarification patterns that are often depicted on the torsos of Luba female figures. Though not as intricate as some amulets, this one is very similar to one that François Neyt, who has recently written extensively about Luba substyles, attributes to a workshop along the Lukuga River (Neyt 1993, 197).

Marc Felix (personal communication, 1986), a Belgian dealer who has spent much time in Zaire, has said that an ivory such as this would have been made by the Luba, but used by the Lega. A formal similarity to a nineteenth-century Songye horn now in the Berlin Museum für Völkerkunde must also be noted (Koloss 1980, cat. no. 41; Beumers and Koloss 1992, pl. 118). Though that horn is more than twice as large and the bottom end is filled with wax and other materials, its delicately carved head, suspension hole, and circle-and-dot motifs clearly resemble the Wielgus example.

References cited

Beumers, Erna, and Hans-Joachim Koloss. 1992. *Kings of Africa: Art and Authority in Central Africa*. Exhibition catalogue. Maastricht: Foundation Kings of Africa.
Colle, R.P. 1913. *Les Baluba*. 2 vols. Collection de monographies ethnographiques, 10, 11. Brussels: Albert de Wit.
Koloss, Hans-Joachim. 1990. *Art of Central Africa: Masterpieces from the Berlin Museum für Völkerkunde*. Exhibition catalogue. New York: Metropolitan Museum of Art.
Neyt, François. 1993. *Luba: Aux sources du Zaïre*. Exhibition catalogue. Paris: Musée Dapper. Also published as *Luba: To the Sources of the Zaire*. Translated by Murray Wyllie. Paris: Musée Dapper, 1994.

Provenance: Acquired from the estate of Frederick Pleasants (Tucson) in 1976

Exhibited: IUAM 1993

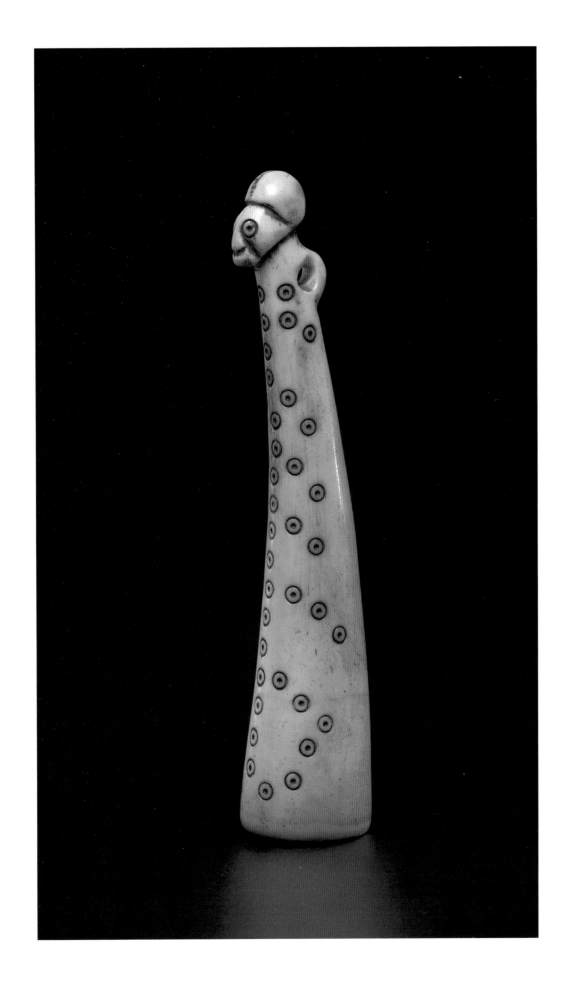

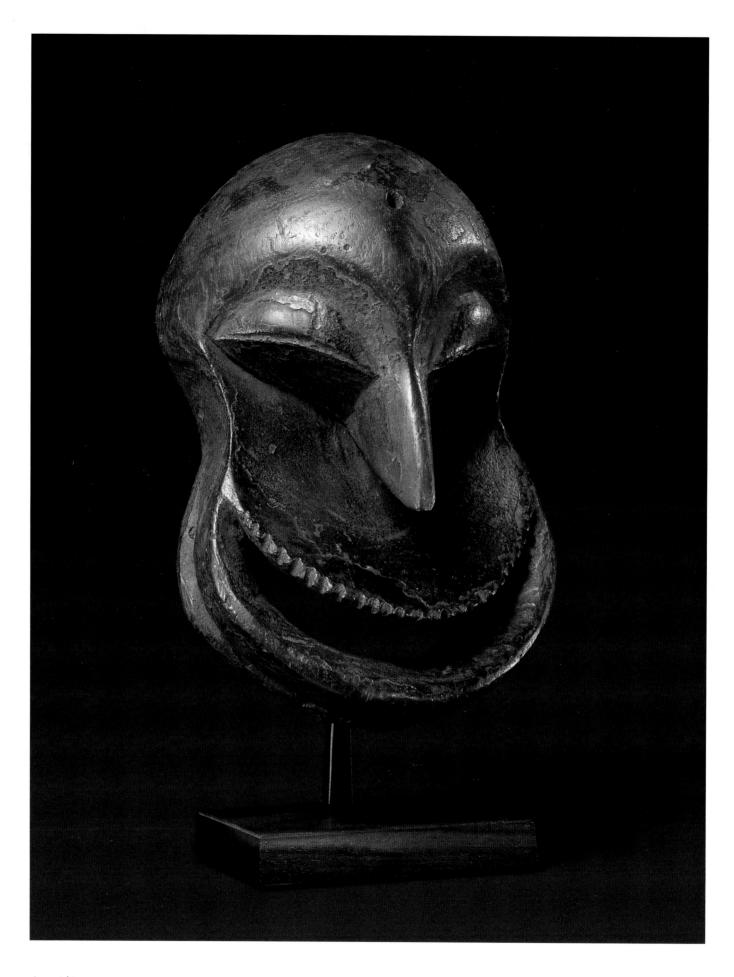

21

Hemba peoples, Makutano locality,
Kongolo zone, Zaire

Mask, *So'o or Soko Mutu*

Wood
H. 6 3/4 in. (17.1 cm)
IUAM 87.24.4 (RW 57-63)

Hemba sculpture was little known to
Westerners until the second half of this
century, and information about masks
such as this one was practically non-
existent as recently as 10 years ago.
However, with a 1987 article by Tho-
mas and Pamela Blakely, who have
carried out extensive research among
the Hemba, our knowledge of the
masks increased dramatically, at least
regarding their iconography and
appearance in funerary contexts.

Particularly in earlier literature,
such a mask was often referred to by
its Swahili name, *soko mutu* (or some
variant), which can be translated as
"chimpanzee-human"; the Hemba
term, however, is *so'o* (in some areas,
soko) or, more precisely, *mwisi gwa
so'o*, "spirit-invested object of the
chimpanzee-human" (Blakely and
Blakely 1987, 85-2). For the Hemba,
the mask, its accoutrements, and the
masquerader's movements and gestures
combine elements associated with
animal and human, the bush and the
village, to create a creature that par-
allels their ideas about the afterlife,
where, they believe, distinct worldly
categorizations are mixed and confused
(ibid., 36).

Westerners usually look favorably
upon the chimpanzee, considering it
among the most humanlike animals.
This type of mask, however, has very
different associations for the Hemba,
for they do not admire the chimpanzee,
but rather regard it as an animal that
can be aggressive and predatory toward
people. Furthermore, the *so'o* mask
also very clearly shows the difficulties
inherent in interpreting even smaller
motifs from different cultures: while
Westerners are probably inclined to see

the mask's mouth as being fixed in a
wide grin, the Hemba see it as a gri-
macing open mouth, not one that in any
way suggests friendliness or good
humor (ibid., 30, 32).

The *so'o* mask's role at Hemba
funerary celebrations, where it is inter-
preted as an allegorical figure of death,
has been described at length (Blakely
and Blakely 1987). *So'o* has other
associations, however. Each mask is
believed to contain the "soul-essence"
of a particular ancestor and is given
that person's name (ibid., 85-2). Neyt
(1993, 176) suggests that some masks
protect households. The mask also has
connections with fertility of both people
and crops. For example, some believe
that an unborn baby may be harmed if
a *so'o* masquerader looks too long at
the mother, and the failure of an indi-
vidual's crop may be taken as a sign for
that person to join a society dedicated
to *so'o* (Blakely and Blakely 1987, 33-
34). As field photos by Thomas and
Pamela Blakely (1987) show, such
masks are worn on the head so that the
masquerader looks out of the mouth.
Neyt (1993, 174, 176) maintains,
however, that at least some masks are
worn at the waist and others are kept
in houses.

This mask is attributed to the
Mambwe chiefdom of the Makutano
area in the northeastern Hemba area
south of the Luika River (François
Neyt, personal communication, July
1994). Most *so'o* masks seem to origi-
nate there, though they are apparently
found over a wider area extending
south to Mbulula, the major Hemba
town, and north beyond the Luika
River.

References cited

Blakely, Thomas D., and Pamela A.R. Blakely.
1987. "*So'o* Masks and Hemba Funerary
Festival." *African Arts* 21, no. 1 (November):
30-37, 84-86.
Neyt, François. 1993. "South-East Zaire:
Masks of the Luba, Hemba and Tabwa." In
Face of the Spirits: Masks from the Zaire Basin,
163-81. Edited by Frank Herreman and
Constantijn Petridis. Ghent: Snoeck-Ducaju
and Zoon.

Provenance: Acquired from Julius Carlebach
(New York) in 1957

Published: MPA 1960b, cat. no. 11; Arts Club
1966, cat. no. 10; IUAM 1986, cat. no. 160 (ill.)
Exhibited: AIC 1957a, MPA 1960b, Arts Club
1966, IUAM 1993

Zulu peoples, South Africa

Snuff Container

Nineteenth century (?)
Wood
W. 10 5/8 in. (27 cm)
Raymond and Laura Wielgus Collection
(RW 60-211)

Although figural arts are more common in Western museums and private collections, many nonfigural utilitarian objects from Africa also demonstrate a mastery of materials, forms, and techniques. This container, carved from a single piece of wood, is such an example. The large oval ring not only attaches to the smaller ring at the top like a link in a chain but also can be moved around the cylinder inside it, from which the two globular receptacles extend.

This type of virtuoso carving and the presence of a double receptacle are not unknown features among the Zulu. The collection of the Field Museum of Natural History in Chicago, for example, includes a snuff container made from one piece of wood consisting of two receptacles connected by wooden links (Conner and Pelrine 1983, 26). Though the form of this container is not unique — there is a similar one in another private collection (Roy Sieber, personal communication to Michael Conner, February 1994) — it is nonetheless rare in the Zulu repertoire.

The form of the two receptacles clearly relates to the shell of the fruit of the *umthongwane* tree (*Oncoba spinosa*). These shells were used as the most common Zulu snuff container, known as an *ishungu* (Kennedy 1988, 102). Zulu men and women have enjoyed snuff for a least three centuries, and both snuff containers and spoons can be included among an individual's personal accessories. An *ishungu* was often suspended from the neck, and it is possible that this example was worn that way, though it would have been very awkward and heavy. If worn at all,

it more likely would have been attached to a belt at the waist. Alternatively, the container might have been suspended inside the home, with one compartment for use by a husband and the other by his wife, reflecting a traditional division by gender of interior space and objects (Conner 1994).

When viewing an elaborate example of an everyday object, Westerners often assume that it must have been a prestige item belonging to someone of high status. In many cases, this is true in Africa (see, for example, cat. no. 16). However, such an idea may not be valid everywhere. For example, nineteenth-century photos of Zulu councils of elders show these men with the everyday fruit-shell snuff containers used by common people (Carolee Kennedy, personal communication, June 1995). Furthermore, traditionally among the Zulu, men often carved for themselves in their spare time, resulting in a variety of singular forms that may indicate individual skill but not necessarily status (Michael Conner, personal communication, June 1995).

References cited

Conner, Michael W. 1994. "Exchanging Identities: The Function and Symbolism of a Zulu Snuff Container." Noon Talk lecture (February), Indiana University Art Museum.
————, and Diane Pelrine. 1983. *The Geometric Vision: Arts of the Zulu*. Exhibition catalogue. West Lafayette, Ind.: Purdue University Galleries.
Kennedy, Carolee. 1988. "Snuff Container." In *Expressions of Belief: Masterpieces of African, Oceanic, and Indonesian Art from the Museum voor Volkenkunde, Rotterdam*, 102. Edited by Suzanne Greub. Exhibition catalogue. New York: Rizzoli.

Provenance: Acquired from Henri Lemaire (Amsterdam) in 1960

Published: Sieber 1980, 190 (ill.)

Exhibited: AFA 1980, IUAM 1993

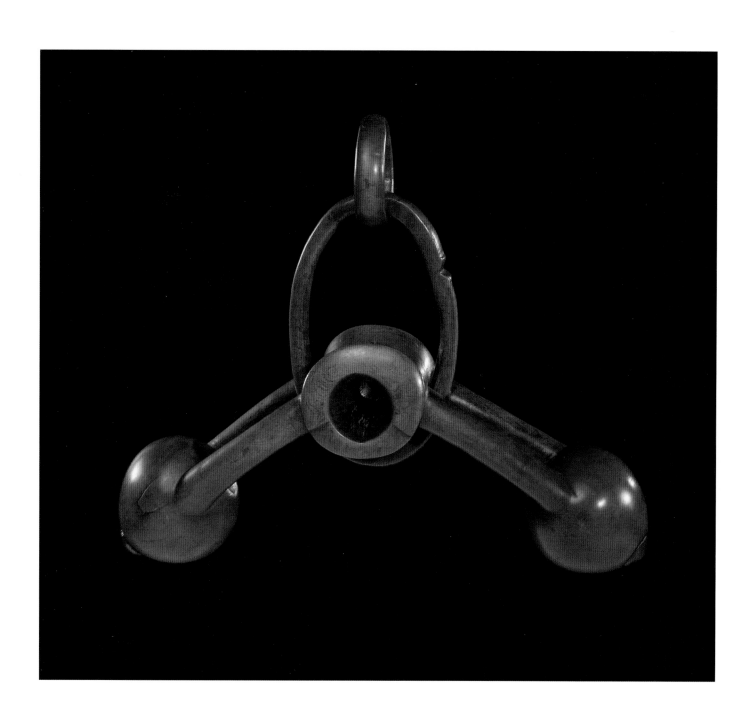

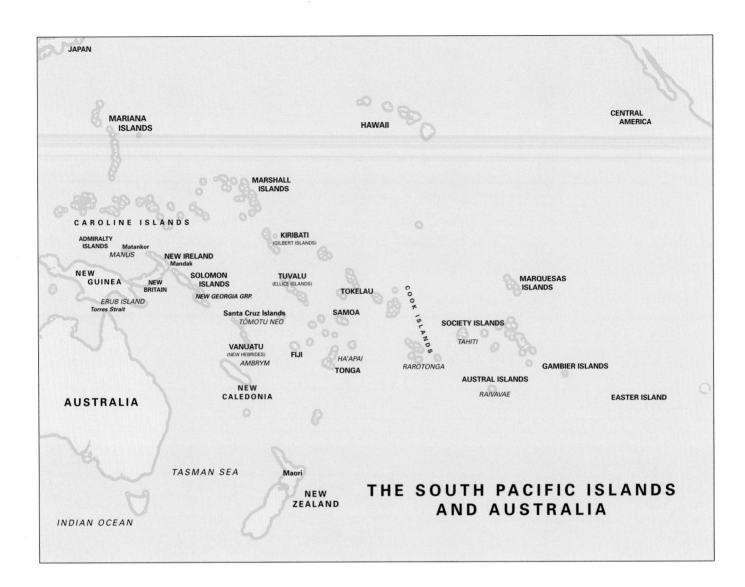

JAPAN

MARIANA
ISLANDS

HAWAII

CENTRAL
AMERICA

MARSHALL
ISLANDS

CAROLINE ISLANDS

KIRIBATI
(GILBERT ISLANDS)

ADMIRALTY
ISLANDS Matankor
MANUS NEW IRELAND
 Mandak
NEW SOLOMON TUVALU
GUINEA ISLANDS (ELLICE ISLANDS) TOKELAU
 NEW MARQUESAS
 BRITAIN *NEW GEORGIA GRP.* ISLANDS
ERUB ISLAND
Torres Strait Santa Cruz Islands SAMOA
 TŌMOTU NEO SOCIETY ISLANDS

 VANUATU *TAHITI*
 (NEW HEBRIDES) FIJI *HA'APAI*
 AMBRYM GAMBIER ISLANDS
 TONGA *RAROTONGA*
AUSTRALIA NEW AUSTRAL ISLANDS
 CALEDONIA EASTER ISLAND
 RAIVAVAE

 C O O K I S L A N D S

TASMAN SEA Maori

 NEW THE SOUTH PACIFIC ISLANDS
 ZEALAND AND AUSTRALIA
INDIAN OCEAN

Oceania

Objects from Oceania (the islands of the South Pacific) comprise the largest portion of the Wielgus Collection. They are almost exclusively from the areas known collectively as Melanesia and Polynesia, two of the major island groupings in this area.

Melanesia (from the Greek for "black islands") includes New Guinea and nearby islands, primarily to the east and south. Current research suggests that New Guinea had been settled by populations from southeast Asia by at least 25,000 B.C. From there and nearby Australia, emigrants traveled east, eventually reaching the other islands of Melanesia and Polynesia. Polynesia ("many islands") consists of widespread islands within the triangle formed by the Hawaiian Islands to the north, Easter Island to the east, and New Zealand to the south. Though Tonga, Samoa, and the Marquesas Islands in central Polynesia had been settled by the first century B.C., the outlying island groups, together with the central Polynesian Cook, Society, and Austral islands, were not occupied until between the fifth and ninth or even tenth centuries A.D.

Until European domination in the nineteenth century, Polynesian social and political institutions were complex, stratified systems based on genealogy. Though the degree of complexity and stratification varied among the island groups, all Polynesians also shared a belief in a pantheon of deities from whom those of the highest rank could trace their descent. Many of these deities affected the course of daily life, and, as a result, priests held powerful positions throughout the islands.

Priests played important roles in practices involving *mana* and *tapu*, twin concepts central to an understanding of Polynesian culture. *Mana* is a kind of supernatural energy or power that all things, living and inanimate, are believed to possess in varying quantities. A *tapu*, or restriction, assured that an individual or object maintained its *mana*, which could be lost through contact with what were considered corrupt or negative influences, such as sickness or death, or with entities containing less mana. According to traditional Polynesian belief, *mana* was inherited, and objects such as fly whisks (cat. nos. 25, 26) and ornaments (cat. nos. 35, 42), which were passed down through generations, contained some of the *mana* of each of their owners. A chief or priest had a great deal of *mana*, while a commoner had much less, but any successes that a person enjoyed were attributable to that individual's *mana*. *Mana* also made a tool or weapon, such as a pole club (see cat. no. 24), work effectively or a plant grow with strength and vigor. Artists, who were often priests, dealt with *mana* from different sources. Their tools and materials all contained it, and through their work and the accompanying prayers, some of their own *mana* could be transferred to the objects they made.

Because of their precious materials and the care with which they were made, we can be sure that Polynesian objects in the Wielgus Collection belonged to high-ranking individuals and possessed much *mana*. They also very clearly exemplify Raymond Wielgus's collecting criterion that an object be "right," for these pieces were made before extensive contact with Europeans brought about the destruction or drastic modification of many traditional

island cultures and the objects associated with them. The rarity of extant Polynesian material from this early period makes these objects particularly noteworthy.

Melanesians also believed in *mana*, but it was not such a powerfully overriding concept in those societies, which were much more varied than those in Polynesia. Generally in Melanesia, a family's ancestors were of prime importance in religious life, for, as in many African societies, their spirits were believed capable of interceding in the physical world. Some of the most powerful sculpture from the South Pacific, such as the Wielgus Angoram figure (cat. no. 52), is associated with these ancestral spirits. Melanesian art also refers to nature spirits, embodied in animals and formations such as rivers and mountains, that were thought to affect people's lives; an example is the friction drum from New Ireland in the form of a bird (cat. no. 48).

In Melanesian societies, achievement played a critical role in establishing a person's status. Achievement was measured in various arenas, such as warfare, food acquisition or production, accumulation of wealth, and, perhaps most importantly in many areas, in the associations and cults that formed the political, social, and religious backbones of communities. Many peoples considered success in war to be an important indication of a man's worth, and objects such as the Admiralty Islands war charm (cat. no. 49) and the *kara ut* from the Abelam peoples of New Guinea (cat. no. 50) helped to ensure such success. Likewise, the dugong charm (cat. no. 64) was believed to bring success in hunting the dugong, a marine mammal that was one source of food for islanders living in the Torres Strait. Advancement through various levels of associations and cults also guaranteed men prominent places within their societies. Initiations into cults with which figures such as the Biwat flute figure (cat. no. 54) were involved, for example, included feasts for initiates that were provided by the flute owner and brought him much prestige.

Like the Polynesian objects, Wielgus Melanesian objects were collected before Western influences subsumed much of the traditional cultures. Though Melanesian art is typically considered not to be as rare as Polynesian, the early dates of the Wielgus Melanesian material make it very significant. Some pieces, such as the Fly River figure (cat. no. 62), were carved without the use of metal tools. Others, such as the Asmat figure (cat. no. 65), are documented as some of the earliest examples of sculpture known from their respective parts of the Pacific.

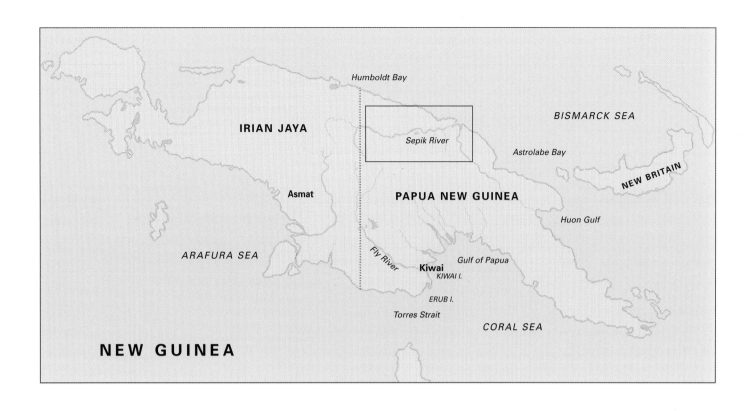

NEW GUINEA

Humboldt Bay

IRIAN JAYA

BISMARCK SEA

Sepik River

Astrolabe Bay

Asmat

PAPUA NEW GUINEA

NEW BRITAIN

Huon Gulf

ARAFURA SEA

Fly River

Kiwai

Gulf of Papua

KIWAI I.

ERUB I.

Torres Strait

CORAL SEA

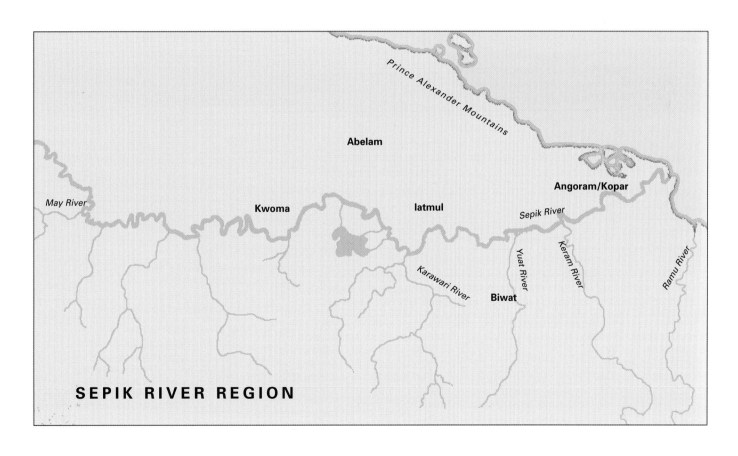

SEPIK RIVER REGION

Prince Alexander Mountains

Abelam

Angoram/Kopar

May River

Kwoma

Iatmul

Sepik River

Yuat River

Keram River

Ramu River

Karawari River

Biwat

23

Ha'apai island group, Tonga

Female Figure

Eighteenth century (?)
Whale ivory
H. 5 in. (12.7 cm)
Raymond and Laura Wielgus Collection
(RW 59-159)

The smooth, worn surface and deep golden color of this female figure from Tonga bespeak much care and handling, fitting for an object made of whale ivory, a most precious and rare material in Tonga and throughout Polynesia. Until the nineteenth century, when European trade made ivory, in the form of whale teeth and walrus tusks, more available, only ivory from the teeth of the occasional stranded sperm whale could be used. The variations in the figure's color and texture reflect the distinct outer and inner layers of the sperm whale tooth from which it was carved.

The figure is one of about a dozen ivory sculptures, all female and nearly all smaller than this example, that have survived from the eighteenth or nineteenth century. Based on similarities with wooden figures that were collected in Ha'apai, a central group of Tongan islands that seem to have been a carving center, the ivory figures are generally attributed there, too.

Little information survives about wooden or ivory figures from Tonga. In a report of his third voyage to the South Pacific, James Cook (1784, I: 397), who visited Tonga in 1777, noted that "they shape bones into small figures of men, birds, and other things." Later Europeans who visited the islands in the eighteenth and early nineteenth centuries also noted the existence of wooden and ivory figures. However, more specific information was not recorded before Taufa'ahau, a chief of Ha'apai who converted to Christianity and later became king of Tonga, had images burned or destroyed and traditional priests killed or removed beginning around 1829.

The figures from Tonga are believed to represent ancestors or goddesses. Those made of ivory may be associated in particular with Hikule'o, an important deity connected with harvest and fertility (Kaeppler 1990, 65). Hikule'o's gender has been debated (Gifford 1929, 287; Larsson 1960, 66; Gunson 1990, 17; Mahina 1990, 42), though most scholars seem to agree that, at least around the time of European contact, she was generally considered female.

Early missionary reports indicate that houses dedicated to Hikule'o, as well as those of other deities, included "polished ivory shrines" that were kept oiled and wrapped, though these "shrines" may have consisted of simply uncarved whale's teeth (Larsson 1960, 66-69). The hole in the back of the head of this figure indicates that it was meant to be suspended. Adrienne Kaeppler (1990, 65), an anthropologist who has studied Tongan culture for many years, has suggested that such figures may have been hung from the ridge pole in a shrine dedicated to Hikule'o or worn by a female leader as a charm or ornament.

Though we know little about how such a figure may have been used, several aspects of its appearance can be related to Tongan ideas about beauty and the human body. The large head, characteristic of Polynesian figures in general, may refer to the belief that the head is the center of a person's *mana*. The figure's stocky proportions, broad shoulders, and large calves are features admired in Tongan women today. The color of the ivory can be related to a Tongan preference, particularly among women of high rank, for light-colored skin, while the smooth, shiny quality of the surface mirrors the ideal body, which is smooth, soft, and shiny with oil (Teilhet 1993).

References cited

Cook, James, and James King. 1784. *A Voyage to the Pacific Ocean ... Performed under the Direction of Captain Cook, Clerke, and Gore in His Majesty's Ships the Resolution and Discovery; in the Years 1776, 1777, 1778, 1779, and 1780.* 3 vols. and atlas. London: G. Nicol and T. Cadell.
Gifford, Edward Winslow. 1929. *Tongan Society*. Bernice P. Bishop Museum Bulletin, no. 61. Honolulu: Bernice P. Bishop Museum.
Gunson, Niel. 1990. "Tongan Historiography: Shamanic Views of Time and History." In *Tongan Culture and History*, 12-20. Edited by Phyllis Herda, Jennifer Terrell, and Niel Gunson. Canberra: Department of Pacific and Southeast Asian History, Australian National University.
Kaeppler, Adrienne L. 1990. "Art, Aesthetics, and Social Structure." In *Tongan Culture and History*, 59-71. Edited by Phyllis Herda, Jennifer Terrell, and Niel Gunson. Canberra: Department of Pacific and Southeast Asian History, Australian National University.
Larsson, Karl Erik. 1960. *Fijian Studies*. Etnologiska studier, 25. Göteborg, Sweden: Etnografiska Museet.
Mahina, 'Okusitino. 1990. "Myths and History: Some Aspects of History in the Tu'i Tonga Myths." In *Tongan Culture and History*, 30-45. Edited by Phyllis Herda, Jennifer Terrell, and Niel Gunson. Canberra: Department of Pacific and Southeast Asian History, Australian National University.
Teilhet, Jehanne. 1993. "Ethnoaesthetics and Constructing the Social Identity of Tongan Women from a Female Image in the Wielgus Collection." Lecture (October), Indiana University Art Museum.

Provenance: Acquired from J.J. Klejman (New York) in 1959

Published: MPA 1960b, cat. no. 48 (ill.); Arts Club 1966, cat. no. 44; Wardwell 1967b, cat. no. 11 (ill.); Schmitz 1971, color pl. 47; Barrow 1973, color pl. 107; Gathercole, Kaeppler, and Newton 1979, cat. no. 9.8 (ill.); Tannous 1980, 93 (ill.); IUAM 1986, fig. 8; Pelrine 1993, ill. 4

Exhibited: MPA 1960b, AIC 1963, Arts Club 1966, AIC 1967, NGA 1979, IUAM 1990; IUAM 1993

Rarotonga, Cook Islands

Pole Club, *Akatara*

Ironwood *(Casuarina equisetifolia)*
L. 98 1/4 in. (249.6 cm)
IUAM 64.12

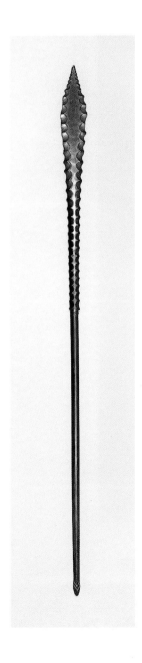

Nowhere in the world did the making of clubs, spears, and other weapons reach higher aesthetic refinement than in the islands of Polynesia before the coming of Christianity. The Cook (formerly Hervey) Islands, which consist of 15 islands spread over a thousand miles, were no exception. As in many parts of Polynesia, weapons were both necessary and numerous, since armed conflict was frequent; family feuds, rivalries between groups, or a leader's wish to expand his territory could all result in warfare (Idiens 1990, 39).

Among the most elegant weapons from the Cook Islands or, indeed, from anywhere in Polynesia is the pole club, or *akatara*. A typical weapon of Rarotonga, the major island in the Cook group, it may only have been manufactured there, though James Cook (1784, 1: 196) described a very similar, but shorter, club at Atiu, an island to the northeast.

The *akatara* was carved from the ironwood tree, or *toa*, specifically from its heart, *taiki*. *Toa* is also a general term for warriors and bravery, while *taiki* also refers to warriors using weapons made from the heart of the ironwood (Buck 1944, 276). The close association between the warrior and his weapon is also represented visually on the butt end of many *akatara*, including this one, which are carved in the form of a phallus. This symbol serves as an emphatic reminder not only of the connections between males and warfare but also of the power and aggressiveness — qualities associated with the male Cook Islander — necessary for success in battle (Idiens 1990, 39).

Blades of the pole clubs vary in width, but all are characterized by symmetrical concave scalloped edges with one or more raised lines on the blade carved parallel to the edges and echoing their shape. Some have long, delicate points at the end; these may originally have been present on most, but would easily have snapped off, either in use or later (Buck 1944, 283). On most clubs, a small carved motif circles the shaft below the blade. The Wielgus club shows a typical decoration: a pair of eyes, depicted in a style similar to those on figure carvings of gods from Rarotonga, with the eyeballs indicated by a central band. Wardwell (1994, 194) has suggested that this similarity might indicate the association of ancestor spirits with the clubs. The remainder of the shaft on this and other clubs is undecorated, except for the usual carving at the bottom, which is one of several variants of the phallic form.

In the earliest surviving Rarotongan reference to their varieties of clubs, Tane, the Cook god of fertility and patron of artists, is credited with directing the carving of eight different forms, one of which was the *akatara* (Buck 1944, 278-79). Before the carving began, he is said to have recited a chant to facilitate the splitting of the wood and to imbue the weapons with *mana*. In the Cook Islands, a *ta'unga*, or male craftsman, no doubt proceeded with carving this club in much the same way, reflecting the Polynesian belief that such work was a religious process that spiritually charged the object being made.

References cited

Buck, Peter H. (Te Rangi Hiroa). 1944. *Arts and Crafts of the Cook Islands*. Bernice P. Bishop Museum Bulletin, no. 179. Honolulu: Bernice P. Bishop Museum.
Cook, James, and James King. 1784. *A Voyage to the Pacific Ocean ... Performed under the Direction of Captain Cook, Clerke, and Gore in His Majesty's Ships the Resolution and Discovery; in the Years 1776, 1777, 1778, 1779, and 1780*. 3 vols. and atlas. London: G. Nicol and T. Cadell.
Idiens, Dale. 1990. *Cook Island Art*. Shire Ethnography, 18. Princes Risborough, Bucks.: Shire Publications.
Wardwell, Allen. 1994. *Island Ancestors: Oceanic Art from the Masco Collection*. Exhibition catalogue. Detroit: Detroit Institute of Arts.

Provenance: Acquired from Henri Lemaire (Amsterdam) in 1963

Exhibited: IUAM 1993

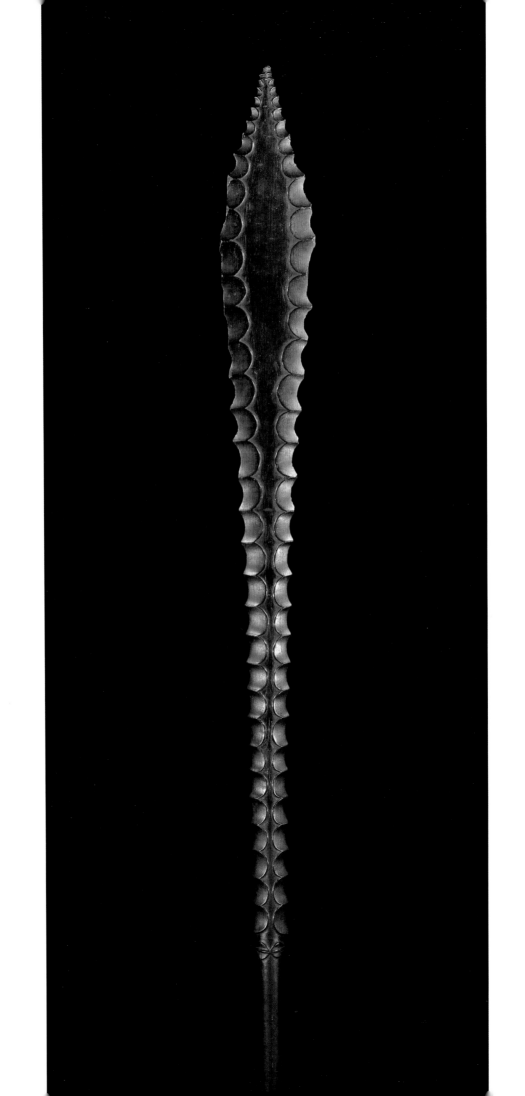

25

Tahiti, Society Islands

Fly-Whisk Handle

Before 1818
Whale ivory, wood, sennit
L. 12 5/16 in. (31.3 cm)
Raymond and Laura Wielgus Collection
(RW 65-271)

Western interactions with the peoples of Tahiti (and of the South Pacific generally) were marked by the exchange of objects, either as gifts or in barter. With the advent of Christian missionaries to Tahiti in 1797 and the rapid conversions that followed, many Tahitians gave these missionaries, as indications of their newly accepted beliefs, objects that had previously carried great spiritual and cultural significance. Many of these objects were burned or destroyed; however, some were kept as souvenirs and objects of curiosity.

This whisk handle, another now in the Metropolitan Museum of Art in New York, and a sennit deity figure are three such objects that were sent in 1818 by King Pomare II (1774-1821) to the Reverend Thomas Haweis, a founder of the London Missionary Society. The king, whose father had, with European help, consolidated political power in Tahiti to become its first monarch, was not only a Christian but also had become head of the Tahitian Christian church (Stevenson 1981, 16-20). In October 1818 he wrote to Haweis, thanking him for a watch and noting that all of the king's "idols," except for a small one, which Pomare was sending to Haweis, had been burned. His letter continued:

> I also send you two little Fans [the whisks] which the Royal Family of these countries were accustomed to fan themselves with. When the Day of the Festival arrived, and the king was prayed for, those were the Fans they used to fan away the flies, etc. [Maggs Bros. n.d., 598-99].

In one of the earliest European accounts of the Society Islands, James Wilson (1799, 357-58) noted that fly whisks, or "fly-flaps," were carried by most people, particularly in areas where food was being prepared or served. Traditionally in the Society Islands, a chief's insignia included a fly whisk or fan (the same Tahitian word, *tahiri*, is used for both), a seat, a canoe and its accoutrements, various utensils and weapons, and, most importantly, a feathered girdle (ibid.; Handy 1930, 35). Though individuals of lower rank might also own some of these objects, those belonging to the most important people were distinguished by their materials and exceptional crafting. In the Society Islands as elsewhere in Polynesia, ivory was among the most prestigious of materials (see cat. no. 23).

Visually, the Wielgus whisk handle is related to the one in the Metropolitan Museum, which was also a gift to Haweis from Pomare II (Wardwell 1967, cat. no. 28; Gathercole, Kaeppler, and Newton 1970, cat. no. 5.7); to one in the Masco Collection (Wardwell 1994, cat. no. 73) that has no provenance; and to one at the University of Aberdeen (Scotland) that was donated in 1823 by an alumnus, C.W. Nockells, who had traveled extensively in the South Pacific (University of Aberdeen n.d., 3, 7). All are carved from sections of whale ivory that have been bound together with braided sennit. The tops of all three depict, in varying degrees of abstraction, single figures bent over backwards. Openwork motifs below each figure have been interpreted as abstract human figures, which may symbolize ancestors and the genealogies of the owners. Oldman (1953, pl. 9) illustrated a wooden whisk handle with a similar openwork pattern and another in whale bone that he attributed to the Austral Islands.

Wear patterns on the arched backs at the top of the Wielgus and Metropolitan handles indicate that a fiber whisk was at one time attached there. The Masco example, however, shows similar wear patterns through a hole at the bottom of the whisk. On the Wielgus handle, that ivory piece has been replaced by a wooden section in the form of the handles of some Society Island food pounders. Barrow (1973, 107) suggests that handles might also have been used without the fiber whisk, as "batons" of rank.

References cited

Barrow, Terence. 1973. *Art and Life in Polynesia*. Rutland, Vermont: Charles E. Tuttle.
———. 1979. *The Art of Tahiti and the Neighbouring Society, Austral and Cook Islands*. London: Thames and Hudson.
Gathercole, Peter, Adrienne L. Kaeppler, and Douglas Newton. 1979. *The Art of the Pacific Islands*. Exhibition catalogue. Washington, D.C.: National Gallery of Art.
Handy, E.S. Craighill. 1930. *History and Culture in the Society Islands*. Bernice P. Bishop Museum Bulletin, no. 79. Honolulu: Bernice P. Bishop Museum.
Maggs Bros. Booksellers. n.d. *Voyages and Travels*. Vol. 4, pt. 9, *Australia and the Pacific*. Catalogue no. 856. London.
Oldman, William. 1953. *Polynesian Artifacts: The Oldman Collection*. 2nd ed. Wellington, New Zealand: Polynesian Society.
Stevenson, Karen. 1981. *Artifacts of the Pomare Family*. Exhibition catalogue. Honolulu: University of Hawaii Art Gallery.
University of Aberdeen. n.d. *Shark Tooth and Stone Blade: Pacific Island Art from the University of Aberdeen*. Aberdeen.
Wardwell, Allen. 1967. *The Sculpture of Polynesia*. Exhibition catalogue. Chicago: Art Institute of Chicago.
———. 1994. *Island Ancestors: Oceanic Art from the Masco Collection*. Exhibition catalogue. Detroit: Detroit Institute of Arts.
Wilson, James. 1799. *A Missionary Voyage to the Southern Pacific Ocean Performed in the Years 1796, 1797, 1798 in the Ship Duff, Commanded by Captain James Wilson*. London: T. Chapman.

Provenance: Given to Rev. Thomas Haweis by King Pomare II in 1818; acquired from Merton Simpson (New York) in 1965

Published: Maggs Bros., n.d., 599, cat. no. 856, pl. 39; Arts Club 1966, cat. no. 46; Wardwell 1967b, cat. no. 29 (ill.); MMA 1970, 332; Barrow 1973, pls. 175, 176; Fine Arts Gallery of San Diego 1973, p. 81 (ill.); Oliver 1974, fig. 6-4; Gathercole, Kaeppler, and Newton 1979, cat. no. 5.6 (ill.); IUAM 1990b, 4 (ill.); Bounoure 1992, 48 (ill.)

Exhibited: Arts Club 1966, AIC 1967, MMA 1970, San Diego 1973, NGA 1979, IUAM 1990, Dapper 1992, IUAM 1993

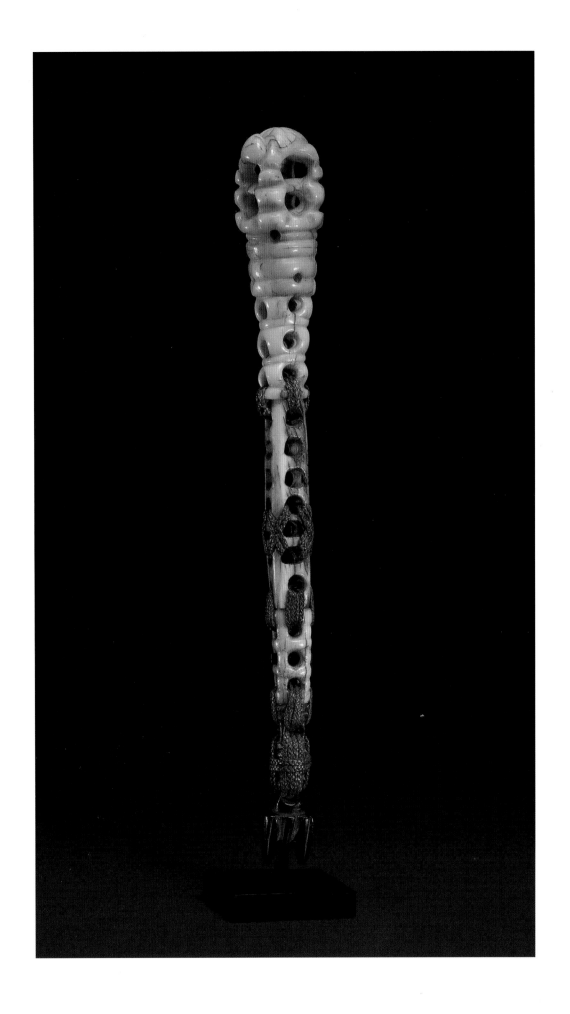

Austral Islands

Fly-Whisk Handle, *Tahiri Ra'a*

Nineteenth century
Wood, sennit, human hair
L. 15 1/2 in. (39.4 cm)
Raymond and Laura Wielgus Collection
(RW 60-193)

The carved images and the presence of sennit and human hair indicate that, like the Tahitian fly-whisk handle (cat. no. 25), this example was intended more as an indicator of status and prestige than as a utilitarian item. Though fly whisks such as this one had long been attributed to Tahiti, a convincing article by Roger Rose (1979) resulted in their being given an Austral Islands provenance. Rose's article not only carefully examines historical sources for information about the whisks and their likely cultural contexts but also divides them into three typological categories. The relatively large size of the figures in relation to the rest of the whisk, their angularity and abstraction, and the multiple disks along the shaft place this whisk in Rose's Type-A group, into which a majority of surviving whisks fall.

Scholars today cannot definitively explain the significance of the janus figures, nor can we be sure of the meaning of the disks below them. However, interpretations of objects from other Polynesian islands suggest some possibilities. In writing about some Hawaiian figures, for example, Kaeppler (1982, 88) has proposed that doubled figures may have genealogical significance, referring to two ancestral lines. The disks below the figures, which vary in number, may refer to the owner's lineage and thus have served as reminders during genealogical recitations, important for establishing status and rank within Polynesian societies. Similar memory aids are found in New Zealand, where notches on bones or wood represent generations, and in knotted strings of the Marquesas Islands

(Handy 1927, 207; Kaeppler 1982, 87). The frieze along the edge of the largest disk has been interpreted as abstract crouching human forms (Rose 1979, 204), stylized phalluses (Gathercole, Kaeppler, and Newton 1979, 90), and stylized pig's heads (Mack 1982, 212).

The coconut-fiber whisk, now missing, was attached to the handle with fiber and human hair, which is braided in diamond-shaped patterns on the lower half of the handle. Human hair, sometimes in combination with sennit, was braided and used throughout Polynesia and in parts of Micronesia and Melanesia for ornaments, fishing lines, and decorative lashings (Turbott 1947). Hair coming from the head, the most sacred part of the human body, contained the *mana* of its owner and therefore increased the spiritual power of any object in which it was used. Similarly, throughout Polynesia, sennit was intimately associated with deities and their physical representations (Barrow 1973, 55), and the braiding of fiber involved chants that were believed to increase the *mana* of the object itself.

Rose (1979, 212) suggests that because Type-A whisks are the most numerous, were consistently carved with metal tools, and were often carelessly crafted, they are the most recent and may have been made for the growing curio market. Furthermore, he notes, some whisks could very well have been used or even made on the Society Islands. Examples of Austral wood carving were common there by the end of the eighteenth century, some Austral Islanders had moved there by the beginning of the nineteenth century, and Society Islanders showed interest in obtaining foreign-made goods, whether from Europe or elsewhere, from the beginning of European contact. The possibility that Society Islanders used the whisks, as they had prestige whisks such as catalogue number 25, fits with Wardwell's observation (1994, 198) that many Type-A whisks seem to have been handled extensively.

References cited

Barrow, Terence. 1973. *Art and Life in Polynesia*. Rutland, Vermont: Charles E. Tuttle.
Gathercole, Peter, Adrienne L. Kaeppler, and Douglas Newton. 1979. *The Art of the Pacific Islands*. Exhibition catalogue. Washington, D.C.: National Gallery of Art.
Handy, E.S. Craighill. 1927. *Polynesian Religion*. Bernice P. Bishop Museum Bulletin, no. 34. Honolulu: Bernice P. Bishop Museum.
Kaeppler, Adrienne L. 1982. "Genealogy and Disrespect: A Study of Symbolism in Hawaiian Images." *Res* 3 (Spring 1982): 83-107.
Mack, Charles W. 1982. *Polynesian Art at Auction 1965-1980*. Northboro, Mass.: Mack-Nasser Publishing.
Rose, Roger G. 1979. "On the Origin and Diversity of 'Tahitian' Janiform Fly Whisks." In *Exploring the Visual Art of Oceania*, 202-13. Edited by Sidney M. Mead. Honolulu: University Press of Hawaii.
Turbott, Olwyn M. 1947. "Hair Cordage in Oceania." *Records of the Auckland Museum* 3, no. 3: 151-55.
Wardwell, Allen. 1994. *Island Ancestors: Oceanic Art from the Masco Collection*. Exhibition catalogue. Detroit: Detroit Institute of Arts.

Provenance: Acquired from J.J. Klejman (New York) in 1960

Published: MPA 1960b, cat. no. 49; Arts Club 1966, cat. no. 45 (ill.); Wardwell 1967b, cat. no. 27 (ill.); *Chicago Tribune* 1970, 1A:1; Barrow 1973, pl. 174; Fine Arts Gallery of San Diego 1973, 79 (ill.); Oliver 1974, fig. 6-5; IUAM 1990b, 4 (ill.)

Exhibited: MPA 1960b, Arts Club 1966, AIC 1967, San Diego 1973, IUAM 1990, IUAM 1993

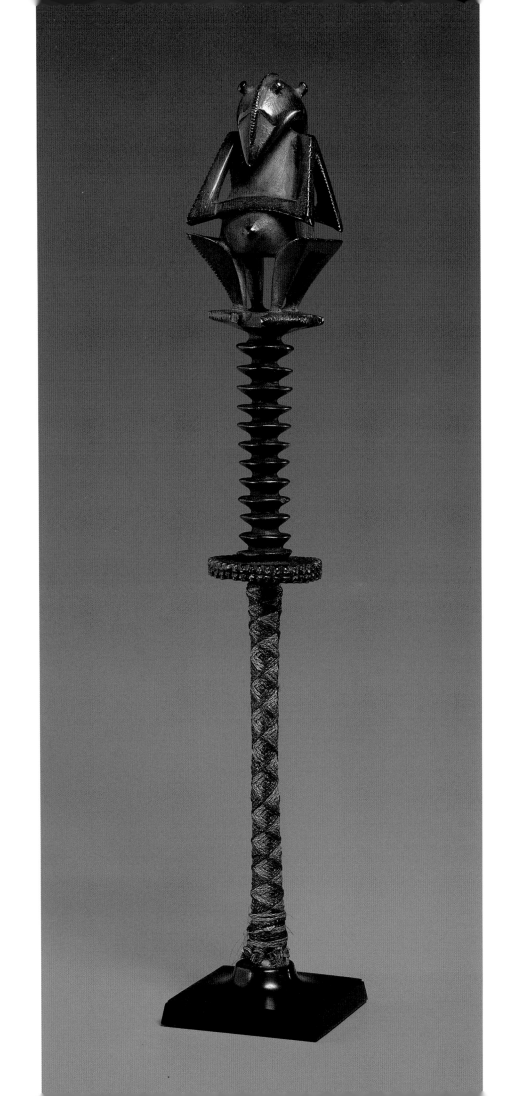

27

Raivavae, Austral Islands

Drum, *Pahu-Ra*

Ca. 1800-1850
Tamanu wood *(Calophyllum inophyllum)*,
sharkskin, sennit
H. 54 in. (137.1 cm)
IUAM 80.5.3 (RW 60-210)

Our information about the Austral Islands, located south of the Cook and Society islands, is scanty for both the pre-contact and early postcontact periods. James Cook first visited the island of Rurutu, or Ohetiroa, in 1769, but the Australs were considered small and out of the way, as most ships in the vicinity used Tahiti as a port, and so contact was irregular. By the early nineteenth century, the population had been decimated by disease and Christianized by missionaries, and Western interest centered primarily on the progress of Christianity and the availability of food and water (Barrow 1979, 51; Rose 1979, 208).

As a result, even with an object such as this drum, we can do little more than admire the magnificent carving for which these islands are known. An often-cited drawing by John Webber, the official artist on Cook's third voyage (1776-80), shows a Tahitian temple area in which similar drums, which may have been imported from the Austral Islands, are being played (Kaeppler 1978, 160, fig. 303); our lack of contextual information about them in the Austral Islands only allows us to suppose that they were used in the same way there.

Only about a dozen of these tall cylindrical Austral drums are known, and all share the same basic form, though the position of the drum cleats and the amount of decorative carving vary. The tympanum is sharkskin, a material that was used for drumheads until the early twentieth century, when it was replaced by cattle or goat skin (Moyle 1990, 34). While some of the drum chambers are plain, this one is carved with repeating rows of three motifs: toothed notches,

crescents, and multiple stylized headless humans with elbows on knees. This last motif is one that is found not only on other Austral carving but also on objects from Mangaia in the Cook Islands, particularly the ceremonial adzes associated with Tane, an important Polynesian deity.

Sennit tension cords, which hold the tympanum, pass over the drum chamber and under a tightening roll to rectangular cleats, each of which is decorated with two rectangular faces and chip carving. The drum stand below the cleats is densely carved with additional bands. The most prominent are pierced rows of dancing figures which alternate with pierced rows of crescents similar to those on the chamber. These crescents have been interpreted as a symbol comparable to the Christian halo and representing "emanating *mana*" (Mack 1982, 210) and as decorative elements inspired by the curved thighs of dancers (Duff 1969, 30), dance skirts (Newton 1986, 64), or the curved pectorals worn by dancers. Near the bottom of the drum, a row of triangular upside-down faces echoes the faces on the cleats; below those, the headless human motif is repeated, along with another motif also associated with another Austral island, Tubuai, which consists of concentric circles ringed with rays.

From the beginning of European contact in the South Pacific, iron nails and other metal pieces and implements were popular trade items, and, as interactions intensified in the late eighteenth century, metal began to replace traditional tools of bone, stone, and teeth. The new tools not only allowed work to be completed more rapidly but also made intricate carving easier. This drum, made with metal tools, is similar in form and motifs to the earliest collected drums (two acquired on Cook's second or third voyage), but its carving is much more complex and elaborate. Though the coming of Europeans was disastrous for traditional Polynesian culture, objects such as this one bear witness to a brief period between contact and acculturation in which skilled carvers reached new heights.

References cited

Barrow, Terrence. 1979. *The Art of Tahiti and the Neighbouring Society, Austral and Cook Islands.* London: Thames and Hudson.
Duff, Roger. 1969. *No Sort of Iron: Culture of Cook's Polynesians.* Exhibition catalogue. Christchurch: Art Galleries and Museums' Association of New Zealand.
Kaeppler, Adrienne L. 1978. "*Artificial Curiosities.*" Exhibition catalogue. Bernice P. Bishop Museum Special Publication, no. 65. Honolulu: Bishop Museum Press, 1978.
Mack, Charles W. 1982. *Polynesian Art at Auction 1965-1980.* Northboro, Mass.: Mack-Nasser Publishing.
Moyle, Richard. 1990. *Polynesian Sound-producing Instruments.* Shire Ethnography, 20. Princes Risborough, Bucks.: Shire Publications.
Newton, Douglas. 1986. "Visual Arts of the Pacific." In *African, Pacific, and Pre-Columbian Art in the Indiana University Art Museum*, 49-97. Essays by Roy Sieber, Douglas Newton, and Michael D. Coe. Bloomington: Indiana University Art Museum in Association with Indiana University Press.
Rose, Roger G. 1979. "On the Origin and Diversity of 'Tahitian' Janiform Fly Whisks." In *Exploring the Visual Art of Oceania*, 202-13. Edited by Sidney M. Mead. Honolulu: University Press of Hawaii.

Provenance: Acquired from Allan Frumkin (Chicago) in 1960

Published: Arts Club 1966, cat. no. 47 (ill.); Wardwell 1967b, cat. no. 31 (ill.); *Chicago Tribune* 1970, 1A:1; MMA 1970, 332; Barrow 1973, pls. 187-89; Gathercole, Kaeppler, and Newton 1979, cat. no. 6.3 (ill.); IUAM 1980, 244 (ill.); IUAM 1986, cat. no. 79 (ill.); IUAM [1989b], 1 (ill.)

Exhibited: Arts Club 1966, AIC 1967, MMA 1970, Tucson 1975, NGA 1979, IUAM 1993

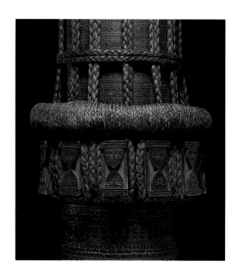

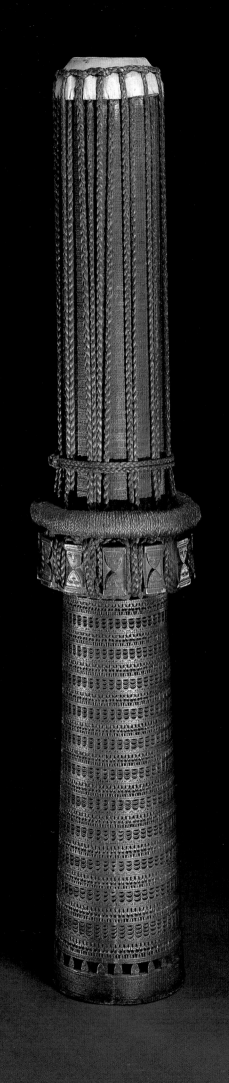

Marquesas Islands

Figure, Tiki

Basalt
H. 6 3/16 in. (15.7 cm)
IUAM 100.23.5.79 (RW 56-54)

Though the large heads of Easter Island are perhaps the best-known examples of stonework in Polynesia, stone arch-itecture and sculpture are found throughout eastern Polynesia. Nowhere was stone more finely worked than on the Marquesas Islands, a group of rugged volcanic outcroppings northeast of the Society Islands.

Marquesas Island stone figures, which take the form of single and double human figures and, more rarely, fish, range from just over five inches to more than eight feet in height. The large figures, associated with temple areas, are generally made of red tuff, a soft stone of volcanic origin. Harder basalt was used for smaller figures, such as this example.

The large head, blocky body with square shoulders, hands on rounded stomach, heavy legs bent at the knees, and rounded buttocks of this example

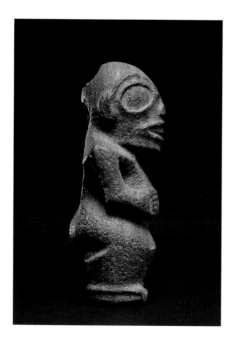

are all characteristic of the human stone figures, though these features are also found on figures elsewhere in Polynesia. The face clearly identifies this piece as from the Marquesas Islands. The goggle eyes, nose with narrow bridge and flaring nostrils, and broad mouth with an indication of the tongue between the lips are uniquely Marques-an and are found on each of the other Wielgus objects from this area (cat. nos. 29-34).

The word *tiki* is used in the Mar-quesas Islands to refer to representa-tions of the human form, as well as to motifs inspired by it. Tiki is also the name of a deity who plays a prominent role in the myths of origin in many parts of Polynesia. In the Marquesas Islands, various myths credit him with teaching the carving of figures or with being the first deity for whom images were carved. Ralph Linton (1925, 85), who served as ethnologist on an expedi-tion to the Marquesas in 1920-21, noted that Marquesan figures were said to represent deities and deified ances-tors, and therefore not all were repre-sentations of the god Tiki. It is possible, of course, that such an association did exist at one time (Smith 1973, 188).

The hole in the back of the head on some but not all of the small figures suggests that they were meant to be suspended, but the weight of this example makes it unlikely that it was worn in this way. Though double figures, carved back to back with a sus-pension hole between, were apparently hung on a line and dropped into the sea as a fishing charm (Dodd 1967, 307), we do not have specific information about how the single figures were used. E.S. Craighill Handy (in Linton 1923, 345), an early twentieth-century ethno-grapher who tried to retrieve surviving information about earlier Marquesan culture, noted only that they were used in healing the sick and as votive offer-ings for success in all sorts of undertak-ings. A person would leave such an offering at the temple area dedicated to the particular deity being invoked; perhaps the figures with holes were suspended there.

References cited

Dodd, Edward H., Jr. 1967. *Polynesian Art: The Ring of Fire*, vol. 1. New York: Dodd, Mead.

Linton, Ralph. 1923. "The Material Culture of the Marquesas Islands." *Memoirs of the Ber-nice P. Bishop Museum* 8, no. 5: 263-471.

————. 1925. *Archaeology of the Marquesas*. Bernice P. Bishop Museum Bulletin, no. 23. Honolulu: Bernice P. Bishop Museum.

Smith, Tracy. 1973. "Tiki." In *Dimensions of Polynesia*, 186-90. Edited by Jehanne Teilhet. Exhibition catalogue. San Diego: Fine Arts Gallery of San Diego.

Provenance: Ex-coll. Warner Muensterberger (New York); acquired from Julius Carlebach (New York) in 1956

Published: MPA 1960b, cat. no. 52; Arts Club 1966, cat. no. 49; Wardwell 1967b, cat. no. 58 (ill.); Schmitz 1971, pl. 249

Exhibited: AIC 1958, MPA 1960b, Arts Club 1966, AIC 1967, IUAM 1993

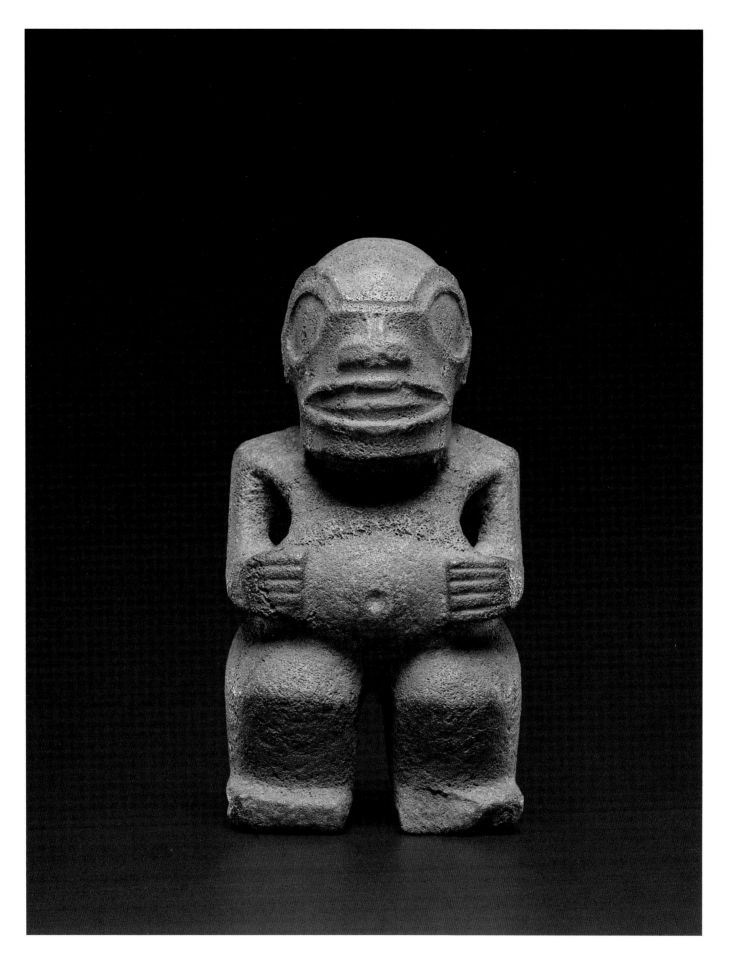

29

Marquesas Islands

Ornament, *Ivi Po'o*

Bone
H. 1 15/16 in. (4.9 cm)
IUAM 79.79.1 (RW 76-290)

30

Marquesas Islands

Ornament, *Ivi Po'o*

Bone
H. 1 1/4 in. (3.2 cm)
Raymond and Laura Wielgus Collection
(RW 91-290)

A comparison of these bone-tube objects with the preceding stone figure (cat. no. 28) clearly illustrates the distinctiveness and consistency of the Marquesan figural style. Though in a different material, the same goggle eyes, flaring nostrils, and broad mouth that characterize the stone figure appear here in miniature.

These ornaments also begin to demonstrate the pervasiveness of the human form in Marquesan art, for, unlike the stone figures, these were primarily secular, decorative objects. Used singly or in pairs and often in combination with seeds, they were ornamental toggles for fiber cords used on objects such as drums and shell trumpets and as slings for household objects such as coconut containers. They were also worn as hair ornaments. A man planning on killing for revenge, for example, is said to have worn one at the end of a single lock of shoulder-length hair (Edler 1990, 68). In addition, some with tufts of human hair attached to them may have been used in supernatural practices designed to revenge a wrong (Rolin in Phelps 1976, 96).

Figural toggles, which are usually between one and a half and just over two inches in height, always take the form of a truncated *tiki*. The Wielgus examples show the most common pose, with hands to stomach, though others,

such as a hand to the face, do occur. Though the hardness of their material kept stone carvers from showing the tatoos for which early Marquesans were known, their depiction is common on the figural bone ornaments; the larger Wielgus example (cat. no. 29), for instance, shows them on the buttocks. The *tiki*-motif ornaments are most popular with art collectors and museums, but Marquesans also carved smaller nonfigural ones in such a way that they look like vertebrae. We cannot be sure whether the resemblance was intentional.

All of the toggles are made of human bone: nonfigural ones from smaller bones, such as the ulna and fibula, and ones carved with the *tiki* motif from the larger femur, humerus, or radius (Linton 1923, 440). These bones were from the bodies of deceased parents, other important ancestors, or slain enemies. Throughout Polynesia, the use of bones and teeth from respected ancestors was believed to be one way of augmenting the *mana* of the object in which they were used and, by extension, that of the object's owner. An ornament made out of an enemy's bone, on the other hand, has been described as "the ultimate insult and symbol of triumphant revenge" (Edler 1990, 68). In addition, however, such an ornament, particularly when worn on the head, the seat of an individual's *mana*, may also have been a way for the victor to acquire some of the *mana* of an opponent who had been especially brave or powerful.

References cited

Edler, John Charles. 1990. *Art of Polynesia.* Honolulu: Hemmeter Publishing Corporation.
Linton, Ralph. 1923. "The Material Culture of the Marquesas Islands." *Memoirs of the Bernice P. Bishop Museum* 8, no. 5: 263-471.
Phelps, Steven. 1976. *Art and Artefacts of the Pacific, Africa and the Americas: The James Hooper Collection.* London: Hutchinson.

Cat. no. 29

Provenance: Acquired from the estate of Frederick Pleasants (Tucson) in 1976
Published: IUAM 1986, cat. no. 87 (ill.)

Cat. no. 30

Provenance: Acquired from Ron Nasser (New York) in 1991

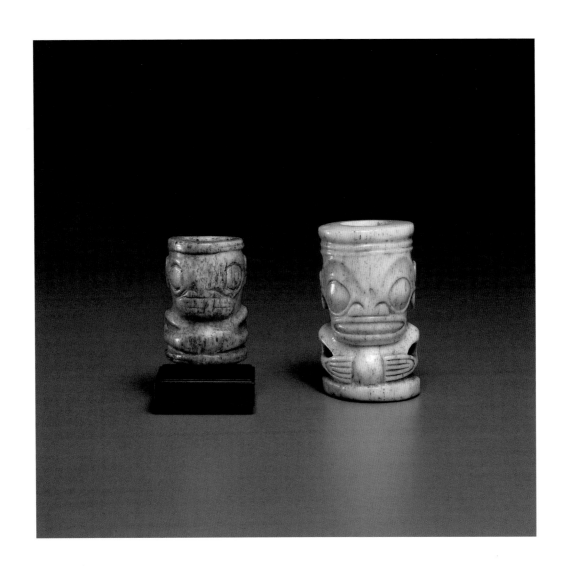

31

Marquesas Islands

Stilt Step, *Tapuva'e*

Wood
H. 17 3/4 in. (45.1 cm)
Raymond and Laura Wielgus Collection
(RW 56-40)

Stilt games in the Marquesas Islands
consisted of races and competitions in
which one man would try to knock
down his opponent by balancing on one
stilt while using the other to strike the
stilts of his rival. Particularly skillful
stilt-walkers could also entertain by
performing somersaults and other
acrobatics. Stilt contests, along with
singing and dancing, are said to have
been the major entertainment at *koina*
and *mau*, festivals marking special
events such as weddings, milestones in
the lives of children from important
families, and the death of a chief or a
tau'a, a priest through whom the gods
were believed to speak (Langsdorff
1813, 1: 136; Handy 1923, 218; Ferdon
1993, 68). Thus, stilt contests were
entertaining, but many were also sacred
activities (Handy 1927, 306-7). They
were believed to be a means of attrac-
ting the attention of deities, as well as a
demonstration of the *mana* of the in-
dividual contestants and the families
and groups they represented.

While stilt contests were also popular
in other parts of Polynesia, such as the
Society Islands, Hawaii, and New Zea-
land, only on the Marquesas did the
stilts themselves become an art form.
A Marquesan stilt consisted of two
parts: a pole, between five and seven
feet long, and a stilt step that was lashed
to it. While some stilts, particularly
those owned by young boys, were plain,
many were decorated. The poles, about
two or three inches in diameter, were
usually carved with simple relief
patterns resembling those on Marque-
san house posts. To help keep a step
from slipping, the pole was wrapped
with *tapa* (beaten barkcloth) approxi-
mately a third of the way up the shaft,

and then the step was lashed in place
over it. These lashings secured the step
in two places: below the horizontal
footrest (behind the head of the large
figure on this example) and at the
bottom (on this one, below the smaller
figure). The lashings were also decora-
tive, as the braided fiber cords were
often dyed black and red and arranged
in ornamental patterns.

The major decorative component of
most stilts, though, was the stilt step,
tapuva'e, usually made from the *mi'o*
tree (*Thespesia populnea*). Carved from
a single piece of wood, it would depict
one or more of the distinctively Mar-
quesan *tiki* figures (see cat. nos. 28-30).
Though the number, pose, and arrange-
ment of figures varies, the most com-
mon form is a single standing *tiki* with
hands on stomach, head attached to the
bottom of the footrest, and buttocks
and legs carved in very high relief
below. The Wielgus *tapuva'e* shows
such a figure, but with the addition of
a smaller crouching figure below it. As
with other Marquesan figures, these
cannot be identified, though the pose
and size of the bottom figure suggest
that it is the less important of the two.
The face of a *tiki* appears once again in
relief on the part of the footrest which
holds the foot in place. More common-
ly, that area is covered with relief
patterns similar to those above the face,
which, like the stilt poles, recall carving
on house posts.

References cited

Ferdon, Edwin N. 1993. *Early Observations
of Marquesan Culture, 1595-1813*. Tucson:
University of Arizona Press.
Handy, E.S. Craighill. 1923. *The Native
Culture in the Marquesas*. Bernice P. Bishop
Museum Bulletin, no. 9. Honolulu: Bernice
P. Bishop Museum.
———. 1927. *Polynesian Religion*. Bernice
P. Bishop Museum Bulletin, no. 34. Honolulu:
Bernice P. Bishop Museum.
Langsdorff, G.H. von. 1813. *Voyages and
Travels in Various Parts of the World During
the Years 1803, 1804, 1805, and 1807*. 2 vols.
London: Henry Colburn.

Provenance: Acquired from J.J. Klejman (New
York) in 1956
Published: MPA 1960b, cat. no. 51; Arts Club
1966, cat. no. 48; Wardwell 1967b, cat. no. 39
(ill.)
Exhibited: AIC 1958, MPA 1960b, Arts Club
1966, AIC 1967, IUAM 1990, IUAM 1993

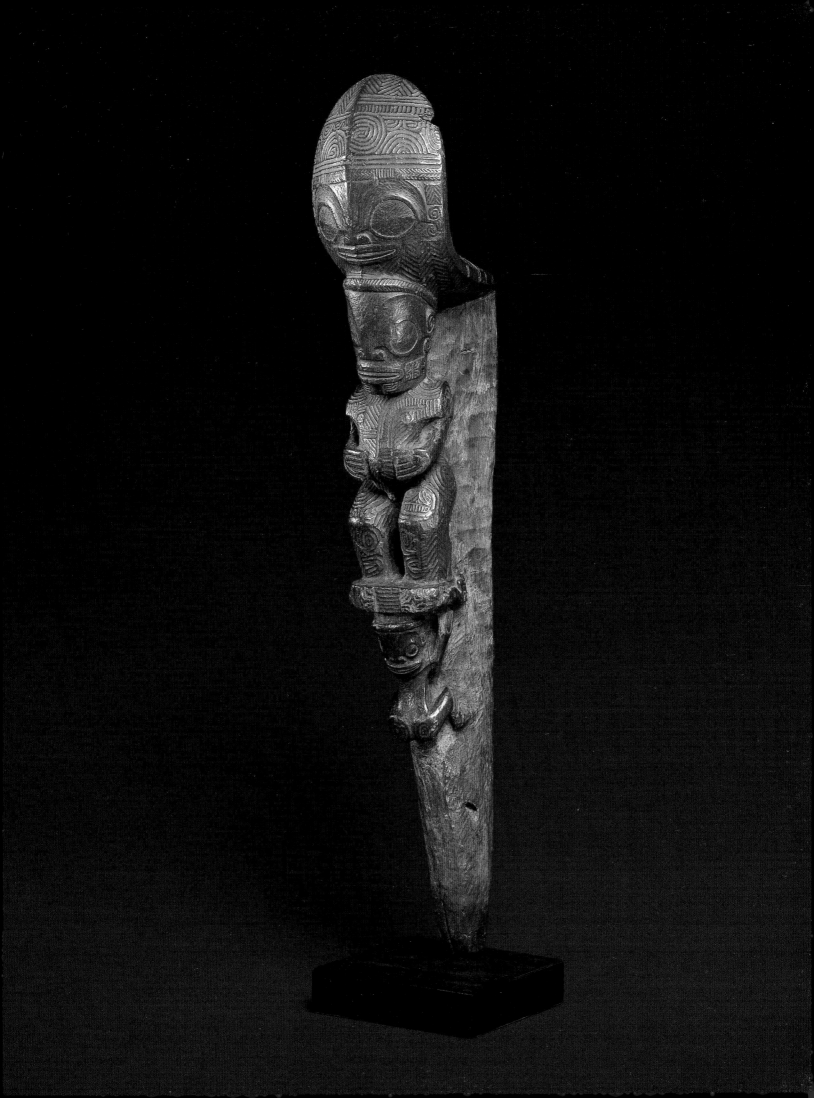

Marquesas Islands

Headband, *Uhikana*

Pearl shell, turtle shell, fiber
L. 19 3/8 in. (49.2 cm)
Raymond and Laura Wielgus Collection
(RW 59-144)

33

Marquesas Islands

Coronet, *Paekaha*

Turtle shell, conch shell, fiber
W. 8 7/8 in. (22.5 cm)
IUAM 69.123 (RW 59-154)

The contrast between the darkness of turtle shell and the lightness of certain seashells must have been admired by the peoples of the Marquesas Islands, for their two most elaborate headdress types prominently feature a combination of those materials.

In a report of his second voyage of exploration in the Pacific, which included a stop at the Marquesas Islands in 1774, James Cook (1777, I: 309-10) included a detailed description of the *uhikana* (cat. no. 32), which he calls the Marquesans' "principal head-dress, and what appears to be their chief ornament." As the Wielgus example shows, it consisted of a fiber band to which a large shell disk was attached. This disk was overlaid with a piece of carved turtle shell, a smaller shell disk, and an even smaller piece of carved turtle shell. On each side of the central disk was a smaller piece of shell, also with turtle-shell overlay. While the turtle shell covering the central disk on the Wielgus example is carved in the form of six heads, other pieces show more abstract patterns similar to the carving on the side pieces here. The *uhikana* seems to have been a male headdress, worn by chiefs, warriors, and male dancers on all the islands (Linton 1923, 438; Ferdon 1993, 19).

The coronet, or *paekaha*, on the other hand, was a headdress worn by high-ranking men and women. It was not owned by an individual, but was worn by various family members on different occasions and was passed down through generations as an heirloom (Handy 1923, 283). Unlike the *uhikana*, Cook made no mention of such coronets, nor did other very early visitors. The apparent explanation is that this headdress type had a much more localized distribution, probably originating in one of the southern islands, perhaps Fatu Hiva, spreading later to some of the nearby islands and, during the early historical period, being traded to Nuku Hiva in the north (Linton 1923, 436, 437). Interestingly, the *paekaha* seems to be more common in Western collections than the *uhikana*; between 1965-80, six coronets (and no headbands) were sold at major auctions (Mack 1982, 194).

The Wielgus *paekaha* shows the standard form: bent turtle-shell plaques alternating with curved pieces of conch shell, all attached to a fiber band. At the ends of the band, pieces of white shell are overlaid with carved turtle shell in a manner similar to the shell layering on the sides of the *uhikana*. The only decoration on the rest of this band is a surface pattern created by the weaving of the fibers, though more elaborate examples are covered with small shell disks or, on later ones, buttons. Standing *tiki* figures (see cat. no. 28) flanked by smaller ones are carved in relief on the turtle-shell plaques. These figures appear upside down when the coronet is worn with the band at the top and the plaques covering the forehead, which is the way early European accounts pictured it. However, in early twentieth-century interviews with Marquesans about their traditional culture, one person indicated that the *paekaha* was originally worn with the band below the plaques so that the figures appeared upright (Linton 1923, 436).

When worn, each of these accoutrements drew attention to the head, considered by Polynesians to be the most sacred part of the body, the seat of a person's *mana*. Sometimes the head would have been emphasized even further. Cook (1777, I: 310) described feathers attached to the band of the *uhikana* that stood up when it was worn, "so that the whole together makes a very sightly ornament." An upright projection was also often worn with the *paekaha*. At festivals, men attached to the band a large plume made from the white beard of a male relative, which was said to give the impression of quickness, while women sometimes wore the coronet with a high coiffure that stood above it (Handy 1923, 283, 291; Linton 1923, 436).

References cited

Cook, James. 1777. *A Voyage Towards the South Pole and Round the World...* 2 vols. London: W. Straham and T. Cadell.
Ferdon, Edwin N. 1993. *Early Observations of Marquesan Culture, 1595-1813*. Tucson: University of Arizona Press.
Handy, E.S. Craighill. 1923. *The Native Culture in the Marquesas*. Bernice P. Bishop Museum Bulletin, no. 9. Honolulu: Bernice P. Bishop Museum.
Linton, Ralph. 1923. "The Material Culture of the Marquesas Islands." *Memoirs of the Bernice P. Bishop Museum* 8, no. 5: 263-471.
Mack, Charles W. 1982. *Polynesian Art at Auction 1965-1980*. Northboro, Mass.: Mack-Nasser Publishing Co.

Cat. no. 32

Provenance: Ex-coll. Yves Petit Dutaillis (France); acquired from J.J. Klejman (New York) in 1959

Published: Portier and Poncetton 1922, pl. 34; MPA 1960b, cat. no. 53 (ill.); Arts Club 1966, cat. no. 50; Wardwell 1967b, cat. no. 56 (ill.); Barrow 1973, pl. 20; Fine Arts Gallery of San Diego 1973, 165 (ill.); Gathercole, Kaeppler, and Newton 1979, cat. no. 2.13 (ill.)

Exhibited: MPA 1960b, Arts Club 1966, AIC 1967, San Diego 1973, NGA 1979, IUAM 1990, IUAM 1993

Cat. no. 33

Provenance: Acquired from J.J. Klejman (New York) in 1959; to Everett Rassiga (New York); to Jay Leff (Uniontown, Penn.); to Sotheby's auction; to Alan Brandt (New York); to IUAM in 1969

Published: MPA 1960b, cat. no. 54; Gathercole, Kaeppler, and Newton 1979, cat. no. 2.12 (ill.); IUAM 1980, 245 (ill.); IUAM 1986, cat. no. 86 (ill.)

Exhibited: MPA 1960b, NGA 1979, IUAM 1993

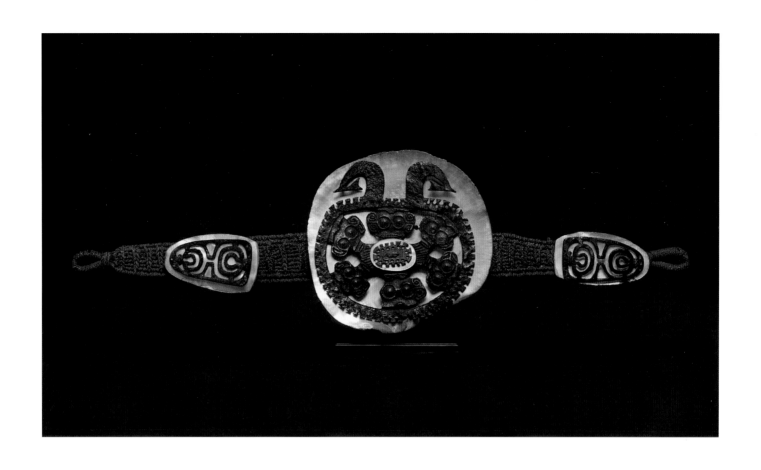

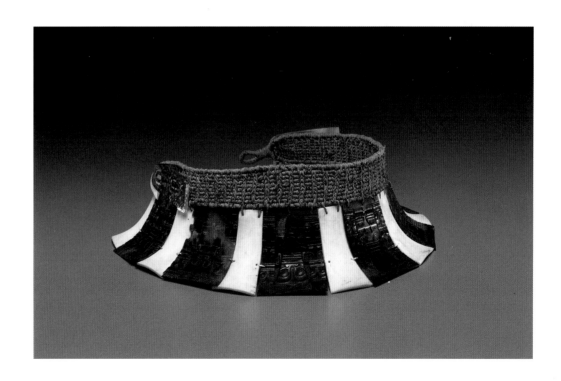

34

Marquesas Islands

Fan, *Tahi*

Pandanus fiber, whale ivory, human teeth, pigment
W. 22 1/2 in. (57.2 cm)
Raymond and Laura Wielgus Collection
(RW 59-155)

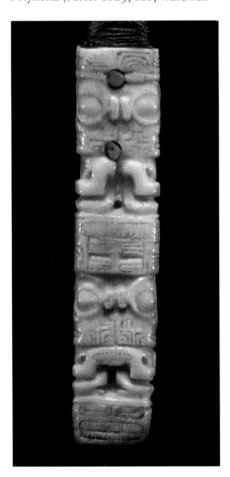

Like fly whisks (see cat. nos. 25, 26), fans were common throughout Polynesia, serving both functional and decorative purposes. Ordinary fans were (and still are) made of a green coconut frond, using the midrib as a handle and plaiting the leaflets to form the fan. Male and female chiefs and priests on the Marquesas Islands, however, owned large, more finely plaited fans, with handles made of wood, ivory, or bone. Wooden handles were more common than those made of bone or whale ivory, which were prestige materials in Polynesia (Porter 1823, 116; Wardwell 1994, 226). Whatever the material, the most elaborate handles were decoratively carved, as in this example. With minor variations, the major motif is the *tiki*, the Marquesan representation of the human form (see cat. no. 28), usually depicted, as here, in the form of two back-to-back pairs.

Though women generally plaited fans, these handles, as with all carvings, were made by men. Professionals who specialized in fan making were considered *tuhuna*, specialists in crafts and trades. Such individuals were well regarded throughout Polynesia, and in the Marquesas Islands they were held in particularly high esteem (Goldman 1970, 136). The fans they made were not primarily utilitarian objects; in fact, the Wielgus blade's large size and broad proportions together with the fineness of its fiber strands make it less effective as a fan than ordinary ones. Such objects were emblems of status and may also have had ceremonial significance. For example, female chiefs carried them at *koina*, festivals held on large community dance courts that included one or more platforms for spectators (Linton 1923, 385). The blades of many fans, including this one, were rubbed with white clay or lime obtained from burning mussel shells, though the significance of this practice is unknown.

Like other Polynesian objects made of precious materials, fans such as this — or at least the handles — would have become heirlooms, passed down through generations (Handy 1923, 293). Through physical contact, a fan handle would have gained *mana* from its owner, thereby becoming more prized and respected with each succeeding generation. This fan's *mana* was also increased with the addition of human teeth. Other fans are reported to have been made of human bone (Porter 1823, 116), which would have had a similar effect. Use of human bone and teeth from a respected ancestor or slain enemy was a common practice in Polynesia and recalls the Wielgus bone ornaments (see cat. nos. 29, 30), also from the Marquesas Islands.

References cited

Goldman, Irving. 1970. *Ancient Polynesian Society*. Chicago: University of Chicago Press.
Handy, E.S. Craighill. 1923. *The Native Culture in the Marquesas*. Bernice P. Bishop Museum Bulletin, no. 9. Honolulu: Bernice P. Bishop Museum.
Linton, Ralph. 1923. "The Material Culture of the Marquesas Islands." *Memoirs of the Bernice P. Bishop Museum* 8, no. 5: 263-471.
Porter, David. 1823. *A Voyage to the South Seas in the Years 1812, 1813, and 1814...* London: Richard Phillips.
Wardwell, Allen. 1994. *Island Ancestors: Oceanic Art from the Masco Collection*. Exhibition catalogue. Detroit: Detroit Institute of Arts.

Provenance: Acquired from J.J. Klejman (New York) in 1959

Published: MPA 1960b, cat. no. 55 (ill. back cover); Arts Club 1966, cat. no. 51 (ill.); Wardwell 1967b, cat. no. 45 (ill.); Schmitz 1971, color pl. 48; Barrow 1973, pl. 157; Gathercole, Kaeppler, and Newton 1979, cat. no. 2.15 (ill.)

Exhibited: MPA 1960b, Arts Club 1966, AIC 1967, Tucson 1976, NGA 1979, IUAM 1990, IUAM 1993

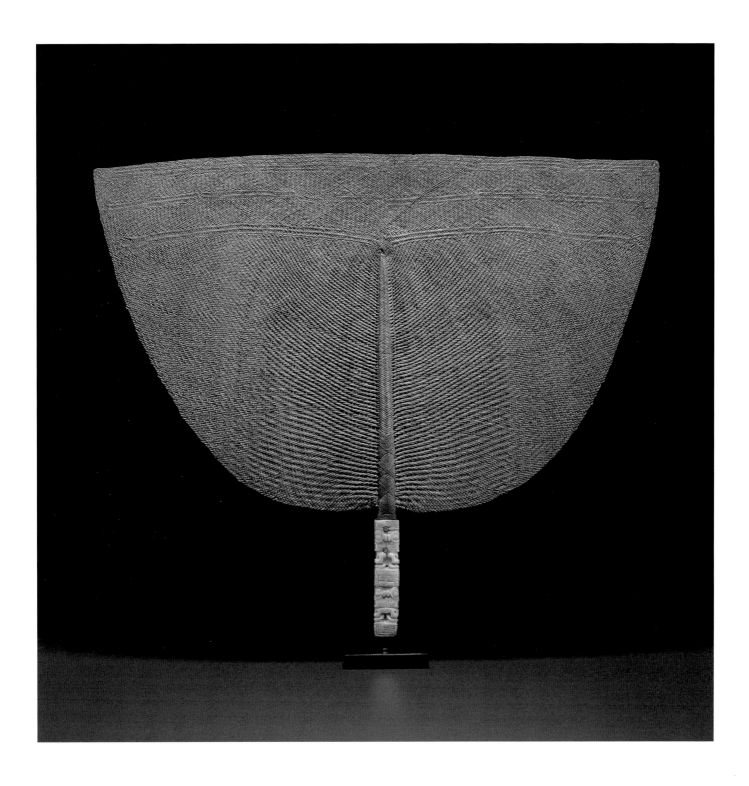

Easter Island

Breast Ornament, *Rei Miro*

Wood, obsidian, bone
W. 15 in. (38.1 cm)
Raymond and Laura Wielgus Collection
(RW 66-276)

No peoples of the South Pacific were more drastically affected by the arrival of Europeans than those of Easter Island, or Rapa Nui, the small island that forms the eastern point of the imaginary triangle delineating the boundaries of Polynesia. Already reeling from major internal turmoil, Easter Islanders not only were subjected to the diseases, missionizing, and intervention in politics and commerce that marked the Western presence in the islands but also suffered severe ruptures with past traditions as a result of the slave trade and forced relocations. As a result, much of the knowledge about precontact Easter Island was lost, and so information about the use, significance, and meaning of many objects, including this ornament and catalogue numbers 36 and 37, remains fragmentary.

These distinctive crescent-shaped breast ornaments are typically carved of *toromiro* wood. The *toromiro* is a small tree that furnished nearly all the wood available on the island. Other examples made of stone, bone, and shell are also known. Holes in the back of the top rim allow them to be suspended. Most *rei miro* are symmetrical, with carved elements, particularly the heads of birds or men, at the crescent points. The heads of men, depicted here, are the most common and are carved in the same style as the heads of the emaciated male figures known as *moai kavakava* (see cat. no. 36). Though the Wielgus *rei miro* heads have bone- and obsidian-inlaid eyes, just as the figures do, that feature is absent from most other breast ornaments. Whether these heads refer to ancestors, as the *moai kavakava* are thought to, is unknown. One scholar, drawing on a

report that connects the ornaments with sweet-potato planting rituals, has suggested that the heads may personify Rongo, the god of agriculture (Fedorova 1990, 28).

The *rei miro* was worn by both men and women. It served as an insignia of high rank for Easter Island males, and the *ariki mau*, paramount chief of the island, was said to have worn two of them as pectorals and two others on his shoulders on special occasions (Métraux [1940] 1971, 231). A noble woman might also wear a *rei miro* at feasts and festivals, though some sources suggest that the female version was smaller or made from a different material, such as shell (ibid.; Routledge 1919, 268).

Various interpretations have been proposed for the derivation and meaning of the crescent form. Though the idea has now been discounted, some earlier scholars thought that it referred to the shape of the boat that brought the first settlers to Easter Island. Others have proposed that the form derives from shell breast ornaments or horizontal whale-tooth pendants worn elsewhere in Polynesia and have noted that the shape is similar to a wooden chest piece that is part of the traditional Tahitian mourning costume (Duff 1969, 58; Barrow 1973, 144). The word *rei* is generally used in Polynesia to mean "neck ornament" and originally referred to a whale tooth. In the traditional language of Easter Island, the word also means "mother-of-pearl shell" (Métraux [1940] 1971, 230).

In parallel with interpretations of the crescent in other areas of eastern Polynesia, it has also been proposed that the form may represent a human figure with upraised arms, which in turn recalls the gods believed to hold the sky above the earth (Van Tilburg 1994, 122). Finally, and perhaps most convincingly, the crescent may be associated with the moon. This relationship is found throughout the rest of Polynesia; at the end of the nineteenth century some Easter Islanders indicated that the variations in the shapes of the *rei miro* referred to different phases of the moon

(Young in Métraux [1940] 1971, 232). Furthermore, scholars studying *rongorongo*, Easter Islanders' system of pictorial symbols, have interpreted the crescent as a sign for the moon (Van Tilburg 1994, 122).

References cited

Barrow, Terence. 1973. *Art and Life in Polynesia*. Rutland, Vermont: Charles E. Tuttle.
Duff, Roger, ed. 1969. *No Sort of Iron: Culture of Cook's Polynesians*. Exhibition catalogue. Christchurch: Art Galleries and Museums' Association of New Zealand.
Fedorova, I.K. 1990. "Ethnological and Folklore Data in the Symbolic Interpretation of Easter Island Art Objects." In *State and Perspectives of Scientific Research in Easter Island Culture*, 23-39. Edited by Heide-Margaret Esen-Baur. Courier Forschungsinstitut Senckenberg, 125. Frankfurt: Senckenbergischen Naturforschenden Gesellschaft.
Métraux, Alfred. [1940] 1971. *Ethnology of Easter Island*. Bernice P. Bishop Museum Bulletin, no. 160. Honolulu: Bernice P. Bishop Museum; reprint ed., Bishop Museum Press Reprints.
Routledge, K.S. 1919. *The Mystery of Easter Island*. London: Sifton, Praed and Co.
Van Tilburg, Jo Anne. 1994. *Easter Island: Archaeology, Ecology, and Culture*. Washington, D.C.: Smithsonian Institution Press.

Provenance: Acquired from Merton Simpson (New York) in 1966

Published: Wardwell 1967b, cat. no. 71 (ill.); Schmitz 1971, pl. 264; Barrow 1973, pl. 251; Fine Arts Gallery of San Diego 1973, 162 (ill.); IUAM [1990b], 3 (ill.)

Exhibited: AIC 1967, San Diego 1973, IUAM 1990, IUAM 1993

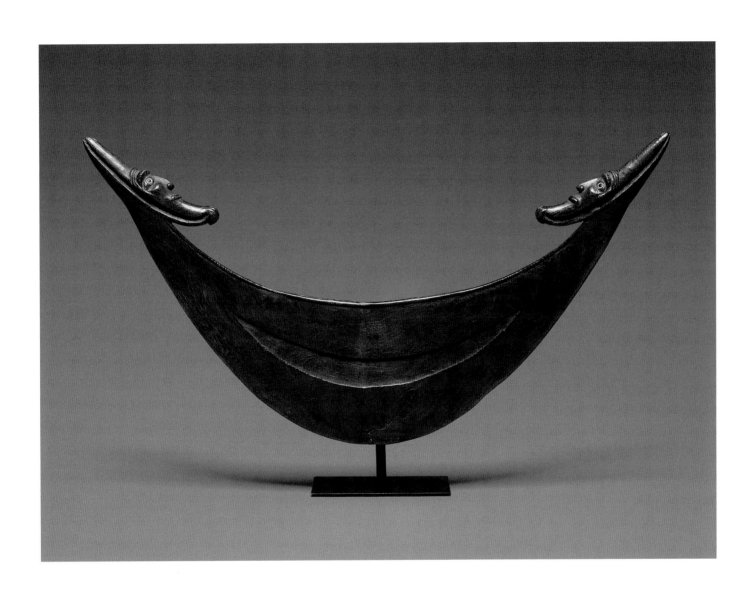

Easter Island

Male Figure, *Moai Kavakava*

Wood, obsidian, bone
H. 15 in. (38.1 cm)
IUAM 80.5.1 (RW 67-283)

Few objects in the Wielgus Collection are as evocative and puzzling in appearance as this male figure and the lizard figure (cat. no. 37), both from Easter Island. Male figures such as this one, called *moai kavakava* ("statue with ribs"), are generally believed to represent ancestral spirits, although recently some scholars have suggested that they may be related to Makemake, the bird-man deity and an important figure in Easter Island religion and mythology (Fedorova 1990, 34; Forment 1990; Wardwell 1994, 256). If the figures are ancestral, their skeletonized appearance may emphasize that the bodies of such spirits are desiccated, or they may refer to ancestors who were affected by famine. The beards, indicating elderhood, also point to an ancestral connection. Other features, such as the beaklike nose, are cited in support of the association with Makemake, as is folklore connected with him that personifies him both as a skull and as a man emerging from a skull.

Another puzzle is the variety of motifs, some resembling Easter Island petroglyphs, that are carved on the heads of many figures. On this example, a creature combining features of a human and a lizard is depicted. Combinations of forms are common motifs in Easter Island art, and this specific one is realized even more vividly in another category of figures, the *moko miro* (see cat. no. 37). If the *moai kavakava* do represent ancestors, then the lizard, which Polynesians connected with death, is a particularly appropriate image.

Such figures are said to have been protective in nature and to have played a role in rites connected with agricultural fertility. Holes at the bases of some

of their necks (though absent in this example) suggest that they were worn or hung, but they were probably kept wrapped in barkcloth most of the time and displayed only on certain occasions. According to some sources, they were brought out at harvest and first-fruit celebrations, when a man danced with all of the figures that he owned (Métraux [1940] 1971, 259).

Like nearly all Easter Island wooden sculpture, this figure was carved from *toromiro* wood. Also characteristic of Easter Island wooden figures is the use of bone and obsidian for inlaid eyes (the ones on this figure are modern replacements). The use of *toromiro*, the fine carving, and the lustrous surface indicate that the figure was certainly made before the middle of the nineteenth century, when carvers, realizing the tourist market potential for their work, began making sculpture for sale.

References cited

Fedorova, I.K. 1990. "Ethnological and Folklore Data in the Symbolic Interpretation of Easter Island Art Objects." In *State and Perspectives of Scientific Research in Easter Island Culture*, 23-39. Edited by Heide-Margaret Esen-Baur. Courier Forschungsinstitut Senckenberg, 125. Frankfurt: Senckenbergischen Naturforschenden Gesellschaft.
Forment, Francina. 1990. "Le Motif de l'oiseau dans la sculpture en bois traditionelle de l'Ile de Pâques." In *L'Ile de Pâques: Une Enigme?*, 116-23. Edited by Heide-Margaret Esen-Baur and Francina Forment. Brussels: Musées Royaux d'Art et d'Histoire.
Métraux, Alfred. [1940] 1971. *Ethnology of Easter Island*. Bernice P. Bishop Museum Bulletin, no. 160. Honolulu: Bernice P. Bishop Museum; reprint ed., Bishop Museum Press Reprints.
Wardwell, Allen. 1994. *Island Ancestors: Oceanic Art from the Masco Collection*. Exhibition catalogue. Detroit: Detroit Institute of Arts.

Provenance: Acquired from Merton Simpson (New York) in 1967

Published: Wardwell 1967a, fig. 4; 1967b, cat. no. 62 (ill.); IUAM 1980, 246 (ill.); *Indianapolis Star* 1985, E21 (ill.); IUAM 1986, cat. no. 91 (ill.); [1989b], 2 (ill.); Pelrine 1993, ill. 6

Exhibited: AIC 1967, IUAM 1993

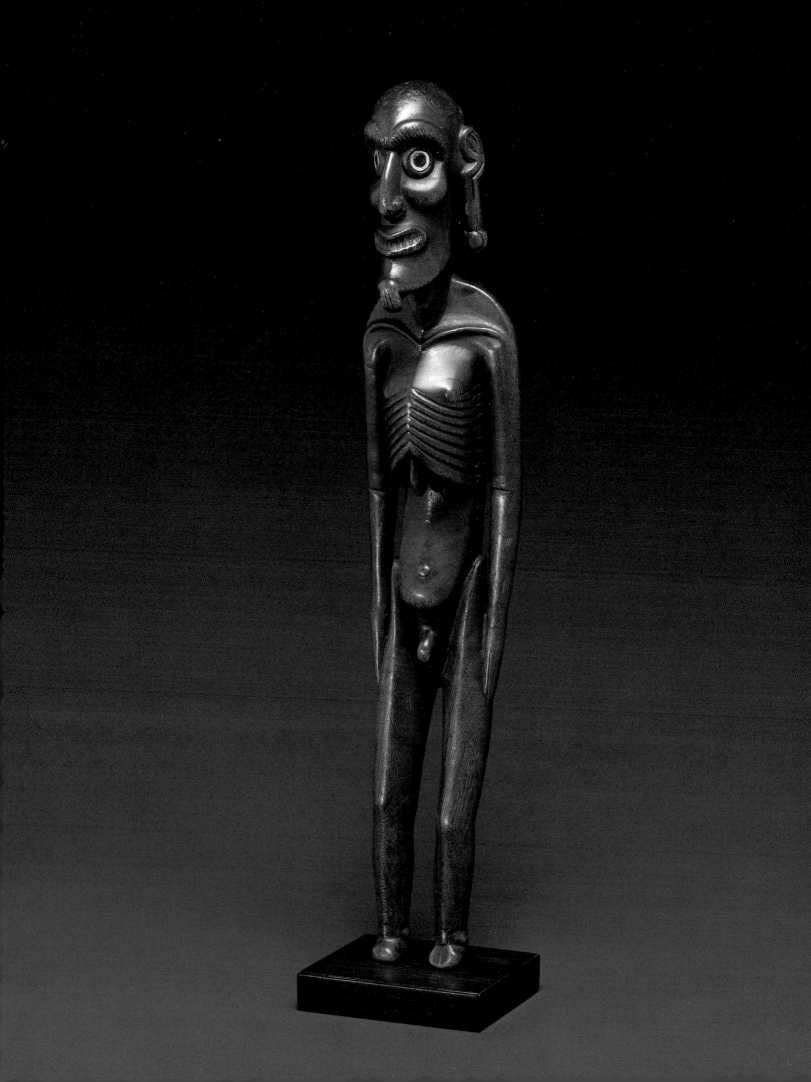

Easter Island

Lizard Figure, *Moko Miro*

Wood, bone, obsidian
L. 15 in. (38.1 cm)
Raymond and Laura Wielgus Collection
(RW 68-285)

Much rarer than the emaciated male figures (see cat. no. 36), Easter Island lizard figures are actually a combination of man and lizard, often with added avian elements. On this figure, the head is that of a lizard. The torso, arms, and legs are human, and the emphasis on the rib cage, the raised spine, and the tapering arms and legs resemble features on the male figures. A small fan-shaped carving at the end of the spine recalls a bird's tail.

As with the male figures, the significance of this form is unclear. Lizards were believed to cause certain illnesses that were associated with death and could be cured only by a priest. Birds, specifically the sooty tern, were associated with Makemake, the Easter Island creator god, who is also represented in sculpture that combines human and avian forms. Jo Anne Van Tilburg (1994, 115), an archaeologist who has conducted fieldwork on Easter Island for over 10 years, suggests that "these objects depict physical transformations which are the probable result of such supernatural actions as spirit possession."

Although we know little about the figures' meaning, we have some information about how they were used. Like the male figures, some lizard figures have suspension holes; this one has a hole in the usual place, just above the midpoint of the spine, which allows it to hang horizontally. *Moko miro* are described as having been worn around the neck and on belts at certain festivals, as the emaciated male figures were. In addition, the handlelike legs of some, including this one, have led some people to suggest that they may have been used as clubs, though their small size

suggests that they were ceremonial rather than actual weapons. Finally, reports also say that such figures were hung or placed on each side of the doorway of a house to protect the inhabitants from intruders (ibid.; Duff 1969, 56).

Like most Easter Island wood sculpture, this figure was carved from *toromiro*. Here, as with other *moko miro*, the curved form of the figure follows the natural growing pattern of the tree, which tends to be crooked. This example also has the round obsidian and bone eyes typical of Easter Island sculpture. Though Van Tilburg (1994, 115) maintains that "all known *moko miro* are post-missionary" (i.e., that they date no earlier than the second half of the nineteenth century), this one and others show the same careful attention to detail and sensitive carving that indicate precontact dates for other types of Easter Island figures. Therefore, a lack of collection data does not necessarily indicate that the figures are post-missionary.

References cited

Duff, Roger, ed. 1969. *No Sort of Iron: Culture of Cook's Polynesians*. Exhibition catalogue. Christchurch: Art Galleries and Museums' Association of New Zealand.
Fedorova, I.K. 1990. "Ethnological and Folklore Data in the Symbolic Interpretation of Easter Island Art Objects." In *State and Perspectives of Scientific Research in Easter Island Culture*, 23-39. Edited by Heide-Margaret Esen-Baur. Courier Forschungsinstitut Senckenberg, 125. Frankfurt: Senckenbergischen Naturforschenden Gesellschaft.
Van Tilburg, Jo Anne. 1994. *Easter Island: Archaeology, Ecology, and Culture*. Washington, D.C.: Smithsonian Institution Press.

Provenance: Acquired from Merton Simpson (New York) in 1968

Published: Sotheby's 1967, lot 136; Barrow 1973, pl. 233; Mack 1982, pl. 25, fig. 3; IUAM [1990b], 3 (ill.); Pelrine 1993, ill. 5

Exhibited: AIC 1967 (MPA only), IUAM 1990, IUAM 1993

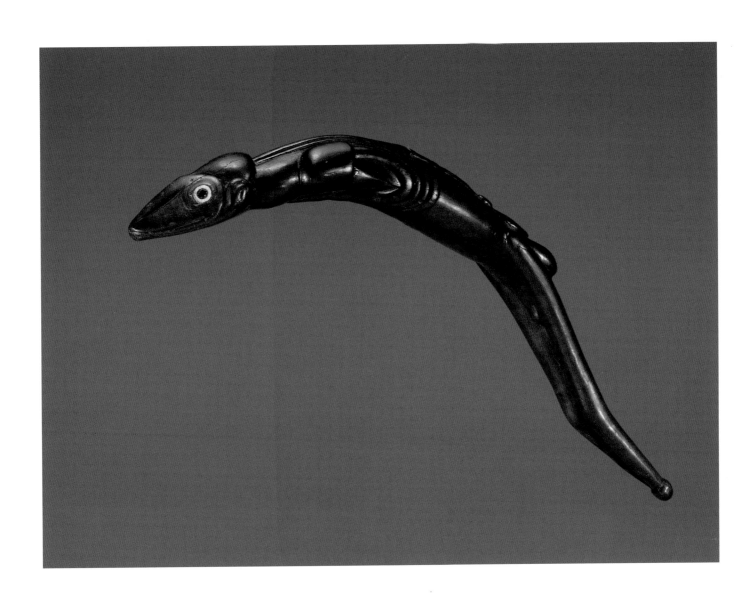

Maori peoples, New Zealand

Object with Two Carved Heads

Wood, haliotis shell, flax
L. 9 1/4 in. (23.5 cm)
Raymond and Laura Wielgus Collection
(RW 61-224)

The last major island group in Polynesia to be populated and, indeed, the last large habitable region in the world to be peopled, New Zealand was probably settled in the third quarter of the first millennium. Maori culture developed from these first settlers, who were likely to have been from the Cook, Austral, or Society islands. By around 1500, it had spread throughout the North Island, the area where a large majority of the people lived at the time of first European contact in 1642.

Maori culture is clearly Polynesian, emphasizing hierarchy and rank, but it also exhibits features not found elsewhere in Polynesia. Some of these features are due, at least in part, to differences in climate and natural resources between New Zealand and the other islands of Polynesia. Weaving, for example, is a traditional part of Maori culture (see cat. no. 40); the trees from

Small face at the end of the shaft.

which other Polynesians made beaten barkcloth do not prosper in New Zealand's temperate climate. Physical isolation from the rest of Polynesia also contributed to the development of distinctive types of objects — such as the endblown flute (see cat. no. 41) and this object with two carved heads — which are unique to the Maori.

The present example is one of a number of similarly made pieces that consist of two basic elements: a face and a pierced shaft. In this instance, the shaft rises at an acute angle from the back of one face and ends in a carving of a much smaller one. The shaft is rounded and worn at the top, and each side is carved as a shallow groove that is pierced in three places: two holes near the larger face, one closer to the smaller face. The flax twine that can be seen in the middle of the mouth of the larger face is tied through the first hole.

Though these objects seem to have been intended for some use, their function remains unclear. They have been called bird snares for catching parrots or parakeets (Wardwell 1967, 89), ceremonial versions of a bird snare (Shawcross 1970, 339-41), parts of a latrine seat that would be bitten as the final step in the removal of *tapu* in certain rites (Simmons 1984, 209), and canoe-prow ornaments (Kaeppler 1978, 201-2). Each of these designations has been debated, however.

Unlike its identity, this object's Maori attribution is unquestionable. Though there are many regional and tribal substyles, the geometric patterns on the face, the inlaid eyes, and the figure-eight mouth are all characteristics of the general Maori carving style. The Maori carver, like his Polynesian counterparts, used the adze as his primary tool. Before metal became available for tools in the eighteenth century, blades were made of stone, shell, or bone. The soft quality of its carving suggests that this object was fashioned with nonmetal tools, though apparently some artists who were accustomed to working with them made and used iron or copper tools with results that closely resemble stone-cut work (Barrow 1984, 49).

References cited

Barrow, Terence. 1984. *An Illustrated Guide to Maori Art*. Honolulu: University of Hawaii Press.
Kaeppler, Adrienne L. 1978. "*Artificial Curiosities*." Exhibition catalogue. Bernice P. Bishop Museum Special Publication, no. 65. Honolulu: Bishop Museum Press.
Shawcross, F. Wilfred. 1970. "The Cambridge University Collection of Maori Artifacts Made on Captain Cook's First Voyage." *Journal of the Polynesian Society* 79, no. 3: 305-48.
Simmons, David R. 1984. "Te Rarangi Taonga: Catalogue." In *Te Maori: Maori Art from New Zealand Collections*, 175-235. Edited by Sidney Moko Mead. Exhibition catalogue. New York: Harry N. Abrams.
Wardwell, Allen. 1967. *The Sculpture of Polynesia*. Exhibition catalogue. Chicago: Art Institute of Chicago.

Provenance: Acquired from Allan Frumkin (Chicago) in 1961

Published: Arts Club 1966, cat. no. 53; Wardwell 1967b, cat. no. 121 (ill.); IUAM [1990b], 2 (ill.)

Exhibited: Arts Club 1966, AIC 1967, IUAM 1990, IUAM 1993

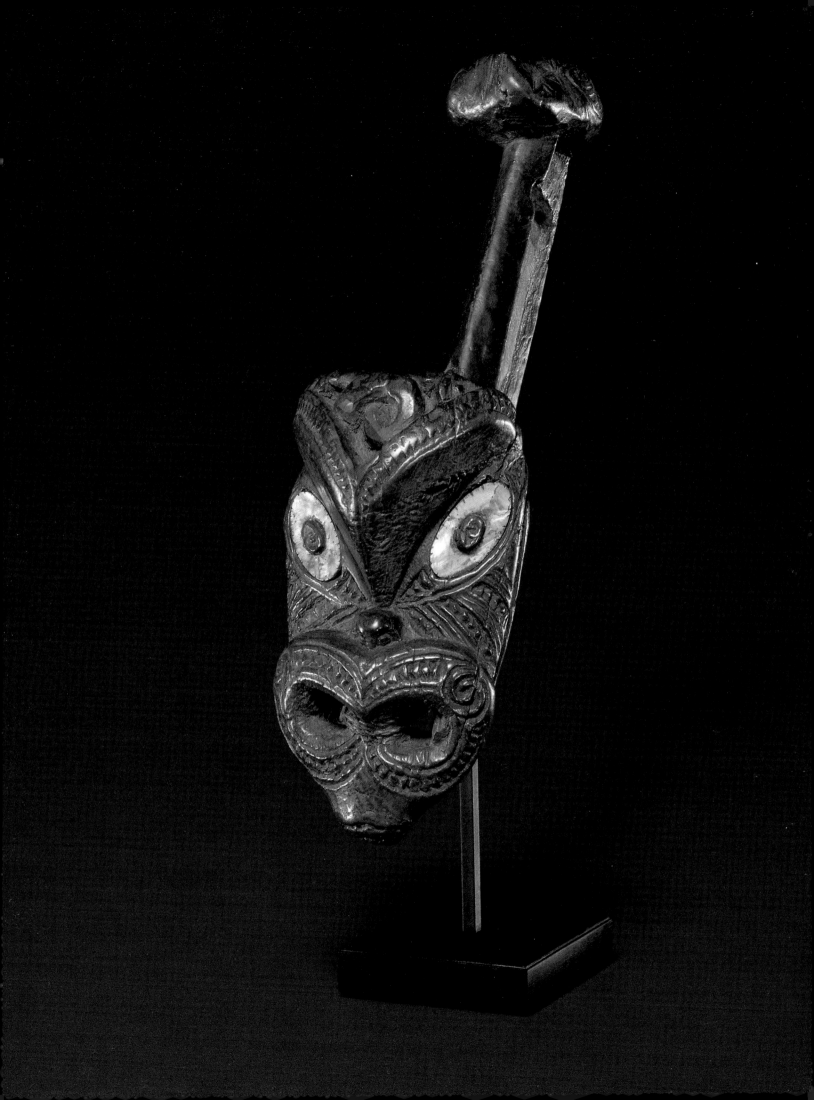

39

Maori peoples, New Zealand

Fish Hook, *Matau*

Eighteenth century
Wood, flax, human bone
H. 6 in. (15.2 cm)
Raymond and Laura Wielgus Collection
(RW 62-241)

Fishing provided the major source of
protein for the Maori and, as befitted
such a critical enterprise, was consi-
dered a sacred activity. A male occupa-
tion, it was carried out on the open sea
and along the coast as well as on the in-
land lakes, rivers, and streams. Fishing
grounds were community property
and were often marked to indicate their
boundaries, with trespassers facing
heavy penalties.

Men fished from boats and from
the shore; both involved assorted para-
phernalia that included nets, lines,
hooks, rods, traps, floats, and sinkers.
Hooks, made in a variety of specialized
forms, were of two types: simple and
composite. Simple ones were made of a
single piece of bone, stone, wood, or
shell. Composite hooks, of which this is
an example, were made of more than
one piece; here, a bone barb has been
lashed to a wooden shank. The barb
is human bone, a material used for
various objects in New Zealand and
other parts of Polynesia (see, for ex-
ample, cat. nos. 29, 30, 34). Some
scholars have suggested that its pre-
sence here reflects a Maori belief that
the use of bone from an ancestor,
expert fisherman, or other important
person increased not only the *mana* of
the hook but also that of its owner
(Beasley [1928] 1980, 107, 108). Others,
however, have suggested that hooks
were made from the bones of enemies
as a further humiliation (Best 1929, 31).

In this example, the wooden shank
was made from a sapling that had been
bent and secured while still growing,
so that when it was cut it retained that
form. This was a common Maori prac-
tice for making wooden shanks (ibid.,

37). The carving on the shank clearly
identifies this as a special hook and
would have increased its *mana*. At the
top is the face of a *tiki*, which may refer
to an important ancestor or to Tanga-
roa, the Maori god of the sea, who was
believed to determine fishing success.
The carving at the bottom, unusual
because of its openwork, may have
been where a bait string was attached
(Beasley [1928] 1980, 13, 14).

This hook might have been intended
to increase its owner's fishing success.
If so, that man would most certainly
have been a person of rank, as only such
a person would have been able to
handle safely the added levels of *mana*.
Alternatively, the hook might have had
ritual significance for a community.
Certain regulations and *tapu* were asso-
ciated with fishing because of its sacred
nature. This was particularly true for
sea fishing, which was considered more
important than fishing in fresh water.
Special rituals were held to inaugurate
fishing seasons and to reopen waters
that had previously been restricted, and
often elaborate versions of ordinary
equipment, such as fish hooks, were
used by priests for these events (Best
1929, 2; Barrow 1973, 72-73). This
hook may have been used on such oc-
casions.

References cited

Barrow, Terence. 1984. *An Illustrated Guide to
Maori Art*. Honolulu: University of Hawaii
Press.
Beasley, Harry G. [1928] 1980. *Pacific Island
Records: Fish Hooks*. London: Seeley, Service;
reprint ed., London: John Hewett.
Best, Elsdon. 1929. *Fishing Methods and
Devices of the Maori*. Dominion Museum Bul-
letin, no. 12. Wellington: Dominion Museum.

Provenance: Ex-coll. Harry Beasley (London);
acquired from J.J. Klejman (New York) in 1962

Published: Beasley [1928] 1980, pl. 24a; Arts
Club 1966, cat. no. 54; Wardwell 1967b, cat.
no. 127 (ill.); *Chicago Tribune* 1970, 1A1;
Schmitz 1971, pl. 277; IUAM [1990b], 2 (ill.)

Exhibited: Arts Club 1966, AIC 1967, IUAM
1990, IUAM 1993

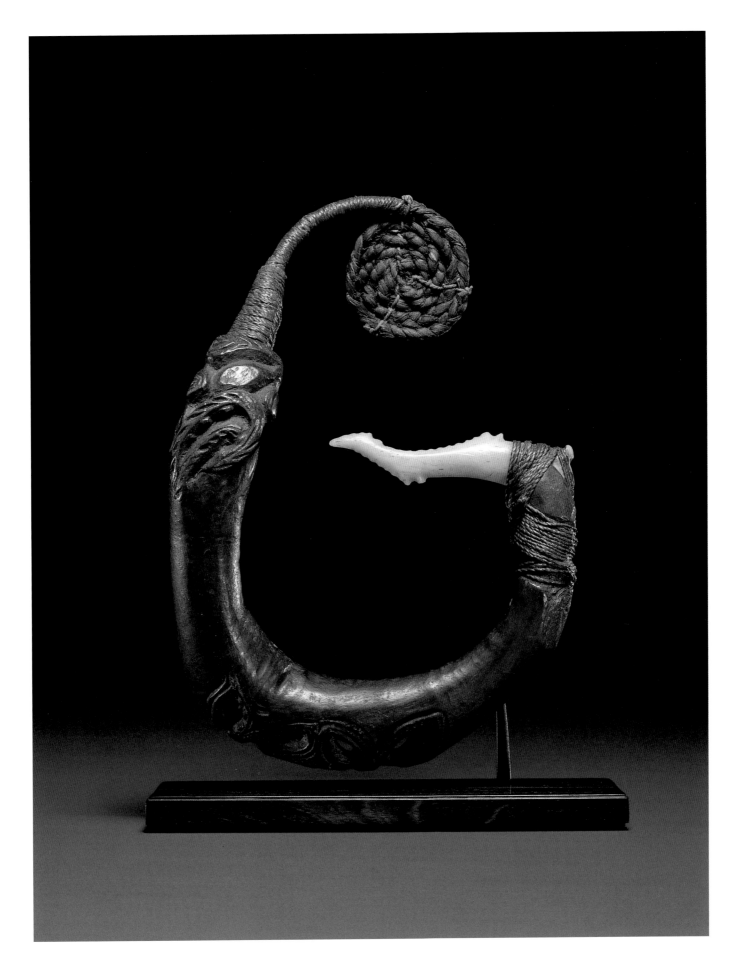

Maori peoples, Taranaki area,
North Island, New Zealand

Weaving Peg, *TuruTuru*

Eighteenth century
Wood, haliotis shell
H. 17 3/4 in. (45.1 cm)
Raymond and Laura Wielgus Collection
(RW 62-242)

While *tapa*, or beaten barkcloth, made
from the bark of the mulberry tree,
supplied clothing in most of Polynesia,
New Zealand's cooler and wetter clim-
ate meant that the plant would not
thrive, nor would barkcloth suffice for
clothing. As a result, the Maori wove
cloaks and wrappers from the many
varieties of flax which were available
and used dog skin for cloaks when
additional warmth was desired.

The Maori did not use looms to
make their cloth, however. Instead,
they simply used two wooden pegs for
a process called twining, or finger
weaving, in which pairs of weft threads
are twisted around hanging warp
threads. To begin, a weaver, who sat
on the ground, tied the ends of a thread
to the two pegs, which were stuck in
the ground. Warp threads were hung
from that thread, and the cloth was
made by twisting weft threads around
them, working from left to right. In
some cases — for instance, when weav-
ing particularly large cloaks — a second
set of pegs might be used to keep the
work off the ground (Best 1898, 627;
Pendergast 1987, 13).

As with other arts and crafts
throughout Polynesia, weaving was
considered a sacred act, subject to
certain regulations and prohibitions.
It was reserved for women, although,
at least in some areas, men may have
participated on a limited basis (Best
1898, 635). Women became weavers
by practicing the technical skills and by
initiation into a *whare pora*, or "house
of weaving," where a priest and the
weaver participated in a ritual designed
to confer the *mana* and confidence nec-

essary for success. During this ritual,
the weaver set up the pegs in prepar-
ation for weaving, and after the priest
recited certain prayers and blessings,
she bit the peg on the right, which was
considered sacred and which was some-
times elaborately decorated, as in this
example. Sidney Mead (1969, 170),
who is himself Maori and who has
studied Maori culture extensively,
suggests that the peg served as "the
medium and the vehicle" by which the
priest's incantations entered the body
of the weaver. The sacred peg was dedi-
cated to the moon goddess Hine-te-
iwaiwa, who was the patron of weaving
(Simmons 1984, 223). It was also sub-
ject to certain regulations. For instance,
it had to be removed from the ground
at sunset and could not be left standing
when a stranger approached the weaver
(Best 1898, 656).

The Wielgus weaving peg, which is
one of the most intricately carved
known examples, illustrates the curvi-
linear complexity of much Maori carv-
ing and demonstrates the crisp detail
that became standard once metal for
tools became available in the eighteenth
century. The intertwining of figures,
here in the form of three arranged ver-
tically on each side of the peg, is also
a hallmark of Maori style. An unusual
feature, however, is that the peg remains
unfinished; the bottom figures have
been blocked out, but the intricate
surface detail was never completed.
We may never know why, but the reason
may have something to do with the
nature and practice of Polynesian
carving. Every stage of the process was
accompanied by prayers and chants,
which both ensured successful com-
pletion of the object and imbued it with
mana. If, for any reason, a carver did
not finish an object, another carver
might have felt unable to complete it
since he could not continue in an un-
broken line the ritual component in
its making (Teri Sowell, personal com-
munication, February 1990).

References cited

Best, Elsdon. 1898. "The Art of the Whare
Pora." *Transactions and Proceedings of the
New Zealand Institute* 31: 625-58.
Mead, Sidney M. 1969. *Traditional Maori
Clothing: A Study of Technological and
Functional Change*. Wellington: A.H. and
A.W. Reed.
Pendergrast, Mick. 1987. *Te Aho Tapu: The
Sacred Thread*. Exhibition catalogue. Hono-
lulu: University of Hawaii Press.
Simmons, David R. 1984. "Te Rarangi Taonga:
Catalogue." In *Te Maori: Maori Art from
New Zealand Collections*, 175-235. Edited by
Sidney Moko Mead. Exhibition catalogue.
New York: Harry N. Abrams.

Provenance: Ex-coll. Harry Beasley (London);
acquired from J.J. Klejman (New York) in 1962

Published: Beasley 1935, pl. facing 64; Oldman
1946, 7; Arts Club 1966, cat. no. 55 (ill.);
Wardwell 1967b, cat. no. 126 (ill.)

Exhibited: Arts Club 1966, AIC 1967, IUAM
1990, IUAM 1993

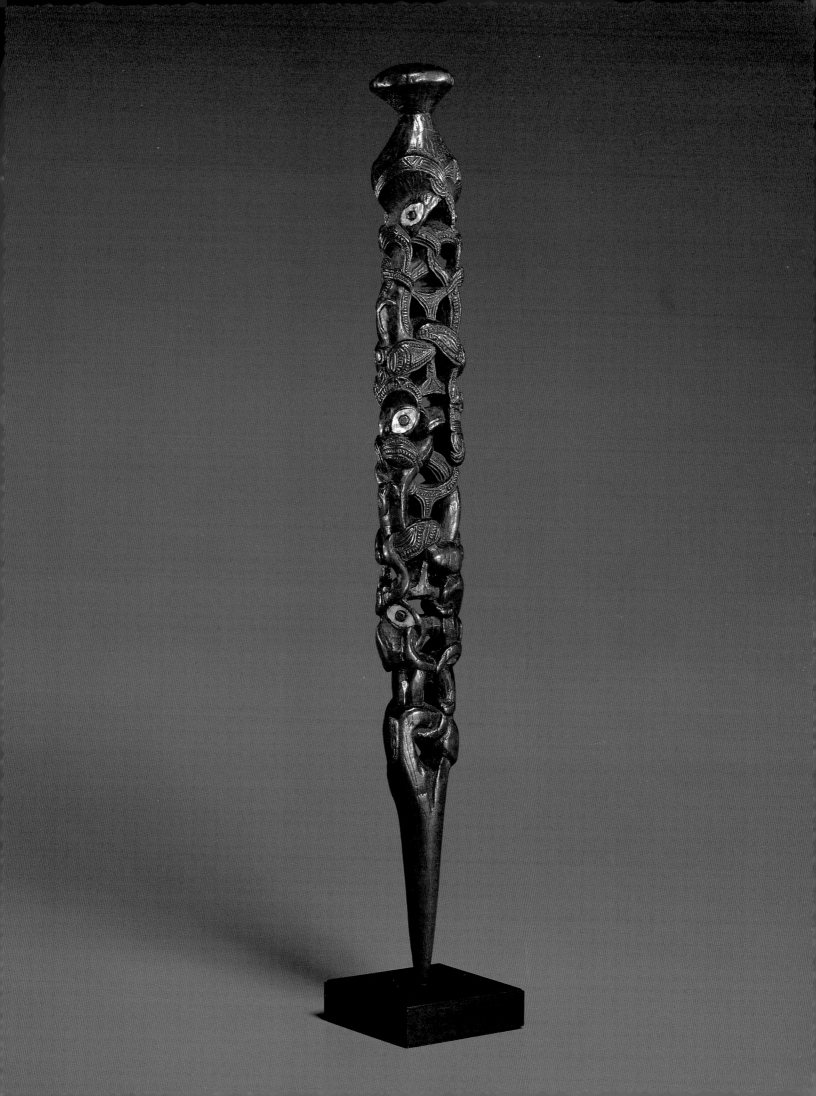

41

Maori peoples, New Zealand

Flute, *Koauau*

Wood, haliotis shell
L. 7 9/16 in. (19.2 cm)
IUAM 100.21.5.79 (RW 60-207)

The *koauau*, one of several traditional Maori musical instruments, is a small endblown flute, usually with three unevenly spaced fingering holes. Suspension holes on many flutes, including this one, enabled them to be worn around the neck as an ornament. Passed down as heirlooms, *koauau*, which were also carved from bone and stone, were so prized by their owners, who were nobles and chiefs, that some flutes were given personal names (Best 1925, 134; Moyle 1990, 51).

Performances often took place outside after the evening meal. A *koauau* musician played *waiata* melodies.

The Wielgus koauau has three fingering holes, but others have as many as six. Still others have no holes.

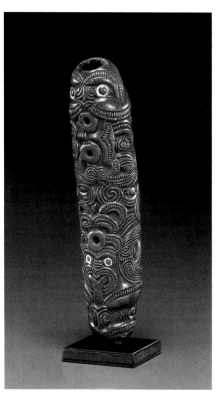

Waiata is a general term for songs, including love songs, lullabies, sorcerers' chants and incantations, and songs sung when receiving a present (Best 1925, 117). Usually, the *koauau* was played to accompany the singing of *waiata*, and, like the singing, the flute performance was supposed to be continuous, without noticeable breaks in the sound. Early reports indicate that up to four performers might play the instruments together, though in later times, when the number of skilled flutists had declined, one was more common (McLean 1968, 217). While being played, the flutes were held at a diagonal below the mouth with the right edge of the blowing end resting on the lips. Pitch was varied by the way in which the musician blew into the flute and by covering the fingering holes in established patterns.

Wooden flutes were carved from trees with nonexistent or soft pith. Flute makers used live coals to create the central tube and rounded the blowing end of the piece of wood, which made the flute easier to play (ibid., 218). Fingering holes were made with a cord drill. Placement of these holes was determined by conventional standards based on lengths of fingers and finger joints; in most cases, as in the Wielgus example, this resulted in the middle hole being closer to the one at the top than to the bottom one. Both position and size of the holes affect the sound, so after the initial drilling was done, each hole was carefully enlarged until it produced the desired note.

Many of the flutes, including this one, have a phallic form that is no doubt intentional. Terence Barrow (1973, 57; 1984, 35), a Polynesian ethnologist who has written widely on art, particularly that of the Maori, points out that among the Maori (as among many Polynesian peoples) an important characteristic of gods and ancestors was sexual virility, and the depiction of a penis was an indication of this virility. In addition, the Maori believed that sexual organs had certain protective powers. While we do not have documentation for ritual uses of

these phallic flutes that would make their form particularly appropriate, such practices would not be surprising; we know, for example, that on certain occasions, ancestral powers were called upon through the playing of *koauau* made from ancestral bones (Best 1925, 141).

Like the Wielgus weaving peg (cat. no. 40), this object demonstrates the Maori penchant for complex, heavily carved surfaces and the repetition of motifs. As on the peg and many other Maori objects (see also cats. 38, 39, 42), the *tiki*, or human form, is evident, though here birdlike features, such as round, lidless eyes and beaked mouths, are intermingled. Shell inlay makes the eyes of some faces immediately clear, while also serving as punctuating spots of light against the dark wood. The Maori carver's interest in creating elements with double meanings is also seen in the way the flute's openings at the top and bottom become the mouths for the faces depicted there.

References cited

Barrow, Terence. 1973. *Art and Life in Polynesia*. Rutland, Vermont: Charles E. Tuttle.
———. 1984. *An Illustrated Guide to Maori Art*. Honolulu: University of Hawaii Press.
Best, Elsdon. 1925. *Games and Pastimes of the Maori*. Dominion Museum Bulletin, no. 8. Wellington: Dominion Museum.
McLean, Mervyn. 1968. "An Investigation of the Open Tube Maori Flute or Kooauau." *Journal of the Polynesian Society* 77, no. 3 (September): 213-41.
Moyle, Richard. 1990. *Polynesian Sound-producing Instruments*. Shire Ethnography, 20. Princes Risborough, Bucks.: Shire Publications.

Provenance: Acquired from J.J. Klejman (New York) in 1960

Published: MPA 1960b, cat. no. 56 (mislabeled as RW 60208); Arts Club 1966, cat. no. 52; Wardwell 1967b, cat. no. 130 (ill.); Schmitz 1971, pl. 276; Barrow 1973, pl. 304; IUAM 1986, cat. no. 83 (ill.)

Exhibited: MPA 1960b, Arts Club 1966, AIC 1967, IUAM 1993

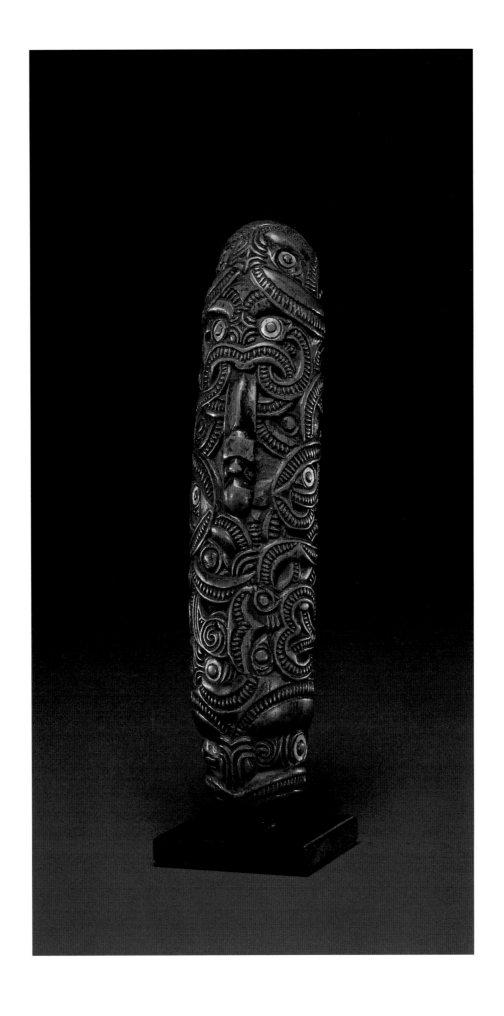

Maori peoples, New Zealand

Pendant, *Hei Tiki*

Nineteenth century
Nephrite, haliotis shell
H. 9 in. (22.9 cm)
IUAM 80.5.2 (RW 62-243)

A contemporary symbol of the nation of New Zealand as a whole, the *hei tiki* is an object rich in significance for the Maori peoples. Carved from nephrite, a kind of jade, or bowenite, a variety of serpentine, *hei tiki* were considered the most precious type of jewelry, worn suspended from a short flax cord around the neck.

Such pendants were valued for two reasons. First, they were carved from nephrite, and bowenite, two minerals collectively named *pounamu* ("green") in Maori. Because of its rarity, hardness, and mythological associations, *pounamu*, also called greenstone, was considered the most precious material available to the Maori at the time of European contact. Rare throughout the world, in Polynesia it is found only on New Zealand's South Island. Maori histories tell of arduous journeys in search of *pounamu* and struggles among various groups to control its trade. For peoples without metal, nephrite's hardness made it valuable for tools and weapons and also increased the prestige of owning jewelry carved from it, since a single piece represented hundreds of hours of a craftsman's time. Finally, in Maori stories of origin, greenstone in personified form is intimately connected with the founding of New Zealand.

Hei tiki also were considered precious because of their connections with ancestors and their attendant *mana*. Though pendants were not thought of as physical likenesses of ancestors, they were associated with specific ones and given personal names. Worn only by women in the nineteenth and twentieth centuries, in earlier times they were worn by high-ranking members of both sexes. A *hei tiki* was a family heirloom, and old ones were considered particularly powerful, having acquired *mana* from their intimate contact with a succession of owners.

The meaning of such pendants' form has been debated. *Tiki* is simply a general reference to the representation of the human form (*hei* means "to suspend"). Some pendants are female, but sex is not indicated on others, including this one. The bent positions of the head, arms, and legs on most examples have led some scholars to suggest that the figure depicts a fetus, a woman during intercourse, or a deceased person (according to traditional Maori custom, a corpse is flexed before burial). None of these interpretations can be substantiated, however, and it is unlikely that a conclusive explanation, if indeed a single one ever existed, is possible (Riley 1987, 60).

Nearly all *hei tiki* measure between two and seven inches tall, making this one of the largest known. The very large figures are generally believed to date later than the smaller ones and to have been inspired by the availability of metal tools (which made carving easier and quicker) and created in response to a perceived European taste for the oversized. Though this pendant's size points to the nineteenth century, when traditional Maori culture was undergoing dramatic changes, its careful carving and rounded forms testify to its having been made by a craftsman who was still a master of his medium.

Reference cited

Riley, Murdoch. 1987. *Jade Treasures of the Maori*. Paraparaumu, New Zealand: Viking Sevenseas.

Provenance: Ex-coll. Sir Jacob Epstein (London); acquired from J.J. Klejman (New York) in 1962

Published: Arts Council of Great Britain 1960, pl. 11; AIC 1963, pl. 20; Arts Club 1966, cat. no. 56 (ill.); Wardwell 1967b, cat. no. 144 (ill.); Schmitz 1971, color pl. 49; Barrow 1973, pl. 307; IUAM 1980, 243 (ill.); *Apollo* 1982, fig. 4; IUAM 1985, 4 (ill.); IUAM 1986, cat. no. 82 (ill.); IUAM [1989b], 2; *Herald-Times* 1990b, D6; Hubbard 1993b, 65 (ill.)

Exhibited: Arts Council 1960, AIC 1963, Arts Club 1966, AIC 1967, Tucson 1975, IUAM 1993

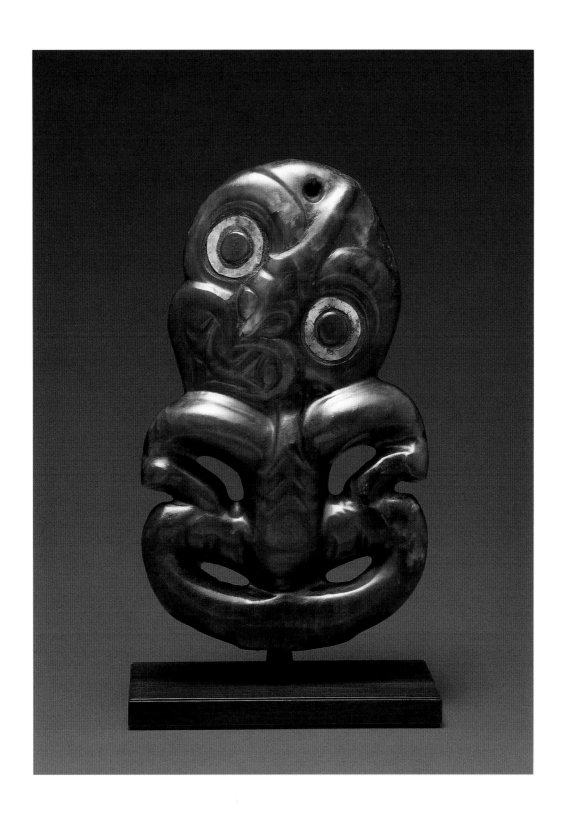

43

Tuvalu (?)

Figure

Wood, shell
H. 14 7/8 in. (37.8 cm)
IUAM 68.214 (RW 60-196)

Little is known about this figure, which
is generally attributed to Tuvalu, for-
merly the Ellice Islands. Geographically
on the border of Micronesia, Tuvalu's
culture is Polynesian. The relative scar-
city of free-standing figures in Micro-
nesia is often noted, though some figures
certainly were carved, perhaps in every
Micronesian group (Fraser 1962, 197;
Feldman 1986). Because its culture is
Polynesian, Tuvalu is perhaps more
likely than other island groups in
Micronesia to have figural sculpture.

Several of this figure's features are
similar to those of others from this
area. Its simplicity connects it to figures
from the nearby Polynesian outlier of
Nukuoro in the Caroline Islands and
Samoa and Fiji in western Polynesia.
The clearly delineated pubic triangle is
another affinity with figures from
Nukuoro and is also found on other
Micronesian sculpture such as gable
ornaments in Belau (Palau).

Overall, however, the figure is most
closely related to two other specific ex-
amples. Though their provenances are
not supported by firm collection data
(Feldman 1986, 31), one is attributed to
Kiribati (formerly the Gilbert Islands;
Fraser 1962, pl. 110), and the other is
said to have come from "Pleasant
Island, Ellice Islands" before 1875
(Gathercole, Kaeppler, and Newton
1979, cat. no. 19.9). All three are very
simplified female forms, with arms to
the sides and rounded faces having shell
eyes. There are also some significant
differences, however. Compared to the
other two figures, the torso of the Wiel-
gus figure is more columnar in form
and has no indications of breasts; its
arms are much longer, its legs shorter,
and its feet much larger; and its face is
simpler, with no mouth or ears.

Whether these differences indicate a
different origin, or whether the artists
in this area were simply more individ-
ualistic (as with, for example, the Nig-
erian Montol figure [cat. no. 8]), is
impossible to say.

We do not know how the figure was
used or who is represented, though an
examination of figures from nearby
areas suggests some possibilities. Three-
dimensional figural sculpture has been
documented as architectural elements
in Belau, as canoe-prow decorations
from Truk, and as weather charms, ob-
jects unique to Micronesia and associ-
ated with the safety of canoes. Perhaps
the best-known Micronesian figures,
however, are those from Nukuoro,
which, like most other Polynesian
sculpture, represent gods and the spirits
of dead ancestors. Tuvalu's Polynesian
heritage suggests that if the Wielgus
figure did indeed originate there, it may
depict similar subject matter. Even if
its attribution were moved west to Kiri-
bati, such a hypothesis would still be
possible, since Kiribati served as one
of the major points of contact between
Polynesian and Micronesian cultures.

References cited

Feldman, Jerome. 1986. "Beyond Form and
Function." In *The Art of Micronesia*, 25-43.
By Jerome Feldman and Donald H. Rubinstein.
Exhibition catalogue. Honolulu: University of
Hawaii Art Gallery.
Fraser, Douglas. 1962. *Primitive Art*. Garden
City, N.Y.: Doubleday.
Gathercole, Peter, Adrienne L. Kaeppler, and
Douglas Newton. 1979. *The Art of the Pacific
Islands*. Exhibition catalogue. Washington,
D.C.: National Gallery of Art.

Provenance: Acquired from Allan Frumkin
(Chicago) in 1960

Published: MPA 1960b, pl. 25; Gathercole,
Kaeppler, and Newton 1979, cat. no. 19.8 (ill.);
IUAM 1986, cat. no. 92 (ill.)

Exhibited: MPA 1960b, NGA 1979, IUAM 1993

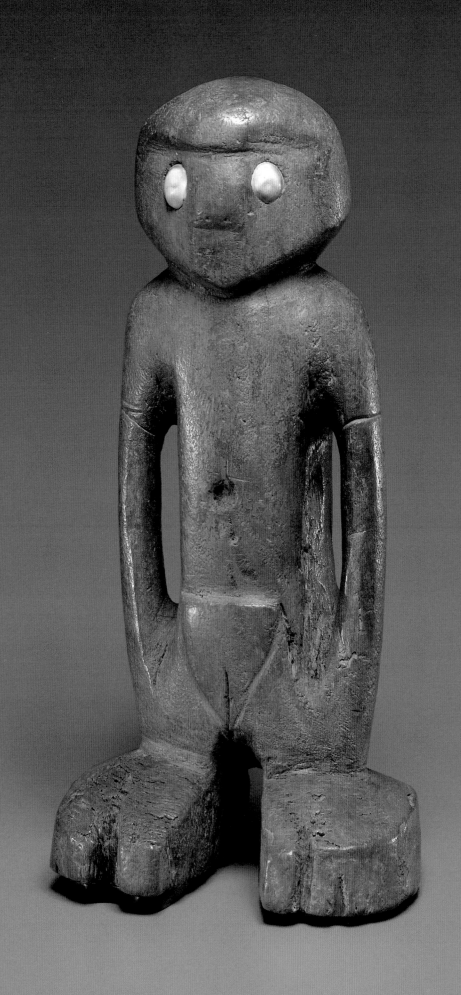

44

Ambrym Island, Vanuatu

Figure for a Men's Society

Fernwood, clay
H. 38 1/4 in. (97.2 cm)
IUAM 63.285 (RW 57-65)

A shredded-wheatlike texture makes figures such as this one of Oceania's most distinctive sculptural forms. Most often attributed to the Banks Islands, Malekula, and Ambrym in Vanuatu, these large anthropomorphic sculptures are nearly always said to be emblems of rank for members moving through the levels or grades of a particular society that dominated the social, political, and ritual lives of men on each island.

Felix Speiser (1990, 337-38, 362-70), a Swiss ethnologist who did fieldwork in Vanuatu in 1910-12, distinguished two different types of men's associations on the islands, however. The first, generally called a grade society, was a public association to which nearly every adult male belonged. It consisted of many levels, the number varying from island to island. A man's ability to rise through the levels depended on his ability to pay the requisite fees and his success in engendering goodwill from senior members. Speiser called the grade society Suque, and, while noting variations from island to island, he described the significant role that it played in establishing a man's importance in this world and, after his death, in the world of the ancestors.

The second type of organization Speiser called secret societies, and, while each island had only one Suque, it could have several active secret societies. Speiser provided comparatively little information about them, but noted that the Suque had no doubt begun as a secret society and that, like the Suque, the secret societies were associated with ancestors. In Ambrym, according to him, both the grade society, which later scholars called Mangki, and the secret societies used fernwood figures.

Speiser (ibid., 351-53, 388-89) also described three types of Ambrym fernwood figures, which were often covered with clay so they could be painted. (Only patches of the clay remain on this example.) Those representing ancestors were usually carved in the form of heads without bodies or limbs. Associated with the grade society, such objects were distinct from what Speiser called "true grade statues," which men would have made to show they had achieved high ranks. These "grade statues" usually consisted of entire figures, as did those that were part of the secret societies. Therefore, a full figure such as the Wielgus example could have belonged to either the Ambrym grade society or one of the secret societies.

Some information surrounding the figure's acquisition, however, may suggest that the secret society context is more likely. Raymond Wielgus chose this figure from two that Allan Frumkin had available in 1957. The other, a female figure 35 inches in height, was purchased by Herbert Baker and is illustrated in the Museum of Primitive Art's catalogue of his collection (Museum of Primitive Art 1969, cat. no. 178). With the exception of an indication of female genitals, the Baker figure is virtually identical to the Wielgus example, suggesting that the two formed a pair. If so, they are comparable to two illustrated by Speiser (1990, 352-53, pl. 63), which he said belonged to one of the Ambrym secret societies and which

> were very strictly secluded from every unauthorized eye and to which a great number of pigs are reported to have been sacrificed. The statues are said to have stood opposite each other in a copulatory position.

Additionally, Speiser maintained that female statues were not connected with the grade society.

References cited

Museum of Primitive Art. 1969. *The Herbert Baker Collection*. Exhibition catalogue. New York: Museum of Primitive Art.
Speiser, Felix. 1990. *Ethnology of Vanuatu: An Early Twentieth Century Study*. Translated by D.Q. Stephenson. Bathurst, Australia: Crawford House Press. Originally published as *Ethnographische Materialien aus den Neuen Hebriden und den Banks-Inseln* (Berlin: C.W. Kreidel, 1923).

Provenance: Acquired from Allan Frumkin (Chicago) in 1957

Published: IUAM 1980, 239 (ill.); IUAM 1986, cat. no. 72 (ill.)

Exhibited: AIC 1958, IUAM 1993

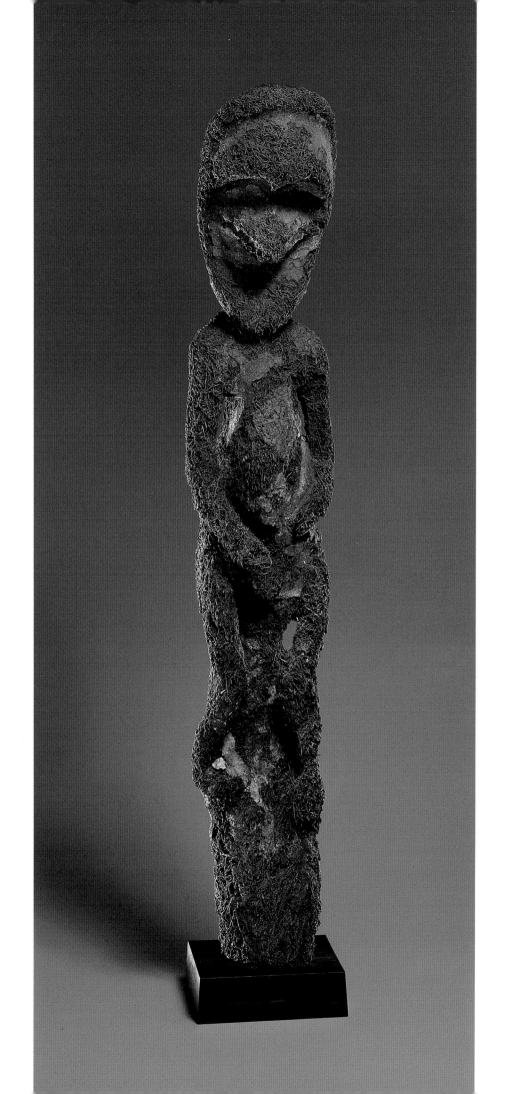

45

New Georgia group, Solomon Islands

Canoe-Prow Ornament,
Musumusu or Nguzunguzu

Nineteenth century
Wood, pearl shell, pigment
H. 5 1/4 in. (13.3 cm)
IUAM 100.6.5.75 (RW 60-204)

Until the end of the nineteenth century, when head-hunting was no longer practiced in the area, figures such as this one were standard parts of war and fishing canoes in certain areas of the Solomon Islands. Sometimes large enough to accommodate more than 30 men, these canoes were built in a graceful crescent shape, with tall prows and sterns, and were decorated with shells, feathers, fiber, and sculpture. While other sculptures were attached to the tops of the prow and stern, figures known generally as *musumusu* or *nguzunguzu* were lashed to the prow, close to the waterline. These figures, used in the neighboring islands of New Georgia, Choiseul, Santa Isabel, and Florida, were believed to protect the canoe and its crew and were associated with a spirit called Kesoko. Boyle T. Somerville (1897, 371, 384), who surveyed the New Georgia group for the British navy in 1893-94, was told that the prow ornaments were named Toto-ishu after one of a group of beings called *mangotta* who had power over land and sea, and that they protected the canoe from Kesoko, "water fiends" who could use the wind and waves to overturn the boat in order to devour the men aboard. Later reports, however, identify the prow ornament itself as Kesoko, here a beneficent spirit who could protect the canoe from dangers at sea and look out for approaching enemies (Waite 1990, 53).

Musumusu consist basically of a head and arms. Like this example, most hold hands to chin, though some hold birds or small human heads, a reference to head-hunting. The styles of the heads vary locally, but those from the New Georgia area generally have lower jaws that project outward, often in a much more exaggerated form than this one. Radomir Joura (personal communication, October 1979), who has extensively studied *musumusu*, attributes the Wielgus example on stylistic grounds to the Kombakotta area of Ranongga, one of the western islands in the New Georgia group.

Most *musumusu*, including this one, depict accessories that were commonly seen on the islanders themselves. Nearly all seem to wear some sort of headgear. The one depicted here may be a European hat, which Somerville (1897, 362-63) noted was a type in high demand. He also observed that the most striking ornaments in New Georgia were large wooden earrings, sometimes with shell inlay and as large as four inches in diameter, which, he said, were favored particularly by unmarried men and women. The ears of the Wielgus figure have clearly been pierced and stretched to accommodate such earrings. Finally, Somerville noted that thin lines painted on the face with lime seemed to have been part of full dress, and those on the face of the Wielgus *musumusu* correspond roughly to what he described as the standard pattern, with lines across the forehead, over the cheekbones, and around the jawline.

On *musumusu*, such lines were made with shell inlay, which was used against blackened surfaces to create striking light-and-dark contrasts. Inlay decorates a variety of Solomon Island wooden objects, from canoes and prow ornaments to food bowls, paddles, and clubs. Its making and application were laborious, and although anyone could decorate small personal objects with shell inlay, specialists were enlisted for larger objects, such as canoes, or for pieces with ritual significance. First, the shell was broken or cut into desired shapes, such as disks, triangles, rectangles, and pieces in the shapes of the letters *x* or *z*, each with a specific name. The edges of each piece were smoothed and then serrated and the shell surface polished. After this preparation, a resinlike material, taken from the *Parinarium* nut, was spread into grooves that had been cut in the object to be decorated. The pieces of shell were then pressed in until they were even with the surface of the wood. Other types of objects, such as coconut containers and overmodeled skulls, were also decorated with inlay, though the application technique was slightly different (McCarthy 1943, 154).

References cited

McCarthy, Frederick D. 1943. "The Shell-Inlay Decoration of the Southern Solomon Islands." *Australian Museum Magazine* 8, no. 5 (September): 154-58.
Somerville, Boyle T. 1897. "Ethnographical Notes in New Georgia, Solomon Islands." *Journal of the Anthropological Institute* 26: 357-412.
Waite, Deborah B. 1990. "Mon Canoes of the Western Solomon Islands." In *Art and Identity in Oceania*, 44-66. Edited by Allan and Louise Hanson. Honolulu: University of Hawaii Press.

Provenance: Acquired from Allan Frumkin (Chicago) in 1960

Published: MPA 1960b, cat. no. 43a; Arts Club 1966, cat. no. 40; Gathercole, Kaeppler, and Newton 1979, cat. no. 15.15 (ill.); IUAM 1986, cat. no. 70 (ill.); IUAM [1989b], 2 (ill.)

Exhibited: MPA 1960b, Arts Club 1966, NGA 1979, IUAM 1993

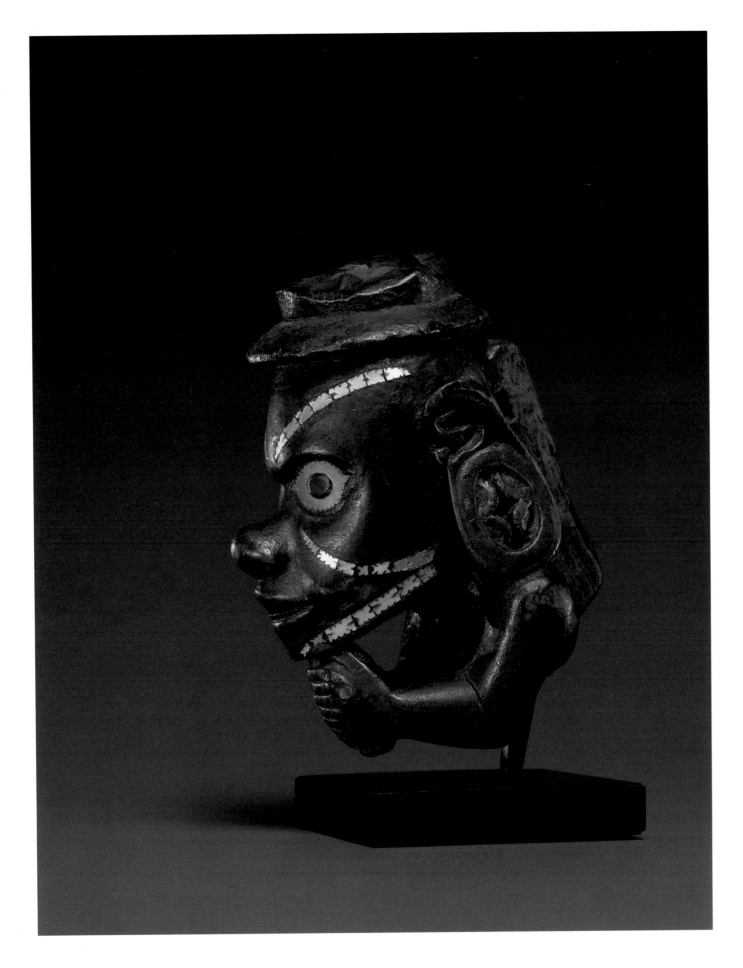

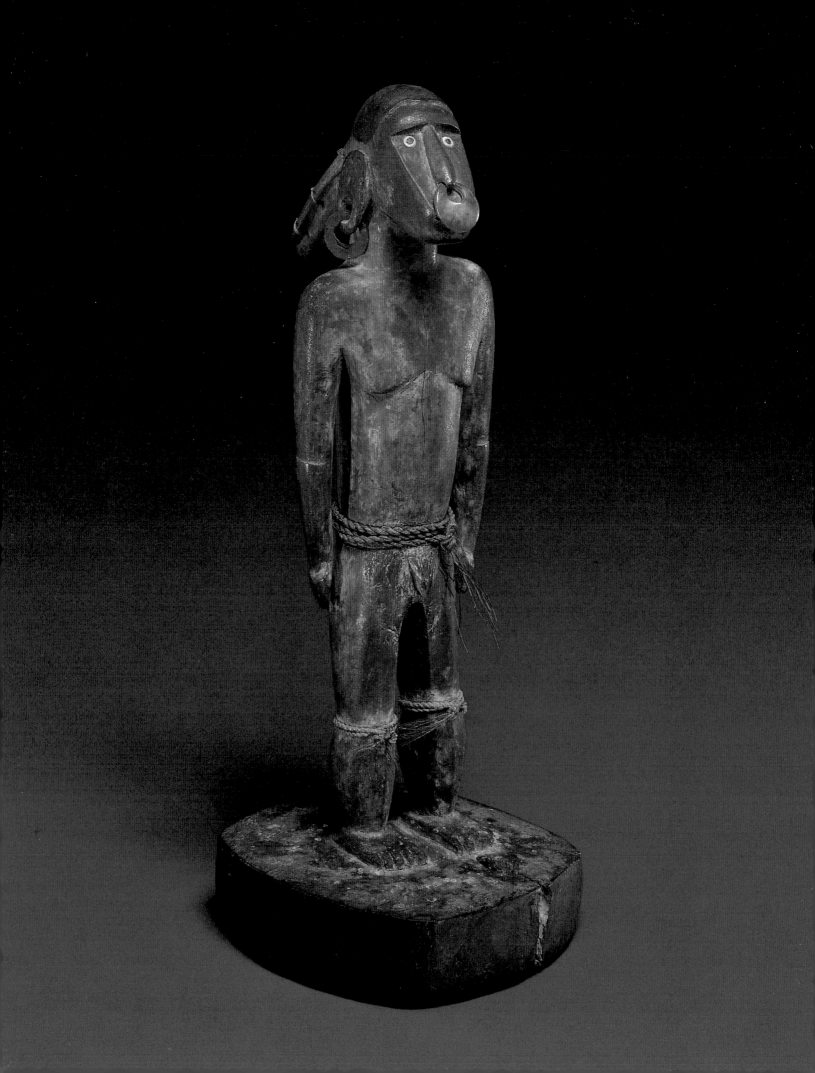

46

Tömotu Neo (Trevanion),
Santa Cruz Islands

Male Figure, *Munge-Dukna*

Wood, fiber, pigment (turmeric), shell,
turtle shell
H. 13 3/4 in. (33.7 cm)
Raymond and Laura Wielgus Collection
(RW 58-100)

Figural sculpture from the Santa Cruz
Islands is rare and was made exclusively
on the island of Nendö (Santa Cruz)
and the small island of Tömotu Neo off
its northwestern coast. While all of the
figures share certain similarities, such as
bases that are part of the figures, those
from Tömotu Neo are more elaborate
and detailed. William Davenport (1990,
108-10), an anthropologist who has
done the most extensive research on
these figures, suggests that all Santa
Cruz examples, which apparently were
not carved by specialists, may have orig-
inated there, a result of contacts the
Tömotu people had with the Solomon
Islands to the east where figural sculp-
ture is common.

This sculpture represents a man's
tutelary deity and was placed on an
altar in his own home or in the com-
munal men's house, a building where
unmarried men slept that was the ritual
and social focus for all adult males in
a village. Called *munge-dukna* ("image
of a deity"), each figure had a personal
name and sometimes depicted charac-
teristics associated with the specific
deity, though these were often known
only to the figure's owner.

Tutelary deities were believed to be
capable of bringing success and aver-
ting disaster, but they were not subject
to formulaic prayers or extraordinary
ritual; instead, they received "virtually
the same ... mannered behaviour that
was directed toward any honored per-
son, who was a guest or resident of a
household" (Davenport 1985, 2). Pri-
marily, this meant that the figures were
offered food before anyone else in the
house began eating a meal, and, when

circumstances warranted special assist-
ance from the deity, an appeal would be
made as if he were simply a person of
higher status. In addition, the deities
were recognized at public celebrations,
when they were associated with batons
or staffs, and with portable charms that
individuals could carry with them when
traveling (Davenport 1990, 101).

People's dress for ritual occasions
was considered the everyday dress of
the gods, and the figures were costumed
accordingly. The projection on the back
of the head depicts an *abe*, a headdress
worn by high-ranking males and made
of barkcloth over a wickerwork frame.
Though some elements are missing
from this example, a complete ensemble
also included a breechcloth, a nose
pendant, earrings, and other shell and
fiber jewelry, which were added and
regularly renewed to keep the figure
looking its best, thereby showing
respect for the deity (ibid., 99).

This figure was undoubtedly one
of more than 20 given sometime before
1928 to a member of the Anglican
Melanesian Mission by recent converts.
The figures were then sold to Fred
Jones, a trader, who in turn sold them
to Harry Beasley. Though most of them
are now in the British Museum and
other museums in the United Kingdom,
individuals acquired some of them, in-
cluding this figure and an ex-Wielgus
one now in the Barbier-Müller Museum
in Geneva (Davenport 1985, 1, 4; perso-
nal communication, April 1981).

References cited

Davenport, William H. 1985. "A Miniature
Figure from Santa Cruz Island." *Bulletin*
(Barbier-Müller Museum) 28 (September).
———. 1990. "The Figurative Sculpture
of Santa Cruz Island." In *Art and Identity in
Oceania*, 98-110. Edited by Allan and Louise
Hanson. Honolulu: University of Hawaii Press.

Provenance: Collected by the Anglican Mela-
nesian Mission; ex-colls. Capt. Fred L. Jones,
Harry Beasley (London); acquired from J.J.
Klejman (New York) in 1958

Published: MPA 1960b, pl. 21; Arts Club 1966,
cat. no. 41; Schmitz 1971, pl. 228

Exhibited: AIC 1958, MPA 1960b, Arts Club
1966, Tucson 1975, IUAM 1993

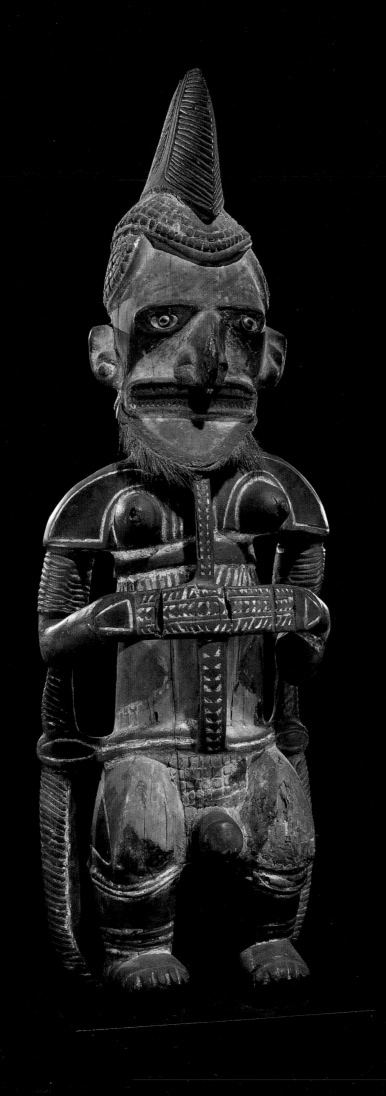

47

Northern Mandak peoples,
Malom village,
Lelet Plateau, New Ireland

Memorial Figure, *Uli*

Wood, pigment, shell, seasnail operculum, fiber
H. 55 in. (139.7 cm)
IUAM 91.498 (RW 59-152)

Imposing memorial figures from New Ireland were displayed at male rites associated with the burial of the skulls of leaders, which concluded funerary celebrations that took place during the year following the death of important men. At that time, a newly carved figure honoring the deceased was shown for the first time, and older commemorative figures, each of which had been made to honor another man, were gathered together, repainted, and displayed with the new one.

Although the intriguing appearance of such figures demands explanation, we have little firm field information about their iconography or the contexts in which they appeared, since they have not been used for several generations. Furthermore, the only two reports that describe the figures in their ceremonial context, by Augustin Krämer (1925) and Peter Peekel (1926-27), were based on activities in a single village on the north coast of New Ireland, away from the central region where the figures originated.

Several features of this *uli* are characteristic of the form. The head crest probably refers to a feathered headdress worn by men during mourning. Also characteristic are the penetrating eyes (made from operculum, the shell plate on the foot of certain mollusks that enables the animal to secure itself inside its shell), the large hooked nose, the grimacing expression, the beard, and the "cage" that surrounds parts of the figure. Although no definitive explanation for this cage has been presented, Philip Gifford (1974, 154-55, 169-79), an anthropologist who has analyzed *uli* extensively, has proposed that

it may be a remnant of the origin of the *uli*, when a skull was propped up on a post.

All of the memorial figures appear to be hermaphrodites. However, they may represent males wearing strapped-on false breasts, as apparently was the custom on certain ritual occasions in parts of New Ireland. Alternatively, they may show exaggeratedly large male breasts, which were admired on the island (Krämer 1925, 61, pl. 23). In either case, the significance remains the same: an affirmation of the importance of fertility for the continuation of a people, and a recognition of the importance and power of both male and female elements in bringing this about.

Krämer divided *uli* into 10 different style categories, though it is unclear if these were actually groupings used by New Irelanders (Krämer 1925, 61; Gifford 1974, 128). He designated this figure as of the *lembankakat egilampe* type, characterized by hands folded across the stomach. These categories, however, present certain problems, as some of them overlap. This figure, for example, also fits Krämer's *lakiserong* category, which is distinguished by the depiction of a bag or purse used to collect and carry shell money that hangs from the figure's left arm.

The Wielgus *uli* was formerly in the collection of the Linden-Museum in Stuttgart, which acquired it from a man named Wostrack, a district commissioner for southern New Ireland, who collected it on the island in 1908. Gifford (1974, 379) has identified the hands of twenty different sculptors and places this figure with a group of six others that he believes are by the same artist.

References cited

Gifford, Philip C. 1974. "The Iconology of the Uli Figure of Central New Ireland." Ph.D. dissertation, Columbia University.
Krämer, Augustin. 1925. *The Malanggans of Tombara*. Munich: Georg Müller.
Peekel, Peter. 1926-27. "Die Ahnenbilder von Nord-Neu-Mecklenberg." *Anthropos* 21: 806-24; 22: 16-44.

Provenance: Collected by Wostrack in 1908; ex-colls. Linden-Museum (Stuttgart), Serge Brignoni (Lugano); acquired from Allan Frumkin (Chicago) in 1959

Published: Krämer 1925, pl. 33; MPA 1960b, cat. no. 41; Arts Club 1966, cat. no. 37 (ill.); *Chicago Tribune* 1970, A1; Gifford 1974, fig. 126; Gathercole, Kaeppler, and Newton 1979, cat. no. 17.2 (ill.); IUAM 1986, cat. no. 67 (ill.); IUAM [1989b], 2 (ill.); IUAM [1990a], 2 (ill.); Valluet 1991, 40 (ill.); Pelrine 1993, ill. 7

Exhibited: MPA 1960b, Arts Club 1966, Tucson 1976, NGA 1979, IUAM 1993

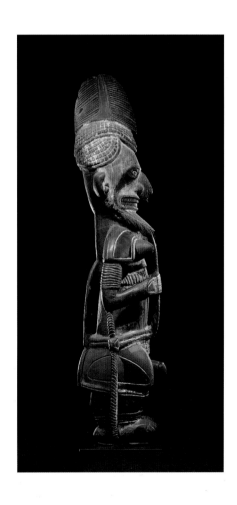

New Ireland

Friction Drum, *Livika*

Before 1909-13
Wood, opercula, traces of lime
L. 18 3/4 in. (47.6 cm)
IUAM 100.1.5.79 (RW 59-163)

Unique to New Ireland, drums such as this one were apparently made in only a few villages in the Lelet Mountains, but were traded over a wider area (Braunholtz 1927, 218). Although generally called friction drums in the literature, they are actually friction idiophones and should perhaps more appropriately be termed friction blocks (Messner 1983, 50). Known by several names, they are called *livika* by the Lelet Mandak.

To play the instrument, a man sits with it between his legs and draws his hands, which have been moistened with palm juice or rubbed with resin, across the length of the tonguelike wedges on the top, beginning, on this drum, with the one closest to the relief carving. The length and thickness of each wedge determine its pitch, while the hollow under it acts as an amplifier. The very intense sound has been likened to the calls of birds, particularly the hornbill and a female parrot (Krämer 1925, 58; Ligvoet 1955, 2). This similarity is recognized in at least two of the drum's names, *lonuat* and *livika*, which both refer to birds.

Many such drums, including this one, also resemble birds. The eyes are marked by opercula, while the relief carving suggests a bird's face and feathers. The wedge at the opposite end of the relief can be interpreted as a tail, while the other two may be legs (Krämer 1925, 56). Augustin Krämer (ibid., 58), who worked in central New Ireland between 1907 and 1909, tried unsuccessfully to determine the species of bird to which the drums related. When he asked villagers, several answers were offered, including the hornbill and the parrot, as well as a bird of totemic

significance and another that was said to run into the bush when seen.

These drums were played at men's rituals and as part of *malagan* ceremonies, elaborate events commemorating deceased community members. According to Krämer (ibid., 57), at a certain point in the festivities, a drum was played by a man hidden in a special building. Krämer was told that the sound frightened away the women, who thought they were hearing ghosts. More recently and in another part of New Ireland, the drums were said to be played in ensembles, with compositions consisting of two or three repeated rhythmic and pitch patterns (Moyle 1989, 48).

Like the Wielgus Angoram figure (cat. no. 52), this drum was one of approximately 14,000 artifacts collected by the Joseph N. Field South Pacific Expedition. Albert Buell Lewis, at the time the Field Museum of Natural History's assistant curator of African and Melanesian ethnology, led the expedition, spending four years (1909-13) traveling, observing, and collecting in Melanesia. Like many museums, the Field has occasionally deaccessioned objects for which it has multiple examples. A major exhibition of New Ireland art organized in 1987, for example, included a friction drum collected by Lewis that remains in the Field Museum collection (Lincoln 1987, cat. no. 23).

References cited

Braunholtz, H.J. 1927. "An Ancestral Figure from New Ireland." *Man* 27: 217-19.
Krämer, Augustin. 1925. *Die Málanggane von Tombára*. Munich: Müller.
Ligvoet, A.W. 1955. "The Livika." In *Exotic and Ancient European Instruments*, 2-3. 's-Gravenhage: Niggh and Van Ditmar.
Lincoln, Louise. 1987. *Assemblage of Spirits: Idea and Image in New Ireland*. Exhibition catalogue. New York: George Braziller in Association with the Minneapolis Institute of Arts.
Messner, Gerald Florian. 1983. "The Friction Block *Lounut* of New Ireland: Its Use and Socio-Cultural Embodiment." *Bikmaus* 4, no. 3: 49-55.

Moyle, Richard M. 1989. *The Sounds of Oceania*. Auckland: Auckland Institute and Museum.

Provenance: Collected by A.B. Lewis on Joseph N. Field South Pacific Expedition, 1909-13; acquired from Field Museum of Natural History (Chicago) in 1959

Published: MPA 1960b, cat. no. 42; Arts Club 1966, cat. no. 38; IUAM [1992], fig. 3

Exhibited: MPA 1960b, Arts Club 1966, IUAM 1993

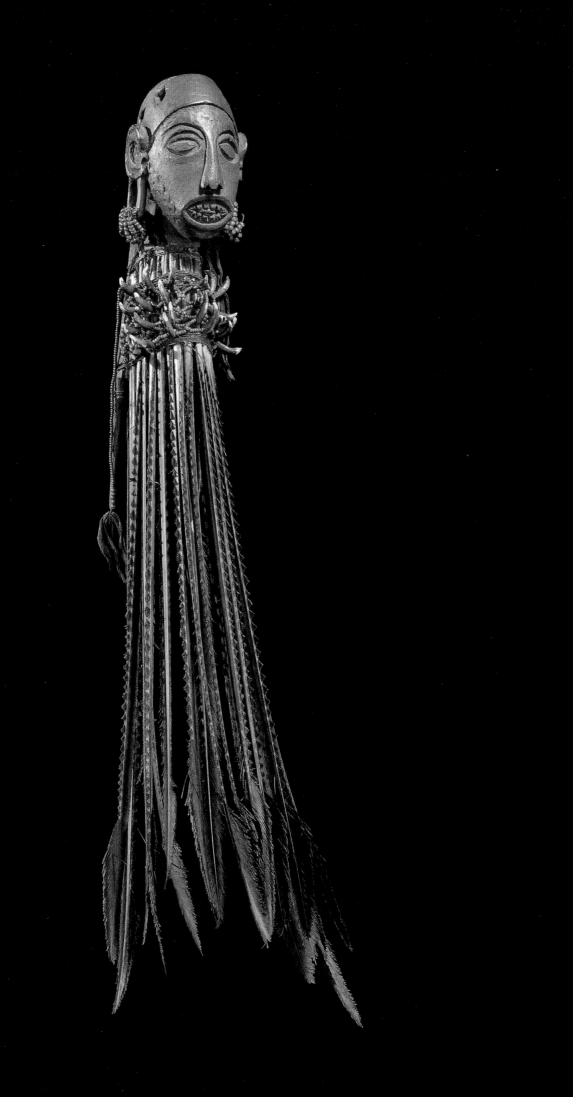

49

Matankor peoples, Manus Island, Admiralty Islands

War Charm

Nineteenth century
Wood, frigate-bird feathers, glass beads, cuscus teeth, cloth, fiber
H. 20 1/2 in. (52.1 cm)
IUAM 76.40 (RW 61-223)

War was an important part of traditional culture in most parts of Oceania, and its significance is reflected in the many beautiful and elaborate weapons and accoutrements that were made. Throughout the Admiralty Islands, part of a warrior's preparation for battle included donning a war charm to increase his courage and protect him in battle. The charm was tied with a short cord to the nape of the neck so the carved head looked out behind the warrior and the feathers curved away from his back.

In describing such charms, Hans Nevermann (1934, 138, 140), a German ethnographer who did research in the Admiralty Islands in the early twentieth century, suggested that they imitated other charms worn by warriors that consisted of a human humerus or femur or, less frequently, a human forearm bone or a bone of an osprey, a large fish-eating hawk. Whichever the bone, it had feathers bound to it so that only its more bulbous top was visible. Like the wooden charms, the bone ones were suspended from the neck and worn on a man's back.

Similar bone charms were described by H.N. Moseley (1877, 400, 416), the naturalist on a British survey vessel that conducted research in the Admiralty Islands in 1875. Moseley did not mention charms carved in the form of human heads at all, saying only that he saw one wooden charm that was carved to imitate the top of a bone. Whether made from the bones of respected relatives or worthy adversaries, such objects would have been a way of increasing the powers of the wearer by drawing upon those of the deceased.

This is perhaps the only Wielgus Oceanic object in which Western contact is easily evident. Though determining whether an object was cut with tools made from imported metal may be difficult (see cat. no. 38), the presence of glass beads is a clear indication of outside influence, for they were not made by indigenous peoples anywhere in Polynesia, Micronesia, Melanesia, or Australia. Beads were certainly important elements of jewelry and ornament, but they were made from local materials such as shells, stone, bone, and teeth until European voyages brought glass ones as trade items. For example, teeth from the cuscus (a marsupial found in parts of the South Pacific), which are interspersed with the beads on this charm, were often strung as beads on necklaces.

Unlike the markings on the face of the Solomon canoe-prow ornament (cat. no. 45), which refer to actual facial decoration, the incised triangles on the sides of this face reflect the Admiralty predilection for patterned borders on many different types of objects.

References cited

Moseley, H.N. 1877. "On the Inhabitants of the Admiralty Islands." *Journal of the Anthropological Institute* 6: 379-429.
Nevermann, Hans. 1934. *Admiralitäts-Inseln*. Hamburg: Friederischen, de Gruyter.

Provenance: Ex-coll. Raymond Tual (Paris); Wielgus acquired from Allan Frumkin (Chicago) in 1961, but later sold or traded it; IUAM acquired from Richard Gray Gallery

Published: IUAM 1980, 241 (ill.); IUAM 1986, cat. no. 64; IUAM [1989b], 3

Exhibited: IUAM 1993

50

Abelam peoples (northern),
Papua New Guinea

Ornament, *Kara Ut*

Fiber, boar tusk, shell, pigment
H. 12 1/8 in. (30.8 cm)
IUAM 100.29.5.79

Living between the foothills of the
Prince Alexander Mountains to the
north and the Sepik River to the south,
the Abelam are not only the largest and
one of the most widespread populations
in the area of the Sepik River but are
also among the most skillful and cre-
ative artists, both in sculpture and in
painting. Although this ornament is
modest when compared to some of
their other arts, such as the flamboyant
painted gables that soar 90 feet into the
air, it has associations that are central to
traditional Abelam life.

The ornament's name, *kara ut*, de-
scribes two of its components. *Kara*
means "boar," an important animal
that was believed to have connections
with the spirit world — here an obvious
reference to the prominent tusks. *Ut* is
a net bag used to hold a variety of
things, including personal belongings.
Its material and manufacture resemble
the body of the ornament.

Contradictory information, in each
case based on fieldwork, appears in the
literature about the wearing of the *kara
ut*. Gerd Koch (1968, 15, 62) maintains
that it is the prerogative of "big men,"
men who, as successful yam farmers,
orators, and, in former times, warriors,
have become leaders in their villages.
Brigitta Hauser-Schäublin (1985, 196),
on the other hand, says that it is a typ-
ical ornament for men, worn every day
and at festivals by all who have passed
the *kara* stage of initiation. Both report
that the *kara ut* is usually tied to a
string and worn on the back, though
Koch indicates that it may also be worn
on the chest (an idea that is corroborat-
ed elsewhere [Stöhr 1971, fig. 225]),
and Hauser-Schäublin is adamant that
it is never worn there.

Though it represents a spirit, the *kara
ut* is a human form created from woven
fiber and boar tusks and decorated with
shells, just as people use shells to orna-
ment themselves (Koch 1968, 62). Two
additional tusks appear to come out
of the figure's head, but, according to
Hauser-Schäublin (1985, 196), the
Abelam do not see it as a figure with
horns. Rather, those tusks relate to
another aspect of the ornament's
function, that of a war charm.

When attacking an enemy, an Abel-
am warrior held a *kara ut* in his mouth
so that the boar tusks appeared to grow
out of his jaw and the figure seemed to
dangle from his mouth. The boar is a
symbol of bravery and aggression for
the Abelam, so wearing the ornament
in this way was believed both to give
courage to the warrior and to frighten
his enemy (Hauser-Schäublin 1985,
197). More recently, the ornaments
have apparently been worn in this way
for dances (Gardi 1960, pl. 50).

In addition to being worn by men,
a *kara ut* might decorate an especially
large yam, which is a symbol of an
Abelam man's virility and status (ibid.,
pl. 48; Newton 1986, fig. 1). Yams are a
staple food, and men hold competitions
to see who has raised the largest ones.
The yams that are judged the best are
displayed wearing basketry masks and
ornaments such as this, a reflection of
both a man's agricultural success and
the favor with which he is regarded
by the spiritual entities that control
fertility.

References cited

Gardi, René. 1960. *Tambaran: An Encounter
with Cultures in Decline in New Guinea*.
Translated by Eric Northcott. London:
Constable.
Hauser-Schäublin, Brigitta. 1985. "Back and
War Ornament." In *Authority and Ornament:
Art of the Sepik River*, 196-97. Edited by
Suzanne Greub. Exhibition catalogue. Basel:
Tribal Art Centre.
Koch, Gerd. 1968. *Kultur der Abelam*. Berlin:
Museum für Völkerkunde.
Newton, Douglas. 1986. "Visual Arts of the
Pacific." In *African, Pacific, and Pre-Columbian
Art in the Indiana University Art Museum*,
49-97. Essays by Roy Sieber, Douglas Newton,
and Michael D. Coe. Bloomington: Indiana
University Art Museum in Association with
Indiana University Press.
Stöhr, Waldemar. 1971. *Melanesien: Schwarze
Inseln der Südsee*. Exhibition catalogue.
Cologne: Rautenstrauch-Joest Museum.

Provenance: Acquired from Wayne Heathcote
(New York) in 1979

Exhibited: IUAM 1993

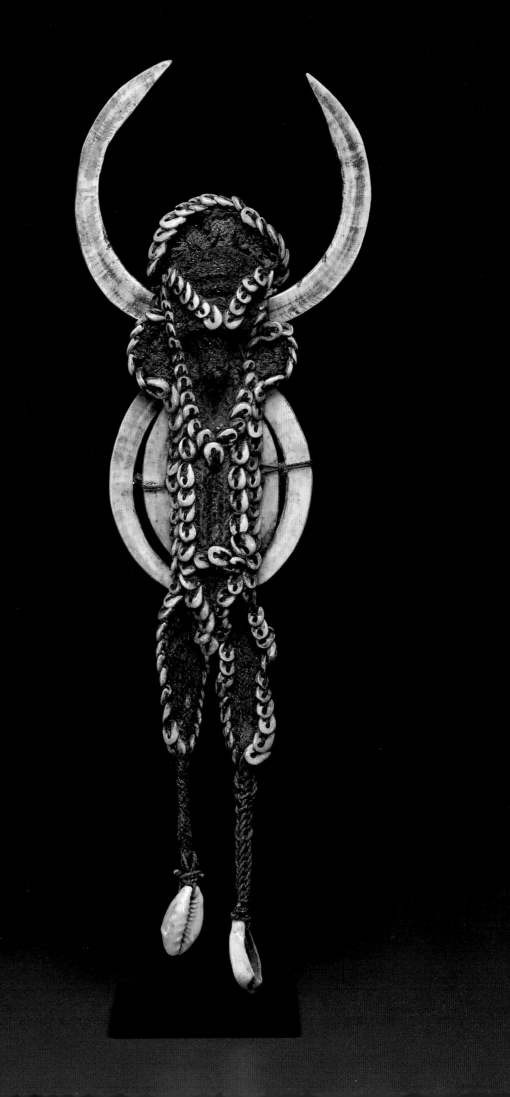

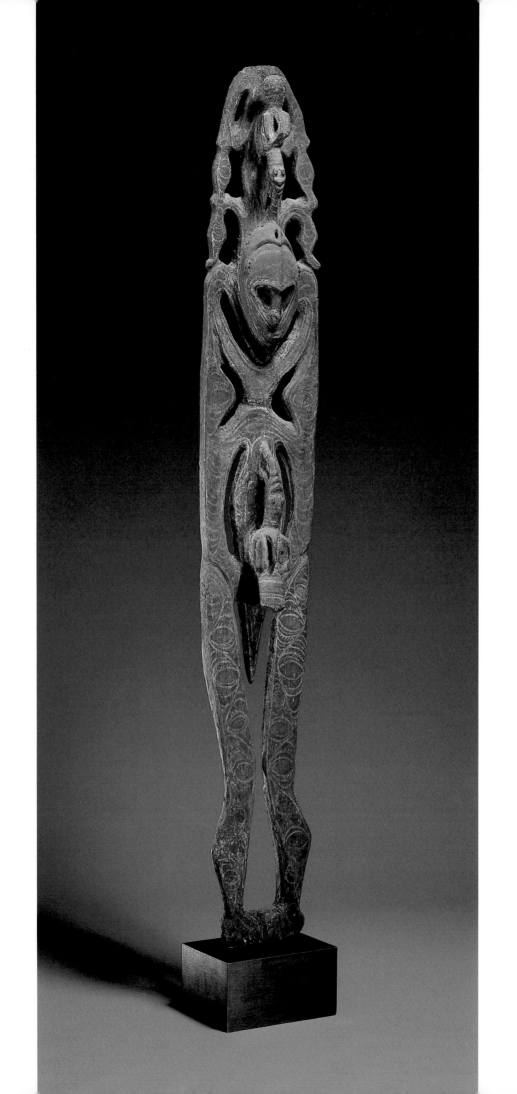

51

Kopar peoples, Singarin village,
Papua New Guinea

Commemorative Figure, *Atei*

Wood, pigment, incrustation
H. 77 1/2 in. (196.9 cm)
Raymond and Laura Wielgus Collection
(RW 57-95)

Carved to commemorate an important
ancestor, this figure straddles the line
between relief sculpture and sculpture
in the round. Its body is a planklike
form punctuated by openwork sections
and clearly meant to be viewed only
from the front, but the face and the two
birds framing it are represented as
rounded sculptural forms.

Figures such as this one were tradi-
tionally made by various peoples in the
lower Sepik River area, a result of ex-
tensive contact with one another, which
makes attributions difficult without
specific collection information (Kelm
1966-68, III: pls. 35-41; Bühler 1969,
76-79). Though a number of such ob-
jects are scattered in museums and
private collections, little contextual
information is available about them,
however.

Typically, an *atei* combines an ab-
stract and stylized representation of a
human body with a relatively realistic
head and one or more depictions of
animals that have totemic significance
in the area, such as crocodiles, pigs, or,
as in this example, birds. The figures
are nearly always male (though some
have female subsidiary figures) with
prominent phalluses, a symbol through-
out Melanesia of the strength, aggres-
siveness, and virility that enable a man
to become a powerful ancestor. How-
ever, whether these figures represent
specific ancestors, mythic ones, or an-
cestorhood in general is uncertain. Set
up in men's houses, they are said to
have been invoked as oracles before
warfare and hunting expeditions
(Bühler 1969, 76) and likely were a
focus for other ritual activities, such as
initiations and funerary celebrations.

Throughout New Guinea, ancestors,
both mythological and real, have trad-
itionally played important roles in
people's lives. Their importance is
based on a two-part belief, shared with
many other peoples worldwide, that
after death a person's spirit maintains
the power and wisdom that the indiv-
idual had accumulated on earth, and
that ancestral spirits can have positive
or negative effects on individuals and
communities. Along the Sepik River,
ceremonies and objects enlist the aid of
these spirits and assure them that they
are respected and remembered. In this
way, it is hoped, the spirits will main-
tain positive feelings about their living
descendants and help them in all
aspects of life.

References cited

Bühler, Alfred. 1969. *Art of Oceania*. Zurich:
Atlantis.
Kelm, Heinz. 1966-68. *Kunst vom Sepik*. 3
vols. Berlin: Museum für Völkerkunde.

Provenance: Ex-colls. Linden-Museum (Stutt-
gart), Serge Brignoni (Lugano); acquired from
Allan Frumkin (Chicago) in 1957

Published: AIC 1958 (ill.), 37; *Time* 1960, 62;
MPA 1960b, cat. no. 33; Arts Club 1966, cat.
no. 27 (ill.); *Chicago Tribune* 1970, IA: I; AIC
1971, fig. I; Wardwell 1971, cat. no. 62 (ill.)

Exhibited: AIC 1958, MPA 1960b, Arts Club
1966, AIC 1971, IUAM 1993

52

Angoram peoples, Papua New Guinea

Commemorative Figure

Wood, pigment, fiber
H. 80 in. (203.2 cm)
Raymond and Laura Wielgus Collection
(RW 59-162)

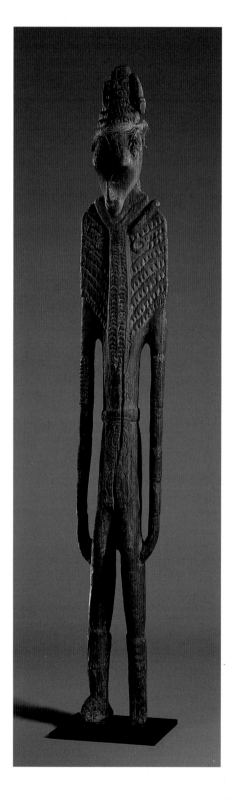

Like catalogue number 51, this remark-
ably powerful figure was made to com-
memorate an ancestor, real or mythical.
Like the Kopar, the Angoram peoples
live on the lower course of the Sepik
River. Life-size and larger sculpture is
not unusual along the Sepik, and
through their towering appearance
such figures demonstrate in an unmis-
takable way that they honor a particu-
larly important and influential person,
such as the founder of a lineage or an
ancestral mythological hero. This figure
was kept inside the village men's house
and displayed at ancestral rites and on
other occasions, such as boys' initiati-
ons, when the significance of ancestors
to Angoram life was emphasized.

The skull-like form of this figure's
head is unusual and emphasizes that
it represents a deceased person. In ad-
dition, this form recalls a practice along
some parts of the Sepik River in which
actual skulls, sometimes incorporated
into wooden figures, commemorated
ancestors. The head's three-dimension-
al form, heightened by its position over-
hanging the chest, contrasts with the
flat body, which recalls in more realistic
form the planklike body of catalogue
number 51. Unlike the painted patterns
on that example, however, this one's
body is completely red, a color associ-
ated with ritual in New Guinea and
elsewhere.

The surface of this commemorative
figure is enlivened by relief carving
portraying clothing and accessories
worn by men living along the lower and
middle Sepik River. Its hat, for example,
is a carved version of a basketry one
(Edge-Partington and Heape [1890-98]
1969, II: 138, nos. 7, 8; Damm 1964,
pl. 66). The carving on the chest shows
a net bag, worn by men over a broad
area of northern New Guinea (for an il-
lustration, see Lawes 1976, cat. no. 11).
These bags were usually decorated; this
one appears to be covered with cowrie
shells and to have two shell rings —
popular ornaments — attached. Not
only jewelry, the bags also often served
as amulets, containing fragments of an-
cestral bones or other substances that
were believed to protect the wearer.

The curved piece over the figure's left
shoulder likely represents a ceremonial
wooden version of an adze, a basic tool
for cutting wood (Museo delle Culture
Extraeuropee 1989, cat. nos. 120, 121).
Incised turtle-shell armlets, which were
made on the northern New Guinea
coast and traded into the interior, and
more shell rings are depicted on the
figure's arms, and it wears a decorated
loincloth, all accessories of a prosper-
ous, successful individual.

References cited

Damm, Hans. 1964. "Ozeanien." In *Orna-
ment und Plastik fremder Völker*, pls. 53-94.
By Dietrich Drost, Hans Damm, and Werner
Hartwig. Leipzig: Edition Leipzig.
Edge-Partington, James, and Charles Heape.
[1890-98] 1969. *An Album of the Weapons,
Tools, Ornaments, Articles of Dress, etc. of
the Natives of the Pacific Islands.* 3 vols. Man-
chester: J.C. Norbury; reprint ed., 3 vols. in 2,
London: Holland Press.
Lawes, Bruce D. 1976. *New Guinea Art: The
Bruce Lawes Collection.* Exhibition catalogue.
Oakland, Calif.: Western Association of Art
Museums.
Museo delle Culture Extraeuropee. 1989. *Cul-
ture extraeuropee: Collezione Serge e Graziella
Brignoni/Extra-European Cultures: The Serge
and Graziella Brignoni Collection.* Edited by
Claudio Gianinazzi and Christian Giordano.
Exhibition catalogue. Lugano.

Provenance: Collected by Captain H. Voogdt,
1908-9; acquired by A.B. Lewis on Joseph N.
Field South Pacific Expedition, 1909-13, at Sin-
garin village; acquired from Field Museum of
Natural History (Chicago) in 1959

Published: MPA 1960b, cat. no. 34, pls. 26, 26a;
Time 1960, 62; Arts Club 1966, cat. no. 28;
Chicago Tribune 1970, 1A: 1; Schmitz 1971,
pls. 49, 50; Wardwell 1971, cat. no. 48 (ill.);
Gathercole, Kaeppler, and Newton 1979, cat.
no. 22.6 (ill.)

Exhibited: MPA 1960b, AIC 1963, Arts Club
1966, AIC 1971, Tucson 1975, NGA 1979,
Dapper 1992, IUAM 1993

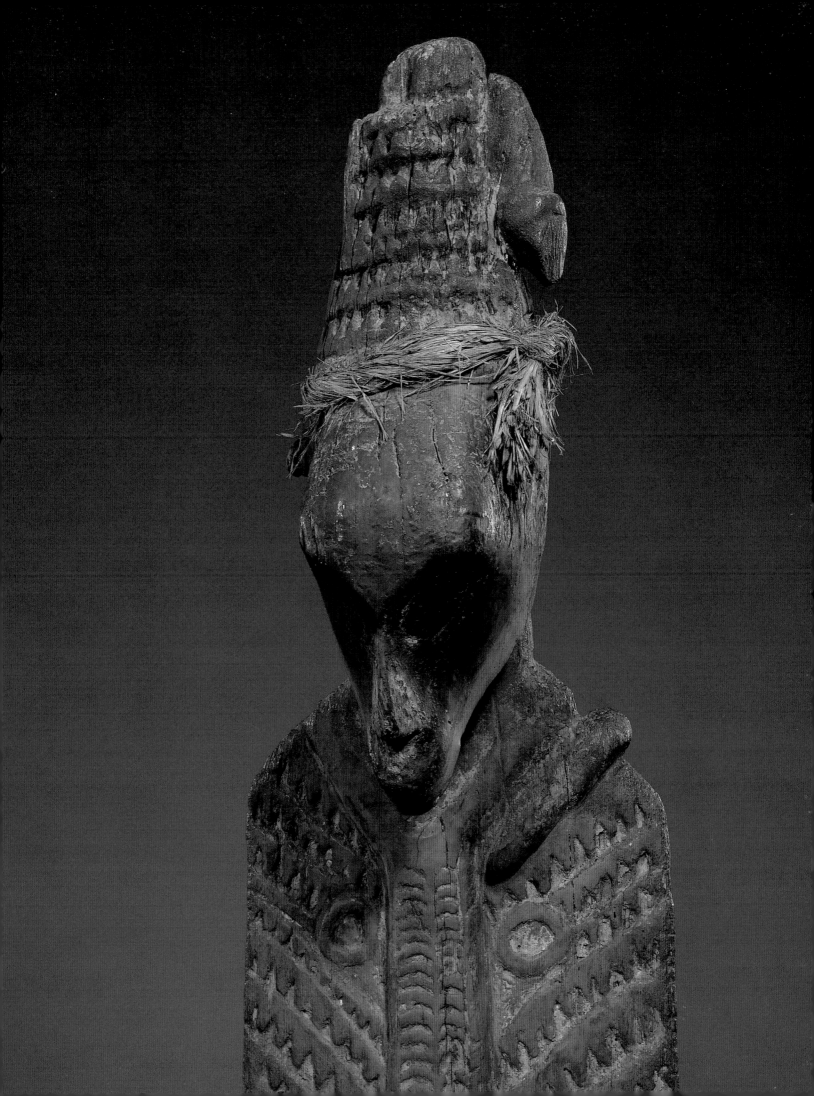

53

Kambot peoples, Papua New Guinea

Mask

Wood, rattan, clay, cowrie shells, nassa shells,
boar tusks, human hair, pearl shell, fiber
H. 21 1/2 in. (54.6 cm)
Raymond and Laura Wielgus Collection
(61-225)

The Kambot, an amalgam of small
groups, some of whom may have been
immigrants from the Sepik River, live
on the Keram River, a southern tribu-
tary of the Sepik, and in the swamps
around it. Perhaps best known for their
featherwork and painted panels of
mythological characters, their masks
are characterized by the combination
of many different natural materials
(Newton 1967, "The Kambot";
Gathercole, Kaeppler, and Newton
1979, 300).

Here, an oval wooden foundation
surrounded by a basketry border has
been overmodeled with clay to which
other materials have been added. Over-
modeling with clay or vegetal paste is a
Melanesian technique most often asso-
ciated with the preservation and display
of the skulls of important ancestors,
though similar modeling techniques
also are found in the mud masks of the
New Guinea highlands. The basketry
border allowed the mask to be attached
easily to costume elements, such as a
hood or other head covering, and prob-
ably served as a support for feathers,
flowers, leaves, or other ephemeral
materials. The use of three different
kinds of shells reflects the traditional
importance shell in both natural and
worked form has for the peoples of
Oceania, not only as a material for
decoration but also as a medium of
exchange. Boar tusks, seen here as
multiple nose ornaments and part of
the headdress, were also highly valued
in Melanesia, where traditionally a
man's wealth was measured in part by
the number of pigs he owned (Thomas
1995, 27-28). In some areas, the two
upper canines of a male pig were re-
moved to encourage the growth of the
lower ones, which would eventually
curl into a circle that was prized as an
ornament.

In their use of these varied materials,
Kambot masks exemplify two general
characteristics that distinguish Mela-
nesian and Polynesian art. First, Mela-
nesian art tends to show the greater
variety of natural materials that were
available on those islands, particularly
New Guinea. Second, much Mela-
nesian art was created for a single use
or with the intention that it would be
regularly renewed. On this mask, for
example, the thickly applied, unfired
clay tends to crack and break. In Poly-
nesia, on the other hand, there was a
greater tendency to make objects that
were intended to last and to become
heirlooms, as the Tahitian fly-whisk
handle (cat. no. 25) and the Maori
pendant (cat. no. 42) in the Wielgus
Collection illustrate.

No ethnography of the Kambot has
been published. However, based on in-
formation about nearby groups, we can
assume that masks such as this one were
connected with men's societies or spirit
cults and likely represented ancestral or
nature spirits.

References cited

Gathercole, Peter, Adrienne L. Kaeppler, and
Douglas Newton. 1979. *The Art of the Pacific
Islands*. Exhibition catalogue. Washington,
D.C.: National Gallery of Art.
Newton, Douglas. 1967. *New Guinea Art in
the Collection of the Museum of Primitive Art*.
New York: Museum of Primitive Art.
Thomas, Nicholas. 1995. *Oceanic Art*. Lon-
don: Thames and Hudson.

Provenance: Ex-coll. J. Van der Straete (Bel-
gium); acquired from Allan Frumkin (Chicago)
in 1961

Published: Malines 1956, pl. 200; Arts Club
1966, cat. no. 26 (ill.); *Chicago Tribune* 1970,
1A: 1; Wardwell 1971, cat. no. 37 (ill.)

Exhibited: Malines 1956, Arts Club 1966, AIC
1971, IUAM 1993

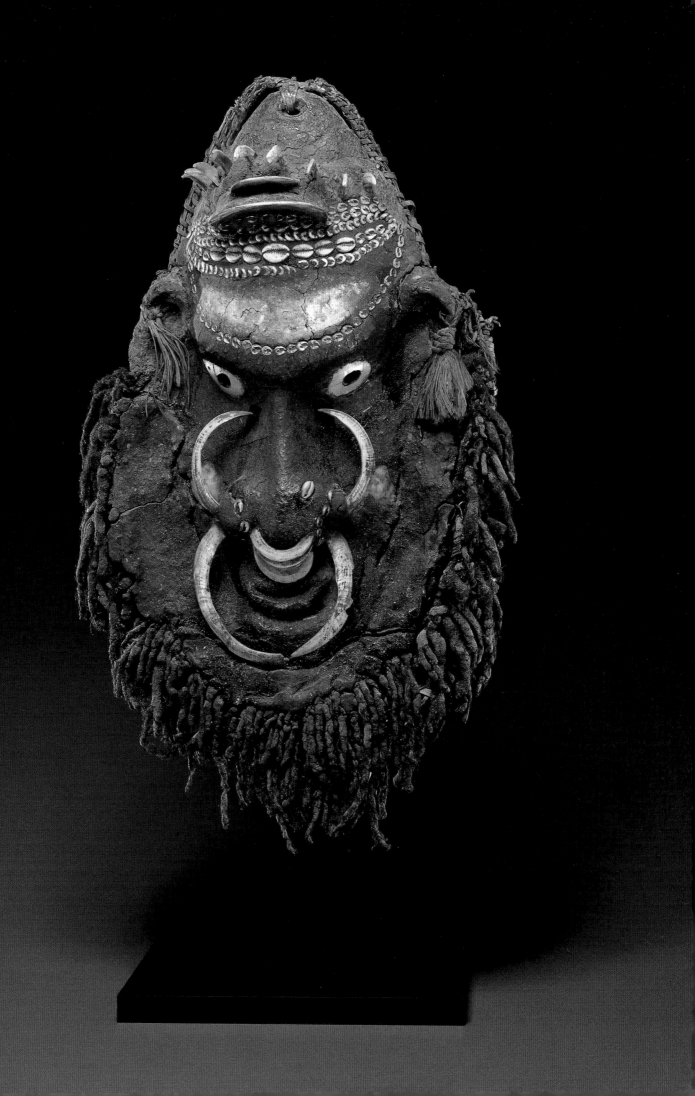

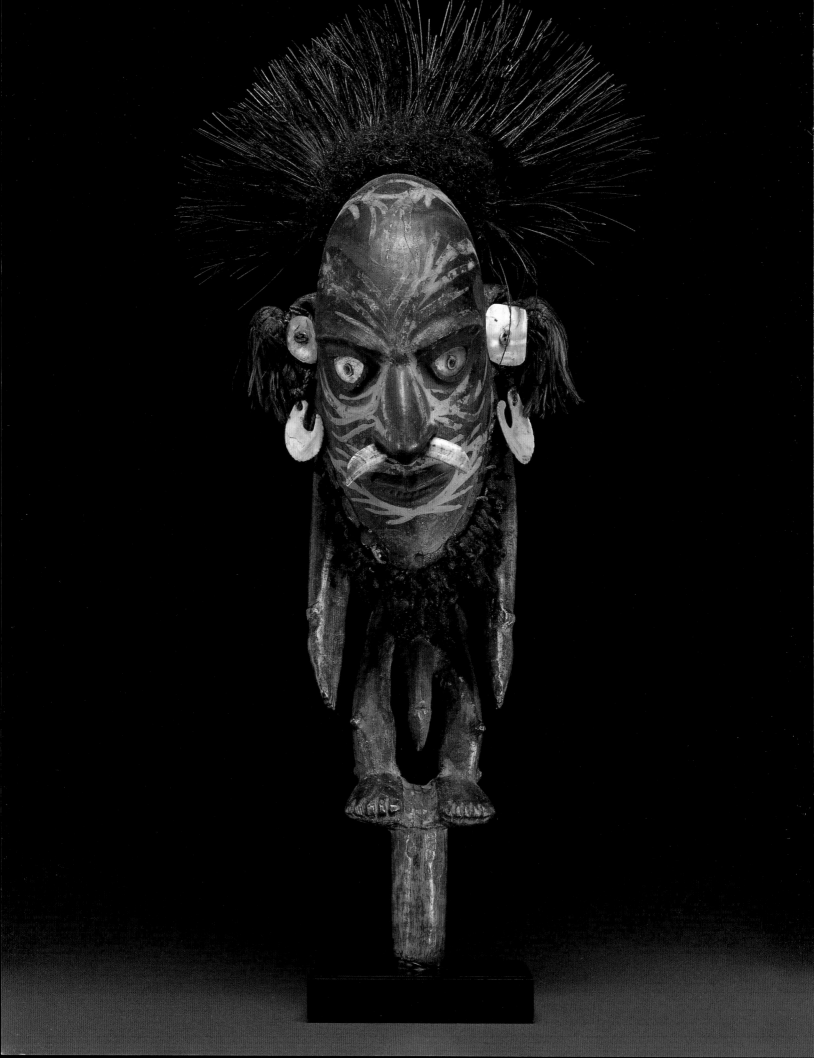

54

Biwat peoples, Papua New Guinea

Figure for a Sacred Flute

Ca. 1900-1920
Wood, stone, shell, boar tusk, human hair,
cassowary feathers, fiber, pigment
H. 20 1/2 in. (52.7 cm)
IUAM 75.53 (RW 59-171)

Living along the Yuat River, a tributary
of the lower Sepik River, the Biwat
people (formerly known as the Mundu-
gumor), like others residing in the vicin-
ity of the Sepik, played sacred flutes for
ceremonial occasions and pig feasts.
These transverse flutes, which were
usually played in pairs or ensembles,
are hollowed bamboo tubes up to eight
feet long. When not in use, a figural
stopper such as this one might be in-
serted into the end of the flute closest
to the mouth hole.

Unlike other Sepik areas where flutes
were community property, individual
Biwat men owned the flutes and their
stoppers and, as the owners of such
sacred objects, had the right to initiate
boys and girls into cults associated
with them (McDowell 1991, 131-32).
Ownership of these objects carried a
great deal of prestige in itself; that pres-
tige was increased by a man's ability
to provide the feasts necessary for new
initiates.

Although several cults existed, we
have little information about any except
the *ashin*, or crocodile, cult. Margaret
Mead and Reo Fortune, whose 1932 re-
search in the Biwat area forms the basis
for much of our knowledge about the
area even today, witnessed an *ashin* in-
itiation and found that an elaborately
decorated flute with a stopper was one
of the essential objects (ibid., 134-47).

A flute and its stopper were made by
a male carver but decorated commun-
ally with prestige materials, such as
feathers, beads, and tusks. After being
decorated, the flute was called a child of
the crocodile spirit, an important super-
natural power, and was stored upright
in the back of the owner's house. Ac-

cording to Mead (1934, 238), the flutes
and their stoppers were sometimes so
heavily encrusted with ornamentation
that they were impossible to play, so
smaller, plain flutes served as the
"voice" of the child.

The figures at the top of the stoppers
range from eight to thirty-eight inches
in height. This figure is characteristic
of those depicting humans, as well as of
Biwat figural style generally, in its stiffly
hanging arms, proportionally small
torso and legs, and enlarged genitalia.
Jutting over the body is a remarkably
enlarged head, which may reflect the
Biwat belief that the head is the most
sacred part of the body. The forehead in
particular is expansive, occupying at
least half of the face and serving as the
diagnostic feature for two identifiable
substyles. The first, of which this figure
is an example, has a rounded forehead,
while the second is characterized by a
forehead that rises up to a rounded
point, mirroring the shape of the figure's
chin.

The Wielgus figure is notable for
the surviving additions to the carving:
the decorations of paint, shells, tusks,
hide, human hair, and feathers from a
cassowary (a large, flightless bird),
which have both ceremonial and pres-
tige significance in many parts of New
Guinea. Many other figures have been
stripped, losing much of their visual
complexity and appearing as a pale
reflection of the wealth and prestige
that they were intended to convey.

References cited

McDowell, Nancy. 1991. *The Mundugumor:
From the Field Notes of Margaret Mead and
Reo Fortune*. Washington, D.C.: Smithsonian
Institution Press.
Mead, Margaret. 1934. "Tamberans and Tum-
buans in New Guinea." *Natural History* 34
(1934): 234-46.

Provenance: Ex-colls. Raymond Tual (Paris),
Paul Chadourne (Paris); acquired from Allan
Frumkin (Chicago) in 1959

Published: Portier and Poncetton 1922, pl. 18;
Galerie Andrée Olive 1948, no. 4 (ill.); MPA
1960b, cat. no. 35; Arts Club 1966, cat. no. 25
(ill.); Wardwell 1971, cat. no. 98 (ill.); IUAM
1978, 115 (ill.); IUAM 1980, 236 (ill.); IUAM
1986, 48 (ill.); IUAM [1989b], 3 (ill.); Rosen-
zweig 1990, 19 (ill.); IUAM [1991], 11 (ill.);
IUAM [1992], fig. 1

Exhibited: Olive 1948, MPA 1960b, AIC 1963,
Arts Club 1966, AIC 1971, IUAM 1993

55

Sepik River area, Papua New Guinea

Ritual Carving

Wood, pigment, incrustation
H. 16 1/2 in. (41.9 cm)
Raymond and Laura Wielgus Collection
(RW 57-94)

56

Sepik River area, Papua New Guinea

Ritual Carving

Wood, pigment, incrustation
H. 12 3/4 in. (32.4 cm)
IUAM 75.99.1 (RW 55-12)

56

Though fieldwork continues today among the peoples of Africa and Oceania, some objects, such as these, are still poorly understood. Our lack of information has several explanations. Among the hundreds of ethnic groups in each of these areas, many have yet to be studied; under Western influences, many peoples have given up traditional practices, and therefore interpretations of objects associated with them have disappeared with the deaths of the elderly; in some situations where traditional practices are still being followed, some information is considered too esoteric to be shared with outsiders.

Our understanding of these two objects has not really expanded since their exhibition in the 1960 Museum of Primitive Art showing of the Wielgus Collection, when they also were designated simply as "ritual carvings." Later, when they were published in Allen Wardwell's important *Art of the Sepik River* (Wardwell 1971, cat. nos. 70, 71), catalogue number 56 was still given a generic title ("ceremonial object"), though catalogue number 55 was identified as a flute ornament. The latter designation was based on the observation that the bottom of the object is in the same form as the ends of flute stoppers such as the Wielgus Biwat example (cat. no. 54). If this is indeed a flute stopper, it is a rare type, however.

Whatever their functions, these two objects show a combination of animal (bird and crocodile or lizard) and human motifs which is common on the Sepik River. The animals depicted in this area's sculpture generally figure in mythology and often have totemic relationships with people. Catalogue number 56's long beak-nose points to an origin in the lower Sepik area, where such a motif is characteristic of masks and figures.

Douglas Newton (personal communication, 1985), an authority on the art of New Guinea, also has suggested a lower Sepik provenance for catalogue number 56; a cryptic note in the museum's files indicates that an individual named Lissauer attributed it to "Tegaui village, Middle Sepik" in 1980.

Reference cited

Wardwell, Allen. 1971. *Art of the Sepik River*. Exhibition catalogue. Chicago: Art Institute of Chicago.

Cat. no. 55

Provenance: Ex-coll. Pierre Loeb (Paris); acquired from Allan Frumkin (Chicago) in 1957

Published: MPA 1960b, pl. 16; Arts Club 1966, cat. no. 30; Wardwell 1971, cat. no. 71 (ill.)

Exhibited: AIC 1958, MPA 1960b, Arts Club 1966, AIC 1971, IUAM 1993

Cat. no. 56

Provenance: Acquired from J.J. Klejman (New York) in 1955

Published: MPA 1960b, cat. no. 37; Arts Club 1966, cat. no. 29; Wardwell 1971, cat. no. 70

Exhibited: AIC 1958, MPA 1960b, Arts Club 1966, AIC 1971, IUAM 1993

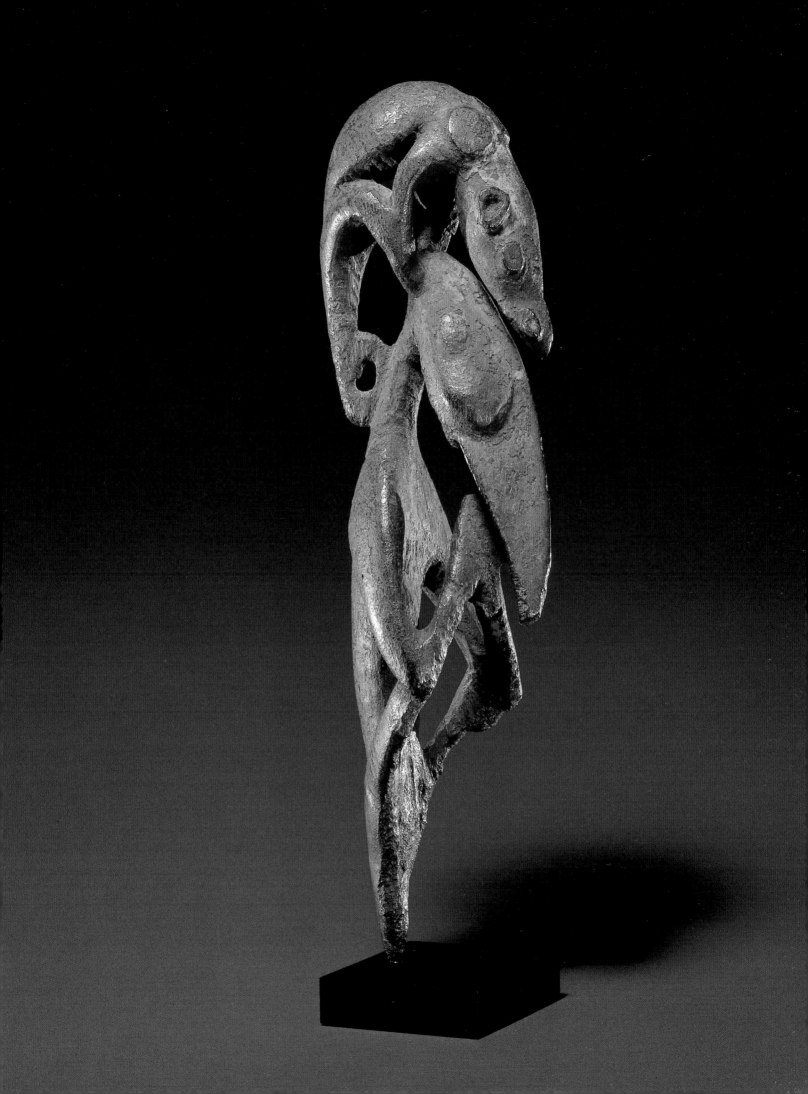

Iatmul peoples (Nyaura subgroup?),
Papua New Guinea

Mask, *Mei*

Wood, pigment, cowrie shells
H. 25 in. (63.5 cm)
Raymond and Laura Wielgus Collection
(RW 56-28)

Mei (also written *mai*) masks are among the best-known objects made by the Iatmul, a group living along the middle Sepik River whose complex, dynamic society has produced a prodigious number of masks, figures, and other decorated objects. Although called a mask, this sculpture has neither eye holes nor sufficient width to cover the face. Instead, it was originally attached to a large, full-length fiber cone that was carried on the shoulders. Such costumes, which usually appeared in two pairs, were worn by young men who made the masks "talk" via concealed bamboo tubes (Greub 1985, 183). These masqueraders appeared at dances that were junior analogues to those honoring ancestors that were performed by senior initiated men (Bateson 1958, 233).

The masks represent ancestral spirits, which the Iatmul conceive of as brother-sister pairs, reflecting a world view "largely based on duality: groupings of pairs of phenomena that were in one sense unified and in another opposed: male-female, earth-sky, older-younger, good-bad, life-death, and so forth" (Metropolitan Museum of Art 1987, 23). The mask pairs are owned by individual clans, and each mask has a personal name of one of the clan's ancestors.

Mei masks are long and narrow and either covered with cowrie shells or painted in a pattern considered appropriate for a particular ancestor. The especially narrow width of this mask suggests that it is from the Nyaura (also written Niyaura), or western, Iatmul. The masks characteristically have exceedingly long noses attached to their chins, said to be a reference to the first ancestors, who were unable to speak until their noses became detached (ibid.). The form of the nose also recalls the beak of a bird, a creature with important mythological significance for people living along the Sepik River. As in this example, the noses of the masks generally end in a small animal (such as a snake, lizard, or frog) or bird that has a totemic relationship with the clan owning the mask.

In 1930, the Wielgus mask was shown in an exhibition of African and Oceanic art at the Galerie Pigalle in Paris. Organized by Tristan Tzara, one of the founders of Surrealism, and Charles Ratton, a prominent dealer, this exhibition was one of three that year displaying the widest variety of Oceanic arts which had been seen in France to date (Peltier 1984, 112). Featured at the Galerie Pigalle were objects from New Zealand and New Guinea, both British colonies and therefore not especially well known in France. Though the catalogue (Galerie Pigalle 1930, cat. no. 309) refers to it as an ornament, and an exhibition review (Sautier 1930, seventh pl. foll. p. 13) calls it a figure, this mask clearly demonstrates the "violent coloring" and "mysterious flavour" that Albert Sautier (1930, 12), a reviewer of the exhibition, found appealing in Oceanic art.

A 1949 photograph of an installation of Oceanic and modern art at another Paris venue, Galerie Pierre Loeb (Peltier 1984, 122), may also show this mask. Though the darkness of the photo makes definitive identification impossible, the outline and visible details appear identical, and we know that the mask was owned around that time by Loeb, a dealer primarily in Surrealist painting who also sold Oceanic objects. The mask is surrounded by a New Caledonia roof finial and a photograph, a drawing, and a sculpture by contemporary European artists. Such a combined display indicates the sympathetic relationship that many dealers, collectors, and artists saw between contemporary and ethnographic arts at the time.

References cited

Bateson, Gregory. 1958. *Naven.* 2nd ed. Stanford, Calif.: Stanford University Press.
Galerie Pigalle, Paris. 1930. *Exposition d'art africain et d'art océanien.* Exhibition catalogue. Paris.
Greub, Suzanne, ed. 1985. *Authority and Ornament: Art of the Sepik River.* Exhibition catalogue. Basel: Tribal Art Centre.
Metropolitan Museum of Art. 1987. *The Pacific Islands, Africa, and the Americas.* Introductions by Douglas Newton, Julie Jones, and Kate Ezra. New York.
Peltier, Philippe. 1984. "[The Arrival of Tribal Objects in the West] from Oceania." In *"Primitivism" in 20th Century Art: Affinity of the Tribal and the Modern,* I: 99-122. Edited by William Rubin. Exhibition catalogue. New York: Museum of Modern Art.
Sautier, Albert. 1930. "Exhibition of African and Oceanic Art at the Pigalle Gallery." *Formes* 3 (March): 12-13.

Provenance: Ex-coll. Pierre Loeb (Paris); acquired from Julius Carlebach (New York) in 1956

Published: Galerie Pigalle 1930, cat. no. 309; Sautier 1930, seventh pl. foll. p. 13; Rousseau 1951, fig. 52; MPA 1960b, cat. no. 28; Arts Club 1966, cat. no. 23; AIC 1971b, cat. no. 109 (ill.); Gathercole, Kaeppler, and Newton 1979, cat. no. 22.41 (ill.)

Exhibited: Pigalle 1930, AIC 1958, MPA 1960b, Arts Club 1966, AIC 1971, NGA 1979, IUAM 1993

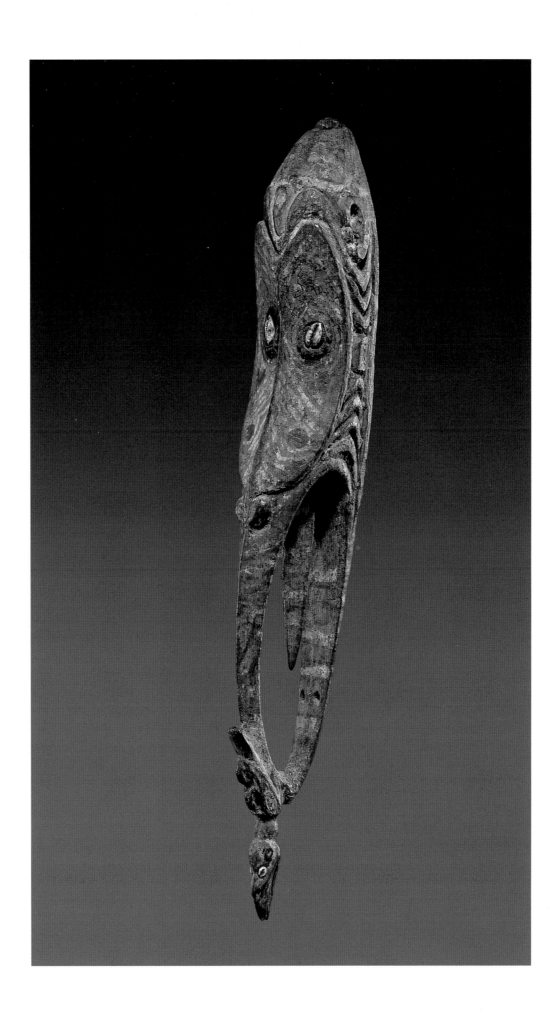

58

Iatmul peoples, Papua New Guinea

Dagger

Cassowary bone
L. 9 1/2 in. (24.1 cm)
IUAM 75.99.2 (RW 57-66)

59

Kwoma peoples, Papua New Guinea

Dagger

Human bone, cowrie shells
L. 13 1/4 in. (33.7 cm)
IUAM 66.72

Daggers were rare in traditional Oceania and were found only in Hawaii, the Admiralty Islands, and New Guinea. Bone daggers were unique to New Guinea and occurred in the area of Humboldt Bay, in the northeastern part of contemporary Papua New Guinea (which includes the area of the Sepik River), in the Ramu River area, in the central highlands on a limited scale, and on the south coast from the Asmat area to the eastern border of the Papuan gulf. Used for stabbing, not cutting, the daggers have sharp points but blunt edges. Unlike most other daggers, they have neither a special handle or grip nor guards to protect the hand.

As these two examples show, many are incised or engraved with abstract and representational patterns that are found on other objects. Many Iatmul objects, for example, depict the human face, which is shown here in typical Iatmul style, with circled eyes and long, curving nose. The spirals on the shaft of the dagger are also typical Iatmul motifs. Likewise, the Kwoma dagger is carved with the same sorts of designs that are used on lime gourds, pottery, spears, and the paintings made for the interior of men's houses. Some daggers also have added decoration, such as shells and feathers. The cowrie shells inserted near the top of one dagger (cat. no. 59) not only enhance its ap-

pearance but also would have increased its prestige value.

New Guinea daggers were primarily weapons for killing people, though in many areas they also had ritual roles. In addition to being an obvious metaphor for strength, bones, as the only lasting remains of deceased people and animals, were believed to have a special connection with the supernatural world (Newton 1989, 306-7). An Iatmul man used a bone dagger such as catalogue number 58, which was usually worn on the upper arm in a plaited arm band, for hand-to-hand fighting and for ritual (Schmid 1985, 191). Like most bone daggers, it was made from the leg of the cassowary, a large flightless bird, resembling an ostrich, that inhabits certain parts of the South Pacific. In New Guinea, some cassowaries are almost as tall as a person, and they are known as dangerous, aggressive birds, making their bones especially appropriate weapons for men who admire those characteristics.

In addition, the cassowary is significant in the mythology of many Sepik peoples as the creator of people and institutions integral to their societies. Douglas Newton (1989, 310), New Guinea scholar and the leading authority on bone daggers, points out allusions to the bird in many rituals, such as boys' initiations, in which "men ... become cassowaries in ritual and, generation by generation, replay the cassowary's role in creation." As a ritual object, then, a cassowary-bone dagger carries associations that are at the core of the ethos of many Sepik societies.

New Guinea men also made daggers from human bone, and among the Kwoma, who live in the Peilunga Mountains north of the Sepik River, it was used more often than cassowary bone. As part of Kwoma funerary rites, the corpse was allowed to decompose and then the bones were buried, except for a man's clavicle, jaw bone, and femur, which were distributed among friends and family (Whiting and Reed 1938, 216). A son inherited his father's femur, which he might then make into a dagger, sometimes adding supernat-

urally charged materials in the back which were believed to increase its effectiveness. Newton (1989, 309) points out that, in general, the use of such bones helps the living to validate their claims to the rights and powers that belonged to their ancestors.

References cited

Newton, Douglas. 1989. "Mother Cassowary's Bones: Daggers of the East Sepik Province, Papua New Guinea." *Metropolitan Museum Journal* 24: 305-25.
Schmid, Christin Kocher. 1985. "Dagger." In *Authority and Ornament: Art of the Sepik River*, 191. Edited by Suzanne Greub. Exhibition catalogue. Basel: Tribal Art Centre.
Whiting, John W.M., and Stephen W. Reed. 1938. "Kwoma Culture: Report on Field Work in the Mandated Territory of New Guinea." *Oceania* 9, no. 2 (December): 170-216.

Cat. no. 58

Provenance: Acquired from J.J. Klejman (New York) in 1957

Published: MPA 1960b, cat. no. 32; Arts Club 1966, cat. no. 24; Wardwell 1971, cat. no. 165 (ill.); IUAM 1986, cat. no. 52 (ill.)

Exhibited: AIC 1958, MPA 1960b, Arts Club 1966, AIC 1971, MMA 1990, IUAM 1993

Cat. no. 59

Provenance: Collected by Wayne Heathcote before 1964 and acquired from him

Exhibited: IUAM 1993

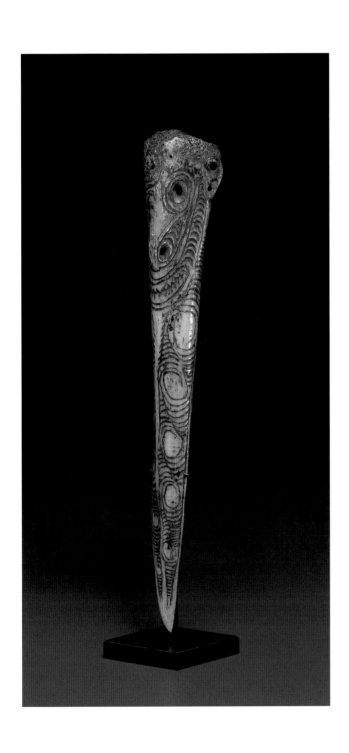

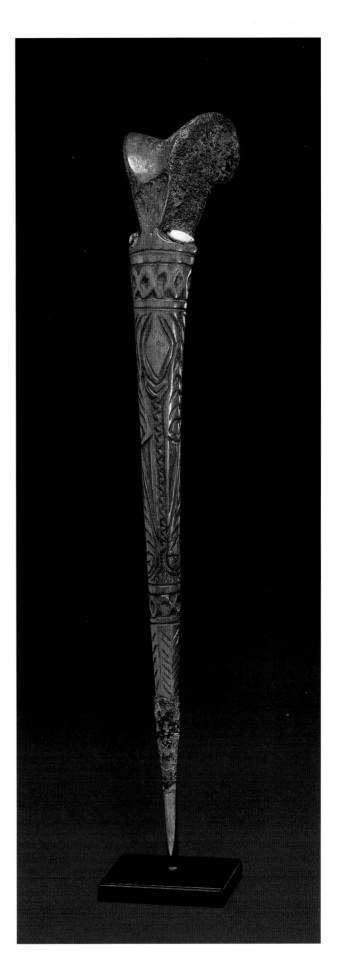

Ramu River area (?),
Papua New Guinea

Lime Spatula

Wood, incrustation, traces of lime
H. 19 1/2 in. (49.5 cm)
IUAM 100.11.5.79 (RW 56-41)

The equipment associated with betel chewing, a custom that stretches across the world from Africa to New Guinea, is a traditional part of a man's personal paraphernalia throughout New Guinea. A lime container, usually made out of a gourd, coconut, bamboo, or, more recently, a small tin or plastic box, and a spatula for extracting it from the container are the minimum required. In addition, a man might include a mortar and pestle and a larger container to hold his equipment and the betel-chewing components.

Three substances are actually chewed together: the nut of a palm, *Areca catechu*, which has a hot, acrid taste similar to nutmeg; the leaf, bean, or stem of the betel vine (*Piper betle*), which is a member of the pepper family; and slaked lime made from burned sea shells or coral or from mountain lime. Before chewing, the nut is crushed, spread on the betel, and mixed with lime. As the mixture is chewed, the lime releases alkaloids in the nut, which, together with an oil that is also present, produces a mild euphoria (Beran 1988, 5; Oliver 1989, 1: 305).

As with the chewing of coca leaves in Peru (see cat. no. 92), betel chewing is a stimulant, reducing hunger, creating a sense of well-being, and increasing a person's capacity for work. In addition, for the people of New Guinea, it has both social and ritual significances. For example, betel is chewed and often shared when men strike up informal conversations, and in many societies it is a traditional way to begin or end meetings (Oliver 1989, 1: 306).

The equipment too may have ritual significance. A lime container and a spatula are often part of the outfit ac-

quired by a newly initiated young man for the ceremony marking his presentation as an adult member of the community, for instance. Furthermore, some lime spatulas, including this one, may have had rings carved along the length so that they would produce a noise as they rubbed against the lime containers during ritual use (Bühler 1969, 132).

Objects associated with ceremonial use or belonging to a prominent man are likely to be decorated. On lime spatulas, which are made of wood or bone, figural imagery tends to consist of people, birds, and animals, most often carved at the tops of the sticks. The type of decoration, of course, varies from place to place and corresponds to the style of other objects from the same area. The twisted limbs, short neck, and long head of the figure on this stick suggest that it may come from the area of the Ramu River, a southern tributary of the Sepik.

References cited

Beran, Harry. 1988. *Betel-Chewing Equipment of East New Guinea*. Shire Ethnography, 8. Princes Risborough, Bucks.: Shire Publications.
Bühler, Alfred. 1969. *Art of Oceania*. Zurich: Atlantis.
Oliver, Douglas L. 1989. *Oceania: The Native Cultures of Australia and the Pacific Islands*. 2 vols. Honolulu: University of Hawaii Press.

Provenance: Acquired from Allan Frumkin (Chicago) in 1956

Published: MPA 1960b, cat. no. 46; Arts Club 1966, cat. no. 43

Exhibited: AIC 1958, MPA 1960b, Arts Club 1966, IUAM 1993

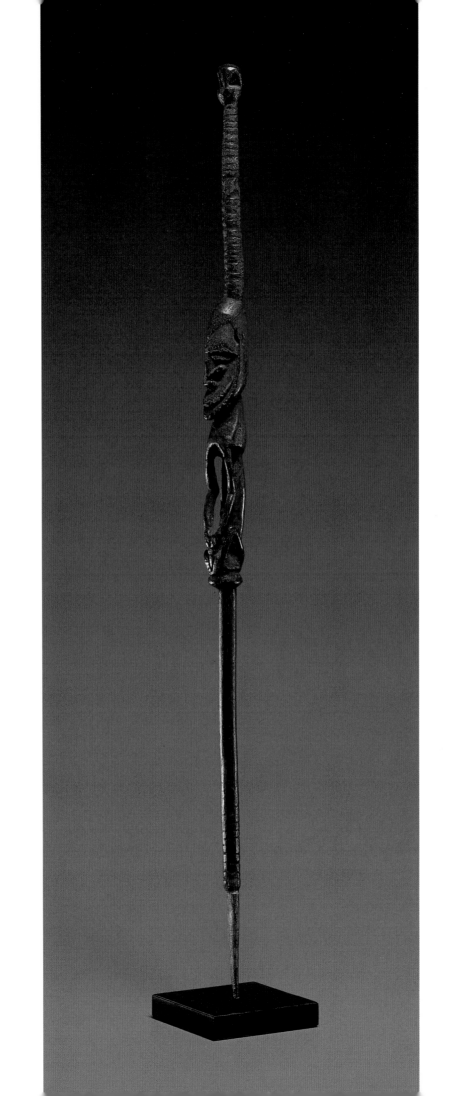

61

Astrolabe Bay, Papua New Guinea

Mask

Before 1925
Wood, pigment, incrustation
H. 16 in. (40.6 cm)
Raymond and Laura Wielgus Collection
(RW 57-57)

Like many peoples of the South Pacific, Africa, and the Americas, those in the area of Astrolabe Bay had their traditional way of life radically disrupted with the advent of Christian missionaries and colonialism. Beginning about 1884, the ways of life for the peoples living for several miles inland around Astrolabe Bay in northeastern New Guinea had so changed that as early as 1897 one ethnographer was unable to find any masks at all, though another earlier in that decade had collected 16 (Bodrogi 1978-80, 87). As a result, we have little information to enable us to attribute masks to any one of the several groups living in the area; early collectors most often identified masks simply as "Astrolabe Bay."

Nor do we have much information about the masks' meaning and contexts. They were connected with a men's association, which was described in early literature as a religious cult that transcended blood and political ties (Bodrogi 1953, 101). Although the associations had different names in different areas, the one about which most information was recorded was called Asa. Boys were initiated into Asa at the time of their circumcisions, though it is not clear whether circumcision was part of Asa or whether the two were separate, but took place together (ibid., 97). After being circumcised, boys recovered for up to six months in a special association building, where masks and other paraphernalia, such as flutes, bull-roarers, and figures, were stored. There, isolated from the rest of the village, the boys acquired the knowledge required of members. The masks are reported to have been worn at the end of this period of seclusion, at a ceremony in which the youths were reincorporated back into their villages as young men. In addition to their roles at initiations, the masks appeared at certain feasts and at funerals (Bodrogi 1978-80, 83).

Since early sources do not discuss who the mask represents, only conjectures are possible. In addition to being the name of the association, Asa (with its variants) was also a mythological devouring spirit. Because such masks were called *Asa-kate* ("Asa head"), Tibor Bodrogi (1978-80, 82), an ethnologist who has written the only studies of Astrolabe Bay art, suggested that the masks personified this spirit. In an earlier publication, however, he indicated that they may have represented ancestors, apparently basing this proposal on assumed parallels with other New Guinea masking traditions (Bodrogi 1959, 59).

Astrolabe Bay masks vary in appearance, but many share some of this mask's features. These include a rounded forehead and overhanging brow, pierced eye holes under the carved ones, a large, slightly curved nose that may be pierced, elaborated pierced ears, and circular projections representing shell and tusk ornaments. The crusty surface on this example and others suggests that the masks were used many times and regularly renewed with fresh additions of color.

References cited

Bodrogi, Tibor. 1953. "Some Notes on the Ethnography of New Guinea." *Acta Ethnographica* 3: 91-184.
———. 1959. "New Guinean Style Provinces: The Style Province 'Astrolabe Bay.'" In *Opuscula Ethnologica Memoriae Ludovici Biró Sacra*, 39-99. Edited by Tibor Bodrogi and L. Boglár. Budapest: Akadémiai Kiadó.
———. 1978-80. "A Mask from the Astrolabe Bay Area." *Minneapolis Institute of Arts Bulletin* 64: 80-87.

Provenance: Collected by Rev. Tauber in 1925; acquired from J.J. Klejman (New York) in 1957

Published: AIC 1958, 36 (ill.); *Chicago Sun-Times* 1958, 3: 8 (ill.); MPA 1960b, pl. 6; Arts Club 1966, cat. no. 32; *Chicago Tribune* 1970 1A: 1; Gathercole, Kaeppler, and Newton 1979, cat. no. 24.6 (ill.)

Exhibited: AIC 1958, MPA 1960b, Arts Club 1966, NGA 1979, IUAM 1993

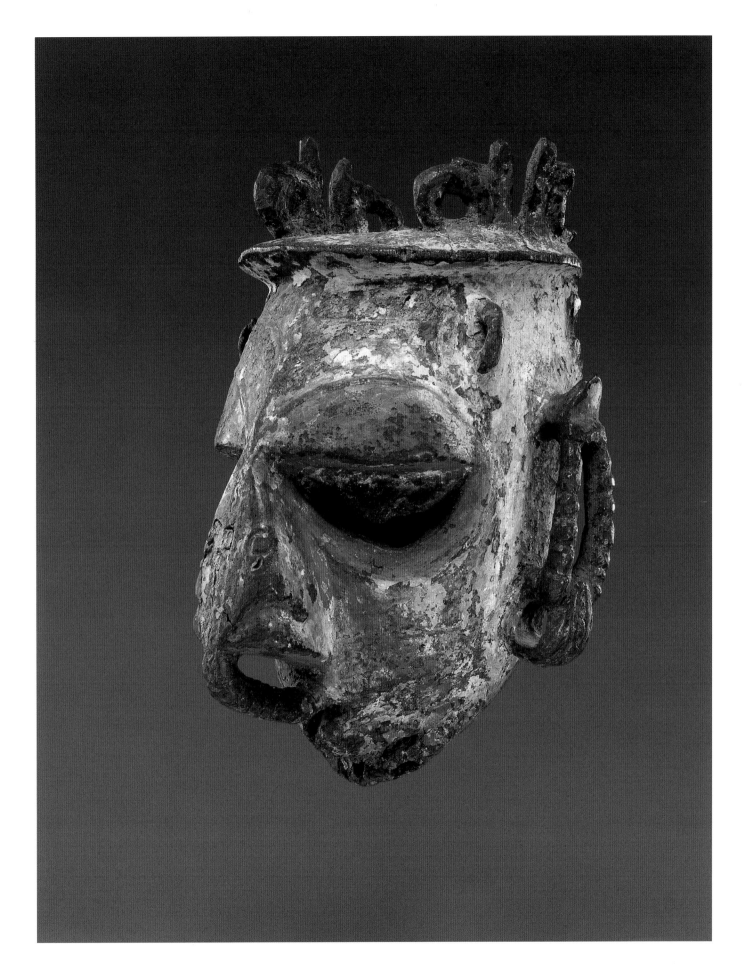

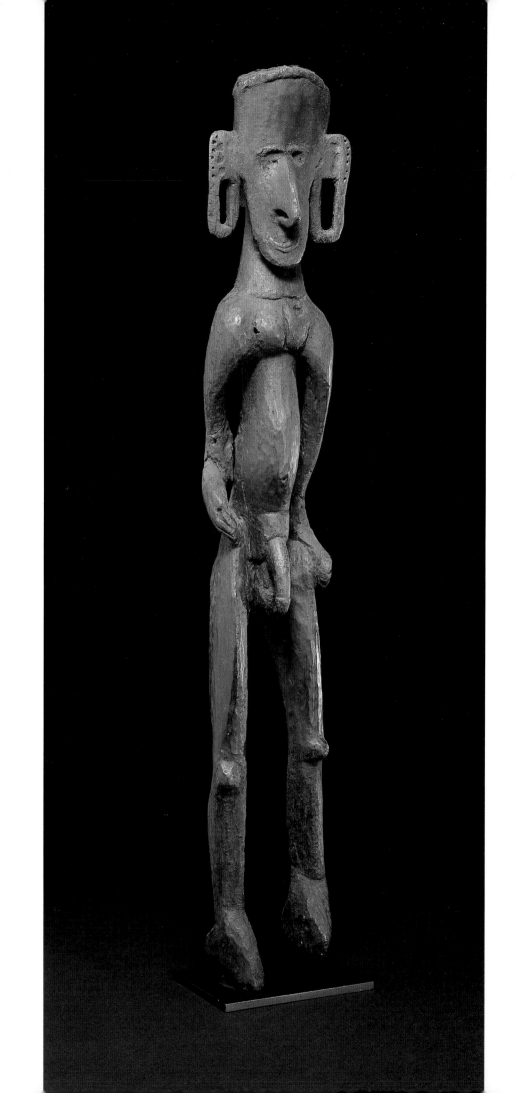

62

Kiwai peoples, Papua New Guinea

Male Figure, *Mimia*

Wood, pigment, human hair
H. 36 in. (91.4 cm)
Raymond and Laura Wielgus Collection
(RW 60-195)

Within Papua New Guinea, distinct differences in the types of objects people make can be found on regional levels. Three-dimensional sculptures are abundant in the Sepik area, for example. However, in the south, around the Gulf of Papua, where the Fly River, the home of the Kiwai peoples, is located, two-dimensional forms, such as the relief-carved and painted ancestral boards called *gope,* are much more common, and figures such as this one are rare.

Called *mimia,* this type of figure was used in a ceremony of the same name. *Mimia* is also the name of an edible plant that was eaten during the ceremony. The *mimia* ceremony was either related to (Landtman 1927, 368) or part of (Riley 1925, 189) the *moguru* rites, a multifaceted annual ceremony to initiate boys and girls into adulthood and to promote the growth of the sago palm, a food staple, and the fertility of the community. During *mimia,* young men received lessons in fighting and warfare and had their strength and endurance tested.

In some villages, human figures, believed to have connections with the world of the spirits, were placed along one side of the men's house where many of the *mimia* events occurred. These figures had a rope attached to them, which was pulled so that the figures could "dance" just as the people did. Though the figures themselves are quite plain, as this one illustrates, they were decorated with headdresses and ornaments for these occasions. Outside the *mimia* context, the figures were also taken in canoes when men went to fight and were pointed in the enemy's direction with the belief that the figures'

spirits would make enemies easier to kill. When not in use, the figures were kept wrapped in the men's house or in a small building outside the village with other ritual paraphernalia (Landtman 1927, 379).

Though we have information about the contexts in which these figures appeared, we do not know who they represented. Both male and female figures are known, but they do not seem to be associated with specific ancestors or mythological characters (ibid., 380).

This example was collected at Gaima, a village on the eastern bank of the Fly River. It is one of several from this area that A.B. Lewis acquired from E. Baxter Riley. Stylistic similarities with a female figure in this group, which remains at the Field Museum of Natural History, Chicago, suggests that they may have been a pair (Newton 1961, 42, ill. 71). Riley (1925, 219), who spent many years in the area, maintained that wooden figures were only used on Kiwai Island in the mouth of the Fly River, and that Kiwai peoples on the coast used stones depicting human heads instead. Gunnar Landtman (1925, 78; 1927, 104), an ethnographer working among the Kiwai between 1910 and 1912, also attributed similar figures to Kiwai Island. Perhaps, then, the Wielgus figure, along with others that show stylistic resemblance to it, should be attributed specifically to Kiwai Island.

References cited

Landtman, Gunnar. 1927. *The Kiwai Papuans of British New Guinea.* London: Macmillan.
————. 1933. *Ethnographical Collection from the Kiwai District of British New Guinea in the National Museum of Finland, Helsingfors (Helsinki).* Helsinki: Commission of the Antell Collection.
Newton, Douglas. 1961. *Art Styles of the Papuan Gulf.* Exhibition catalogue. New York: Museum of Primitive Art.
Riley, E. Baxter. 1925. *Among Papuan Headhunters.* Philadelphia: J.B. Lippincott.

Provenance: Collected by E. Baxter Riley at Gaima; acquired by A.B. Lewis on Joseph N. Field South Pacific Expedition, 1912; acquired from Field Museum of Natural History (Chicago) in 1960
Published: MPA 1961, fig. 72; Arts Club 1966, cat. no. 34

Exhibited: AIC 1958, MPA 1961, Arts Club 1966, Tucson 1976, IUAM 1993

Erub Island, Torres Strait

Mask

Eighteenth–nineteenth century
Sea-turtle shell, clam shell, resin, sennit,
wood, human hair, cassowary feathers
H. 20 1/2 in. (52.1 cm)
Raymond and Laura Wielgus Collection
(RW 61-230)

Turtle-shell masks from the islands of
the Torres Strait, a narrow band of
water connecting the Indian and Pacific
oceans between Australia and Papua
New Guinea, are both striking in their
appearance and unusual in their manu-
facture. This mask has been attributed
to Erub (Darnley) Island (Fraser 1959,
89, 231), one of the easternmost in the
Torres Strait group and an island
known for the large number of turtles
that come to its shores (Lawrie 1970,
283). Though not confined to Erub,
turtle-shell masks are a unique product
of the Torres Strait islands.

Because of its large size, the shell of
the hawksbill turtle was favored for
masks, as well as for fish hooks and
ornaments (Haddon 1912, 160). This
mask, like others, was made by heat-
molding pieces of turtle shell and sew-
ing them together. Smaller elements,
such as the clam-shell eyes, were at-
tached with a resinlike substance. The
incising on the face and the fretwork
that surrounds it are typical forms of
decoration. Though there is no color on
this mask, most were usually painted,
sometimes completely (ibid., 296).
When worn, they were decorated with
feathers, shells, and rattles.

Though particular practices varied
throughout the islands, initiations and
funerary rites were the major contexts
in which the masks, which have not
been made since the nineteenth century,
appeared. They were worn at dances
held at the end of boys' initiations,
periods of seclusion lasting several
months when teenage boys underwent
the education and training required to
be considered adult members of their

communities and eligible for marriage.
During these dances, which were held
at night, senior men wore the masks
with long grass costumes and were
accompanied by drums and chanting to
reinforce the ideas and information that
had been presented to the boys. Turtle-
shell masqueraders also danced during
funerary ceremonies held to ensure that
the spirit of the deceased left the com-
munity and traveled to the "isle of the
dead," so that it would not bring harm
to the living (Moore 1984, 32). A.C.
Haddon (1935, 369), who led expe-
ditions to the islands in 1888-89 and
1898, suggested that some masks may
have been restricted to particular oc-
casions and worn only by certain men.

Though a number of turtle-shell
masks have been preserved in collec-
tions, information about specific con-
texts and the masks' iconography is
sparse. Diego de Prado, a Spanish ex-
plorer, recorded turtle-shell construc-
tions as early as 1606 (Metropolitan
Museum of Art 1987, 31), but most of
our knowledge of the islands comes
from anthropological work done at the
end of the nineteenth century. By this
time, traders and missionaries had insti-
gated major changes in traditional ways
of life, including the abandonment of
making turtle-shell masks.

More common than human face
masks such as this one are masks in the
form of animals and human/animal
composites. A mask portraying an an-
imal was probably worn only by clans
for whom that animal was a totem. Hu-
man faces such as this no doubt refer to
mythical ancestors, who were believed
to have traveled through the islands,
teaching people the skills necessary for
survival and showing them the cere-
monies necessary for ensuring ancestral
help. Although we cannot say with
certainty, particular masks may have re-
presented specific mythological figures
(Haddon 1935, 369).

References cited

Fraser, Douglas. 1959. "Torres Straits Sculp-
ture: A Study in Oceanic Primitive Art." Ph.D.
dissertation, Columbia University. Also pub-
lished by Garland Press (New York, 1978).
Haddon, Alfred Cort. 1912. *Reports of the
Cambridge Anthropological Expedition to
Torres Straits*. Vol. 4: *Arts and Crafts*. Cam-
bridge: Cambridge University Press.
———. 1935. *Reports of the Cambridge
Anthropological Expedition to Torres Straits*.
Vol. 1: *General Ethnography*. Cambridge:
Cambridge University Press.
Lawrie, Margaret. 1970. *Myths and Legends
of Torres Strait*. New York: Taplinger Publish-
ing.
Metropolitan Museum of Art. 1987. *The
Pacific Islands, Africa, and the Americas*. Intro-
ductions by Douglas Newton, Julie Jones, and
Kate Ezra. New York: Metropolitan Museum
of Art.
Moore, David R. 1984. *The Torres Strait
Collections of A.C. Haddon: A Descriptive
Catalogue*. London: British Museum Publi-
cations.

Provenance: Ex-coll Le Corneur Roudillon
(Paris); acquired from J.J. Klejman (New York)
in 1961

Published: Rousseau 1951, fig. 115; *Burlington
Magazine* 1954, pl. 16; Musée des Arts Décora-
tifs 1954, cat. no. 475; Cannes 1957, no. 346
(ill.); Fraser 1959, 65; Musée Guimet 1959, cat.
no. 26; McCarthy 1961, fig. 2; Guiart 1963, pl.
109; Musée Guimet 1965, 21 (ill.); Arts Club
1966, cat. no. 35 (ill.); Gathercole, Kaeppler,
and Newton, 1979, cat. no. 25.22 (ill.); Pelrine
1993, ill. 9

Exhibited: Arts Décoratifs 1954, Cannes 1957,
Guimet 1959, AIC 1963, Arts Club 1966, Tuc-
son 1975, NGA 1979, IUAM 1993

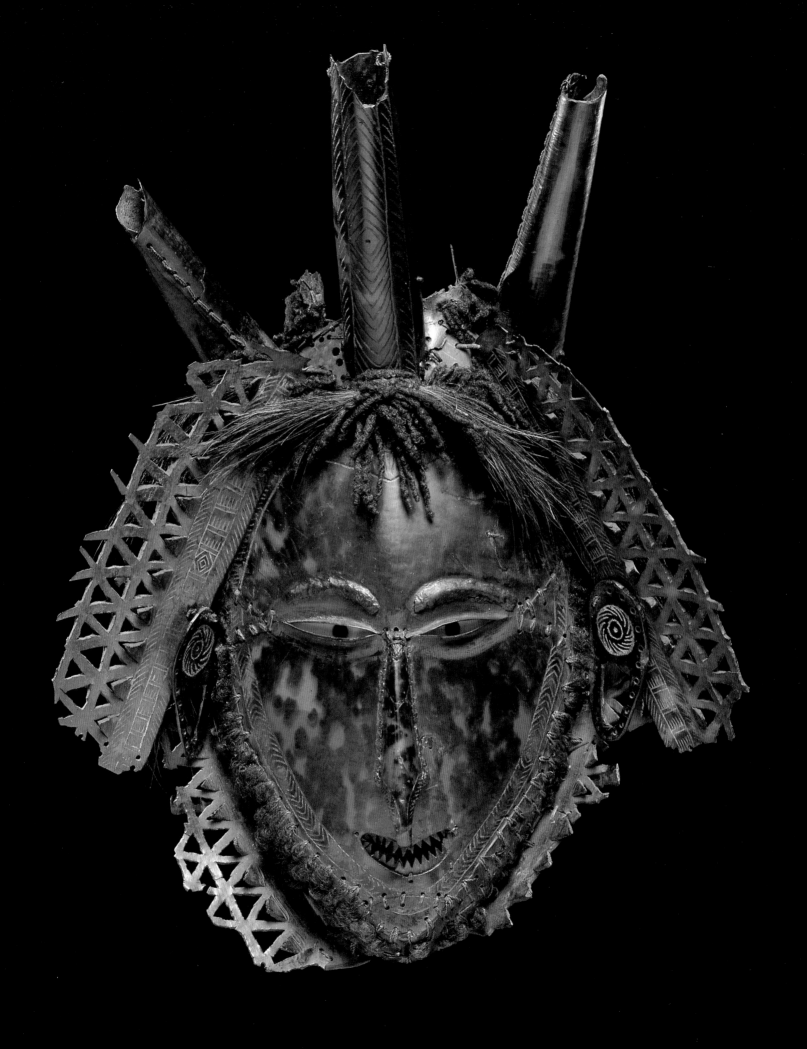

Torres Strait

Dugong Hunting Charm

Wood, stone, sennit, pigment
L. 9 in. (22.9 cm)
Raymond and Laura Wielgus Collection
(RW 67-279)

The dugong is an aquatic mammal found in the Red Sea, the Indian Ocean, and the Torres Strait. For the islanders of the Torres Strait, it is an animal of great significance. Reaching lengths greater than nine feet, dugong, which are related to manatees, travel in herds and swim in the deeper waters of the strait, but move to shallower waters for feeding on marine grasses.

While Torres Strait women are responsible for obtaining food from the land, whether by gathering or farming, men look to the sea in search of dugong, as well as turtle and fish, all of which are important sources of protein. In addition to eating the animal's meat, islanders also believed that rubbing dugong fat over their bodies enhanced health and strength and insulated men from the cold as they went in and out of the water. Apart from these uses, the dugong is a totem for several clans, though because of its nutritional importance, it does not carry the usual eating prohibitions connected with other totems (Haddon 1904, 186). The dugong also figures prominently in folktales (ibid., 38-44, for example).

Carvings of dugong were believed to ensure success in dugong hunting. Torres Strait islanders in canoes hunt dugong with barbed harpoons. Particularly in the western islands, where greater concentrations of the animal are found, they also speared them from bamboo platforms erected in shallow feeding waters, but that practice seems to have disappeared (Haddon 1912, 167-68; Singe 1979, 142). To ensure that an animal would come to the vicinity of a platform, a dugong carving was suspended beneath it. Such charms may also have been attached to canoes

(Moore 1984, cat. no. 525), though, at least in some areas, canoe charms took the form of carvings ending in pointed sticks that could be stuck in the boats (Haddon 1904, 43-44).

Most published dugong charms consist of a single animal carved out of stone or wood. This charm, however, shows two animals: a smaller carving of a calf has been placed on the back of the larger dugong. Catching both a dugong and her calf was considered particularly lucky (ibid., 339), since it provided additional meat. This charm is also unusual in having the sennit suspension cord intact and in the two stones that hang below the animals. The binding of both carvings with sennit and the attachment of such weights may refer to the way in which dugong were hunted. A harpoon could wound a dugong, but it rarely killed one. Instead, after they had reached a tired and weakened state, the animals were tied with ropes and kept submerged until they drowned. In addition, stones, both worked and unworked, were used in rituals for a variety of purposes, such as ensuring the growth of crops and controlling animal life (Haddon 1935, 360-63).

In the Torres Strait, the use of effigies was not restricted to dugong hunting. Human and animal figures were also used to promote agricultural success, bring rain or wind, keep fires lit, ensure successful turtle hunting, and bring luck on canoe expeditions (Moore 1984, 34).

References cited

Haddon, Alfred Cort. 1904. *Reports of the Cambridge Anthropological Expedition to Torres Straits*. Vol. 5: *Sociology, Magic and Religion of the Western Islanders*. Cambridge: Cambridge University Press.
———. 1912. *Reports of the Cambridge Anthropological Expedition to Torres Straits*. Vol. 4: *Arts and Crafts*. Cambridge: Cambridge University Press.
———. 1935. *Reports of the Cambridge Anthropological Expedition to Torres Straits*. Vol. 1: *General Ethnography*. Cambridge: Cambridge University Press.
Moore, David R. 1984. *The Torres Strait Collections of A.C. Haddon: A Descriptive Catalogue*. London: British Museum Publications.

Singe, John. 1979. *The Torres Strait: People and History*. St. Lucia, Queensland: University of Queensland Press.

Provenance: Ex-coll. Pitt-Rivers Museum (Oxford); acquired from Merton Simpson (New York) in 1967

Exhibited: IUAM 1993

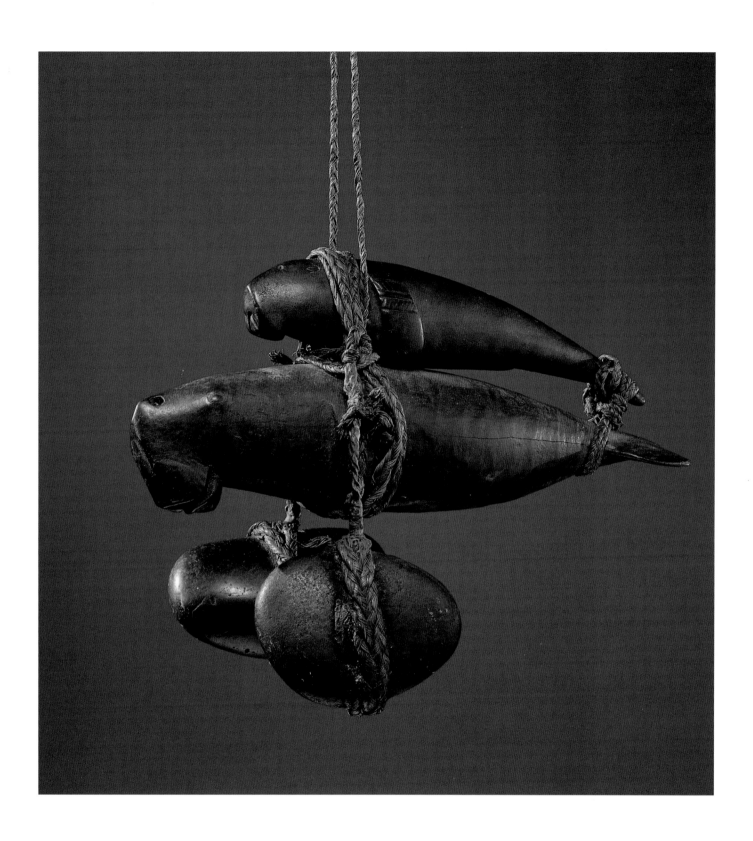

Asmat peoples (northwest), Irian Jaya

Seated Female Figure

Before 1913
Wood, pigment, seeds, fiber
H. 22 1/2 in. (57.2 cm)
Raymond and Laura Wielgus Collection
(RW 61-232)

This figure comes from the northwest Asmat area in the western half of New Guinea, now a part of Indonesia known as Irian Jaya. Like other ancestor-related Asmat objects, the figure was probably named after a specific person. Traditionally, the Asmat believe that enemies cause all deaths, through either physical or supernatural means (Smidt 1987, 73-74; Schneebaum 1990, 28); by giving an object a deceased person's name, family members are constantly reminded that the death must be avenged so that the spirit of the deceased can leave the land of the living and assume its rightful place in the land of the spirits (Schneebaum 1990, 26).

The distinctive elbow-to-knees pose and insectlike head of this figure recall a praying mantis. Because of the female mantis's propensity to eat the male's head during mating, the insect is a symbol of head-hunting, formerly a widespread and accepted Asmat manner of avenging a death. Head-hunting was also a way for a man to increase his own life force, for the Asmat believed that by following certain prescribed steps, he could assimilate some of the enemy's life force (Smidt 1987, 74). The figure's pose is also associated with the *ambirak*, a malicious birdlike female spirit who lives in rivers and streams, as well as the Asmat creation myth (Smidt 1993, 92). Though details vary from area to area, the basic story relates that the first people were made of wood, with their elbows and knees attached to each other. Fumeripitsj, the creator, played a drum that brought the figures to life, and, in dancing, their knees and elbows became separated. Symbolic reenactments of Fumeripitsj's creation take place even today during the consecration feast for a new men's house, and scholars believe that figures such as this were displayed at those ceremonies. Whether individual figures appeared at only one feast or were kept for later use is debated, however (Gerbrands 1967, 32; Tigges in Smidt 1990, 90).

Though traditionally, all Asmat men could carve basic utilitarian objects, a *wowipitsj*, or master woodcarver, was commissioned to make ancestor figures and other special objects. Today, figures may be carved out of hard wood, but traditionally they were carved out of one that was relatively soft and fibrous. After carving, three colors were used for painting: white, the color for skin, was made from shells that had been burned and crushed; certain mud, burned for a richer color, produced red, used to delineate limbs and for scarification; and black for hair and genitals was obtained from crushed charcoal. The sculpture was completed with the addition of decorations, such as fiber, feathers, and seeds (Schneebaum 1990, 33; Smidt 1993, 47-50). On this figure, the tassels on the top of the head are strung with a common seed from grass called Job's tears (*Coix lachryma-jobi*).

One of the earliest sculptures collected from the Asmat peoples by Europeans, this figure was acquired by Antony Jan Gooszen, an officer in the Dutch Indies army, who commanded exploration parties into the interior of southern New Guinea during 1907-8 and 1913. During these expeditions, he collected over nine hundred Asmat objects, which were given to the Rijksmuseum voor Volkenkunde (then the Rijks Ethnographisch Museum) in Leiden. Following the custom of many museums who have multiple examples of one type of object, the Leiden museum later deaccessioned this and several other Gooszen objects. Among the five remaining Gooszen figures at the museum, one, though smaller, is almost assuredly by the same carver as this figure (Smidt 1993, pl. 7.30). Though the color is faded, it sits in an identical pose and shows the same distinctively shaped head, melding of hands and feet, deep and wide channels for limb markings, and treatment of volumes that make this figure such a remarkable sculpture. Like the Wielgus carving, it was collected along the Pomatsj (Northwest) or Unir (Lorentz) River.

References cited

Gerbrands, Adrian A. 1967. "Introduction: Art and Artist in Asmat Society." In *The Asmat of New Guinea: The Journal of Michael Clark Rockefeller*, 11-39. Edited by Adrian A. Gerbrands. New York: Museum of Primitive Art.
Schneebaum, Tobias. 1990. *Embodied Spirits: Ritual Carvings of the Asmat*. Salem, Mass.: Peabody Museum of Salem.
Smidt, Dirk A.M. 1987. "Death and the Asmat." In *The Seasons of Humankind*, 73-80. Edited by P.L.F. van Dongen, Th. J.J. Leyenaar, and K. Vos. Leiden: Rijksmuseum voor Volkenkunde.
———, ed. 1993. *Asmat Art: Woodcarvings of Southwest New Guinea*. New York: George Braziller in Association with Rijksmuseum voor Volkenkunde.

Provenance: Collected by A.J. Gooszen, 1907-8 or 1913; ex-colls. Rijksmuseum voor Volkenkunde (Leiden), Serge Brignoni (Lugano); acquired from Allan Frumkin (Chicago) in 1961

Published: Arts Club 1966, cat. no. 36 (ill.); Schmitz 1971, pl. 148; Gathercole, Kaeppler, and Newton 1979, cat. no. 21.8 (ill.); Pelrine 1993, ill. 8

Exhibited: Arts Club 1966, Tucson 1975, NGA 1979, IUAM 1993

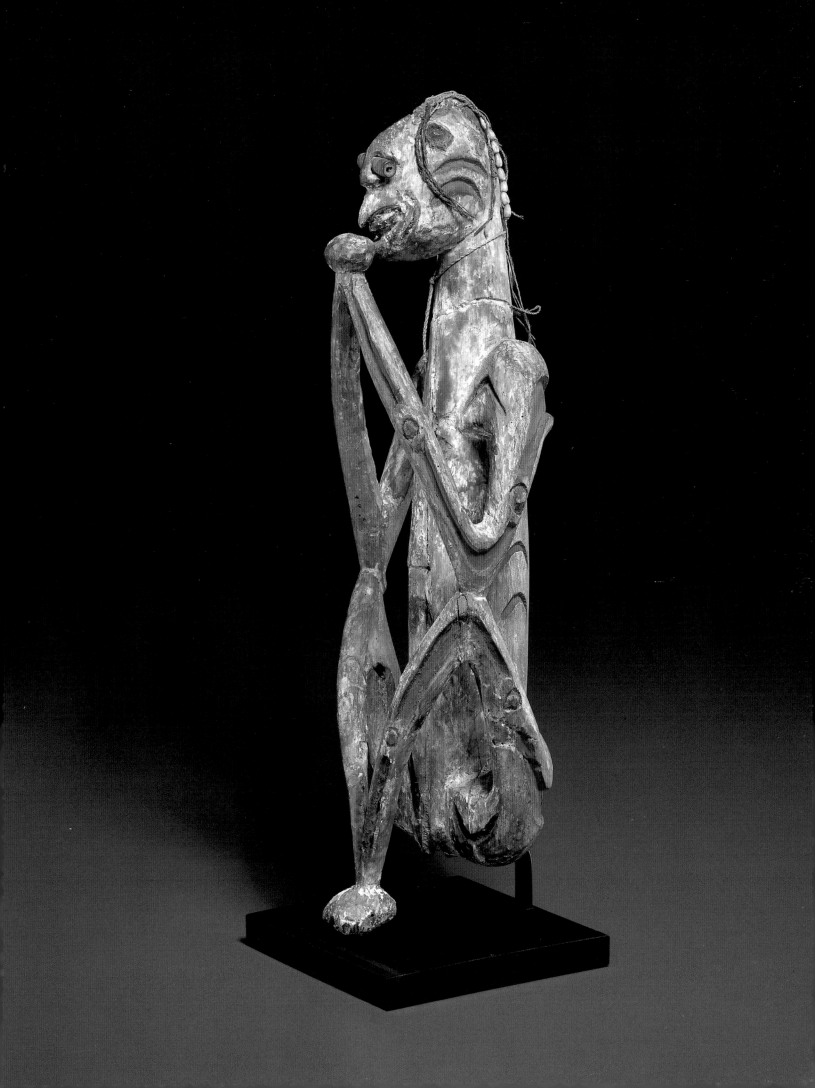

The Americas

Pre-Columbian objects, so called because they were made before the time of the European conquests in the sixteenth century, predominate in the Wielgus Americas collection. Such objects belonged to the religious and secular elites, which often were one and the same and in which rulers were considered the embodiment of gods, and priests determined efficacious days for battles and even had strategic influence over economic decisions.

We tend to think of the Pre-Columbian era in terms of the rise and fall of discrete entities, such as the Maya or Moche, but it is more useful to consider these groups and areas as waxing and waning in influence and power, remembering, for example, that excavations at Monte Albán in Oaxaca, Mexico, indicate occupation extending over a period of at least a thousand years. In addition, we should remember that although a group may have been centered in one area, trade and cultural influences usually extended much farther. The Wielgus Olmec vase, seated figure, and vessel in the form of an old woman (cat. nos. 66-68) are tangible examples of such contacts; although the Olmec heartland was located along Mexico's Gulf coast, these objects originated in Olmec-influenced areas in the interior.

Mesoamerica — that is, northern Mexico to the Gulf of Nicoya in Costa Rica — is particularly well represented in the Wielgus Collection, with objects from cultures that flourished during the so-called Formative (1200 B.C.-A.D. 300), Classic (A.D. 300-1000), and Post-Classic (A.D. 1000-1521) periods. Most surviving objects from these cultures are made from non-perishable materials, particularly clay and stone, making two wooden Aztec objects (cat. nos. 77, 78) particularly rare and interesting.

The collection also contains pieces from southern Central America, Colombia, and Peru. Although archaeological fieldwork has been less extensive in most of these areas than in Mexico, scholars have, for the most part, found patterns that correspond to those farther north; that is, various cultures flourished at different times in different areas. In Peru, for example, archaeologists conventionally demarcate early, middle, and late periods, usually called horizons, and distinguish cultures that flourished in the northern, central, and southern coasts and highlands. As in Mexico, many ceramics survive. In addition, though, the dry climate and burial caves in the Andes have preserved many arts made from perishable materials, such as the Moche wooden ceremonial digging stick (cat. no. 89). Perhaps best known from these caves, however, are complex woven textiles. Their absence from the Wielgus Collection is a reflection of personal taste, as Raymond Wielgus has always been more interested in three-dimensional, sculptural forms.

Most of these cultures had disappeared long before Spanish explorer Hernán Cortés's 1519 invasion of the Mexican Aztec capital and before his counterpart in the Peruvian Andes, Francisco Pizarro, destroyed the Inka (Inca) empire in 1532. Except for some accounts written shortly after the European conquests and some studies of present-day descendants of ancient Americans, most of our information about these cultures comes from the objects and architectural remains they left behind, as interpreted by researchers such as archaeologists, art historians, and anthropologists. Though the

smaller, portable objects in most museums and private collections tell us much about these cultures, equally important is architecture, often monumental, which was integral to the daily and ceremonial lives of these ancient Americans.

Wielgus material from North America is later in date and is represented by only six objects. All are from northwestern North America, and four are Tlingit. Even with this smaller sampling, the collection again shows the consistency of the Wielgus aesthetic, ranging from the intricacy exemplified by a Tlingit amulet (cat. no. 99) to the simple charm of a miniature Inuit ivory figure (cat. no. 100).

MEXICO

GULF OF MEXICO

Teotihuacan ▲

Tlatilco ▲ ▲ Tlapacoya

Aztec

Xochimilco ▲ ▲ Las Bocas

Santa Cruz ▲

VERACRUZ

Olmec

MORELOS

Cerro de las Mesas ▲

Zapotec

San Gerónimo ▲ Monte Albán ▲

OAXACA Mixtec

Jaina ▲ CAMPECHE

YUCATÁN PENINSULA

PETÉN

CHIAPAS

Maya

BELIZE

Quemistlán ▲

SANTA BÁRBARA

GUATEMALA HONDURAS

EL SALVADOR

NICARAGUA

CARIBBEAN SEA

Nahuange ▲

Tairona

GUANACASTE

NICOYA PENINSULA

COSTA RICA

PANAMA

Coclé

Sitio Conte ▲

VENEZUELA

PACIFIC OCEAN

COLOMBIA

ALASKA

Inuit

Tlingit

BRITISH COLUMBIA

WASHINGTON

Wishram

Columbia River Valley

Wasco

OREGON

ECUADOR

Chimú

Sicán

LAMBAYEQUE VALLEY

Moche

BOLIVIA

PERU

Huari

Paracas

▲ Teojate

ICA VALLEY

Tiwanaku

THE AMERICAS

66

Olmec culture, Tlapacoya, Mexico

Bowl

Early Formative period, 1200-900 B.C.
Clay, pigment
Diam. 7 1/4 in. (18.4 cm)
IUAM 81.32.3 (RW 62-240)

"Olmec" is a name given by archae-
ologists to what is thought of as the
Mexican "mother culture" that was
centered along the eastern (Gulf) coast.
The Olmec developed extensive trade
networks reaching as far as the state of
Guerrero to the west and Guatemala to
the south. These networks and the pres-
ence in some of the relevant areas of
objects in two clearly different styles
have led many archaeologists to posit
an Olmec presence and style extending
beyond the Gulf coast. Whether de-
scribed as influence or as physical settle-
ments of people from the Gulf coast,
Olmec culture is believed to have inter-
woven with the cultures of the inhabit-
ants of certain other areas. Some ar-
chaeologists, however, lend a note of
caution to this interpretation, noting
that designating objects found outside
the Gulf coast as Olmec is more a
matter of convenience and habit than
of accuracy and does not reflect current
knowledge (Grove 1989).

This bowl, for example, is one of a
group of similar vessels found outside
the Olmec heartland but attributed to
that civilization. Called Calixtlahuaca
ware, after a site near the modern city
of Toluca where such objects were first
reported, these bowls are characterized
by a cylindrical, flat-bottomed form, a
slip coating that fired white to buff in
color, and motifs generally considered
Olmec in nature. In addition to Calix-
tlahuaca, such bowls have been found
in Tlapacoya in the Valley of Mexico
and in the state of Morelos, although
no center of manufacture has been
established.

Although much about the Olmec re-
mains unknown, their mythology and
religious beliefs seem to have involved
the mating of a woman with a jaguar.
The offspring, known as a "were-
jaguar," is an important, though little-
understood Olmec image, that occurs
in many variations. In an extensive
study of Olmec iconography, Peter
David Joralemon (1971, 1976) identifies
182 motifs relating to this image on ob-
jects generally attributed to the Olmec.
By analyzing how they were combined,
he defines ten Olmec deities, which he
later refines to six.

The two images on this vase depict
his God VI, a figure always shown in
profile with a cleft head, an almond-
shaped eye with an incised iris, a band
through the eye, and an open mouth
with prominent gum ridges (Joralemon
1971, 79). The cleft head and gum
ridges are common in other Olmec
depictions, but Joralemon (ibid., 90)
suggests that the banded eye identifies
this figure as the god of spring, renewal,
and resurrection. While this association
may indeed be accurate, it is based on
Post-Classic iconography, and even
during that period eye bands were
found not only on depictions of Xipe
Totec, the god of renewal, but also on
images of other deities (Nicholson in
Coe 1989, 75).

References cited

Coe, Michael D. 1989. "The Olmec Heartland:
Evolution of Ideology." In *Regional Perspec-
tives on the Olmec*, 68-82. Edited by Robert
J. Sharer and David C. Grove. Cambridge:
Cambridge University Press.
Grove, David C. 1989. "Olmec: What's in a
Name?" In *Regional Perspectives on the
Olmec*, 8-14. Edited by Robert J. Sharer and
David C. Grove. Cambridge: Cambridge Uni-
versity Press.
Joralemon, Peter David. 1971. *A Study of
Olmec Iconography*. Studies in Pre-Columbian
Art and Archaeology, 7. Washington, D.C.:
Dumbarton Oaks.
———. 1976. "The Olmec Dragon: A Study in
Pre-Columbian Iconography." In
*Origins of Religious Art and Iconography in
Preclassic Mesoamerica*, 27-72. Edited by
Henry B. Nicholson. Latin American Studies
Series, 31. Los Angeles: UCLA Latin American
Center.

Provenance: Ex-coll. George Pepper (Califor-
nia); acquired from Everett Rassiga (New York)
in 1962
Published: Coe 1965, pl. 21; Arts Club 1966,
cat. no. 66; Joralemon 1971, fig. 235; IUAM
1986, cat. no. 1 (ill.); IUAM [1989a], 1 (ill.);
The Olmec World 1995, cat. no. 98 (ill.)
Exhibited: MPA 1965, Arts Club 1966, IUAM
1993, Princeton 1995 (Princeton only)

Roll-out drawing of the bowl.

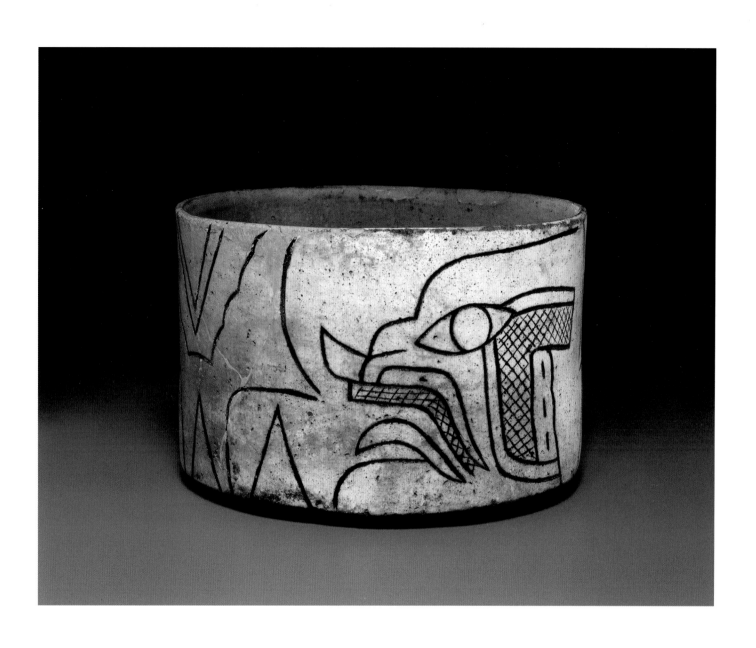

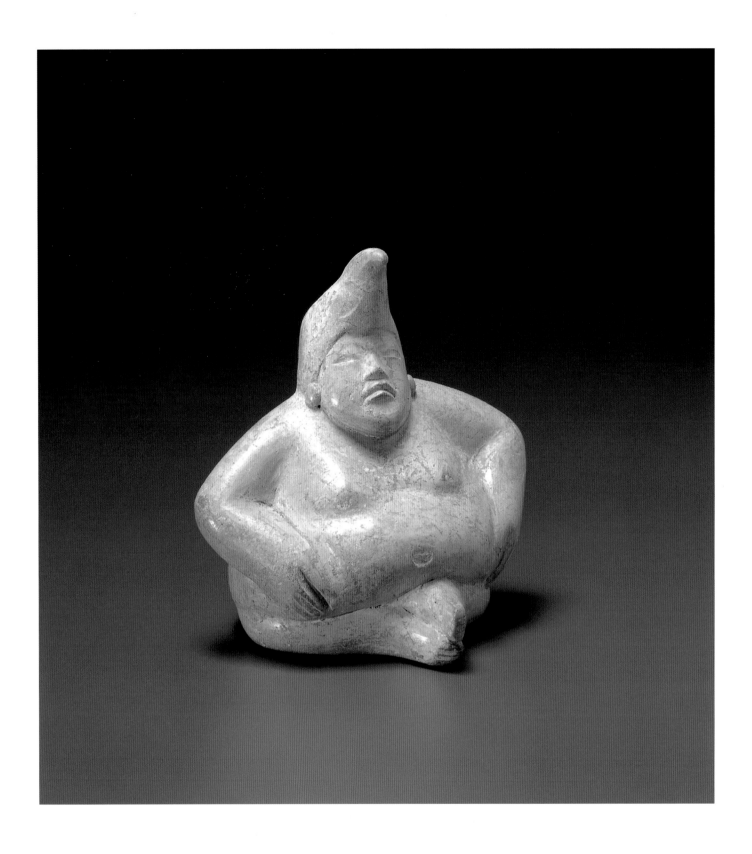

67

Olmec culture, Las Bocas, Mexico

Seated Figure

Early Formative period, 1200-900 B.C.
Clay, cinnabar
H. 4 1/2 in. (11.4 cm)
IUAM 100.18.5.79 (RW 64-255)

Like the bowl from Tlapacoya (cat. no. 66), this figure is from an area in which objects have been found that most archaeologists believe show a strong Olmec influence. As in Tlapacoya, Olmec influence in Las Bocas, which is in the state of Puebla, dates to the Early Formative period, when the Gulf coast site of San Lorenzo seemed to establish a strong presence in the central Mexican highlands.

This figure is one of a group of small and large clay figures with Olmec features that were found in graves in Las Bocas. Whether hollow or solid, all are of white-slipped clay, and many, including this example, have traces of red pigment. Though the sizes and poses of the figures vary, they tend to be obese and of indeterminate sex, to have slit eyes, and to show a primary diagnostic feature of Olmec art: a downturned mouth, which, in some instances, becomes a snarl, a powerful symbol of the important were-jaguar (see cat. no. 66).

One subtype of the Las Bocas figures is a depiction of an extremely obese seated individual, such as this example. Similarly corpulent figures are known from the Early and Middle Formative periods on the Gulf coast, the central Mexican highlands, and Guatemala and El Salvador, but their identity remains unknown. Michael Coe (1965, 105), a prominent archaeologist who excavated the Olmec site of San Lorenzo, suggests that the figures may be early depictions of the Fat God, a poorly understood deity who is first known in the Late Formative period and who was associated with excess (see cat. no. 80). Alternatively, such figures may represent overfed rulers or priests, obese eunuchs, or persons with genetic or endocrine abnormalities (Joralemon 1988, 28).

The top of this figure's cap is restored. Coe (1965, pl. 193) illustrates an earlier restoration, in which the peak pointed to the back. Feeling that something was not quite right, Raymond Wielgus changed the cap after seeing a similarly styled hat on a figure from Monte Albán. However, a more recently published seated corpulent figure from Las Bocas, smaller in size, wears a similar hat with the peak pointing backward (Goldstein 1987, cat. no. 17), so both forms may be correct.

References cited

Coe, Michael D. 1965. *The Jaguar's Children: Pre-Classic Central Mexico*. Exhibition catalogue. New York: Museum of Primitive Art.
Goldstein, Marilyn M., ed. 1987. *Ceremonial Sculpture of Ancient Veracruz*. Exhibition catalogue. Brookville, N.Y.: Hilwood Art Gallery, Long Island University.
Joralemon, Peter David. 1988. "The Olmec." In *The Face of Ancient America: The Wally and Brenda Zollman Collection of Precolumbian Art*, 9-50. By Lee A. Parsons, John B. Carlson, and Peter David Joralemon. Exhibition catalogue. Indianapolis: Indianapolis Museum of Art in Cooperation with Indiana University Press.

Provenance: Ex-coll. George Pepper (California); acquired from Everett Rassiga (New York) in 1964

Published: Coe 1965, pls. 193, 193a; Arts Club 1966, cat. no. 65 (ill.); *Indianapolis Star* 1985, E: 21 (ill.); IUAM 1986, cat. no. 3 (ill.); IUAM [1989a], 1; *The Olmec World* 1995, cat. no. 16 (ill.)

Exhibited: MPA 1965, Arts Club 1966, Tucson 1975, IUAM 1993, Princeton 1995 (Princeton only)

68

Olmec culture, Santa Cruz, Mexico

**Vessel in the Form of
an Old Woman**

Early Formative period, 1200-900 B.C.
Clay
H. 8 1/2 in. (21.6 cm)
Raymond and Laura Wielgus Collection
(RW 66-274)

This vessel has been described as one of
the most powerful ceramic sculptures
from Pre-Columbian Mexico, and, in-
deed, the gaping mouth, which forms
the spout of the vessel, and the body,
which is both skeletonized and rotund,
make the figure an extraordinary
image. It is said to come from Santa
Cruz, one of many sites in central
Mexico where objects generally con-
sidered to be in the Olmec style have
been found. Located along the Cuautla
River in the state of Morelos, Santa
Cruz is a Formative site contemporary
with Tlatilco in the Valley of Mexico
and is known for ceramics that display
artistry as well as technical skill.

Female figures are among the best-
known objects from the Formative
period in Mexico. Often called "pretty
ladies," these small clay figures have
been found in large numbers in burials,
particularly at sites such as Tlatilco.
Depictions of old women are rare
throughout Mesoamerica during this
time, however, and such renderings in
the form of vessels are even less com-
mon. The images that we do know are
generally associated with areas of
Olmec influence. Figures from Las
Bocas in the Mexican highlands and
from La Venta on the Gulf coast, for
example, show similar wrinkled faces,
pendulous breasts, prominent ribs, and
thin limbs, and one from Las Bocas,
though in a seated rather than a crouch-
ing posture, is also in the form of a
vessel (Joralemon 1981, figs. 1, 2; Brad-
ley 1992, cat. no. 7).

Although this vessel clearly depicts
an old woman, her pose is a traditional
one among Mexican Indians for giving

birth. The figure's enlarged stomach
seems to confirm the accuracy of that
interpretation. The kneeling posture is
not exclusive to childbirth, though, and
Olmec scholar David Joralemon (1981,
177), who has studied the old-woman
theme extensively, has pointed out
that the figure might portray an aged
woman with an illness resulting in a
bloated stomach or a priestess or other
religious practitioner with a similar
affliction.

The idea that the figure combines the
themes of old age and birth suggests
another intriguing possibility. These
two contrasting aspects of womanhood
united in a single image may be a refer-
ence to a deity appearing throughout
ancient Mexican cultures, the mother
of all gods and humans, who, along
with her consort, determines exactly
when each person will be born, and, in
doing so, seals that person's fate. This
deity was considered older than cre-
ation and, among her many attributes,
was associated with midwifery, making
an image such as this one an entirely
appropriate emblem (ibid., 179).

References cited

Bradley, Douglas E., and Peter David Jorale-
mon. 1993. *The Lords of Life: The Iconogra-
phy of Power and Fertility in Preclassic Meso-
america*. Notre Dame, Ind.: Snite Museum of
Art.
Joralemon, Peter David. 1981. "The Old Wo-
man and the Child: Themes in the Iconography
of Preclassic Mesoamerica." In *The Olmec
and Their Neighbors: Essays in Memory of
Matthew W. Stirling*, 163-80. Edited by Eliza-
beth P. Benson. Washington, D.C.: Dumbarton
Oaks.

Provenance: Ex-coll. Robert Stolper
(Mexico/New York); acquired from Carlo Gay
(New York) in 1966

Published: Coe 1965, pl. 77; Arts Club 1966,
cat. no. 67 (ill.); Joralemon 1981, fig. 12; Pel-
rine 1993, ill. 10; *The Olmec World* 1995, cat.
no. 252 (ill.)

Exhibited: MPA 1965, Arts Club 1966, Tucson
1975, IUAM 1993, Princeton 1995 (Princeton
only)

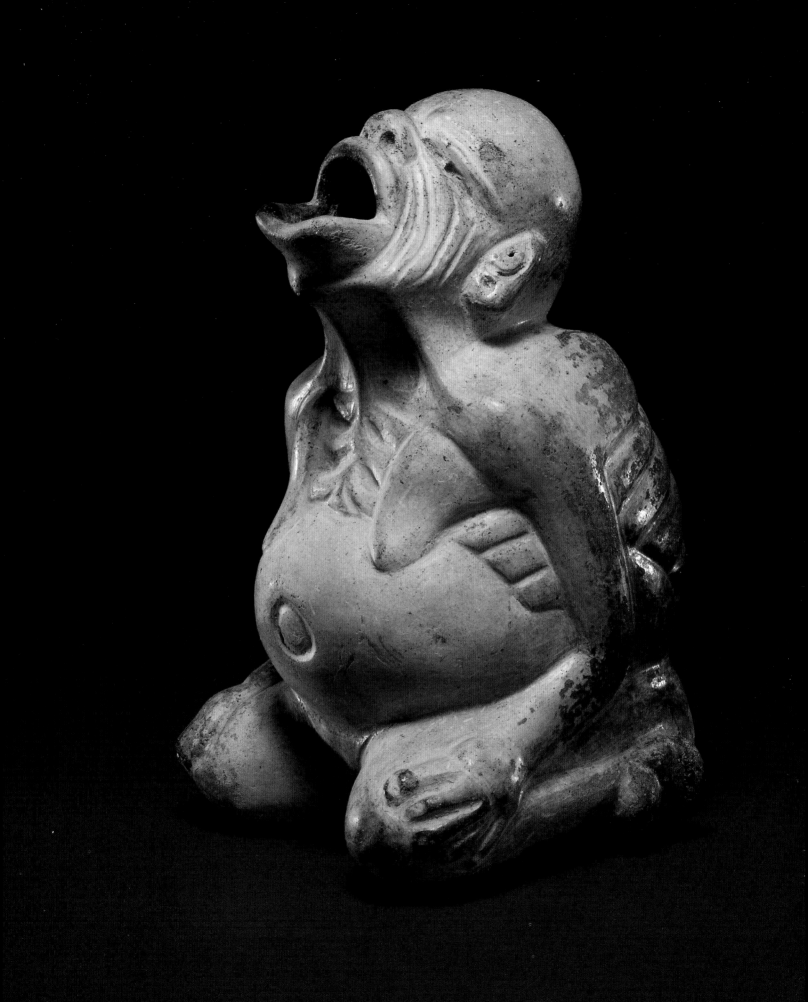

69

Olmec culture, Mexico

Three Ritual Objects, *"Pulidores"*

Early Formative period, 1200-900 B.C.
Stone, clay
L. 1 3/8, 1 1/2, 1 3/4 in. (3.5, 3.8, 4.4 cm)
IUAM 84.12.1-.3

These are further examples of types of objects that have been found outside the Olmec heartland along the Gulf coast at Las Bocas, Tlatilco, and sites in Guerrero. They have been discovered in Veracruz as well, though not at any of the great ceremonial centers. Such objects are generally called *pulidores* ("polishers"), a misnomer arising from an initial mistaken belief that they were polishing tools. However, their very careful manufacture and lack of wear, quite different from known polishing tools, have led researchers to conclude that these objects must have served another function. Gillett Griffin (1981, 218-19), who has studied the Olmec for many years, has proposed that they may have been owned by shamans and used in divination, perhaps by being cast.

Pulidores are made of stone, particularly agate (the two examples on the left) or impacted clay (the one on the far right). Forms vary: some are triangular; others crescent-shaped; still others, such as these, resemble faceted footballs. All *pulidores* are solid, with no holes indicating that they might have been worn or attached to something, peaked in the middle, and polished. Mirror-image pairs are known, and a few have carved designs or inlays. Though most of these objects look quite simple, their manufacture using stone-age technology would have required many hours of skilled work.

Pulidores are rare and, like many other Pre-Columbian objects, they have been discovered in grave contexts. At Tlatilco in the Valley of Mexico, for example, they have been found in elite burials, often in conjunction with necklaces (Tolstoy 1989, 109, 113). Beyond the obvious idea that *pulidores* seem to have been associated with important people, however, the significance of these finds is not clear.

Although displayed together here, we do not know that these three *pulidores* were a set or used together in their original context.

References cited

Griffin, Gillett G. 1981. "Olmec Forms and Materials Found in Central Guerrero." In *The Olmec and Their Neighbors: Essays in Memory of Matthew W. Stirling*, 209-22. Edited by Elizabeth P. Benson. Washington, D.C.: Dumbarton Oaks.
Tolstoy, Paul. 1989. "Coapexco and Tlatilco: Sites with Olmec Materials in the Basin of Mexico." In *Regional Perspectives on the Olmec*, 85-121. Edited by Robert J. Sharer and David C. Grove. Cambridge: Cambridge University Press.

Provenance: Acquired from the estate of Frederick Pleasants (Tucson) in 1976

Exhibited: IUAM 1993

70

Zapotec culture, Oaxaca, Mexico

Bowl in the Form of a Head

Monte Albán II, 200 B.C.-A.D. 200
Clay
H. 4 3/4 in. (12.1 cm)
IUAM 81.32.4 (RW 58-120)

Zapotec, a Nahuatl word meaning "cloud people," is a name given to a group of people which dominated the Oaxaca valley in southern Mexico from around 600 B.C. until the ninth century. Still the dominant group in Oaxaca today, the Zapotec built a hilltop ceremonial center, Monte Albán, that overlooks the city of Oaxaca. Archaeologists distinguish four phases of Monte Albán history and have identified corresponding styles and types of artworks. This bowl has been designated as belonging to Monte Albán II, the second phase. Monte Albán I was marked by the architectural definition of a main plaza area, the carving of monumental stone relief sculptures that probably served as war memorials, and the development of a writing system, possibly the result of Olmec contact. Monte Albán II saw a continuation of these activities, as well as the elaboration of ceramics.

In museums and private collections, the Zapotec of Monte Albán are perhaps best known for their finely made grayware funerary urns (see cat. no. 71). Such urns are found in their simplest forms during the Monte Albán I phase, as are other pieces of ceremonial grayware, such as this bowl, as well as yellow and brown utilitarian ceramics. Many of the anthropomorphic ceramics from this period show affinities with the Olmec style, particularly in the depiction of narrow, often slanted eyes and downturned mouths, the latter represented on this bowl.

Both human and animal forms are depicted on ceramics from this period, and it is not entirely clear which is portrayed here. Michael Coe (1986, 13) suggests that the face may represent the Old Fire God (see cat. no. 74) or a monkey deity who was the patron of scribes, artists, musicians, and dancers (see cat. no. 75). Other scholars refer to this and similar depictions simply as old men or gods (Boos 1966, fig. 422a; Schuler-Schömig 1970, pls. 197, 198, 233a). The face also resembles that of a deity taking the form of an old man that is found on Zapotec funerary urns, though that deity is not positively identified until Monte Albán III (Boos 1966, 142-50). Certainly, the wrinkled face and large holes for earspools are features associated with the Old Fire God, though, like the Oaxacan deity, he is first identified with certainty during the Classic period. Though contemporary viewers may suppose that the earspool holes indicate that the image is human, it may not be. The Wielgus vessel in the form of a monkey from Veracruz (cat. no. 75) and a bowl in the form of the Maya monkey god (Carlson 1988, cat. no. 56) both have these holes. Likewise, the faces on those pieces have lines (albeit in simpler form) that are similar to those on this vessel.

The bowl was broken at some point, and some pieces, particularly below the left side of the chin, are contemporary restorations.

References cited

Boos, Frank H. 1966. *The Ceramic Sculptures of Ancient Oaxaca*. South Brunswick, N.J.: A.S. Barnes.
Carlson, John B. 1988. "The Maya Lowlands." In *The Face of Ancient America: The Wally and Brenda Zollman Collection of Precolumbian Art*, 51-131. By Lee A Parsons, John B. Carlson, and Peter David Joralemon. Exhibition catalogue. Indianapolis: Indianapolis Museum of Art in Cooperation with Indiana University Press.
Coe, Michael D. 1986. "The Art of Pre-Columbian America." In *African, Pacific, and Pre-Columbian Art in the Indiana University Art Museum*, 9-47. Essays by Roy Sieber, Douglas Newton, and Michael D. Coe. Bloomington: Indiana University Art Museum in Association with Indiana University Press.
Schuler-Schömig, Immina v. 1970. *Figurengefässe aus Oaxaca, Mexico*. Berlin: Museum für Völkerkunde.

Provenance: Acquired from Everett Rassiga (New York) in 1958

Published: Powell 1959, 41 (ill.); *New York Times* 1959b, 10: 19 (ill.); MPA 1960b, pls. 28, 28a (mislabelled); Arts Club 1966, cat. no. 77; Boos 1966, figs. 422a, 422b; IUAM 1986, cat. no. 13 (ill.); IUAM [1989a], 1

Exhibited: Brooklyn 1959, MPA 1960b, Arts Club 1966, IUAM 1993

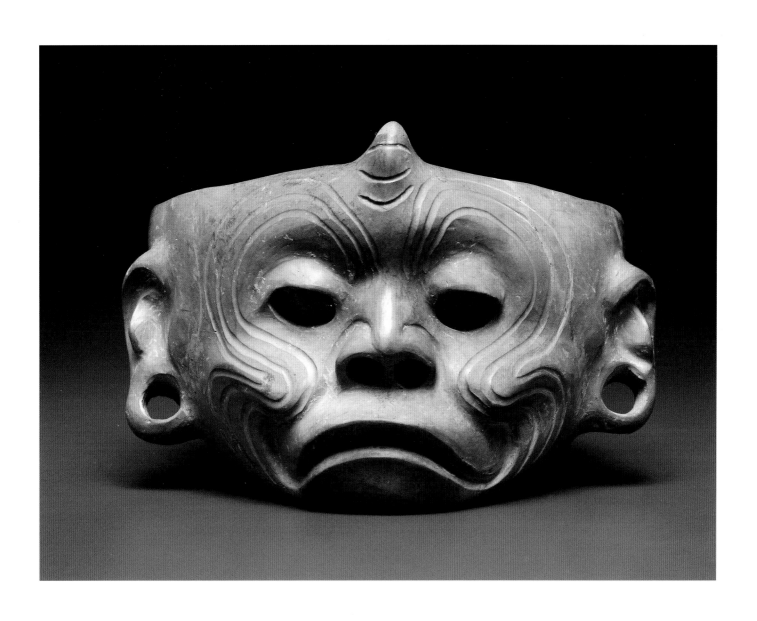

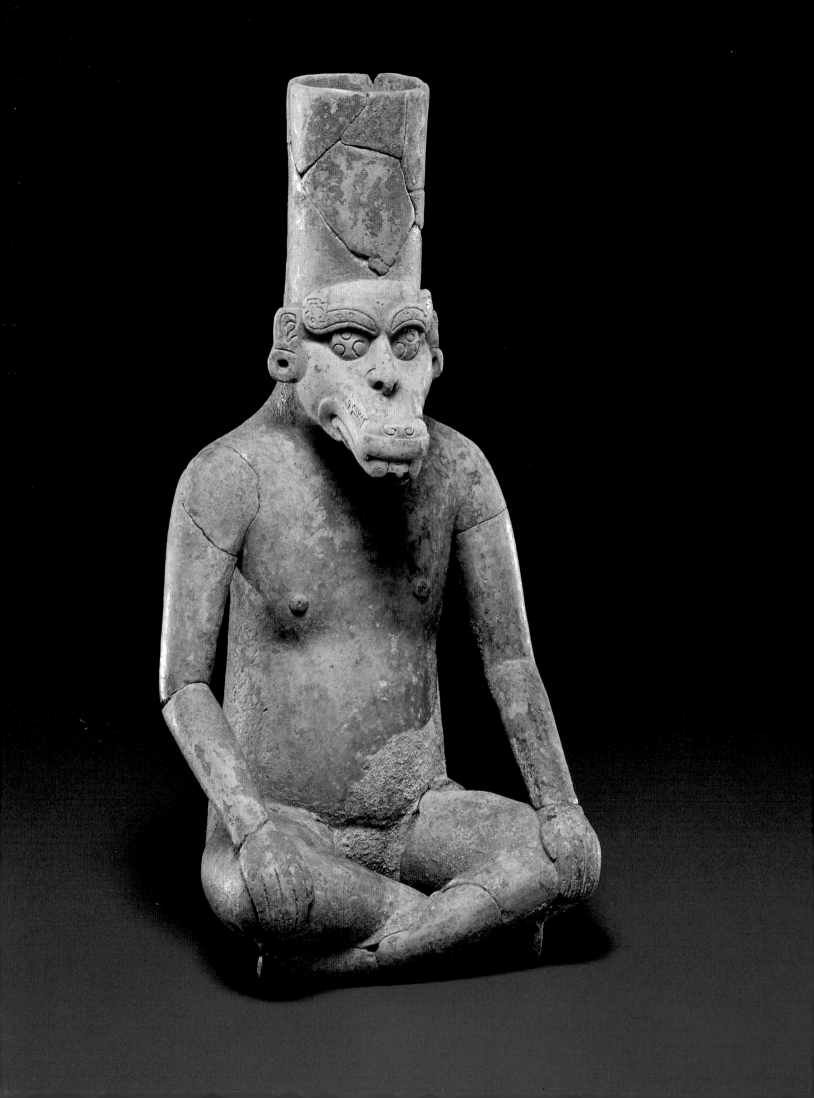

71

Zapotec culture, Oaxaca, Mexico

Urn in the Form of a Seated Figure

Monte Albán II, 200 B.C.-A.D. 200
Clay
H. 11 7/16 in. (29.1 cm)
Raymond and Laura Wielgus Collection
(RW 64-258)

Ceramic figural urns, ranging in size from under three inches to nearly life-size, are perhaps the best-known portable art form from Oaxaca, home of the Zapotec people and their ceremonial center of Monte Albán. Because most have been found in tombs, these urns are generally thought of as funerary, though some were also placed in the floors of ceremonial complexes and buried in boxes. Multiple urns were usually placed on the floor of a tomb, with a larger one depicting a deity and between three and seven smaller identical ones placed in a semicircle around it. These smaller urns, known as "companions," may represent priests, priestesses, or other devotees. While the figural aspect of such objects is visually the most interesting, all are also vessels, though we do not know the specific purpose they served. Some may have held offerings of food or drink, though no traces of either have survived (Boos 1966, 14, 22).

Based on the work of Alfonso Caso and Ignacio Bernal (1952), Frank Boos (1966) has classified the gods represented on these urns. According to him, the concept of the *nagual*, a "personal spirit or alter ego" possessed by humans and deities alike, is basic to interpreting the figures. The *nagual* could take the form of an animal, plant, or other natural phenomenon, and is frequently symbolized on the figure's headdress and in the form of the mask that often covers the lower part of its face. Additional clues to identity may be provided in the depictions of jewelry, particularly pectoral ornaments.

Unlike many of the figures, this one wears a plain headdress without the usual ornament to associate it with a particular deity. While unusual, such a plain headdress is not unique; Monte Albán II figures representing a deity known as the God with the Buccal Mask of the Serpent are characteristically depicted with tall, unadorned conical headdresses such as this one. Although this figure's bill-like mask differs from the one generally worn by that deity, Alfonso Caso (personal communication to Frank Boos, March 1966) felt that the serpent deity, whom he saw as an archaic form of Quetzalcoatl, the Aztec plumed serpent, is the one represented here. If that is correct, then this is one of the earliest associations of a serpent deity with the bill-type mask that would later, among the Aztecs, indicate Quetzalcoatl in his guise as Ehecatl, the wind god (see cat. no. 76). Caso (ibid.) suggested that the deviation from the usual Monte Albán mask type was due to the figure's having originated outside the Oaxaca valley, perhaps in an area bordering the state of Veracruz.

The relative simplicity of this urn dates it to Monte Albán II; Caso (ibid.) suggested that it is from the beginning of that period. The basic form of such urns — a vessel in the form of a figure — remained the same from that period onward, although a chronological examination shows an increasing complexity of form and decoration.

References cited

Boos, Frank H. 1966. *The Ceramic Sculptures of Ancient Oaxaca*. South Brunswick, N.J.: A.S. Barnes.
Caso, Alfonso, and Ignacio Bernal. 1952. *Urnas de Oaxaca*. Mexico City: Instituto Nacional de Antropología e Historia.

Provenance: Acquired from Everett Rassiga (New York) in 1964

Published: Arts Club 1966, cat. no. 78 (ill.); Boos 1966, fig. 128a-c; *Chicago Tribune* 1970 1A: 1 (ill.)

Exhibited: Arts Club 1966, Tucson 1975, IUAM 1993

72

Teotihuacan culture, Mexico

Mask

Classic period, A.D. 200-750
Metamorphic granite
H. 6 1/2 in. (16.5 cm)
IUAM 79.6.2 (RW 66-277)

Even six hundred years after its de-
struction, the urban center that existed
north of the Aztec capital of Tenoch-
titlan between A.D. 150 and 750 was
so impressive that the Aztecs named it
Teotihuacan, "place of the gods," the
name by which it is still known today.
Well-ordered streets, gigantic pyramid-
temple platforms, and many ad-
ministrative and residential compounds
comprised the city, which is estimated
to have maintained a population of over
125,000 in A.D. 600, making it the
sixth largest city in the world at the
time.

More stone masks survive from
Teotihuacan than from any other Meso-
american culture. Using carving and
chipping tools fashioned from bone,
horn, and stone, drills from bird bone,
and water and sand for abrasion, Teoti-
huacan craftsman painstakingly carved
them to approximately life-size. Their
weight, lack of pierced eyeholes, and
flat backs indicate that such masks were
not worn; instead, holes along the inner
rims suggest that they were attached to
something.

These masks are generally considered
funerary, and most literature suggests
that they were tied over the face of the
deceased, a practice followed by other
Pre-Columbian peoples, including the
Olmec and the Maya. A Teotihuacan
ceramic figure identfied as a burial
bundle and depicted with a small re-
movable mask indicates that this is a
plausible interpretation (Castro 1990,
cat. no. 34). However, since only three
full-size stone masks have been excavat-
ed, and since they were found in ad-
ministrative and temple buildings, not
in burial contexts, some scholars ques-
tion whether the masks actually were

funerary. Instead, it has recently been
proposed that they may have been at-
tached to wooden figures or armatures
in order to resemble more costly figures
made entirely of stone. Such figures
may have been dressed in costumes and
displayed as "composite ancestor and
nature spirits" that were becoming gods
(Pasztory 1988, 63; 1993, 54).

Teotihuacan masks share similar
features, which include a wide, straight
forehead; horizontal or slightly curved
eyebrows created by the intersection of
the forehead and upper eye sockets;
narrow eyes parallel with an open
mouth; simple, projecting, rectangular
pierced ears; and modeled cheeks and
lips. Some of these characteristics may
reflect a Teotihuacan ideal; some skulls,
for example, show that heads were
broadened through artificial cranial
deformation (Pasztory 1988, 63). While
these similarities give the masks a uni-
form appearance at first glance, Esther
Pasztory (ibid., 64), a leading authority
on the art of Teotihuacan, has pointed
out that closer examination and a
familiarity with Teotihuacan's flat,
abstract style reveal many variations.

In addition, the masks were probably
more individualized at one time than
they are now. The stains around the
eyes of some masks, including this one,
indicate that they once held inlays,
probably of iron pyrite (which left the
orange stain) and shell. Simulated teeth,
made of small pieces of shell, have also
been found on some masks. Finally, face
painting on the masks and costumes
associated with them may have indicat-
ed specific individuals or groups of
people (Crouch 1991, 30-31).

References cited

Castro, Rubén Cabrera. 1990. "Funerary
Bundle Figure." In *Mexico: Splendors of Thirty
Centuries*, 98-99. Introduction by Octavio Paz.
Exhibition catalogue. New York: Metropolitan
Museum of Art.
Crouch, N.C. Christopher. 1991. *Faces of Eter-
nity: Masks of the Pre-Columbian Americas.*
Exhibition catalogue. New York: Americas So-
ciety.

Pasztory, Esther. 1988. "A Reinterpretation of
Teotihuacan and Its Mural Painting Tradition."
In *Feathered Serpents and Flowering Trees: Re-
constructing the Murals of Teotihuacan*, 45-77.
Edited by Kathleen Berrin. San Francisco: Fine
Arts Museums of San Francisco.
———. 1993. "Teotihuacan Unmasked:
A View through Art." In *Teotihuacan: Art
from the City of the Gods*, 44-63. Edited by
Kathleen Berrin and Esther Pasztory. Ex-
hibition catalogue. New York: Thames and
Hudson.

Provenance: Acquired from John Stokes (New
York) in 1966
Published: IUAM 1986, cat. no. 4 (ill.)
Exhibited: IUAM 1993

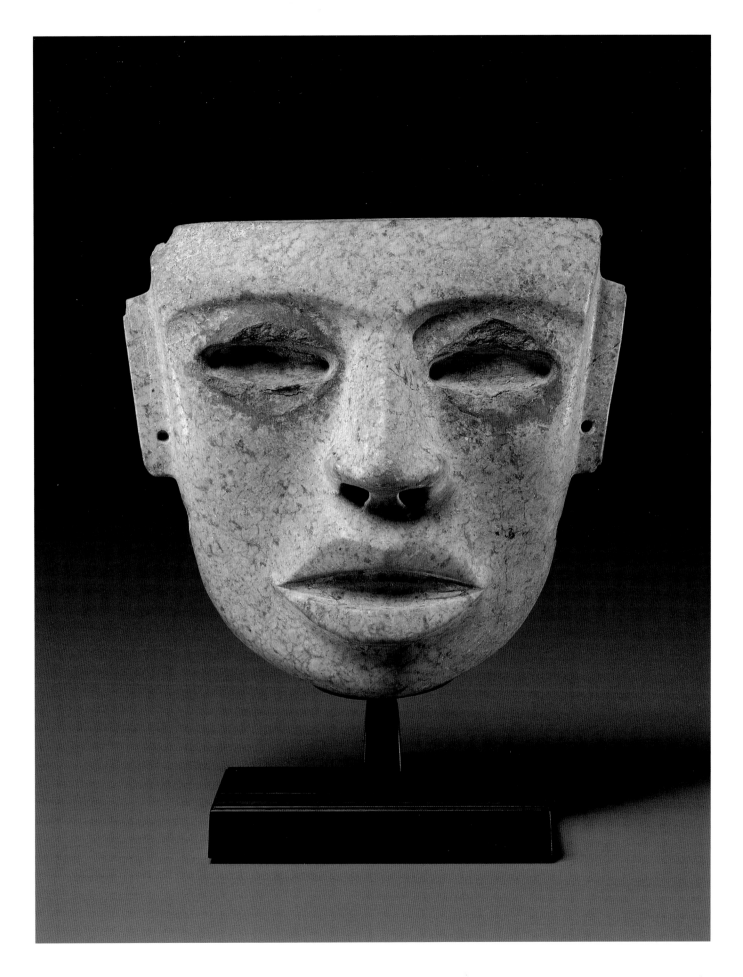

73

Teotihuacan culture, Mexico

Seated Figure

Classic period, A.D. 200-750
Aragonite
H. 10 1/2 in. (26.7 cm)
IUAM 76.8 (RW 59-139)

The austerity and hardness of this figure seem to us today to reflect the self-sacrifice, organization, and even rigidity that were characteristic of the great metropolis of Teotihuacan. Beyond that, however, we can say little with any certainty, for the figure also demonstrates very clearly the problems that occur when Pre-Columbian objects — or those from any ancient culture — are removed without records from their archaeological contexts.

While we know nothing about where this particular figure was found, we can assign it a Teotihuacan origin based on its style. The figure was carved from a relatively soft stone — aragonite, or Mexican alabaster — that was more commonly used for masks and containers. Even without metal tools (see cat. no. 72), Teotihuacan carvers working in hard stone were able to achieve sharp details; however, the nature of aragonite lends itself to softer, more simplified forms. The face and general flatness of the head recall Teotihuacan stone masks (see cat. no. 72), and the body's simplified naturalism, including the manner in which the lower rib cage is depicted, is similar to the fragment of a male standing figure that was found during excavations near the Pyramid of the Sun, one of the city's focal points (ibid. 1993, cat. no. 13).

Esther Pasztory (ibid., 183) compares the posture of the Wielgus figure to that of Old God brazier figures, which are also carved from stone, though those figures are depicted with heads and backs bent forward to support braziers on their heads, unlike this example, which sits up straight. In another publication, Pasztory (1992, 142) notes that in Teotihuacan iconography, up-turned hands generally refer to the divine hand from which gifts and abundance flow and were a favored pose for the depiction of both deities and members of the Teotihuacan elite.

Because of the rarity of this type of figure, we cannot compare it with similar figures whose contexts were recorded and then discuss with some confidence its function or meaning. Larger standing stone figures have been excavated from temples and apartments near the Street of the Dead, Teotihuacan's major axis, suggesting that they were important ritual objects. Based on mural images, scholars have theorized that those figures may have been costumed in real clothing and jewelry and used as major images in temples. Figures smaller than this one, on the other hand, might have served as offerings on important ritual occasions (Berrin and Pasztory 1993, 176).

References cited

Berrin, Kathleen, and Esther Pasztory, eds. 1993. *Teotihuacan: Art from the City of the Gods.* Exhibition catalogue. New York: Thames and Hudson.
Pasztory, Esther. 1992. "The Natural World as Civic Metaphor at Teotihuacan." In *The Ancient Americas: Art from Sacred Landscapes,* 135-45. Edited by Richard F. Townsend. Exhibition catalogue. Chicago: Art Institute of Chicago.

Provenance: Ex-coll. Miguel Covarrubias (Mexico); acquired from Everett Rassiga (New York) in 1959

Published: Groth-Kimball 1954, pl. 27; Covarrubias 1957, pl. 30; Emmerich 1959, 55 (ill.); MPA 1960b, cat. no. 73; *New York Times* 1960, 10: 11 (ill.); Arts Club 1966, cat. no. 68; Easby 1970, pl. 117; *Gazette des Beaux-Arts* 1977, 90; IUAM 1977, 61 (ill.); IUAM 1980, 247 (ill.); IUAM 1985, 3 (ill.); IUAM 1986, cat. no. 5 (ill.); IUAM 1990a, 4 (ill.); IUAM [1991], 10 (ill.); Berrin and Pasztory 1993, cat. no. 22 (ill.); Pelrine 1993, ill. 11

Exhibited: MPA 1960b, Arts Club 1966, MMA 1970, De Young 1993, IUAM 1993

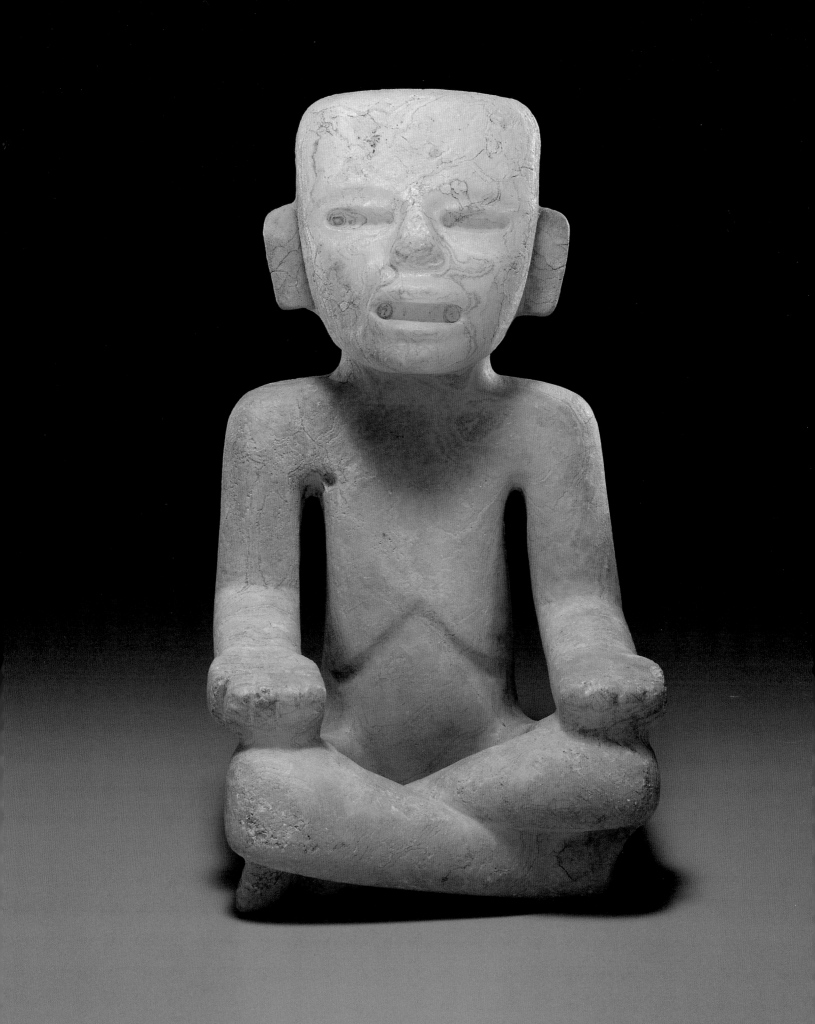

74

Veracruz, Cerro de las Mesas, Mexico

**Vessel in the Form of
the Head of the Old Fire God**

Early Classic period, A.D. 300-600
Clay
H. 9 3/4 in. (24.8 cm)
IUAM 77.93 (RW 61-220)

Bordering the Gulf of Mexico, the state of Veracruz has thousands of ancient ruins from the Formative and Classic periods, most still unexcavated. One exception is the ceremonial site of Cerro de las Mesas, located east of Alvarado Bay in south-central Veracruz, where a number of objects suggesting a close relationship with Teotihuacan were found. Among them were fragments of ceramic figures of old men, one greater than life-size. The heads of those figures have many of the same characteristics as this one: a beard, wrinkled face, nearly toothless mouth, and earspools (Drucker 1943, pls. 8, 45).

In Pre-Columbian iconography, this combination of features is usually associated with the Old Fire God, who is often called by his Aztec name, Huehuetéotl, which means "old, old deity." Although common in the art of Teotihuacan, the Old Fire God is far more ancient and may have originated with the Olmec civilization; his image first appears during the Formative period and continues through the Post-Classic. Most depictions come from sites in central Mexico, such as Teotihuacan, and in West Mexico, Yucatán, Kaminaljuyu (Guatemala), and Veracruz.

Among the Aztecs, fire not only provided heat for cooking and warmth but also had ritual significance, for the beginning of a new year could only be assured with the successful lighting of a new fire. Huehuetéotl was associated with residences rather than temple complexes (Miller and Taube 1993, 92), but even as a household deity, he was significant, for, as Richard Townsend (1992, 114), an Aztec specialist, points

out, "The idea of sacred fire stems from its most basic function in the domestic hearth." Furthermore, in one Aztec creation myth, Huehuetéotl was considered the ultimate creator, mother and father of gods and people (Castro 1990, 98). We cannot be certain, of course, that the Old Fire God had the same associations for earlier peoples, but the consistency of his depictions over time and the Aztec acknowledgment of his antiquity suggest that his essence remained constant.

We must consider the interpretation of this head as the Old Fire God with one caveat. His usual representation is as a seated figure, with head and back bent forward under the weight of a brazier that he holds on his head. Some scholars believe that the absence of the brazier, which is frequent in Veracruz sculpture, may signify that a piece simply depicts an elderly man and not the Old Fire God. However, others have suggested that over time such features as the wrinkled face and beard had become so standardized that it became unnecessary to depict the brazier.

References cited

Castro, Rubén Cabrera. 1990. "Huehueteotl." In *Mexico: Splendors of Thirty Centuries*, 98. Introduction by Octavio Paz. Exhibition catalogue. New York: Metropolitan Museum of Art.
Drucker, Philip. 1943. *Ceramic Stratigraphy at Cerro de las Mesas, Veracruz, Mexico*. Bureau of American Ethnology Bulletin, no. 141. Washington, D.C.: Smithsonian Institution.
Miller, Mary Ellen, and Karl Taube. 1993. *The Gods and Symbols of Ancient Mexico and the Maya*. London: Thames and Hudson.
Townsend, Richard F. 1992. *The Aztecs*. London: Thames and Hudson.

Provenance: Acquired from Everett Rassiga (New York) in 1961

Published: Arts Club 1966, cat. no. 75 (ill.); IUAM 1980, 252 (ill.); IUAM 1986, cat. no. 10 (ill.); IUAM [1989a], 2 (ill.)

Exhibited: Arts Club 1966, IUAM 1993

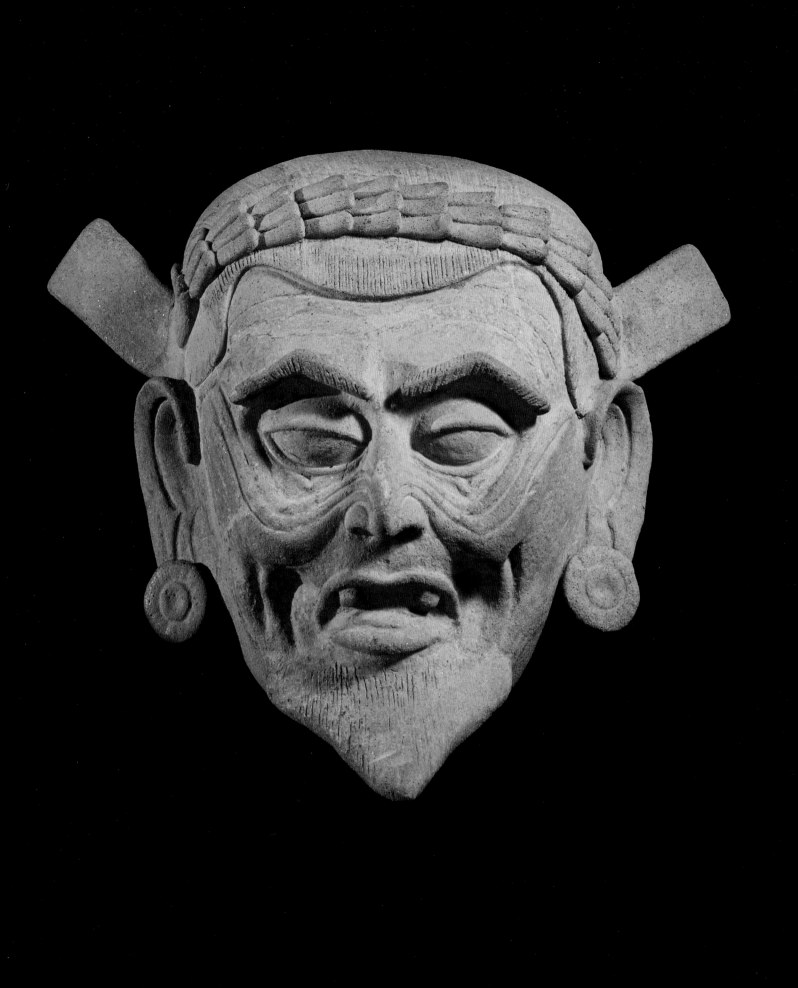

75

Veracruz, Mexico

Vessel in the Form of a Monkey

Late Classic period, A.D. 800-900
Clay
H. 8 5/8 in. (21.9 cm)
IUAM 100.7.4.75 (RW 62-233)

Spider, howler, and capuchin monkeys were all indigenous to the tropical lowlands of Pre-Columbian Mexico and Guatemala, and some, particularly the capuchin, which is no longer found in the area, were kept as pets. Monkeys are frequently shown in Pre-Columbian works of art, often with a degree of realism which enables the particular species to be identified. This vessel, for example, portrays a spider monkey, but even as a simple depiction of a common animal, it no doubt also had other associations for the people of Veracruz, just as images of monkeys did for other Pre-Columbian peoples.

Among the Maya, for example, a monkey deity was the patron of scribes, artists, musicians, and dancers. Jeanette Peterson (1990, 52), who has examined the depiction of animals in Mesoamerican art, suggests that the linking of monkeys and the arts may be a result

of their behavior. The spider monkey, for example, resembles a dancer in its graceful, yet acrobatic movements. However, as related in the *Popul Vuh*, a sixteenth-century epic of the Quiché Maya of the Guatemalan highlands which is believed to preserve mythology and traditions of the ancient Maya, this association came about when two brothers, Hun Batz (1 Howler Monkey) and Hun Chuen (1 Spider Monkey), who were masters of music, writing, singing, and the visual arts, were turned into monkeys by their half-brothers. These half-brothers, the Hero Twins, were demigods who later defeated the gods of the underworld. Maya artists depicted the monkey brothers either as real monkeys or as humans with monkey attributes. On this vessel, the monkey has pierced ears, just as people did, suggesting a melding of human and animal forms.

We have no indication that the people of Veracruz shared the particular mythology of the Maya, but we do know that there was a close relationship between the Maya and the people of the Gulf coast during the Classic period. So even if they were unaware of the source for the link between monkeys and the arts, they may still have made the association. Some scholars have also suggested that spider monkeys depicted in Classic Veracruz art may be linked with licentiousness and sexual abandon, an association made by the Maya (Miller and Taube 1993, 118).

Similar vessels, usually dated to the Post-Classic period, also were carved in stone. Most are made of a soft, white stone such as aragonite (Bliss 1957, pl. 51; Marin 1967, ill. 25; Kubler 1986, ill. 68). The Post-Classic site of Isla de Sacrificios off the Veracruz coast is said to have been a major center for carving in this material. Another example found in Texcoco, a Post-Classic city-state near the Aztec capital of Tenochtitlan in central Mexico, indicates that obsidian was also used (Covarrubias 1957, pl. 59).

Though this vessel resembles the stone ones in overall form, the medium of clay allowed a more detailed, plastic

treatment, resulting in a very lifelike and lively sculpture. This liveliness is aural as well as visual, for when the monkey is moved, it chatters with the rattling of a pebble or other small object sealed inside it.

References cited

Bliss, Robert Woods. 1957. *Pre-Columbian Art: Robert Woods Bliss Collection.* By S.K. Lothrop, W.F. Foshag, and Joy Mahler. London: Phaidon.
Covarrubias, Miguel. 1957. *Indian Art of Mexico and Central America.* New York: Alfred A. Knopf.
Kubler, George, ed. 1986. *Pre-Columbian Art of Mexico and Central America.* New Haven: Yale University Art Gallery.
Marin, Carlos Martinez. 1967. *National Museum of Anthropology.* Mexico City: Instituto Nacional de Antropología e Historia.
Miller, Mary Ellen, and Karl Taube. 1993. *The Gods and Symbols of Ancient Mexico and the Maya.* London: Thames and Hudson.
Peterson, Jeanette Favrot. 1990. *Precolumbian Flora and Fauna: Continuity of Plant and Animal Themes in Mesoamerican Art.* Exhibition catalogue. San Diego: Mingei International Museum.

Provenance: Acquired from Everett Rassiga (New York) in 1962

Published: Arts Club 1966, cat. no. 76 (ill.); IUAM 1986, cat. no. 12 (ill.); IUAM [1989a], 2

Exhibited: Arts Club 1966, IUAM 1993

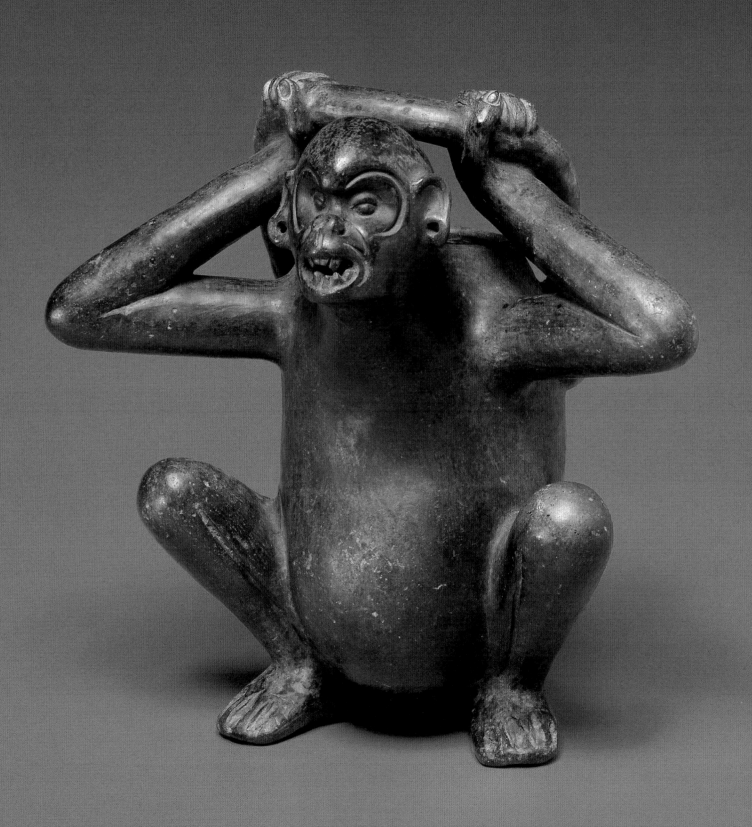

76

Mixtec culture, Mexico

Labret

Late Post-Classic period, 1200-1521
Gold
L. 2 1/4 in. (5.7 cm)
IUAM 78.11.1 (RW 59-145)

When the Spanish arrived in Mexico, they were captivated by the quantities of gold they saw, although they were shocked to find it was not considered as precious as jade and tropical bird feathers, rare materials that also had sacred significance. In their greed and contempt for these "savage" cultures, they confiscated gold objects of all sorts, some apparently of monumental size. Most objects, including all of the large pieces, were melted down and made into bullion, coins, or jewelry suiting European tastes. As a result, few gold pieces from the Aztec capital survived. Mixtec metalwork from the Oaxaca homeland fared a bit better than most, and our appreciation of these craftsmen's skills is based on small, portable objects, particularly jewelry such as this labret.

Labrets made of precious materials such as obsidian, rock crystal, jade, and metal were worn by important officials in many areas of the Pre-Columbian Americas. Such an ornament fit in a hole beneath the lower lip and was held in place by a flange that rested against the lower teeth and gum. This example is made of gold, a material that was unknown in Mesoamerica until late in the Classic period and not worked in Mexico until the Post-Classic era. Called *teocuitlatl* ("excrement of the gods") by the Aztecs, the metal was prized not only for its rarity but also for its associations with the sun, an important aspect of many Pre-Columbian religions.

During Post-Classic times, the Mixtec peoples, who lived in the valley of Oaxaca that gave rise to Monte Albán (see cat. nos. 70, 71), became known far and wide for their artistry in gold,

silver, and other precious materials, such as stones and feathers. In fact, many scholars believe that much of the goldwork found in the Aztec capital of Tenochtitlan was made by Mixtec craftsmen who were brought to the city to live and work (Townsend 1992, 184). Even those pieces not directly made by them were most likely a product of skills and techniques acquired from them.

This labret was cast by the *cire perdue* (lost-wax) method, a technique at which the Mixtec excelled. First, powdered charcoal was mixed with clay and water, allowed to dry, and sculpted into the desired form. Next, beeswax was pressed over the form and details added in wax. This was then covered with another layer of clay and charcoal. When the mold was heated, the wax was poured out and molten gold poured in. After cooling, the clay portions were broken away, leaving the gold ornament (Sahagún 1959, 73-75).

The bird beak on this labret suggests that it may represent Quetzalcoatl, the plumed serpent and one of the most important Pre-Columbian deities, in his manifestation as the wind god, Ehecatl, who the Aztecs believed swept the streets before every rain. In Aztec mythology, Ehecatl was associated with the creation of the second sun, or world, that existed before the current fifth sun. In Mixtec codices, pictorial manuscripts that have survived from the Post-Classic and early Colonial eras, Ehecatl is an important culture hero (Miller and Taube 1993, 84-85).

References cited

Miller, Mary Ellen, and Karl Taube. 1993. *The Gods and Symbols of Ancient Mexico and the Maya*. London: Thames and Hudson.
Sahagún, Bernardino de. 1959. *Florentine Codex: General History of the Things of New Spain: Book 9 — The Merchants*. Translated by Charles E. Dibble and Arthur J.O. Anderson. Monographs of the School of American Research and the Museum of New Mexico, no. 14, pt. 10. Santa Fe: School of American Research and the University of Utah.
Townsend, Richard F. 1992. *The Aztecs*. London: Thames and Hudson.

Provenance: Acquired from Everett Rassiga (New York) in 1959

Published: MPA 1960b, pl. 9; Los Angeles County Museum 1964, pl. 1; Arts Club 1966, cat. no. 71; Wardwell 1968a, cat. no. 126 (ill.); IUAM 1986, cat. no. 15 (ill.); IUAM [1989a], 2 (ill.)

Exhibited: Brooklyn 1959, MPA 1960b, Los Angeles 1964, Arts Club 1966, MFA 1968 (Chicago only), IUAM 1993

77

Aztec culture (?), San Gerónimo, Mexico

Fan Handle

Late Post-Classic period, 1200-1521
Wood
H. 12 1/4 in. (31.1 cm)
IUAM 94.221 (RW 64-252)

78

Aztec culture, Xochimilco, Mexico

Spatula (?)

Late Post-Classic period, 1200-1521
Wood
H. 12 5/16 in. (31.3 cm)
IUAM 94.220 (RW 64-257)

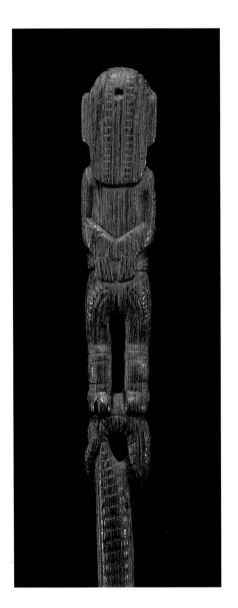 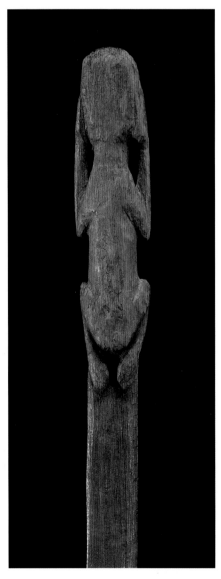

Few Pre-Columbian wooden objects survived in Mesoamerica, and we have only a handful that are attributed to the powerful Aztec state in central Mexico that Cortés conquered in the early sixteenth century. Neither of these objects is from Tenochtitlan, the Aztec capital; instead, they are said to have been found in outlying areas. This may explain why the several scholars who have examined them in person or through photographs agree that they appear to be authentic, but are very unusual.

Although the style of carving does not look particularly Aztec, the snake and the bound captive on the fan handle (cat. no. 77) are consistent with Aztec iconography. The snake is a prominent image throughout Pre-Col-

umbian Mesoamerica, and the feathered serpent, called Quetzalcoatl by the Aztecs, was an important deity as early as Olmec times. Rattlesnakes are a frequent theme in Aztec art, as is human sacrifice, which was considered necessary to maintain the good will of the gods and thus to sustain human life. The Aztecs were known as great warriors, and their "Flowery Wars" were battles waged for the primary purpose of obtaining captives for sacrifice. This fan handle is said to be from San Gerónimo, a site in West Mexico.

Catalogue number 78 is identified as a spatula because no one has been able to offer a definitive explanation for what it might be. Raymond Wielgus has speculated that it might be similar to the vomiting spatulas of the Taíno cultures, which were touched to the inside of the throat to induce vomiting for ritual purification; admittedly, there is no evidence from the Aztecs for such practices. Formally, the long, narrow shape topped by a carving resembles some staffs, though its flatness would make it awkward to hold. This object is said to have been found in Xochimilco, a Post-Classic town that was a tributary state of Tenochtitlan.

Cat. no. 77

Provenance: Acquired from John Stokes (New York) in 1964

Published: Arts Club 1966, cat. no. 74 (ill.); IUAM 1986, cat. no. 9 (ill.)

Exhibited: Arts Club 1966, IUAM 1993

Cat. no. 78

Provenance: Acquired from John Stokes (New York) in 1964

Published: Arts Club 1966, cat. no. 72

Exhibited: Arts Club 1966, IUAM 1993

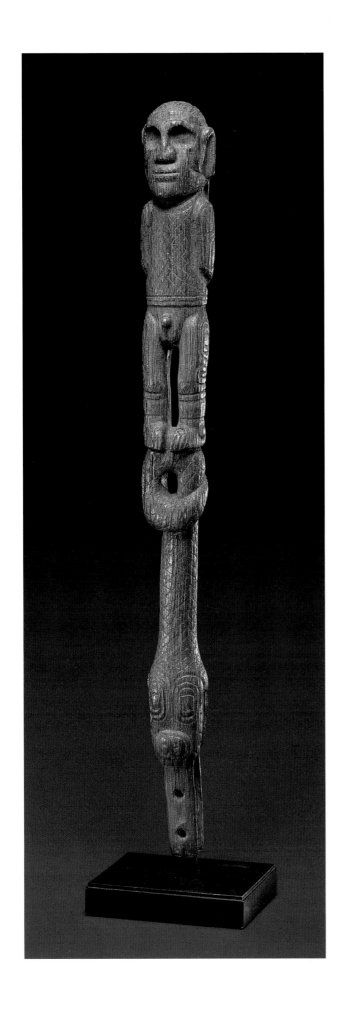

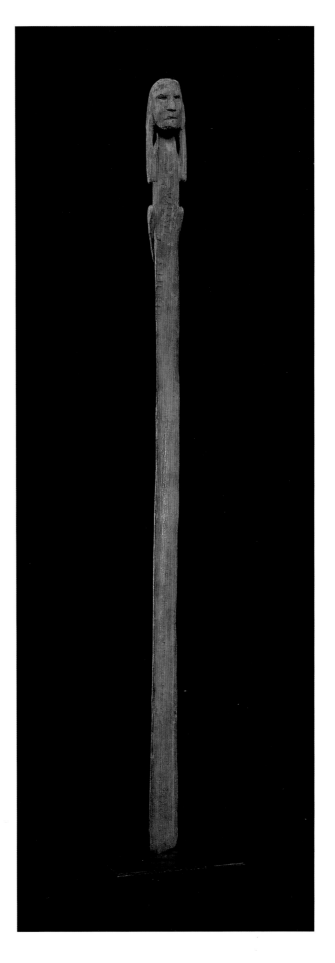

79

Maya culture, Jaina (?), Mexico

Plaque

Late Classic period, ca. A.D. 700-800
Shell
H. 4 11/16 in. (11.9 cm)
IUAM Oarjaua (IUAM 1.111)

Maya civilization, which flourished
from about A.D. 250 until 900 in areas
of present-day Mexico, Guatemala,
Belize, Honduras, and El Salvador, is
considered by many to be the most ac-
complished and impressive in the Pre-
Columbian Americas. These years,
known as the Classic period, saw major
achievements, such as detailed astro-
nomical and mathematical studies, an
accurate calendrical system, hierogly-
phic writing, and complex visual arts
ranging from monumental stone archi-
tecture and sculpture to intricately
painted ceramics (see cat. no. 82) and
finely worked small-scale carvings such
as this plaque.

Most, if not all, of these achievements
were intimately tied to a religious
system that included a sometimes be-
wildering assortment of deities and
other supernatural beings, which are
the primary subject matter of much
Maya art, including this plaque. In the
center of the plaque lies the Jaguar God
of the Underworld, who represents the
sun when it is in Xibalbá, the Maya
underworld, and who may have been
the patron of war. A combination of
several features identifies him: a Roman
nose, a hank of hair hanging over his
forehead, a curved line extending across
his nose from eye to eye (known as a
cruller, because its shape resembles that
of the pastry), jaguar ears above his ear
flares, and jaguar paws instead of hands
and feet.

His pose and the presence of two
other deities suggest that the Jaguar
God may be ready to be sacrificed, an
important religious practice that the
Maya and other Mesoamerican people
believed was necessary for the continu-
ation of humankind. To his right is the

God of Pax, patron of the month with
the same name and the god associated
with sacrifice of the lower jaw. His
usual attribute is a pointed blade-
tongue (depicted here) or spurting
blood-scrolls in place of a missing
lower jaw. At the time of the Spanish
conquests, the month of Pax was con-
sidered a particularly appropriate time
for sacrifice, and his depiction in Maya
art is usually in the context of sacrifice
(Miller and Schele 1986, 221-8). To the
left of the Jaguar God is God L, one of
the co-rulers of the underworld, iden-
tified by his headdress depicting the
muan (moan) bird, an owl-like bird
associated with Xibalbá.

Although the imagery seems clear,
the object's function is a bit more ambig-
uous. The Maya prized shells from the
lowlands and precious stones from the
highlands for jewelry and sacred ob-
jects. Along with elaborate headdresses,
capes, skirts, and belts, members of the
Maya elite wore shell and jade jewelry
(see cat. no. 81) on ritual occasions; sus-
pension holes at the top of this plaque
indicate that it could have been worn as
a pendant. However, the slightly flared
and undecorated bottom portion of the
object also could have been tucked into
a headdress, belt, or other costume
element. Alternatively, of course, the
plaque may have been a ritual object
that was held or displayed. Whichever
the case, it was certainly considered a
precious object and likely was buried
with its owner.

Michael Coe (1986, 18), an authority
on Maya art, has suggested that the
plaque may come from Jaina, a small
island off the coast of Campeche, a
Mexican state on the western side of
the Yucatán Peninsula. Jaina was a late
Classic necropolis for members of the
nearby Maya elite and is famous for
the rich tomb offerings, particularly
ceramic figures, that have been found
there. Unlike other areas, where the
climate and geography hastened the
destruction of perishable materials, in-
cluding shell, Jaina has calcareous soil
that has helped to preserve them.

References cited

Coe, Michael D. 1986. "The Art of Pre-Colum-
bian America." In *African, Pacific, and Pre-
Columbian Art in the Indiana University Art
Museum*, 9-47. Essays by Roy Sieber, Douglas
Newton, and Michael D. Coe. Bloomington:
Indiana University Art Museum in Association
with Indiana University Press.

Miller, Mary Ellen, and Linda Schele 1986.
*The Blood of Kings: Dynasty and Ritual in
Maya Art*. Exhibition catalogue. New York:
George Braziller.

Provenance: Acquired from Julius Carlebach
(New York) in 1960

Published: MPA 1960b, cat. no. 77 (ill.); Arts
Club 1966, cat. no. 79 (ill.); IUAM 1986, cat.
no. 25 (ill.)

Exhibited: MPA 1960b, Arts Club 1966, IUAM
1993

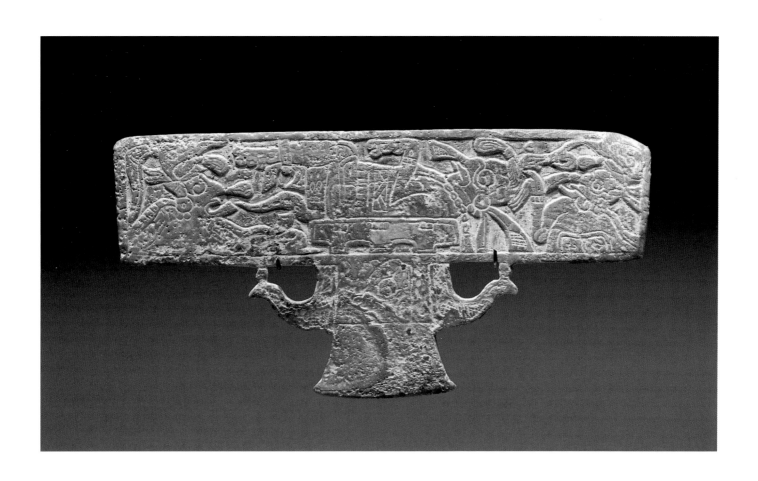

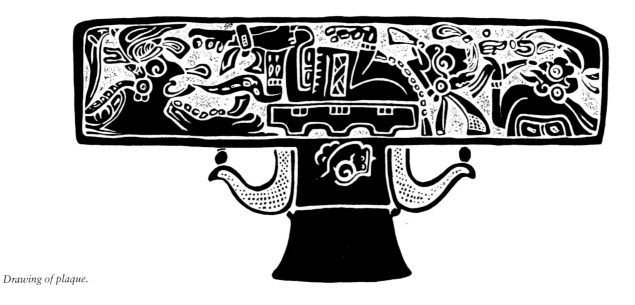

Drawing of plaque.

80

Maya culture, Chiapas (?), Mexico

**Ornament in the Form
of the Fat God**

Late Classic period, A.D. 600-900
Bone, cinnabar
H. 1 3/8 in. (3.5 cm)
IUAM 76.147 (RW 62-238)

81

Maya culture, Petén (?), Guatemala

**Pendant in the Form
of the Sun God**

Late Classic period, A.D. 600-900
Jadeite
H. 1 3/4 in. (4.4 cm)
IUAM 77.91 (RW 66-278)

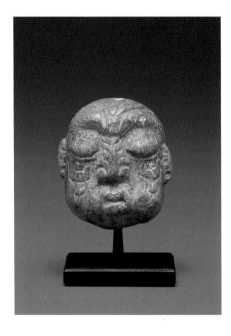

Maya ornaments took many forms, and among the most interesting to people today are objects that show faces. Many of these are so individualized that scholars believe they must be portraits, but others, such as these two, display standardized features that are associated with particular deities in the Maya pantheon.

The heavy, closed eyelids, round face, and puffy cheeks, for example, identify catalogue number 80 as the Fat God, a little-understood deity who first appeared in the Formative period and who was portrayed during the Classic era not only by the Maya but also by artists from Teotihuacan and Veracruz. In his Maya manifestations, the Fat God is sometimes accompanied by hieroglyphs suggesting that he was considered gluttonous and given to other excesses. Late Classic artists frequently showed him as a dancer or entertainer, perhaps reflecting his role as a ritual clown personifying intemperance and greed (Miller and Taube 1993, 86). In this role, the Fat God may carry a rattle, a sign of a performer. That attribute is also present in this ornament, albeit in an adapted form: the head is actually a rattle bead. Given the negative ideas associated with the Fat God, it is unclear whether such a bead would have been worn by members of the Maya elite as part of their elaborate costumes. However, the face does show traces of cinnabar, a red mineral ore that had been rubbed on ritual objects by Mesoamerican peoples since Olmec times.

As with the Fat God, certain characteristics identify the face on the pendant (cat. no. 81) as the Sun God. These include the large, squarish eyes with pupils high up in the inner corners, the prominent Roman nose, and the front teeth filed into a T-shape. A member of the complex Maya pantheon in which a deity may assume various forms and features, the Sun God is one manifestation of a deity that also appears as the Jaguar God of the Underworld (see cat. no. 79).

With a presence that belies its small size, this pendant becomes all the more remarkable when one considers that,

like the stone mask and figure from Teotihuacan (cat. nos. 72, 73), it was carved without metal tools. Although metallurgy was known in Mesoamerica from about A.D. 800, the Maya used metal primarily for jewelry and other luxury goods. Like their counterparts at Teotihuacan, Maya sculptors worked with hammers, chisels, and drills made from bone, horn, and stone and used sand as an abrasive for grinding and polishing.

Though its hardness made it difficult to work, jadeite was considered a most precious material, as were feathers, particularly those from the tail of the quetzal. Both were rare and green, the color of water, the sustainer of life, and were valued more than gold (Digby 1972, 10). These materials were the prerogative of priests and rulers, and depictions of Maya male and female royalty in painting and sculpture frequently show them wearing jadeite jewelry, including pendants of the Sun God.

References cited

Digby, Adrian. 1972. *Maya Jades*. Rev. ed. London: British Museum Publications.
Miller, Mary Ellen, and Karl Taube. 1993. *The Gods and Symbols of Ancient Mexico and the Maya*. London: Thames and Hudson.

Cat. no. 80

Provenance: Acquired from John Stokes (New York) in 1962

Published: Arts Club 1966, cat. no. 80

Exhibited: Arts Club 1966, IUAM 1993

Cat. no. 81

Provenance: Acquired from John Stokes (New York) in 1966

Published: IUAM 1979, 59 (ill.); IUAM 1986, cat. no. 26 (ill.); IUAM [1989a], 2; Pelrine 1993, ill. 12

Exhibited: IUAM 1993

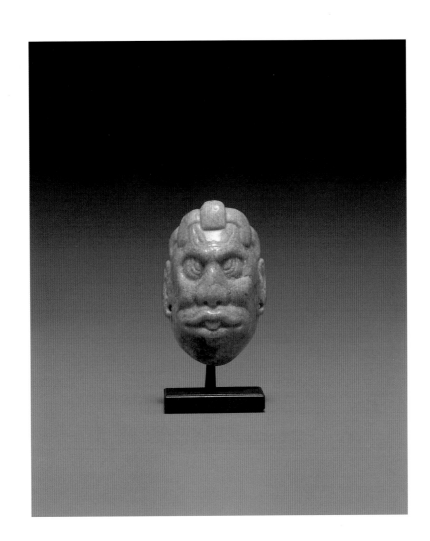

82

Maya culture, Petén (?), Guatemala

Vase

Late Classic period, ca. A.D. 700-800
Clay, pigment
H. 6 1/2 in. (16.5 cm)
IUAM 80.114 (RW 67-280)

Scholars are not sure what role, if any, decorated ceramics such as this played for the Maya of the Classic period. Plain pottery was used for such daily activities as food preparation. Only fragments of pictorial pottery have been found near homes; almost all of the elaborate ceramics have been found in tombs of elite individuals. As burial offerings, such ceramics were accompanied by a variety of other objects, all meant both to honor the deceased and to help him or her pass successfully through the dangers of the underworld, so that the soul could attain rebirth or deification.

Their presence as tomb offerings is one factor that has led many scholars to believe that the majority of Maya pictorial ceramics depict scenes from the underworld. On this vase, for example, Michael Coe (1986, 14), whose groundbreaking interpretations revolutionized thinking about these objects, suggests that the major figure, who wears a deer headdress, may be the deceased man for whom the vase was made, while the figure behind him is God N, one of the rulers of the underworld.

Though they may depict scenes from the underworld, the ceramics offer us a detailed view of how living Maya looked. Three of the four figures on this vase, for example, possess the smooth profile from forehead to nose that the Maya considered a mark of beauty and that they attempted to attain by using cosmetics and by molding the foreheads of babies. The profile of the fourth figure, who is shown with its back to the viewer, is distinctive because it is a conventionalized representation. This helps to identify it not as a person but as God N. All of the figures wear ornaments and elaborate headdresses, which the Maya considered essential costume elements for ritual occasions (Miller and Schele 1986, 67).

Although subject matter and iconography were standardized, Maya painters showed their artistry through their individual styles and in the dexterity with which they applied line and color with the finely pointed animal-hair brushes that were their basic tools. Although the scene on this vase is not as complex as some, the artist shows a mastery of line and color which is first-rate. Similarities in style that are apparent in a number of painted ceramics, which are among the most studied Maya art forms, have allowed scholars to identify different schools of painting and, in some cases, individual workshops. Like artists the world over, Maya painters ranged in talent, with relatively few producing such exceptional examples as this one.

References cited

Coe, Michael D. 1986. "The Art of Pre-Columbian America." In *African, Pacific, and Pre-Columbian Art in the Indiana University Art Museum*, 9-47. Essays by Roy Sieber, Douglas Newton, and Michael D. Coe. Bloomington: Indiana University Art Museum in Association with Indiana University Press.
Miller, Mary Ellen, and Linda Schele. 1986. *The Blood of Kings: Dynasty and Ritual in Maya Art*. Exhibition catalogue. New York: George Braziller.

Provenance: Acquired from Everett Rassiga (New York) in 1967

Published: *Indianapolis Star* 1985, E: 21 (ill.); IUAM 1986, 8 (ill.); Hubbard 1993a, 49 (ill.)

Exhibited: IUAM 1993

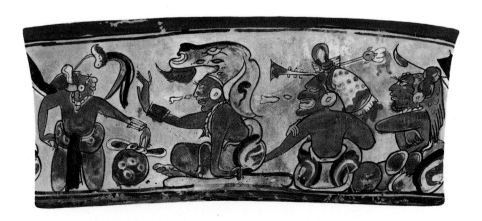

Watercolor roll-out of the vase by Claude Bentley.

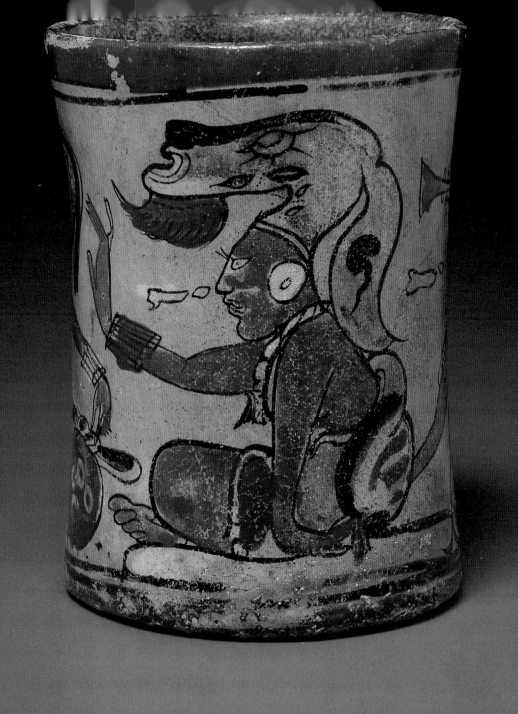

83

Maya culture (?), Quemistlán,
Santa Bárbara, Honduras (?)

Bell

Late Classic/Early Post-Classic period, A.D.
900-1100
Copper
H. 4 5/8 in. (11.7 cm)
IUAM 81.32.2 (RW 62-239)

The most common Pre-Columbian
metal objects, bells were worn as neck-
laces, anklets, and attachments to
clothing and were carried as dance rat-
tles. This bell is something of an
enigma, however. While the round face
and puffy cheeks and eyelids recall the
Maya Fat God (see cat. no. 80), we
cannot identify it positively, nor are we
certain whether the bell was made by
Maya craftsmen or traded into the area.

Like the Mixtec labret (cat. no. 76),
this bell was cast using the lost-wax
process. Details such as the lines and
spirals on the forehead were both tedi-
ous and time-consuming to execute, as
fine threads of wax had to be applied
individually. Individual threads of wax
also produced the borders along the
mouth of the bell. These borders, which
occur on other but not all bells, may
have been added to strengthen the
edges, to hid a ragged cut, or to identify
a particular workshop or area of manu-
facture (Coggins 1984, 107).

Pre-Columbianists Elizabeth Kennedy
Easby and John F. Scott (1970, cat. no.
269) have attributed the bell to Que-
mistlán in the mountains of Honduras
or, more precisely, to a site near there
called the Bell Cave, just outside the
Maya area. More than eight hundred
plain and decorated copper bells, some
in the form of animals and human
faces, have been found at the cave along
with pieces of unworked copper. A.
Hooton Blackiston (1910, 540), who
first reported the site to the archaeol-
ogical community, noted that most of
the bells seemed to be Maya in style.
However, Warwick Bray (1977, 393), a
specialist in Pre-Columbian metalwork,

has reported that the cave contained
Mexican and Honduran bells from
different metal sources, and the lines
and spirals on the forehead of this bell's
face represent a technique that is associ-
ated with Mexican rather than Hondur-
an metalworking (ibid., 365). While
metal objects were apparently traded
over a wide territory, the Maya area
was the one place where Mexican and
Honduran metalworking came together
in direct, continuous contact, and cast
objects and copper ingots were ap-
parently imported from both places.
Whether the Wielgus bell was made by
an itinerant foreign smith working to
suit Maya taste or by a native Maya
smith is impossible to say (ibid., 365,
397).

Michael Coe (1986, 18) proposes
that this bell may date to before A.D.
900, and, although metalworking was
not extensively practiced in Mesoamer-
ica until the Post-Classic period, metal
objects are known in Mexico and the
Maya area that date to the Late Classic
period. However, a later date seems
more likely. Similarly shaped copper
bells found in the Cenote of Sacrifice at
Chichén Itzá, for example, have been
dated to the latter part of a period end-
ing around 1150 (Coggins 1984, 107).

References cited

Blackiston, A. Hooton. 1910. "Recent Discov-
eries in Honduras." *American Anthropologist*
12: 536-41.
Bray, Warwick. 1977. "Maya Metalwork and
Its External Connections." In *Social Process in
Maya Prehistory: Studies in Honour of Sir Eric
Thompson*, 365-403. Edited by Norman Ham-
mond. New York: Academic Press.
Coe, Michael D. 1986. "The Art of Pre-Colum-
bian America." In *African, Pacific, and Pre-
Columbian Art in the Indiana University Art
Museum*, 9-47. Essays by Roy Sieber, Douglas
Newton, and Michael D. Coe. Bloomington:
Indiana University Art Museum in Association
with Indiana University Press.
Coggins, Clemency Chase. 1984. "The Cenote
of Sacrifice: Catalogue." In *Cenote of Sacrifice:
Maya Treasures from the Sacred Well at
Chichén Itzá*, 23-165. Edited by Clemency
Chase Coggins and Orrin C. Shane III. Exhibi-
tion catalogue. Austin: University of Texas
Press.
Easby, Elizabeth Kennedy, and John F. Scott.
1970. *Before Cortés: Sculpture of Middle Ame-
rica*. Exhibition catalogue. New York: Metro-
politan Museum of Art.

Provenance: Acquired from John Stokes (New
York) in 1962

Published: Arts Club 1966, cat. no. 70 (ill.);
Easby 1970, pl. 269; Wuthenau 1975, fig. A,
18a; IUAM 1986, cat. no. 27 (ill.)

Exhibited: Arts Club 1966, MMA 1970, IUAM
1993

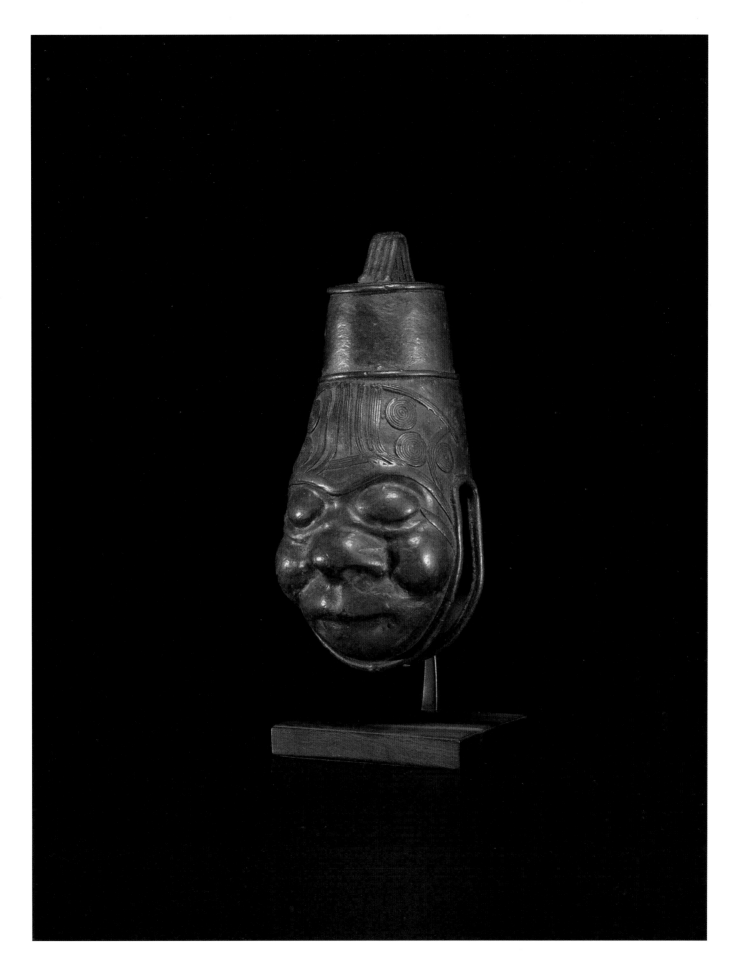

84

Costa Rica

Pendant

500 B.C.-A.D. 500
Chalcedony
H. 2 in. (5.1 cm)
IUAM 80.102 (RW 76-289)

This charming figure is part of a long-standing Costa Rican lapidary tradition. It is carved from chalcedony (a crypto-crystalline form of quartz that is translucent with a waxlike shine), a material that archaeologists sometimes call "social jade." This is a reference to the idea that while the stone is not jadeite like the Maya pendant (cat. no. 81), it nevertheless was considered precious and used in the same contexts.

Most Costa Rican jades have not been found in archaeological contexts, making their specific origins difficult, if not impossible, to determine. Complicating the situation is the popularity of both uncut and cut jade as trade items, resulting in some objects being found far from their place of manufacture. Using some that have been found at the site of La Unión de Guapiles, Carlos Balser (1961, 211, 213, figs. 1b-c) delineated characteristics of Costa Rican axe-god pendants, distinguishing those from two of the major archaeological regions, the Guanacaste-Nicoya zone, which includes the Nicoya peninsula on the Pacific side of the country, and the Atlantic Watershed area along the Caribbean coast. These pendants, found as early as the Olmec, consist of figures shaped as though they had been made from axes or celts.

Those characteristics that Balser used to describe Atlantic Watershed pieces also fit this jade: a long, rectangular nose, without indications of nostrils, that extends to the top of the forehead; eyes and mouth indicated by small holes or incisions; arms with marked fingers that point up; and legs and feet that are clearly defined and separated. Furthermore, he noted that objects from Línea Vieja, an archaeological zone in the Atlantic Watershed area named after an old railroad line that runs through it, are more likely to be made of chalcedony and less likely to have surface damage than those from the Nicoya peninsula.

The sources of Costa Rican jade have not been satisfactorily identified (Easby 1968, 14-15; 1981, 131; Ruenes 1993, 62). Some is believed to have come from the mountains above Guatemala's Motagua Valley, but the large numbers of jade objects have suggested to many scholars that a local source must have been available. Most investigations have focused on the Pacific side of the country, but without success; recent studies point to possible sources in the Atlantic Watershed area.

References cited

Balser, Carlos. 1961. "Some Costa Rican Jade Motifs." In *Essays in Pre-Columbian Art and Archaeology*, 210-17. By S.K. Lothrop et al. Cambridge: Harvard University Press.
Easby, Elizabeth Kennedy. 1968. *Pre-Columbian Jade from Costa Rica*. New York: André Emmerich.
————. 1981. "Jade." In *Between Continents/Between Seas: Precolumbian Art of Costa Rica*, 135-51. By Suzanne Abel-Vidor et al. Exhibition catalogue. New York: Harry N. Abrams.
Ruenes, Margarita Reynoard de. 1993. "A Possible Source of Raw Material for the Costa Rican Lapidary Industry." In *Precolumbian Jade: New Geological and Cultural Interpretations*, 61-67. Edited by Frederick W. Lange. Salt Lake City: University of Utah Press.

Provenance: Acquired from the estate of Frederick Pleasants (Tucson) in 1976

Published: Easby 1968, 22 (ill.); IUAM 1986, cat. no. 29 (ill.)

Exhibited: IUAM 1993

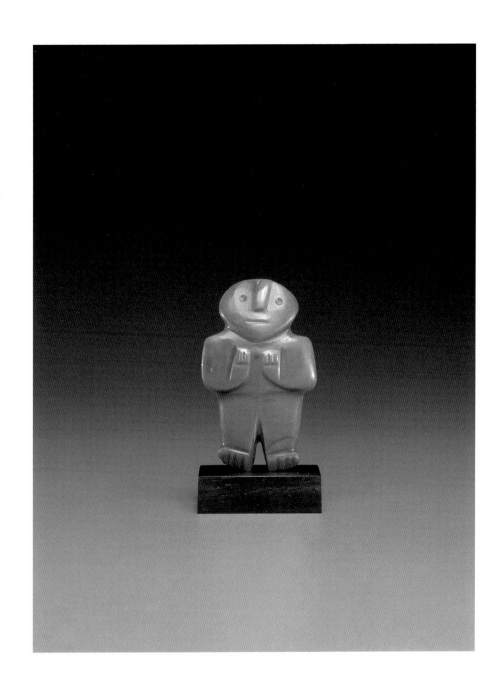

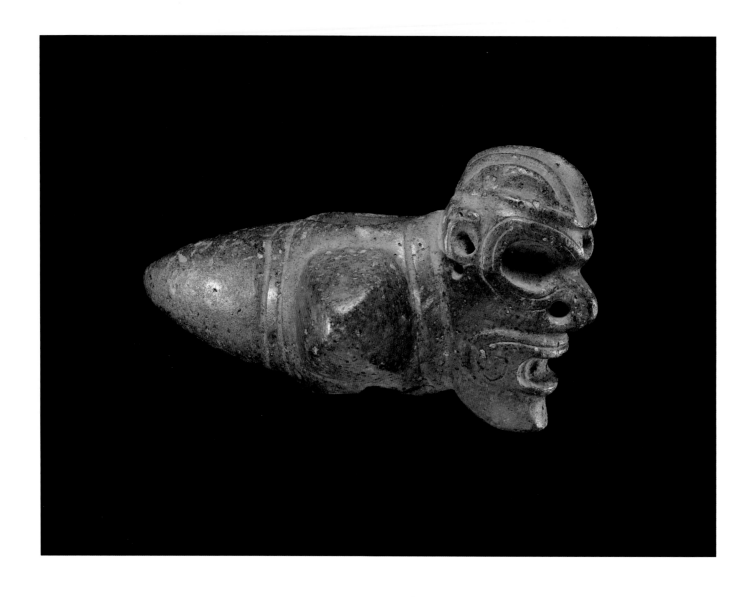

85

Guanacaste-Nicoya zone (?), Costa Rica

Mace Head with Human Face

A.D. 1-500
Igneous stone
L. 3 7/16 in. (12.1 cm)
IUAM 62.102 (RW 60-192)

Like many other Pre-Columbian objects, most Costa Rican mace heads have not been found in controlled excavations. However, those that have were all unearthed in funerary contexts, and when discovered with elaborately carved stone *metates* (flat stone mortars) with three legs and jade axe-pendants (see cat. no. 84), they mark elite burials in Costa Rica. Excavations associate them with the area that includes the Nicoya peninsula and Guanacaste province on the Pacific side of Costa Rica. Some in a similar style are said to have been found in the Central Highlands-Atlantic Watershed areas, suggesting that these object, like the jades, were part of trade networks (Snarskis 1981, 186).

Holes in the middle of the mace heads suggest that they were probably attached to wooden staffs. Earlier literature sometimes refers to them as weapons, and those in spherical form or with a pointed end, such as this one, look as if they could have been used in this way. While clubs may have been the inspiration for the form, however, the intricate carving on some mace heads renders them useful only as ceremonial versions, and so it is more likely that they alluded to the power associated with military prowess rather than served as weapons (Graham 1981, 118).

In addition, the variety of motifs depicted on the mace heads suggests to some scholars that they may have served as badges of office or indications of clan or moiety affiliation (Snarskis 1981, 185). Among the figural representations are human skulls and the heads of humans, monkeys, birds (particularly owls), coyotes, felines, and bats (de la Cruz 1988, 122, 125). This example, which combines human and avian features, is an unusual but not unique form.

References cited

de la Cruz, E. Ivonne. 1988. "Mace Heads as Stylistic Signaling Devices." In *Costa Rican Art and Archaeology: Essays in Honor of Frederick R. Mayer*, 111-30. Edited by Frederick W. Lange. Boulder, Colo.: University of Colorado.
Graham, Mark M. 1981. "Traditions of Costa Rican Stone Sculpture." In *Between Continents/Between Seas: Precolumbian Art of Costa Rica*, 113-134. By Suzanne Abel-Vidor et al. Exhibition catalogue. New York: Harry N. Abrams.
Snarskis, Michael J. 1981. "Catalogue." In *Between Continents/Between Seas: Precolumbian Art of Costa Rica*, 177-227. By Suzanne Abel-Vidor et al. Exhibition catalogue. New York: Harry N. Abrams.

Provenance: Collected by Samuel Lothrop from José María Velasco (Santa Cruz, Costa Rica); acquired from Peabody Museum of Archaeology and Ethnology (Cambridge, Massachusetts) in 1960

Published: MPA 1960b, pl. 27; IUAM 1986, cat. no. 28 (ill.)

Exhibited: MPA 1960b, IUAM 1993

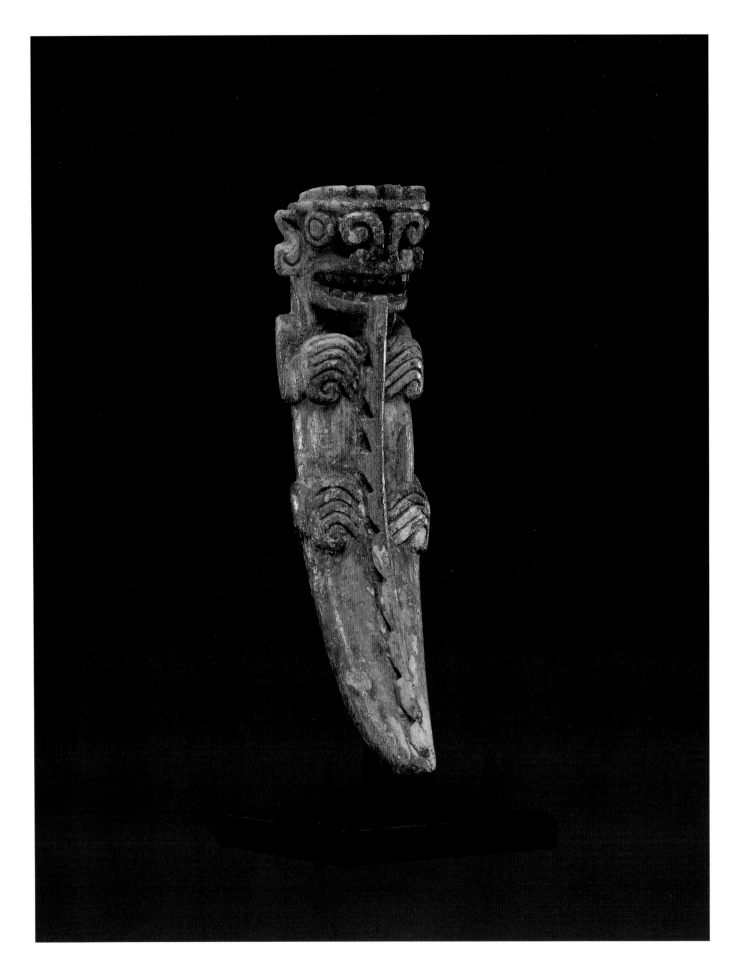

86

Coclé culture, Sitio Conte, Panama

Crocodile-God Pendant

A.D. 700/800-900
Manatee rib
H. 6 1/4 in. (15.9 cm)
IUAM 79.6.1 (RW 58-121)

The Coclé culture of central Panama, which takes its name from the contemporary province that it encompasses, is perhaps best known for exquisite goldwork and colorful, intricately painted pottery, but this figure, known as the crocodile god, can be found in nearly every medium. Its frequent appearance suggests that it must have represented an important deity or concept in Coclé religion.

The crocodile and its relatives the caiman and alligator, which were not always distinguished, are common images in Pre-Columbian arts, as is the lizard, with which the crocodile was sometimes conflated. Although we do not know the crocodile's specific significance for Coclé culture, its ferocious nature makes it a powerful symbol, which some scholars see as one of several animal metaphors that "express the qualities of aggression and hostility that characterized the social and political life of this and later periods in the central provinces" (Sapir 1977, 70). Further associations were likely. For example, in other Pre-Columbian societies, the crocodile was associated with the underworld because of its watery habitats, which were considered entrances to that other world. Some people also believed that a crocodile supported the world on its back, and crocodiles appear in myths about the origin of agriculture (Benson 1992, 28, 31).

As with much Pre-Columbian imagery, this is not a simple naturalistic depiction. The face, for example, appears human because it is parallel to the body, not at right angles to it, as a real crocodile's would be. The crenellation on the figure's head may be a stylized rendering of the scutes, or knobby projections, on the reptile's back, and Samuel Lothrop (1937, 174), who excavated Sitio Conte, interpreted the notched line extending from the figure's mouth down its length as the same feature. He further suggested that these elements relate the image visually to other hybrid animal forms in both Peru and Mexico.

The form of this pendant — the back is pierced for hanging — also may have had some special meaning, for, though made of manatee bone, the piece has been carved to resemble other pendants made from whale teeth that do not depict the crocodile god. The whale-tooth shape, either in simple outline or elaborated with anthropomorphic or zoomorphic imagery, was also imitated in other media, such as gold (Lothrop 1937, 176).

This pendant was one of many objects found in graves at Sitio Conte, the major site in Coclé and the first major find in the isthmus of Panama to be excavated by professionals. Located 10 miles inland from the Bay of Parita on the Gulf of Panama and used as a cemetery for important chiefs from A.D. 450 to 900, the site was named after the Conte family, who owned the land and who arranged for excavations to be carried out. These were led by teams from Harvard's Peabody Museum of Archaeology and Ethnology in 1930, 1931, and 1933 and from the University of Pennsylvania's University Museum of Archaeology and Anthropology in 1940. The Harvard expeditions uncovered 59 graves, often containing multiple interments, and 38 caches, pits unrelated to burials that contained a variety of materials. In grave 24, where this pendant was discovered, 10 people had been buried, along with many other objects including more than 150 pottery vessels, 115 stone blades, and a large quantity of jewelry. This pendant was one of two lying at the feet of one of the skeletons; two more were found in another part of the grave (ibid., 262-67).

References cited

Benson, Elizabeth P. 1992. "The Iconography of Sitio Conte Gold Plaques." In *River of Gold: Precolumbian Treasures from Sitio Conte*, 22-31. Edited by Pamela Hearne and Robert J. Sharer. Exhibition catalogue. Philadelphia: University Museum of Archaeology and Anthropology, University of Pennsylvania.
Lothrop, Samuel Kirkland. 1937. *Coclé: An Archaeological Study of Central Panama, Part 1*. Memoirs of the Peabody Museum of Archaeology and Ethnology, 7. Cambridge: Harvard University.
Sapir, Olga F. Linares de. 1977. *Ecology and the Arts in Ancient Panama: On the Development of Social Rank and Symbolism in the Central Provinces*. Studies in Pre-Columbian Art and Archaeology, 17. Washington, D.C.: Dumbarton Oaks.

Provenance: Collected by Samuel K. Lothrop in 1933 from grave 24, Sitio Conte; acquired from Peabody Museum of Archaeology and Ethnology (Cambridge, Massachusetts) in 1958

Published: Lothrop 1937, fig. 162c; Steward [1948] 1963, fig. 37a; MPA 1960b, cat. no. 78; Arts Club 1966, cat. no. 81; Easby 1970, pl. 229; IUAM 1986, cat. no. 31 (ill.); IUAM [1989a], 3

Exhibited: MPA 1960b, Arts Club 1966, MMA 1970, IUAM 1993

87

Tairona culture, Nahuange, Colombia

Ornament in the Form of a Caiman

A.D. 1000-1530
Triton shell
L. 2 11/16 in. (6.7 cm)
IUAM 78.11.3 (RW 66-275)

The large-scale political organization
and its resulting urban centers and
elaborate state rituals that characterized
Pre-Columbian Mesoamerica were,
for the most part, not typical of the
northern Andes, where small, in-
dependent villages tended to be the
rule. One exception was the Tairona
culture, which was located in the foot-
hills of the Sierra Nevada de Santa
Marta in northern Colombia. There,
larger towns had authority over smaller
neighboring villages, and by the six-
teenth century, two large confederations
dominated the area (Labbé 1986, 180).

This ornament was one of seven sim-
ilar pieces excavated by J. Alden Mason
at Nahuange, one of the sixteen coastal
sites he investigated during his 1922-23
excavations in the Tairona region. All
were found in an area he designated site
2, a low mound or house site that in-
cluded some burials (Mason 1931-39,
I: 36). Though he did not publish the
exact locations in which the objects
were found, he noted that other finds
from site 2 included pottery, crescent-
shaped shell pendants, shell and stone
beads, and some gold objects.

All seven of the ornaments found at
Nahuange are in the same form and
were carved from a univalve mollusk
shell. Each is in the form of the stylized
head of a caiman or crocodile with
drilled and incised details. Though the
ones collected by Mason have worn sur-
faces with minimal decoration, other
similar objects have finely incised sur-
face patterning (ibid., II: pl. 135; Saville
1928, figs. 84, 85). Each ornament also
has a large hole drilled in the top, which
connects with what was the hollow in-
terior of the shell, as well as smaller
holes drilled in the back. These smaller

holes indicated to Mason (ibid., II: 243)
that the ornaments may have been sus-
pended, while the larger vertical one
suggested that they also could have
been finials on staffs or sticks.

As with the Coclé culture (see cat.
no. 86), we do not know the specific
role that the crocodile or caiman played
in Tairona traditions. However, mythol-
ogy of the Kogi, contemporary people
directly descended from the Tairona
culture, suggests that it was significant,
for Duginavi, their culture hero, was
considered the father of caimans,
gourds, and corn (Ellen Steinberg, per-
sonal communication, August 1991).

This ornament has been assigned a
general date for the Tairona culture.
However, it may be earlier. More recent
work at Mason's Nahuange site 1 has
suggested a date in the sixth or seventh
century, though we cannot assume that
sites 1 and 2 were necessarily contem-
porary. Furthermore, similar objects
have also been found at other sites, such
as Pueblo Bello, that some archaeolo-
gists believe may be older than the
Tairona culture (ibid.).

References cited

Labbé, Armand J. 1986. *Colombia Before Col-
umbus: The People, Culture, and Ceramic Art
of Prehispanic Colombia*. New York: Rizzoli.
Mason, J. Alden. 1931-39. *Archaeology of
Santa Marta, Colombia: The Tairona Culture*.
3 vols. Field Museum of Natural History
Anthropological Series, 20, nos. 1-3. Chicago:
Field Museum of Natural History.
Saville, Marshall H. 1928. "Shell Carvings
from Colombia." *Indian Notes* 5, no. 4 (Octo-
ber): 357-64.

Provenance: Collected by J. Alden Mason on
Marshall Field III Colombian Expedition,
1922-23; acquired from Field Museum of Nat-
ural History (Chicago) in 1966

Published: Mason 1936, pl. 133, fig. 1; Arts
Club 1966, cat. no. 82

Exhibited: Arts Club 1966, IUAM 1993

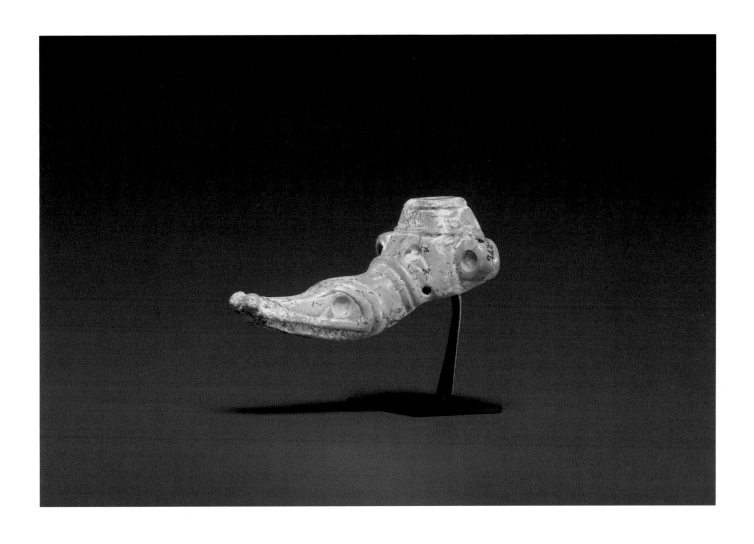

Paracas culture, Teojate (Juan Pablo),
Ica Valley, Peru

Double-Spout-and-Bridge Vessel

Paracas VII (600-300 B.C.)
Clay, pigment
Diam. 7 1/2 in. (19.1 cm)
IUAM 90.70, Gift of Mr. and Mrs. Allen
Wardwell (RW 58-129)

Paracas culture flourished on the southern coast of Peru from about 800 until about 100 B.C., with its heartland in the Ica and Pisco valleys. Like most other Pre-Columbian cultures, it is known primarily through ceramics, the majority of which were found in burial contexts. This vessel came from the cemetery site of Teojate, also known as Juan Pablo, in the upper Ica Valley, though it was not excavated by archaeologists. Therefore, we do not have specific contextual information about where it was found.

The rounded bottom is typical of Paracas pottery in general, while the compressed globular form indicates that it is from one of the later phases — earlier Paracas pots tend to have taller proportions (Menzel, Rowe, and Dawson 1964, 76). The double spout and handle, or bridge, is also characteristic of all Paracas phases. One of the spouts is nonfunctioning and modeled in the form of a bird, a common motif. A bird motif appears again on each side of the vertical panel on the front of the pot, although in even more stylized form; there, the bird's long reddish beak touches the panel, and its body and wings are represented by parallel lines in back of the head, which includes only a dot for an eye. This simplification and extreme stylization are other typical features of Paracas pottery.

This vessel also illustrates the predilection in southern Peru for decorative two-dimensional surfaces. Even though the vessels are separated widely in time, a comparison with catalogue number 94 shows the differences between northern and southern ceramics that persisted for much of the Pre-Columbian period. In the north, typified here by the Lambayeque jar, an emphasis was placed on sculptural form. In the south, on the other hand, potters relied on line and color to create their images, as this vessel demonstrates.

The pottery wheel was unknown in the Pre-Columbian Americas. This example was made using a coiling technique, whereby long rolls of clay were wound on top of a hand-modeled base and then pinched together and smoothed. Patterns were incised while the clay was still damp. Firing was probably done in a shallow pit; after firing, the vessels were dark gray to black. Color was then applied, using a resin paint that is a hallmark of Paracas ceramics. To make this paint, resin from a plant such as the acacia bush or Peruvian pepper tree was mixed with mineral pigments. The paint was then brushed on, with the incising serving as outlines for color areas. Because no brush marks are visible, some scholars have suggested that the vessels may have been held over a fire after painting to soften the resin and thereby make the brush marks disappear (Donnan 1992, 21-22, 35). The resulting surface was very smooth and shiny but also fragile, since exposure to heat or excess moisture would cause the paint to blister or deteriorate. The somewhat dull and powdery colors on many surviving Paracas ceramics, including this one, is a result of this sort of deterioration.

References cited

Donnan, Christopher B. 1992. *Ceramics of Ancient Peru*. Los Angeles: Fowler Museum of Cultural History.
Menzel, Dorothy, John H. Rowe, and Lawrence E. Dawson. 1964. *The Paracas Pottery of Ica: A Study in Style and Time*. University of California Publications in American Archaeology and Ethnology, 50. Berkeley: University of California Press.

Provenance: Collected by Pablo Soldi (Peru); Wielgus acquired from Alan Sawyer (Chicago) in 1958; acquired by Allen Wardwell from Wielgus; given to IUAM in 1990

Published: MPA 1960b, cat. no. 89

Exhibited: MPA 1960b, IUAM 1993

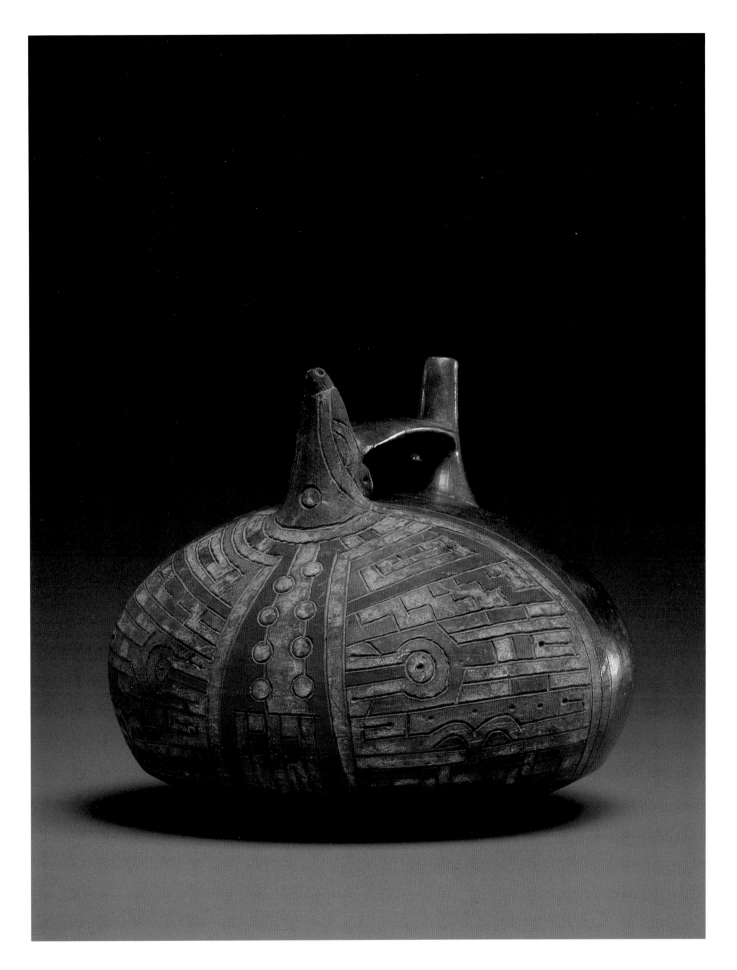

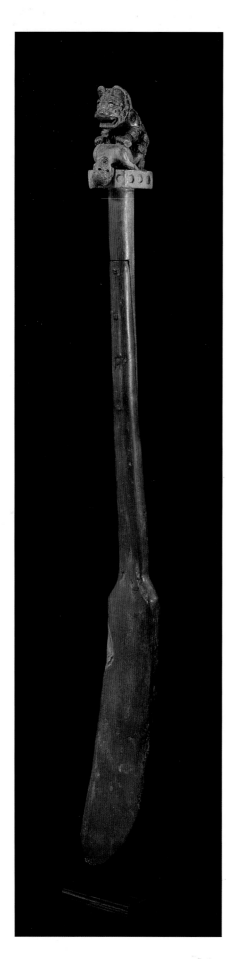

89

Moche culture, Peru

Ceremonial Digging Stick

A.D. 400-800
Wood, copper, resin
H. 54 in. (137.2 cm)
IUAM 100.8.5.75 (RW 62-237)

Pre-Columbian Peru is known for the large numbers of textiles and other objects in perishable materials that have survived in dry climates and cave burials. The Moche culture, however, which flourished along Peru's north coast between the fifth and ninth centuries A.D., was centered in an area where rains are frequent enough that few such objects have survived, making this ceremonial digging stick a rare artifact as well as a powerful sculpture. In fact, there are few more compelling images in the Wielgus Collection than this one of a jaguar clawing at the chest of a man whose head is thrown back in obvious agony. Carved in a realistic style for which the Moche culture is known, the figures occupy the top of what looks like a digging stick, an implement used in farming. However, their expressiveness suggests that this is a ritual, rather than a utilitarian, object, an idea perhaps confirmed by other digging sticks with carvings on the top that have been found in elite burials (Benson 1972, pl. 7). We cannot be certain if such sticks had a function outside burial contexts, although this one has what seems to be an ancient repair, suggesting that the piece may have been an heirloom (Elizabeth Benson, personal communication, 1977).

The jaguar was a significant creature in Pre-Columbian cultures of both Mesoamerica and Peru. Admired for its strength and cunning and associated with waterways that sustained life, the animal has also been associated with the supernatural world, particularly the transformative powers of priests. Among the Moche, the jaguar was an animal closely associated with at least two important deities, the creator god

and another god. This other god, perhaps a second aspect of the creator, depicted with feline fangs and a jaguar headdress, is occasionally accompanied by a jaguar and was believed to be active in human affairs.

Although we are not certain what the carving on this staff means, Elizabeth Benson (1974, 25-29), a noted Pre-Columbian scholar, suggests that it may refer to the defeat of enemy warriors by the Moche. After capture, defeated warriors were presented to the chief priest and/or political leader, who wore the costume of the feline deity. In addition, the warriors may have been sacrificed by jaguars, either real ones held in captivity or humans wearing jaguar costumes. In either case, the significance of the jaguar would have extended beyond the animal itself to its identification with the Moche people and therefore would have been a symbol of the power of the Moche and their gods in vanquishing all opponents.

The circular depressions on the jaguar — recalling its spotted pelt — and on the platform probably held shell or stone inlays. Though earlier published illustrations of this object (for example, Anton 1972, pl. 156; 1973, pl. 107) show inlays of mother-of-pearl, they were modern replacements that have been removed.

References cited

Benson, Elizabeth P. 1972. *The Mochica: A Culture of Peru*. New York: Praeger.
————. 1974. *A Man and a Feline in Mochica Art*. Studies in Pre-Columbian Art and Archaeology, 14. Washington, D.C.: Dumbarton Oaks.

Provenance: Acquired from Carmen Oechsle (Switzerland) in 1962

Published: Anton 1959, pl. 21; Rautenstrauch-Joest-Museum 1959, pl. 8; Anton 1962, pl. 49; Arts Club 1966, cat. no. 87; Disselhoff 1966, fig. 30; Anton and Dockstader 1968, 191; Anton 1972, pl. 156; 1973, pl. 107; Benson 1974, fig. 18; Donnan 1978, fig. 45; *Primitive Art* 1979, 191 (ill.); IUAM 1986, cat. no. 35 (ill.); IUAM [1989a], 34 (ill.)

Exhibited: Cologne 1959, Arts Club 1966, Guggenheim 1968, UCLA 1978, IUAM 1993

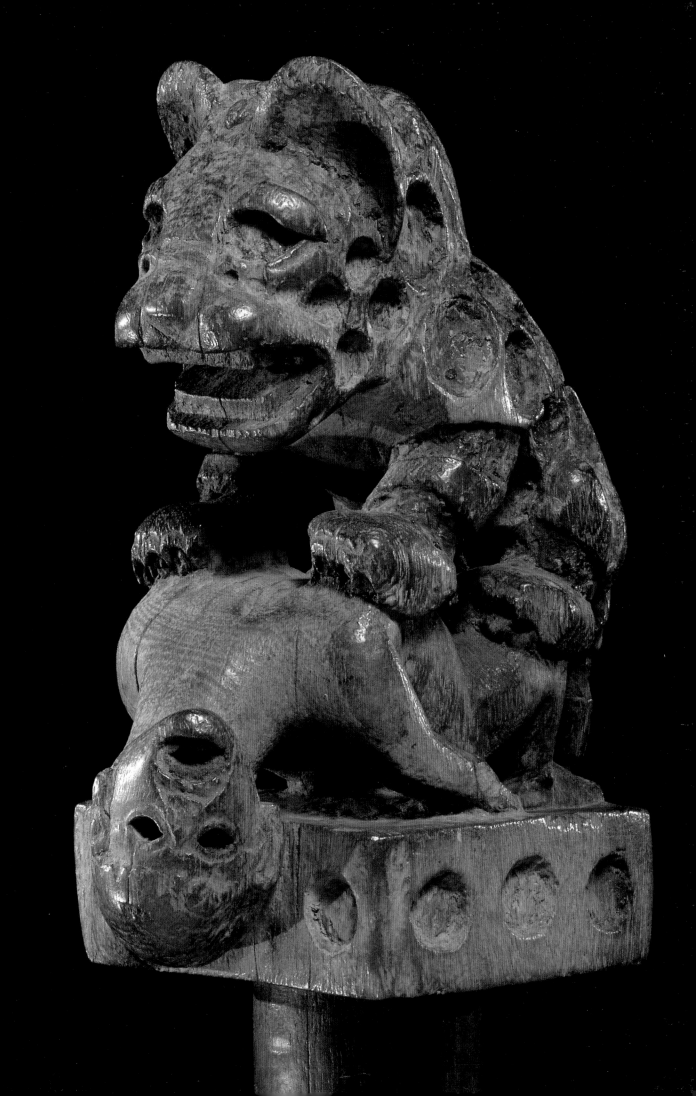

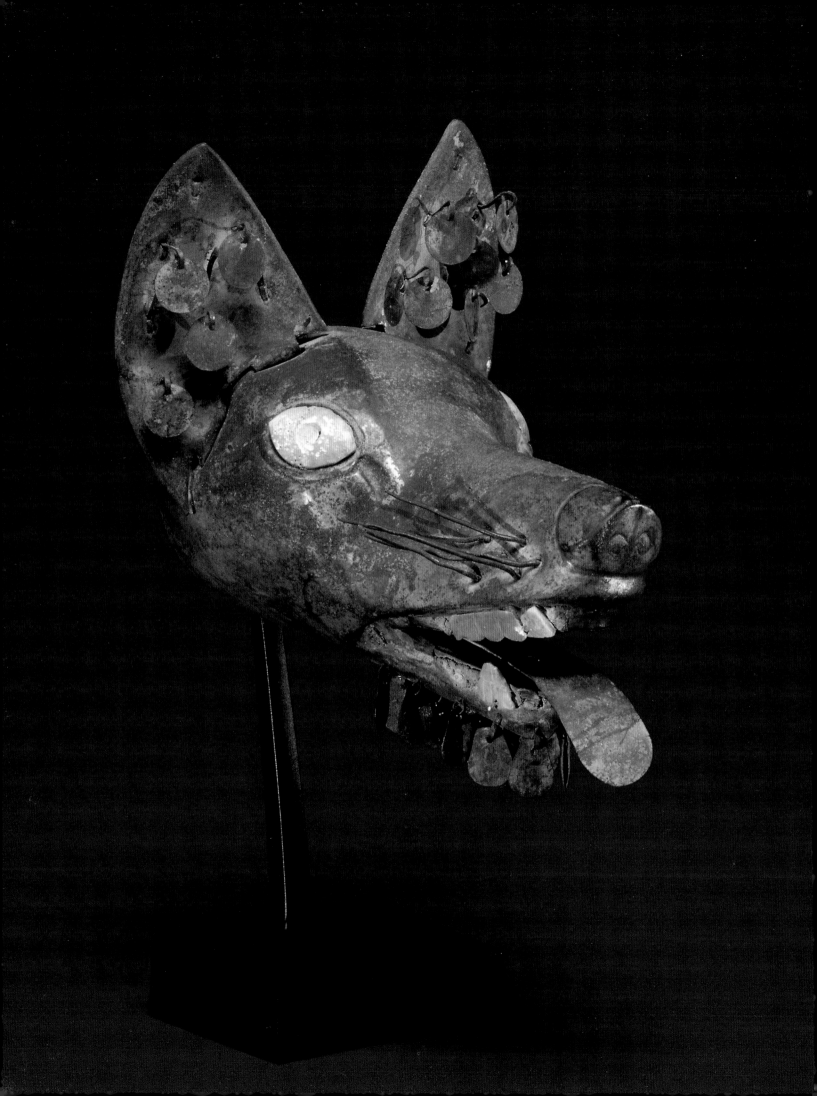

90

Moche culture, Peru

**Headdress Element in the Form
of a Fox Head**

A.D. 400-800
Copper, silver wash, shell
L. 6 in. (15.2 cm)
IUAM 100.26.5.79 (RW 65-267)

The realism for which the Moche are known is apparent here in a less threatening depiction than the ceremonial digging stick's jaguar and man (cat. no. 89). The Moche considered the fox, here complete with lolling tongue, a lunar symbol because of its nocturnal habits and admired the animal for its cunning and agility (Anton 1972, 29; *Primitive Art* 1979, 189).

The Moche have long been considered master metalsmiths, a belief that has been reinforced by the recently publicized finds in the tombs of Sipán (see cat. no. 91), where a fox head very similar to this one was found. This head is made of sheet copper that was covered with a very thin coating of silver; such silvering, as well as gilding, are characteristic of much Moche metalwork, and several different techniques were used. On this example, the silver was applied to the copper using a sophisticated electrochemical plating technique, and then the surface was heated to permanently bond the silver to the copper (Lechtman, Erlij, and Barry 1982). Other common techniques were depletion gilding and surface fusion. In the first, alloys of gold, silver, and copper were used in a process by which repeated hammering and annealing caused the copper and silver to rise to the surface, from which it could then be chemically removed. For surface fusion, either gold foil was hammered onto a copper surface, which was then heated, melting the two metals together, or molten gold was spread over the surface with the same result (Morris and Von Hagen 1993, 221).

Like most Moche objects that were gilded or silvered, most of the coating on this object is now gone. The way the pieces of metal are attached to each other by means of tabs and slots, not by soldering or welding, is also typical.

We are not certain how this fox head was used, but its open back and the similar head found at Sipán suggest that it was probably part of a headdress. Animal headdresses number among the variety of headgear worn by the Moche, which ranged from small cloth beanies to copper helmets to bird headdresses made from feathers (Benson 1972, 108). This fox head would have made a dramatic headdress: the shell teeth and wire whiskers add realistic detail, the small disks on the ears and chin would have caught the light and tinkled when the headdress moved, and the tongue is designed so that it moves freely (for a construction diagram, see Alva and Donnan 1993, 184). Fox heads such as this have been found over a wide area of Moche territory, from Loma Negra in the north to Sipán in the central region and the Huaca de la Luna in the Moche Valley toward the south.

References cited

Alva, Walter, and Christopher B. Donnan. 1993. *Royal Tombs of Sipán*. Exhibition catalogue. Los Angeles: Fowler Museum of Cultural History.
Anton, Ferdinand. 1972. *The Art of Ancient Peru*. Translated by Mary Whittall. Rev. ed. London: Thames and Hudson.
Benson, Elizabeth P. 1972. *The Mochica: A Culture of Peru*. New York: Praeger.
Lechtman, Heather, Antonieta Erlij, and Edward J. Barry, Jr. 1982. "New Perspectives on Moche Metallurgy: Techniques of Gilding Copper at Loma Negra, Northern Peru." *American Antiquity* 47, no. 1 (January): 3-30.
Morris, Craig, and Adriana Von Hagen. 1993. *The Inka Empire and Its Andean Origins*. New York: Abbeville Press.
Primitive Art. 1979. By Ferdinand Anton, Frederick J. Dockstader, Margaret Trowell, and Hans Nevermann. New York: Harry N. Abrams.

Provenance: Acquired from Walter Randel (New York) in 1965

Published: Arts Club 1966, cat. no. 88 (ill.); IUAM 1986, cat. no. 36 (ill.); Bierhorst 1988, 231 (ill.)

Exhibited: Arts Club 1966, IUAM 1993

91

Moche or Chimú culture, Peru

Finial in the Form of a Bird

Copper, shell
H. 4 1/2 in. (11.4 cm)
IUAM 94.222 (RW 57-90)

The arts of Pre-Columbian Peru are known primarily through offerings that were placed in tombs, such as those belonging to the great Lords of Sipán. While we do not know the context in which this charming finial was found, we can assume that it too was owned by a person of importance and may have accompanied him to his grave.

Until the discovery of the Sipán tombs, most people probably knew the Moche best for their lifelike ceramic portrait vessels. The naturalism, delicacy, and fine craftsmanship of the bird recall similar characteristics in the pottery. However, as the fox head (cat. no. 90) and this finial show, the Moche were also outstanding metalworkers in copper, silver, and gold. These metals were considered precious not only by the Moche but also by other Pre-Columbian Peruvian peoples. However, Moche metallurgy was unsurpassed by any peoples before or after them, and their techniques were also used by their north-coast descendants, the Chimú.

Birds are a frequent theme in Moche art. This one's long, straight beak indicates that it is a hummingbird. That bird, sometimes in anthropomorphized form, is usually portrayed as a warrior or runner (Benson 1972, 52). Moche warriors were associated with various animals and birds, which, presumably, had characteristics considered important for warriors to possess, too. One can imagine that a hummingbird's quickness would be one of those characteristics. Likewise, their depiction as messengers or runners probably drew on the same associations.

The bird's rich green surface is a patina that has developed over the centuries. Though its original appearance would have been quite different, the warm color of copper would have provided the same sort of contrast between metal and shell that makes the piece so appealing today.

Reference cited

Benson, Elizabeth P. 1972. *The Mochica: A Culture of Peru*. New York: Praeger.

Provenance: Acquired from Chan Kan (Lima, Peru) in 1957

Published: AIC 1957b, 34 (ill.); MPA 1960b, cat. no. 102; *Christian Science Monitor* 1961, C: 1; Arts Club 1966, cat. no. 85; *Horizon* 1962, frontis.; IUAM 1986, cat. no. 39 (ill.)

Exhibited: AIC 1957b, MPA 1960b, AMNH 1961, Arts Club 1966, IUAM 1993

92

Huari/Tiwanaku culture, Peru

Lime Container

Ca. A.D. 800
Wood, stone, shell, bone, reed
H. 3 3/8 in. (8.6 cm)
Raymond and Laura Wielgus Collection
(RW 64-254)

The delicate complexity of this lime container suggests that, like the Maya pendant (see cat. no. 81), this object was created for a member of its society's elite. Flourishing between A.D. 600 and 900, the Huari empire, with a capital of the same name, spread over large areas of coastal Peru and was closely related to another, more inland culture called Tiwanaku, which was centered in the area of Lake Titicaca, Bolivia.

The container was part of the paraphernalia associated with coca chewing, an ancient practice by which very small amounts of cocaine are released into the body from coca leaves, creating a mild state of euphoria, decreased appetite, and increased physical endurance (see cat. no. 60). Although we cannot be sure why coca was chewed in Pre-Columbian times, some evidence suggests that it may have been reserved for male use and taken particularly during religious activities. The leaves were not actually chewed; instead a man stuffed dried leaves into his cheek, added a small amount of lime (often made from shells), and sucked the leaves to extract the cocaine (Jones 1974, I, 5).

The dried coca leaves were stored in a cloth bag, often luxuriously woven, while the lime was kept in a container and removed with a narrow spatula or spoon that might be made of copper, gold, or silver and ornamented with finials depicting birds, animals, and humans. Though many lime containers were plain gourds or other simple vessels, some, including this one, were elaborately made; the Huari and Tiwanaku cultures were especially

known for their fine stone and shell inlays.

The image resembles a bat, but whether that, some fantastic animal, or even a deity was intended, we are not sure. Among the earlier Moche, bats were associated with sacrifice and ritual (Benson 1972, 52).

References cited

Benson, Elizabeth P. 1972. *The Mochica: A Culture of Peru*. New York: Praeger.
Jones, Julie. 1974. *Rituals of Euphoria: Coca in South America*. Exhibition catalogue. New York: Museum of Primitive Art.

Provenance: Ex-coll. Julius Carlebach (New York); acquired from Harry Zelenko (New York) in 1964

Published: Arts Club 1966, cat. no. 89 (ill.); Jones 1974, fig. 26; Pelrine 1993, ill. 13

Exhibited: Arts Club 1966, MPA 1974, IUAM 1993

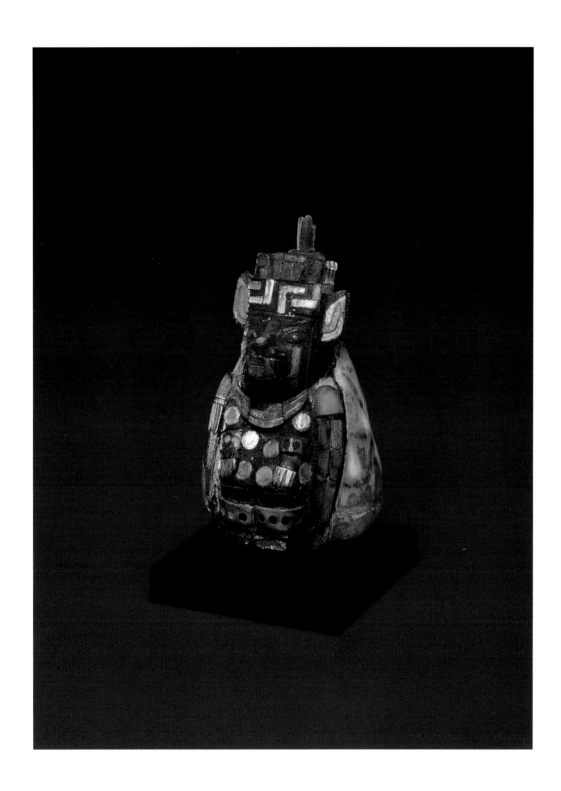

93

Sicán culture, Lambayeque Valley, Peru

Earspool

A.D. 900-1375
Gold
Diam. 4 1/4 in. (10.8 cm)
Raymond and Laura Wielgus Collection
(RW 58-101)

After the Moche, the Lambayeque Valley was dominated by a culture known as Sicán that reached its height between A.D. 900 and 1100 and then was incorporated into the Chimú kingdom around 1375. Sicán's major ceremonial site was Batán Grande, near which many metalworking sites have been found. Like their Moche predecessors, lords and other important people were buried in lavishly appointed tombs, many of which have been looted by individuals searching for the fabulous gold objects for which the Sicán culture is known. The Sicán often seemed to emphasize quantity rather than quality in their gold production, for many pieces feel rather flimsy and look as if they were mass produced. However, in general earspools are among the most finely made objects, and this one is a beautifully worked example.

This earspool illustrates several techniques used by Pre-Columbian gold workers. It is made from annealed gold sheets, sheets that were alternately hammered and heated to achieve a desired shape and thickness. Because of the metal's properties, repeated hammering creates a phenomenon known as strain hardening, whereby the gold no longer stretches from blows with the hammer, but instead becomes more brittle and eventually cracks. Heating it restores its malleability, enabling a piece of the metal to be pounded into the desired shape and thickness. Annealing requires skillful judgment, for the metal must be made hot enough to become malleable, but not so hot that it begins to melt (Emmerich 1965, 158). Repoussé decoration — relief patterning created by hammering or pushing from the back — can be seen on the earspool disk, while motifs have been cut into, or incised, on the shaft.

Bird and water imagery dominates. At the center of the disk is a bird on a reed raft, holding a fish with one foot. Around that bird are other figures with bird heads and human bodies who are also on rafts or boats. These bird-headed creatures are repeated on the earspool's shaft. Although we do not know their significance, anthropomorphized birds were depicted as warriors and as messengers and assistants to humanized deities or rulers among both the Moche and Chimú. The Moche also depicted similar boats, made of bundles of reeds tied together; such boats are still used by some Peruvian fishermen today.

What looks like the mate to this earspool is in the Museo Nacional de Antropología y Arqueología in Lima, Peru (*Treasures* 1965, cat. no. 84), and was said to have been found at Batán Grande. Among the later Incas, the wearing of earspools was restricted to the nobility, and gold ones were worn only by those of the highest rank. Unlike many ceramics and other gold objects, such as funerary masks, earspools such as these would have marked a living man as from the top echelons of society. The shaft of each earspool passed through pierced and enlarged earlobes and were held in place by a thread that passed across the back of the head and was attached to a hole in each shaft.

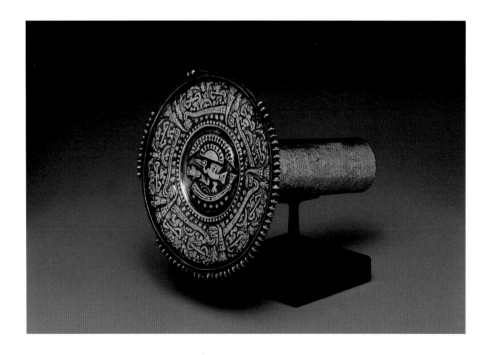

References cited

Emmerich, André. 1965. *Sweat of the Sun and Tears of the Moon: Gold and Silver in Pre-Columbian Art*. Seattle: University of Washington Press.
Treasures of Peruvian Gold: An Exhibition Sponsored by the Government of Peru. 1965. Exhibition catalogue. Washington, D.C.: National Gallery.

Provenance: Acquired from Nasli Heeramaneck (New York) in 1958

Published: MPA 1960b, cat. no. 104; Los Angeles County Museum 1964, pl. 187; Arts Club 1966, cat. no. 83 (ill.); Wardwell 1968a, cat. no. 15 (ill.)

Exhibited: MPA 1960b, Los Angeles 1964, Arts Club 1966, MFA 1968 (Chicago only), Tucson 1975, IUAM 1993

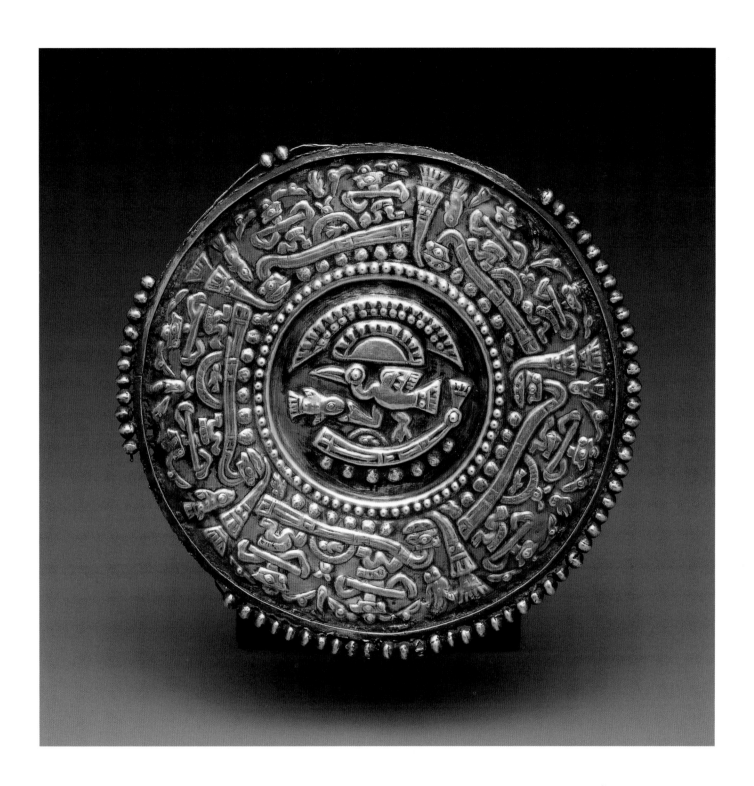

94

Lambayeque Valley, Peru

Whistling Jar with Bridged Spout

A.D. 800-1200
Clay, slip
H. 9 in. (22.9 cm)
IUAM 75.99.3 (RW 58-107)

In addition to their fine goldworking (see cat. no. 93), craftsmen from the Lambayeque Valley around the turn of the millennium were known for their pottery, which combined aspects of their Moche heritage with local preferences to create ceramics that are both elegant and refined. Lambayeque ceramics show the same naturalistic modeling and sensitivity for which the Moche are known. However, the linear painting that decorates many Moche pots is not nearly as usual. In addition, double-chambered pots, which had not been popular among the Moche for five hundred years, are common. Press molds, first developed by the Moche, were used extensively. Unlike the Moche, who painted their pottery, however, these later artists preferred plain blackware, such as this vessel. Its flat, ribbonlike bridge between the head of the animal — probably a dog or other canine — and the plain, elongated spout are also typical of the Lambayeque style (Bawden and Conrad 1982, 64; Donnan 1992, 90-92).

This vessel is a whistling jar; that is, when a person blows across the spout or when the vessel is partially filled with liquid and tilted, it makes a whistling sound. The sound is created by a mechanism consisting of a tube and a hollow sphere with a small opening. When air directed from the tube blows across the opening in the sphere, it resonates, creating the sound. On most vessels, this mechanism was incorporated into the sculptural form on top, and the pot would whistle when a person blew across the spout. Tipping a double-chambered vessel, such as this one, when it was at least half full of liquid would displace air in the chamber with the whistling mechanism, thus also creating the sound. Whistling jars probably originated to the north, but were known in Peru by 1000 B.C. (Donnan 1992, 23).

The dark color was created during the firing process. Like other ceramics, this piece was placed in a shallow pit and covered by fuel, usually wood, which was then heated. During firings in which an orange or buff color was desired, the vessels were simply heated in this way. Creating pottery that ranged from dark gray to black, however, required an additional step in which more fuel was added and the pot was covered with sand or dirt. Unlike the earlier stage, when oxygen could circulate around the pottery, its level was reduced at this point and a heavy smoke formed, which made the pottery black by driving carbon into the walls of the vessel (ibid., 20).

References cited

Bawden, Garth, and Geoffrey W. Conrad. 1982. *The Andean Heritage.* Cambridge, Mass.: Peabody Museum Press.
Donnan, Christopher B. 1992. *Ceramics of Ancient Peru.* Los Angeles: Fowler Museum of Cultural History.

Provenance: Acquired from Lou Sturmer (Peru) in 1958

Published: MPA 1960b, pl. 17; Arts Club 1966, cat. no. 84; IUAM 1980, 253 (ill.); IUAM 1986, cat. no. 37 (ill.)

Exhibited: MPA 1960b, AMNH 1961, MPA 1962, Arts Club 1966, IUAM 1993

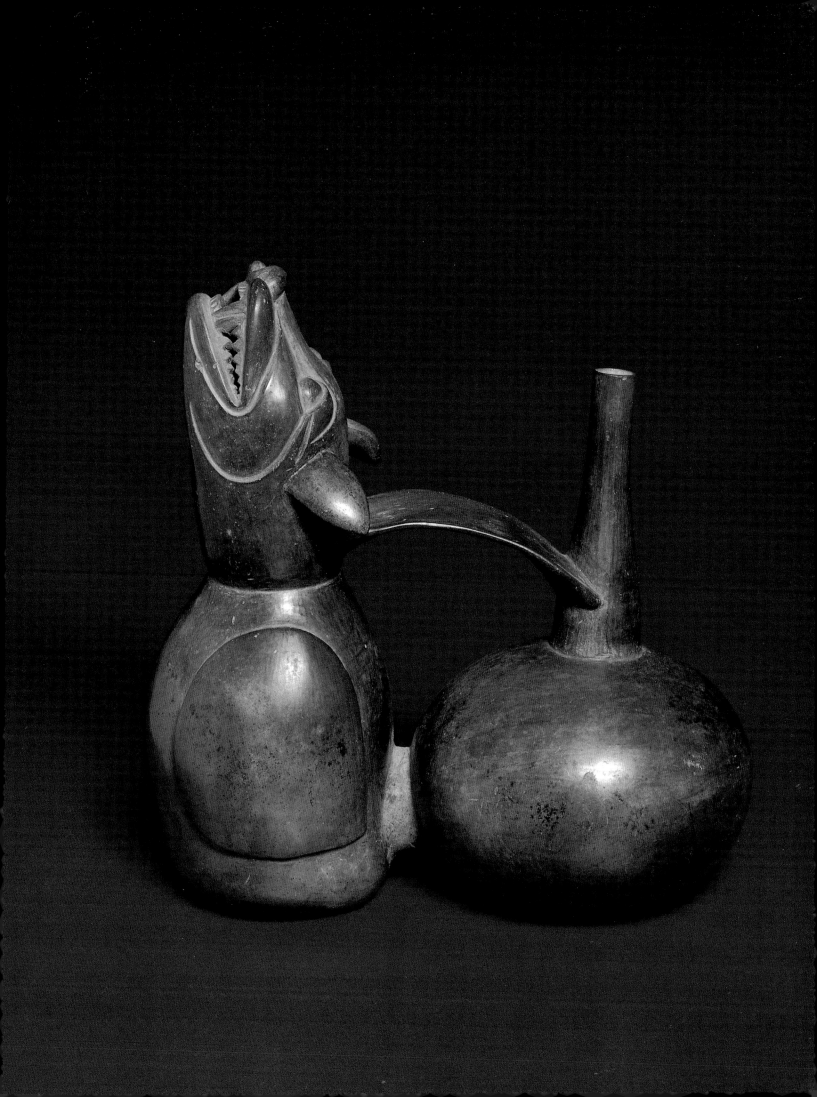

95

Wishram/Wasco peoples,
Washington/Oregon

Adze

Elk antler, rawhide, steel, brass
L. 11 5/8 in. (29.5 cm)
Raymond and Laura Wielgus Collection
(RW 65-262)

By conscious choice, most objects in the Wielgus Collection have few visual indications of the contact with European and Euro-American societies that so transformed the cultures of Africa, Oceania, and the Americas. The Admiralty Islands war charm (cat. no. 49), with its glass beads, is one example, as is this adze from the area of the Columbia River in North America.

The Wishram and Wasco peoples formerly lived across from each other along the middle Columbia River in the vicinity of The Dalles, with the Wishram living on the north bank and the Wasco on the south. (Today, many Wishram live on the Yakima Reservation in Washington, and the Wasco are primarily on the Warm Springs Reservation in Oregon.) The two groups are closely related, being the easternmost Chinookan peoples along the river and speaking basically the same language. Both had settlements on the Columbia, which they fished extensively, but they also hunted and gathered plants from higher ground.

Both the Wishram and the Wasco served as middlemen in the enormous trade that took place in this area (Spier and Sapir 1930, 153; Zucker, Hummel, and Hogfoss 1983, 58). Even before 1700, this trade covered a wide area, with local products, such as fish, from the lower Columbia, the coast, and southern Oregon being traded for goods from the eastern and northern interior. From about 1700, European trade goods began trickling into the area, and then, after the Euro-American discovery of the Columbia River in 1792 and Lewis and Clark's journey up and down the river in 1805-6, direct contact with whites and their goods was established.

This adze is clearly a result of such trade, for the blade is imported steel. Its form is a straight adze; that is, one in which the blade is in line with the handle, rather than perpendicular to it, as is more commonly the case. These tools were used by the Wishram and Wasco for a variety of purposes, including carving at least the basic forms of wooden objects.

Though the blade was imported, the elk-antler handle was certainly local. Elk, along with deer, were among the animals frequently sought by Wishram and Wasco hunting parties. According to tradition, the man who had killed the animal was entitled to its hide and antlers, though the rest of it might be divided among the hunters if only it had been killed.

The image on the handle is a figure with human and animal characteristics. It may refer to a particular spirit with whom the owner was associated. Among the Wishram and, presumably, the Wasco, people believed that the spirits of animals, birds, reptiles, fish, and insects could protect individuals from harm and illnesses. As children, individuals could learn through dreams or visions which spirits would help them during their lives. Although a person did not verbally reveal who his or her spirit was, certain clues, such as patterns of behavior and dance-costume elements, indicated its identity to others (Spier and Sapir 1930, 236).

References cited

Spier, Leslie, and Edward Sapir. 1930. "Wishram Ethnography." *University of Washington Publications in Anthropology* 3, no. 3: 151-300.
Zucker, Jeff, Kay Hummel, and Bob Hogfoss. 1983. *Oregon Indians: Culture, History and Current Affairs*. Portland, Oregon: Western Imprints.

Provenance: Ex-coll. James Hooper (London); acquired from J.J. Klejman (New York) in 1965

Published: Arts Club 1966, cat. no. 64 (ill.); *Chicago Tribune* 1970, 1A: 1 (ill.); Feder 1971, pls. 144, 144a

Exhibited: Arts Club 1966, IUAM 1993

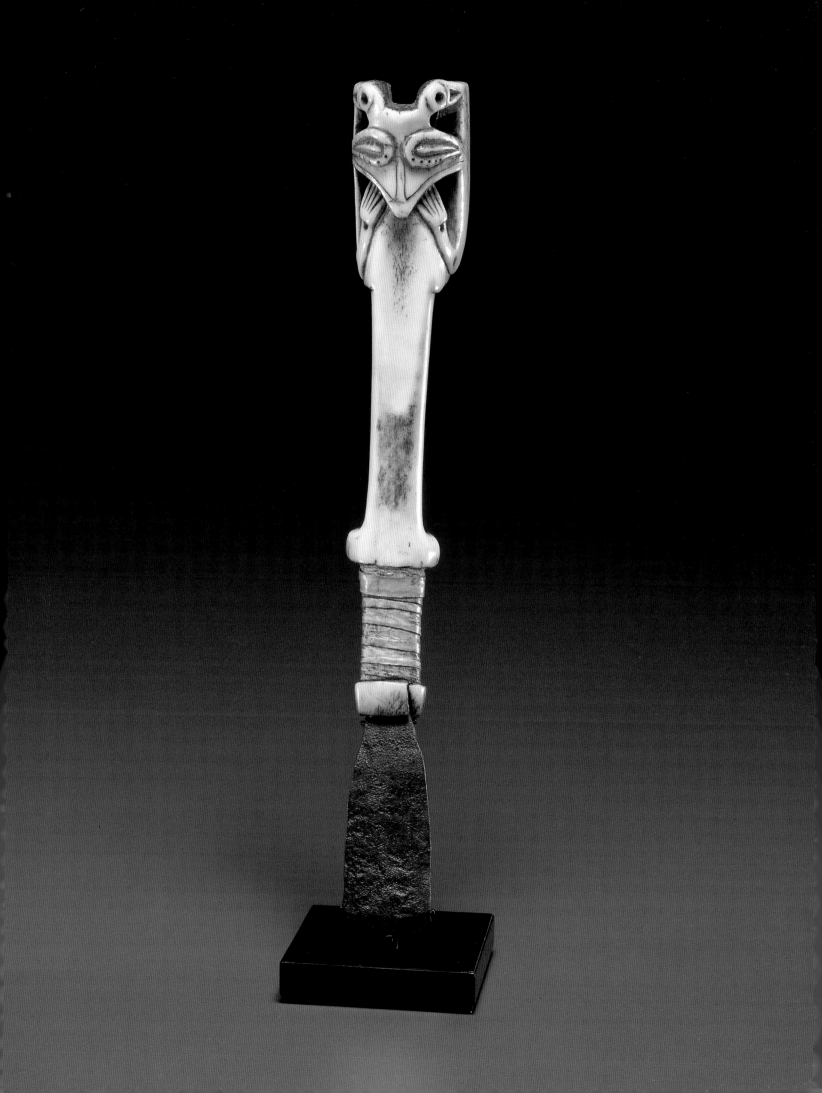

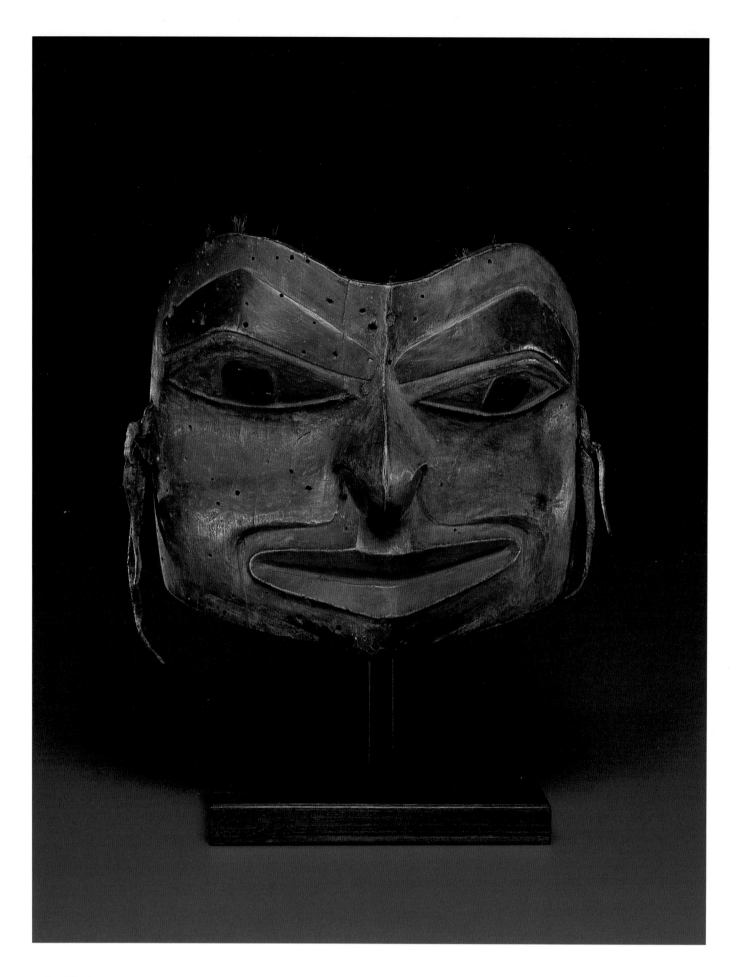

96

Tlingit peoples, British Columbia,
Canada

Headdress Ornament

Wood, pigment, buckskin
W. 6 7/8 in. (17.5 cm)
IUAM 77.25 (RW 55-2)

The Tlingit, like other peoples of the
Northwest Coast (the area stretching
south from Yakutat Bay in Alaska along
Canada's west coast to the northern
coast of Washington), are known for
their variety of masks and headdresses.
Most of these are wood, though conical
basketry hats woven with the same
imagery depicted on the wooden masks
and headdresses also might be worn
ceremonially and could achieve the
same status as their wooden counter-
parts (Holm 1983, 47). Some wooden
ones simply cover the face, while others
are helmets that fit over the entire head.
Still others are frameworks or visorlike
constructions that are worn on the fore-
head. The small size and lack of open-
ings through which one could see indi-
cate that this ornament was part of one
of these constructions.

Many of these masks and headdress-
es depict certain animals, including the
raven, eagle, hawk, killer whale, wolf,
bear, frog, and beaver, that have pro-
minent roles in the mythologies of fam-
ilies or clans and that were believed to
have intimate spiritual links to those
families with which they were associ-
ated. The rights to own and wear masks
depicting these animals were inherited
by family members and symbolized the
special ties between the family or clan
and a particular creature. The masks
were (and in some instances continue
to be) worn at social ceremonies meant
to demonstrate a family or clan's status
and wealth, at winter initiation cere-
monies, and at curing rituals presided
over by shamans.

This image is the hawk, identified by
the beak that curves down and then in-
ward, touching the face. It is typical of
the styles of the northern Northwest

Coast peoples, who include the Tlingit,
in its restrained simplicity and realistic
features. Though the hawk is not de-
picted as frequently as the raven or
eagle, distinguishing the three is gener-
ally easy: the raven has a long, straight
beak, while the eagle's beak is curved
with the tip pointing down but not
curving inward.

Although this mask represents a
hawk, it has clearly been anthropomor-
phized, for even the beak — the only
birdlike feature depicted — looks like a
nose when viewed frontally. Originally,
it would have appeared even more
humanlike, for the remnants of tufts
of fur or hair are visible above the fore-
head. Humanized birds and other crea-
tures are typical of Northwest Coast
art and have reference points. Some
Northwest Coast legends relate that in
the beginning all creatures looked like
humans, until the Transformer changed
them into particular species based upon
what they were doing at the time
(Stewart 1979, 34). Furthermore, the
humanizing of a creature associated
with a particular clan or family em-
phasizes the connection between the
two. Finally, such imagery also recalls
the powers that some people and
animals are believed to have that enable
them to transform themselves from
one state to the other.

Black, red, and blue-green, the colors
on this ornament, were traditionally the
only colors used on Tlingit woodcarv-
ings. Although commercial pigments
had become available by the early nine-
teenth century, local mineral-based
colors continued to be used. Black was
obtained from coal or charcoal, and red
from hematite, cinnabar, or iron oxide.
Blue-green, a color held in high regard,
is generally said to have been made
from a form of copper oxide, although
recent research suggests that it was
probably derived from iron potassium
silicate, also known as green earth or
green sand. These pigments were mixed
with chewed salmon eggs to produce a
tempera paint, which was applied using
brushes made from porcupine hair
bound to wooden handles (Emmons
1991, 196-97).

References cited

Emmons, George Thorton. 1991. *The Tlingit
Indians*. Edited with additions by Frederica de
Laguna. Seattle: University of Washington
Press.
Holm, Bill. 1983. *The Box of Daylight:
Northwest Coast Indian Art*. Exhibition cata-
logue. Seattle: Seattle Art Museum and Uni-
versity of Washington Press.
Stewart, Hilary. 1979. *Looking at Indian Art
of the Northwest Coast*. Seattle: University of
Washington Press.

Provenance: Ex-coll. Paul Eluard (Paris); ac-
quired from Julius Carlebach (New York) in
1955

Published: Hôtel Drouot [1931] 1972/73, fig.
194; *New York Times* 1960, 10: 11 (ill.); MPA
1960b, pl. 29 (mislabeled); Wardwell 1964,
cat. no. 59 (ill.); Arts Club 1966, cat. no. 59;
IUAM 1980, 255 (ill.)

Exhibited: MPA 1960b, AIC 1964, Arts Club
1966, IUAM 1993

97

Tlingit peoples,
Alaska / British Columbia

Shaman's Amulet

Ca. 1750-1800
Sperm-whale ivory
L. 4 3/8 in. (11.1 cm)
Raymond and Laura Wielgus Collection
(RW 67-282)

98

Tlingit peoples,
Alaska / British Columbia

Shaman's Amulet

Ca. 1820-50
Sperm-whale ivory
L. 6 9/16 in. (16.7 cm)
Raymond and Laura Wielgus Collection
(RW 60-197)

99

Tlingit peoples,
Alaska / British Columbia

Shaman's Amulet

Ca. 1830-50
White-tailed deer antler
L. 3 in. (7.6 cm)
Raymond and Laura Wielgus Collection
(RW 65-263)

The Northwest Coast shaman was both priest and healer, someone intimately connected with the spirits of animals and humans inhabiting the supernatural world. A shaman cured illnesses (by exorcising the spirits), advised chiefs during battles, and acted to ensure the well-being of communities (Emmons 1991, 370-71). Among his paraphernalia were masks, rattles, and amulets like these, made of bone, antler, and ivory, which were worn around his neck and attached to his clothing. Such amulets were believed to be capable of driving away evil spirits.

The depictions on the amulets refer to visions that appeared to the shaman while dreaming or in a trance, or they represent animal and/or human spirits with whom he had a particularly close relationship. Shamans might carve the amulets themselves or commission an artist to make them according to individual specifications (ibid., 376).

Catalogue number 97 depicts an otter which, like the shaman, is able to exist in more than one realm. The land otter was also a spirit associated with most shamans (ibid., 371). According to Allen Wardwell (personal communication, August 1993), a leading authority on these amulets, its dark patina, the evidence of wear, and the simplified details suggest an early date, perhaps even as early as the beginning of the eighteenth century. Its period of manufacture is most certainly precontact, a term referring to the years before the voyage of James Cook to the Northwest Coast in 1778, which marks the beginning of extensive European and American contact.

The intricate combination of human and animal forms in catalogue number 98 also suggests the complexity for which much Northwest Coast art is known. The major motif is a sea monster or marine mammal devouring a human, likely a reference to the shaman's powers of transformation which enabled him to take the form of the animals with whom he had a special relationship. Birds, a bear, other humans, and perhaps a frog are intertwined with the sea creature, all images presumably meaningful to the shaman who owned the amulet (Allen Wardwell, personal communication, 1993).

Transformation is also the theme of catalogue number 99, in which the form of the material, a branching antler, is reflected in the form of the sculpture. The main figure, which probably represents a shaman, is shown either riding on a bear or emerging from its head; both interpretations suggest the special relationships that shamans had with animal spirits. In addition, above the figure's head is a smaller head with its eyes closed, a reference to sleep, death, or a trance state, all realms in which a shaman was able to travel (Wardwell 1993). Finally, the charm's silhouette evokes traditional depictions of the killer whale, a Tlingit totem and an animal connected to the shaman in myth (Maurer 1977, 308).

When a shaman died, he was interred in a grave house with objects he had used in his practice. These grave houses were believed to become focal points for powerful spirits that had aided shamans during their lifetimes, and most people therefore avoided them. Living shamans, however, particularly those who had been trained by the deceased or were related to him, might enter the grave houses and retrieve objects that they then used in their own practices. In this way, amulets such as these were used for several generations.

References cited

Emmons, George Thorton. 1991. *The Tlingit Indians*. Edited with notes by Frederica de Laguna. Seattle: University of Washington Press.
Maurer, Evan M. 1977. *The Native American Heritage: A Survey of North American Indian Art*. Chicago: Art Institute of Chicago.
Wardwell, Allen. 1993. "Tangible Visions: Tlingit Amulets." Lecture (November), Indiana University Art Museum.

Cat. no. 97

Provenance: Acquired from Merton Simpson (New York) in 1967

Published: Delataille 1992, fig. 29; Wardwell 1995, no. 260

Exhibited: Brussels 1992, IUAM 1993

Cat. no. 98

Provenance: Collected by Rev. Robert Doolan before 1900; ex-colls. Harry Beasley, G.T. Emmons; acquired from J.J. Klejman (New York) in 1960

Published: Emmonds [i.e., Emmons] and Miles 1939, pl. 19, fig. 1; MPA 1960b, cat. no. 65 (ill.); Wardwell 1964, cat. no. 136 (ill.); Burland 1965, 5253; Arts Club 1966, cat. no. 60; Wardwell 1968b, fig. 1; Maurer 1977, pl. 28, fig. 484; Pelrine 1993, ill. 14; Wardwell 1995, no. 202

Exhibited: MPA 1960b, AIC 1964, Arts Club 1966, AIC 1977, IUAM 1993

Cat. no. 99

Provenance: Acquired from J.J. Klejman (New York) in 1965

Published: Arts Club 1966, cat. no. 62 (ill.); Maurer 1977, fig. 485; Wardwell 1995, no. 256

Exhibited: Arts Club 1966, AIC 1977, IUAM 1993

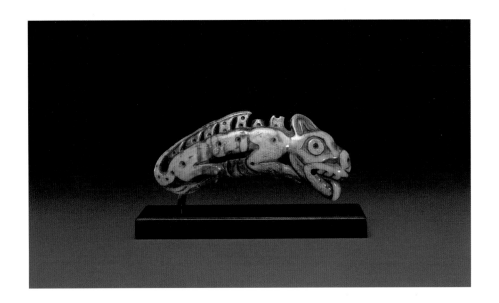

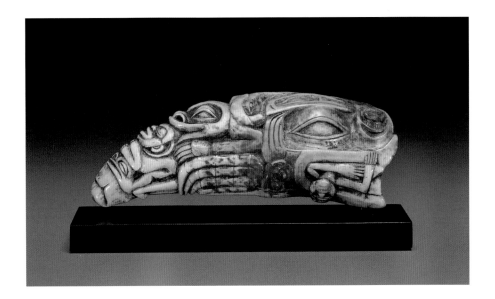

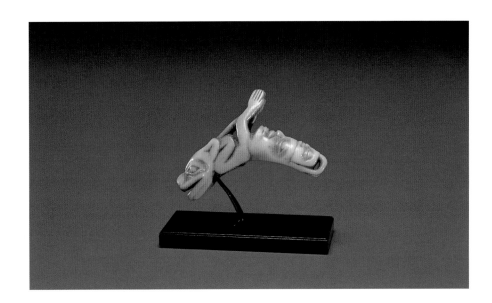

Inuit peoples, Alaska

Toggle in the Form of a Figure

Nineteenth century (?)
Sperm-whale ivory
H. 1 3/4 in. (4.4 cm)
Raymond and Laura Wielgus Collection
(RW 55-3)

Although the Inuit, or Eskimo, peoples live in one of the harshest environments in the world, their resourcefulness and creativity, whether in the form of inventions, such as the parka and kayak, or of objects that resemble contemporary mainstream sculpture, are much admired. Objects made from ivory have been found among the earliest Inuit remains, and ivory carving continues to this day, albeit most often in the form of sculptures and other items such as cribbage boards that can be sold on the tourist market.

For their traditional way of life, though, Inuit men carved many different types of ivory objects. Small figures; jewelry, including hair ornaments and earrings; combs; pipes and snuff tubes; sewing equipment, such as needle cases and bodkins; and a variety of tools and implements, including arrow-shaft straighteners, harpoon sockets, handles, skin scrapers, fish lures, and toggles, sometimes very artfully worked, are just some of the things that were created from whale and walrus ivory (Collins et al. 1977, 18). The hole through this figure's torso and wear patterns around it indicate that it was a toggle, a device used to fasten garments or bags together by means of a double cord that passed through the hole.

Miniature figures of people and animals are common and may relate to a belief that the soul of any creature, whether animal or human, is a miniature version of that creature and resides in its bladder (Furst and Furst 1982, 141). While animals are often depicted in great detail, human figures frequently display the simplification and lack of detail seen on this figure. We are not sure why, but the reason may be connected with the desire to make certain that the spirits of animals feel properly acknowledged and respected so they will look favorably upon people and continue to allow themselves to be killed for food.

Traditional Inuit believe that an object contains some of the essence of the material from which it was made. Thus, an object such as this one carved from whale ivory contains some of the spirit of the whale. It therefore would be highly regarded, for the importance of that animal to the Inuit of Alaska is demonstrated in a cluster of beliefs and practices concerning its hunting which continue to play a significant role in daily life beyond the whaling season and into the winter months (ibid., 140-41).

References cited

Collins, Henry B., Frederica de Laguna, Edmund Carpenter, and Peter Stone. 1977. *The Far North: 2000 Years of American Eskimo and Indian Art*. Bloomington, Ind.: Indiana University Press in Association with the National Gallery of Art.
Furst, Peter T., and Jill L. Furst. 1982. *North American Indian Art*. New York: Rizzoli.

Provenance: Acquired from J.J. Klejman (New York) in 1955

Published: MPA 1960b, cat. no. 62; Arts Club 1966, cat. no. 57 (ill.); *Chicago Tribune* 1970, 1A: 1 (ill.); Maurer 1977, fig. 532

Exhibited: MPA 1960b, Arts Club 1966, AIC 1977, IUAM 1993

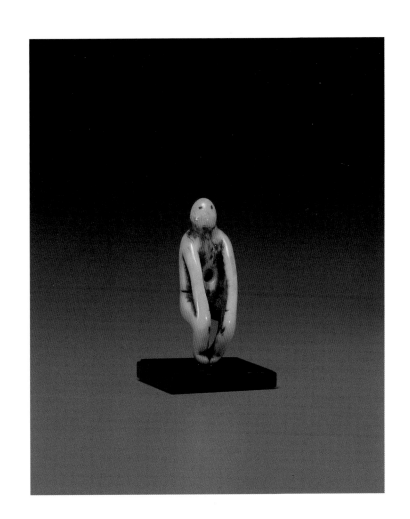

Ex-Collection Objects

The following list is not comprehensive, including only the most significant ex-Wielgus Collection objects. Most of these have Wielgus numbers (RW 64-255, for example); the first two digits of those numbers indicate the year an object entered the collection (in the previous example, 1964). Where available and/or known, the most recent published illustration is indicated. In a few cases where no published illustration is known, "Pub." indicates that the object is only part of a catalogue checklist.

Africa

Dogon, Mali
Figure
Wood
H. 31 1/2 in. (80 cm)
Provenance: acquired from Frumkin (RW 58-104)
Current location: private collection
Ill.: MPA 1960b, pl. 22

Dogon, Mali
Figure
Wood
H. 13 1/2 in. (34.3 cm)
Provenance: acquired from Klejman (RW 55-22)
Current location unknown
Ill.: Layton 1957, cat. no. 6

Dogon, Mali
Mask, *Satimbe*
Wood, pigment, fiber
H. 39 3/4 in. (101 cm)
Provenance: acquired from Klejman (RW 55-10)
Current location: private collection
Ill.: Robbins and Nooter 1989, fig. 4

Dogon, Mali
Female Figure
Wood
H. 16 1/4 in. (43.1 cm)
Provenance: acquired from Klejman (RW 55-11)
Current location: Metropolitan Museum of Art, New York
Ill.: Allen Memorial Art Museum 1955, pl. 7

Dogon, Mali
Figure
Wood, incrustation
H. 10 3/8 in. (26.4 cm)
Provenance: acquired from Klejman (RW 56-48)
Current location: private collection
Pub.: AIC 1957a, cat. no. 5

Bamana, Mali
Antelope Headdress, *Ci Wara*
Wood
H. 31 in. (78.7 cm)
Provenance: acquired from Segy (RW 55-21)
Current location unknown
Ill.: AIC 1957a, cat. no. 15

Bamana, Mali
Mask for Kono Society
Wood, incrustation
H. 35 in. (88.9 cm)
Provenance: acquired from Frumkin (RW 56-34)
Current location: private collection
Ill.: Robbins and Nooter 1989, fig. 66

Baga, Guinea
Altar Piece, *Elek*
Wood
H. 23 1/2 in. (59.7 cm)
Provenance: acquired from Klejman (RW 57-76)
Current location: Art Institute of Chicago
Ill.: Portland Museum of Art 1971, cat. no. 11

Senufo, Côte d'Ivoire
Figure, *Kafigueledio*
Wood, cloth, feathers, fiber, iron
H. 32 1/2 in. (82.5 cm)
Provenance: acquired from Frumkin (RW 57-97)
Current location: Metropolitan Museum of Art, New York
Ill.: MPA 1964b, pls. 19, 20

Baule, Côte d'Ivoire
Figure
Wood
H. 22 1/2 in. (57.2)
Provenance: ex-coll. Derain; acquired from Frumkin (RW 55-14)
Current location: Art Institute of Chicago
Ill.: Portland 1971, cat. no. 31

Akan, Ghana
Goldweight in the Form of Two Figures
Brass
H. approx. 1 1/2 in. (3.8 cm)
Provenance: acquired from Segy (RW 55-20)
Current location: Art Institute of Chicago

Akan, Ghana
Equestrian
Brass
H. approx. 2 in. (5.1 cm)
Provenance: acquired from Segy (RW 55-16)
Current location: Art Institute of Chicago

Asante, Ghana
Goldweight in the Form of a Belt
Brass
W. 1 1/2 in. (3.8 cm)
Provenance: acquired from Carlebach
Current location: Cincinnati Art Museum
Ill.: Cincinnati Art Museum 1970, 162

Asante, Ghana
Goldweight in the Form of a Scorpion
Brass
W. 1 7/16 in. (3.6 cm)
Provenance: acquired from Carlebach
Current location: Cincinnati Art Museum
Ill.: Cincinnati Art Museum 1970, 162

Asante, Ghana
Goldweight
Brass
H. 2 1/2 in. (6.4 cm)
Provenance: acquired from Segy (RW 55-6)
Current location: Art Institute of Chicago
Ill.: Segy 1958, pl. 45

Yoruba, Nigeria
Drum
Wood
H. 14 1/2 in. (36.8 cm)
Provenance: collected by Sieber
in Abeokuta, Nigeria, 1958; ac-
quired from him (RW 60-205)
Current location: Metropolitan
Museum of Art, New York
Ill.: Dagas 1993, 189

Yoruba, Nigeria
Staff for Sango Cult
Wood, incrustation
H. 15 in. (38.1 cm)
Provenance: acquired from
Frumkin (RW 59-186)
Current location: University of
Iowa Museum of Art, Iowa City

Hausa or Fulani, Niger/Nigeria
Bird Decoy
Bird beak, shell, leather, wood
H. 17 1/4 in. (43.8 cm)
Provenance: ex-coll. Eluard;
acquired from Frumkin
(RW 59-150)
Current location: private
collection
Ill.: Hôtel Drouot [1931] 1972/73

Kenga, Nigeria
Female Figure
Wood
H. 8 3/4 in. (22.2 cm)
Provenance: acquired from Segy
Current location unknown
Ill.: Segy 1952, cat. no. 113

Ibibio, Nigeria
Mask
Wood
H. 10 1/2 in. (26.7 cm)
Provenance: acquired from
Lemaire
Current location: Art Institute
of Chicago
Ill.: AIC 1965, cat. no. 73

Ibibio (Oron subgroup), Nigeria
Figure
Wood
H. 24 in. (61 cm)
Provenance: acquired from
Judith Small Nash
Current location: private
collection

Nigeria
Mask
Gourd, fiber, incrustation
H. approx. 9 in. (22.9 cm)
Provenance: acquired from
Frumkin (RW 60-212)
Current location unknown

Bafo (?), Cameroon
Figure
Wood
H. 5 in. (12.7 cm)
Provenance: acquired from
Carlebach (RW 56-47)
Current location: private
collection
Ill.: Layton 1957, cat. no. 30

Fang, Gabon
Reliquary Figure, *Bieri*
Wood
H. 18 in. (45.7 cm)
Provenance: acquired from Segy
(RW 55-4)
Current location: Art Institute
of Chicago
Ill.: Segy 1952, figs. 80, 81

Kota, Gabon
Reliquary Figure, *Ngulu*
Wood, brass
H. 12 in. (30.5 cm)
Provenance: acquired from Segy
Current location: private
collection
Ill.: Segy 1952, cat. no. 174

Kota, Gabon
Reliquary Figure, *Ngulu*
Wood, metal
H: 24 in. (61 cm)
Current location: private
collection
Ill.: Segy 1952, fig. 68

Kongo, People's Republic of the
Congo/Zaire
Power Figure
Wood, nails
L. 19 3/4 in. (50.2 cm)
Current location: private
collection
Ill.: AIC 1960, cat. no. 178

Kongo, People's Republic of the
Congo/Zaire
Power Figure
Wood, metal, incrustation
H. 36 1/4 in. (92.1 cm)
Provenance: acquired from
Frumkin (RW 57-70)
Current location: Des Moines Art
Center
Ill.: MPA 1960b, pls. 10, 10a

Yanzi (?), Zaire
Figure
Wood, traces of tukula powder
H. 6 1/4 in. (15.9 cm)
Provenance: acquired from Segy
(RW 55-5)
Current location: private
collection
Ill.: Segy 1952, fig. 261

Ngala, Zaire
Figure
Wood
H. 9 in. (22.9 cm)
Provenance: acquired from Segy
Current location unknown
Ill.: Segy 1958, pl. 114

Lega, Zaire
Figure
Wood, pigment
H. 12 in. (30. 5 cm)
Provenance: acquired from
Kamer
Current location: M.H. de Young
Memorial Museum, San
Francisco
Ill.: Robbins and Nooter 1989,
fig. 1230

Lega, Zaire
Figure
Wood
H. 9 in. (22.9 cm)
Provenance: acquired from Segy
(RW 56-21)
Current location: private
collection
Ill.: Segy 1958, pl. 153

Lega, Zaire
Mask
Wood
H. 11 3/4 in. (29.8 cm)
Provenance: acquired from Segy
(RW 59-165)
Current location: private
collection
Pub.: MPA 1960b, cat. no. 20

Lega or Zande, Zaire
Male Figure
Ivory
H. 10 5/16 in. (26.7 cm)
Provenance: acquired from
Carlebach (RW 56-25)
Current location: Metropolitan
Museum of Art, New York
Ill.: Toledo 1959, cat. no. 179

Mbole, Zaire
Male Figure
Wood, pigment
H. 13 in. (33 cm)
Provenance: ex-coll. Van der
Strate (Brussels); acquired from
Segy (RW 55-18)
Current location: Metropolitan
Museum of Art, New York
Ill.: MPA 1969a, cat. no. 443

Pende, Zaire
Pendant
Ivory
H. 2 3/16 in. (5.6 cm)
Provenance: acquired from
Frumkin (RW 60-202)
Current location: private
collection
Pub.: MPA 1960b, cat. no. 27

Pende, Zaire
Cup
Wood
H. 6 in. (15.2 cm)
Provenance: acquired from
Carlebach
Current location: Art Institute
of Chicago
Pub.: AIC 1957a, cat. no. 40

Kuba, Zaire
Cup
Wood
H. 5 5/8 in. (14.3 cm)
Provenance: acquired from Segy
Current location: Art Institute
of Chicago
Pub.: AIC 1957a, cat. no. 41

Kuba, Zaire
Cup
Wood
H. 5 1/2 in. (14 cm)
Provenance: acquired from
Klejman
Current location: private
collection

Kuba, Zaire
Box
Wood
Provenance: acquired from
Frumkin
Current location: private
collection

Kuba, Zaire
Box and Lid
Wood, rattan
L. 26 in. (66 cm)
Provenance: acquired from
Frumkin (RW 60-201)
Current location: Metropolitan
Museum of Art, New York
Ill.: Sieber 1980, 185

Songye, Zaire
Power Figure
Wood, iron
H. 7 in. (17.8 cm)
Provenance: acquired from
Carlebach
Current location: Art Institute
of Chicago
Pub.: AIC 1957a, cat. no. 47

Songye, Zaire
Power Figure
Wood, horn
H. 9 3/8 in. (23.8 cm)
Provenance: acquired from
Carlebach
Current location: Cincinnati Art
Museum
Ill.: Mount 1980, fig. 10

Songye, Zaire
Power Figure
Wood, leather, reptile skin
H. 16 1/2 in. (41.9 cm)
Collected by Webster Plass
(RW 56-51)
Current location: private
collection
Ill.: Sotheby 1956, cat. no. 116
(pl. VI)

Luba, Zaire
Figure
Ivory
H. 3 in. (7.62 cm)
Current location: private
collection
Ill.: Segy 1958, pl. 101

Zulu, Republic of South Africa
Snuff Container
Wood
H. 10 3/4 in. (27.3 cm)
Provenance: acquired from
Lemaire
Current location: private
collection

Bari, Sudan
Figure
Wood, pigment
H. 19 1/4 in. (27.3 cm)
Provenance: acquired from Herta
Haselberger (Vienna)
Current location: Metropolitan
Museum of Art, New York

Oceania

Maori, New Zealand
Canoe Bailer, *Tata*
Wood
L. 18 3/8 in. (47 cm)
Provenance: acquired from Kelner
(Australia)
Current location: Art Institute
of Chicago

Maori, New Zealand
Fishing Canoe Prow Ornament
Wood
L. approx. 24 in. (61 cm)
Provenance: acquired from
Frumkin
Current location: Field Museum
of Natural History, Chicago

Maori, New Zealand
Short Club, *Wahaika*
Wood, haliotis shell
L. 14 3/4 in. (37.5 cm)
Provenance: acquired from
Frumkin (RW 61-214)
Current location unknown
Ill.: Wardwell 1967, no. 140

Maori, New Zealand
Pendant, *Hei Tiki*
Nephrite
H. 4 3/4 in. (12.1 cm)
Provenance: acquired from
Nagatani (Chicago; RW 61-222)
Current location unknown
Ill.: Wardwell 1967, no. 145

Hawaii
Necklace, *Lei Palaoa*
Human hair, walrus ivory, fiber
H. of ivory pendant 3 7/8 in.
(9.5 cm)
Provenance: acquired from
Frumkin (RW 59-170)
Current location: private
collection
Pub.: Wardwell 1967, no. 84

New Caledonia
Mask
Wood
H. 18 1/8 in. (46 cm)
Provenance: acquired from
Frumkin (RW 57-61)
Current location: Art Institute
of Chicago
Ill.: AIC 1965, no. 80

New Caledonia
House Spire
Wood
H. 73 in. (185.4 cm)
Provenance: RW 59-147
Current location: private
collection
Pub.: MPA 1960b, cat. no. 45

Loyalty Island, New Caledonia (?)
Figure
Wood
H. 3 5/8 in. (8.9 cm)
Provenance: acquired from
Frumkin (RW 61-226)
Current location: Metropolitan
Museum of Art, New York

Ambrym Island, Vanuatu
Mask
Wood
H. 14 in. (35.6 cm)
Provenance: acquired from
Frumkin (RW 56-43)
Current location: Metropolitan
Museum of Art, New York
Ill.: Schmitz 1971, pl. 44

New Ireland
Memorial Figure, *Uli*
Wood, pigment, fiber
H. approx. 36 in. (91.4 cm)
Provenance: acquired from
Frumkin (RW 56-50)
Current location unknown
Ill.: Hausenstein 1923, pl. 4

Tolai, New Britain
Mask, *Lor*
Skull, hair, parinarium nut paste,
pigment
H. 11 1/2 in. (29.2 cm)
Provenance: acquired from
Carlebach (RW 57-58)
Current location: private
collection
Ill.: MPA 1960b, cat. no. 40, pl. 7

Baining, New Britain
Mask
Hibiscus bark, seaweed (?)
H. approx. 16 in. (40.6 cm)
Provenance: acquired from
Frumkin
Current location: Field Museum
of Natural History, Chicago

Santa Cruz
Bowl
Wood
L. 18 in. (45.7 cm)
Current location: private
collection

Santa Cruz
Breast Ornament, *Tema*
Shell, turtle shell
H. approx. 3 1/2 in. (8.9 cm)
Provenance: acquired from
Klejman (RW 58-102)
Current location: private
collection

Temotu Island, Santa Cruz
Figure, *Munge-Dukna*
Collected before 1928
Wood, shell
H. 5 1/2 in. (14 cm)
Provenance: collected by Anglican
Melanesian Mission; acquired
from Klejman (RW 63-250)
Current location: Barbier-Müller
Museum, Geneva
Ill.: Waite 1983, 139, no. 66

Solomon Islands
Canoe Prow Ornament
Wood, pigment, shell
H. 11 in. (27.9 cm)
Provenance: acquired from
Klejman (RW 58-103)
Current location unknown
Ill.: Arts Club 1966, cat. no. 39

Solomon Islands
Shield
Bark, pearl shell, cane, wood
H. 32 5/8 in. (82.5 cm)
Provenance: RW 58-123
Current location: Field Museum
of Natural History, Chicago

Astrolabe Bay,
Papua New Guinea
Sago Scoop
Wood
H. approx. 15 in. (38.1 cm)
Provenance: acquired from
Frumkin
Current location: private
collection

Aitape area, Papua New Guinea
Figure
Wood, pigment
H. 10 in. (25.5 cm)
Provenance: acquired from
Frumkin (RW 55-26)
Current location: private
collection
Ill.: Greub 1985, cat. 170

Coastal Sepik River, Papua New Guinea
Mask
Wood, pigment, fiber, hair
H. 11 in. (27.9 cm)
Provenance: collected by Cpt. Haug at Wewak, ca. 1909; ex-coll. Brignoni; acquired from Frumkin
Current location: private collection
Ill.: AIC 1971b, no. 12

Sepik River, Papua New Guinea
Mask
Wood
H. 17 in. (43.2 cm)
Provenance: acquired from Frumkin (RW 55-28)
Current location unknown
Pub.: MPA 1960b, cat. no. 28

Sepik River, Papua New Guinea
Shield
Wood, pigment
H. 54 3/4 in. (139.1 cm)
Provenance: acquired from Carlebach (RW 56-38)
Current location: private collection
Ill.: Wardwell 1971, cat. no. 141

Sepik River, Papua New Guinea
Neckrest
Wood, traces of red and white pigment
H. 6 3/8 in. (16.5 cm)
Provenance: ex-coll. M. Rousseau; acquired from Klejman
Current location: private collection
Ill.: Wardwell 1971, cat. no. 80

Sepik River, Papua New Guinea
Spear Thrower
Wood
L. 26 7/8 in. (68.2 cm)
Provenance: acquired from Frumkin
Current location: University of Iowa Museum of Art, Iowa City

Sepik River, Papua New Guinea
Canoe-Prow Mask
Wood, traces of red and white pigment
H. 11 1/8 in. (28.2 cm)
Provenance: acquired from Klejman
Current location: private collection
Ill.: AIC 1971b, no. 110

Sepik River, Papua New Guinea
Seated Figure
Wood, pigment
H. 20 in. (50.8 cm)
Provenance: collected by J. Kirschbaum; acquired from Carlebach (RW 56-45)
Current location: private collection
Ill.: Wardwell 1971, cat. no. 60

Sepik River, Papua New Guinea
Head
Wood
H. 7 in. (17.8 cm)
Provenance: RW 57-62
Current location unknown
Pub.: MPA 1960b, cat. no. 31

Sepik River, Papua New Guinea
Pestle
Wood
H. 19 1/2 in. (49.5 cm)
Provenance: acquired from Frumkin (RW 59-151)
Current location: private collection

Kambot, Papua New Guinea
Mask
Wood, pigment, fiber
H. 12 1/8 in. (30.8 cm)
Provenance: acquired from Frumkin (RW 58-105)
Current location: Metropolitan Museum of Art, New York
Ill.: MMA 1987, 22

Korowari River, Papua New Guinea
Mask
Wood, pigment
H. 39 in. (99.1 cm)
Provenance: acquired from Wayne Heathcote (New York)
Current location: private collection
Ill.: AIC 1971b, cat. no. 215

Inyai village, Upper Korowari River, Papua New Guinea
Figure
Wood, pigment
H. 42 in. (106.7 cm)
Provenance: acquired from Wayne Heathcote (New York)
Current location unknown
Pub.: Wardwell 1971, cat. no. 207

Papuri Delta, Papua New Guinea
Figure
Wood
H. 13 1/2 in. (34.3 cm)
Provenance: acquired from Frumkin (RW 56-39)
Current location unknown
Ill.: Newton 1961, fig. 10

Fly River, Papua New Guinea
Figure
Wood
H. 12 5/8 in. (32.1 cm)
Provenance: acquired from Frumkin (RW 59-169)
Current location: private collection
Ill.: Newton 1961, no. 74

Australia
Sacred Board
Wood
H. approx. 29 in. (73.7 cm)
Provenance: acquired from Frumkin
Current location: private collection

Dayak, Borneo, Malaysia/Indonesia
Pair of Earrings
Brass
H. 1 3/4 in. (4.4 cm)
Provenance: acquired from Kelley Rollings (Tucson; RW 82-288)
Current location: private collection

Americas

Pre-Columbian Americas

Olmec, Mexico
Figure
Stone
H. 6 1/2 in. (16.5 cm)
Provenance: acquired from Rassiga
Current location: private collection
Ill.: AIC 1960, cat. no. 1

Olmec (?), Mexico
Figure
Stone
H. 7 1/2 in. (19 cm)
Provenance: acquired from Stokes
Current location: Indiana University Art Museum, Bloomington

Tlatilco, Mexico
Figure
Clay
H. 4 1/4 in. (10.8 cm)
Provenance: RW 55-30
Current location unknown
Pub.: University of Kansas Museum of Art 1957, cat. no. 1

Colima, Mexico
Coiled Rattlesnake
Clay, pigment
Diam. 10 in. (25.4 cm)
Ex-coll. Stendahl
Current location unknown
Ill.: Sotheby's 1987, no. 128

Colima, Mexico
Iguana with Mouth Spout
Clay, pigment
L. 19 1/2 in. (49.5 cm)
Ex-coll. Stendahl
Current location: private collection
Ill.: Sotheby's 1987, no. 129

Colima, Mexico
Dog
Clay, pigment
H. 10 in. (25.4 cm)
Ex-coll. Stendahl
Current location unknown
Ill.: AIC 1957b, 6

Colima, Mexico
Vessel
Clay
H. 7 in. (17.8 cm)
Ex-coll. Stendahl
Current location unknown
Ill.: Sotheby's 1987, no. 397

West Coast, Mexico
Effigy Urn
Clay
H. 12 in. (30.5 cm)
Provenance: acquired from
Stendahl
Current location: private
collection
Ill.: AIC 1960, cat. no. 25

West Coast, Mexico
Figure of a Dwarf
Clay, pigment
H. 12 1/2 in. (31.8 cm)
Provenance: acquired from
Edward Primus
Current location: private
collection
Ill.: AIC 1960, cat. no. 23

West Coast, Mexico
Twelve Miniature Female Figures
Clay, polished red slip
H. (max.) 1/2 in. (1.3 cm)
Ex-coll. Frederick Pleasants
Current location: private
collection

Zapotec, Monte Albán III,
Mexico
Funerary Urn, "Accompanante"
Clay, cinnabar
H. 8 in. (20.3 cm)
Provenance: acquired from
Claude Bentley (RW 55-27)
Current location: private
collection
Ill.: Boos 1966, fig. 50

Zapotec, Monte Albán IIIa,
Mexico
Funerary Urn Fragment
Clay
H. 8 1/2 in. (21.6 cm)
Provenance: acquired from
Claude Bentley
Current location: private
collection
Ill.: Boos 1966, fig. 236

Zapotec, Monte Albán IIIb,
Mexico
Beaker
Clay
H. 5 in. (12.7 cm)
Current location: National
Museum of the American Indian,
Washington, D.C.
Ill.: Boos 1966, fig. 285

Zapotec, Monte Albán IIIb,
Mexico
Double Beaker
Clay
H. 4 in. (10.2 cm)
Current location: National
Museum of the American Indian,
Washington, D.C.
Ill.: Easby and Easby 1962

Oaxaca, Mexico
Pendant
Jadeite
H. 3 1/4 in. (8.25 cm)
Provenance: acquired from
R. Dehesa (Mexico City)
Current location unknown
Pub.: University of Kansas
Museum of Art 1957, no. 79

Veracruz, Mexico
Closed Yoke
Stone
L. approx. 18 in. (45.7 cm)
Provenance: collected by Dr.
G.A. Vawter; acquired from
Robert R. Brintnell
Current location: Field Museum
of Natural History, Chicago

Remojades, Veracruz, Mexico
Warrior
Clay
H. 15 7/8 in. (40.3 cm)
Provenance: acquired from
Robert Stoper
Current location: private
collection
Pub.: AIC 1960, cat. no. 30

Veracruz, Mexico
Pair of Earspools
Clay
Diam. 1 1/4 in. (3.2 cm)
Current location: Art Institute
of Chicago

Maya, Chiapas, Mexico
Figure on a Turtle
Clay, blue pigment
H. 21 1/4 in. (54 cm)
Provenance: acquired from Stokes
(RW 59-157)
Current location: Metropolitan
Museum of Art, New York
Ill.: MPA 1969a, cat. no. 624

Huastec, Mexico
Armband with Trophy Heads
Shell
L. 3 7/8 in. (9.8 cm)
Provenance: acquired from Bob
Huber
Current location: private
collection

Toltec, Mexico
Tripod Bowl
Clay, cloisonné fresco
Diam. 6 1/4 in. (15.9 cm)
Provenance: acquired from Stokes
(RW 59-156)
Current location: Field Museum
of Natural History, Chicago
Ill.: Collier 1967, 9

Mixtec (?), Tehuacan, Puebla,
Mexico
Earspool
Wood, turquoise, shell
Diam. approx. 3 in.
Provenance: acquired from Bob
Huber
Current location: Field Museum
of Natural History, Chicago

Mixtec, Mexico
Ornament in the Form of the
Rain God
Copper
H. 2 1/4 in. (5.7 cm)
Provenance: RW 61-221
Current location: private
collection

Aztec, Texcoco, Mexico
Head
Stone
H. 9 in. (22.9 cm)
Provenance: acquired from
Rassiga (RW 61-217)
Current location: Field Museum
of Natural History, Chicago
Ill.: Collier 1967, 9

Chorotego (?), Nicoya Peninsula,
Costa Rica
Figure of a Woman (Effigy Jar)
Period V, Early Polychrome phase,
A.D. 500-800
Clay, pigment
H. 9 in. (22.8 cm.)
Current location: Field Museum
of Natural History, Chicago
Ill.: Easby 1970, no. 216

Nicoya Peninsula (?), Costa Rica
Ceremonial Mace Head
Stone
L. 4 3/4 in. (12.1 cm)
Provenance: Samuel Lothrop ac-
quired from José Maria Velasco,
a priest for parishes of Nicoya
and Santa Cruz, 1916-17; ex-
coll. Peabody Museum of Archae-
ology and Ethnology, Cambridge,
Massachusetts; RW 59-158
Current location unknown
Pub.: MPA 1960b, cat. no. 83

Veraguas style, Rincon Curcal,
Panama
Pedestal Plate
Clay, pigment
W. 9 1/2 in. (24.1 cm)
Provenance: ex-coll. Peabody
Museum of Archaeology and
Ethnology, Cambridge, Massa-
chusetts; RW 59-160
Current location: University of
Iowa Museum of Art, Iowa City
Pub.: MPA 1960b, cat. no. 82

Veraguas, Panama
Pendant in the Form of a Man
Gold
H. 2 1/4 in. (5.7 cm)
Provenance: RW 57-81
Current location: Art Institute of
Chicago

Veraguas, Panama
Pendant in the Form of a Jaguar
Gold
L. 2 3/8 in. (6.4 cm)
Provenance: RW 57-85
Current location: Art Institute of
Chicago
Ill.: Wardwell 1968a, cat. no. 106

Venado Beach style, Panama
Gorget
Shell
Provenance: acquired from
Gordon Ekholm (RW 57-99)
Current location: Metropolitan
Museum of Art, New York

Manabi, Ecuador
Throne
Stone
H. 17 1/4 in. (43.8 cm)
Provenance: acquired from War-
walram Von Schoeler (RW 57-91)
Current location: on long-term
loan to Denver Art Museum from
a private collection
Ill.: AIC 1965, cat. no. 44

Cupisnique, Peru
Vessel
Clay
H. 9 1/4 in. (24.4 cm)
Provenance: acquired from Soldi
(RW 59-166)
Current location: Art Institute of
Chicago
Ill.: AIC 1965, cat. no. 6 (ill)

Nazca I, Peru
Drum
Clay
H. 17 3/4 in. (45.1 cm)
Provenance: acquired from
Sawyer (RW 57-74)
Current location: Metropolitan
Museum of Art, New York
Ill.: MPA 1a, cat. no. 489

Nazca I, Peru
Seated-Figure Bottle
Clay
H. 8 7/8 in. (22.5 cm)
Provenance: acquired from Soldi
(RW 58-126)
Current location: Metropolitan
Museum of Art, New York
Ill.: MMA 1987, 151

Nazca, Peru
Effigy Jar
Clay, pigment
H. 11 in. (27.9 cm)
Provenance: acquired from
Sawyer (RW 59-161)
Current location: private
collection

Paracas, Ica Valley, Peru
Spout-and-Bridge Vessel
Clay, pigment
Diam. 6 1/2 in. (16.5 cm)
Provenance: acquired from
Sawyer
Current location: National
Museum of the American Indian,
Washington, D.C.
Ill.: Dockstader 1967, pl. 98

Paracas, Juan Pablo, Ica Valley,
Peru
Vessel
Clay, pigment
H. 7 1/2 in. (19.1 cm)
Provenance: acquired from
Sawyer (RW 57-80)
Current location: National
Museum of the American Indian,
Washington, D.C.
Pub.: MPA 1960b, cat. no. 86

Paracas, Juan Pablo, Ica Valley,
Peru
Bowl
Clay, pigment
Diam. 7 1/2 in. (19.1 cm)
Provenance: acquired from
Sawyer (RW 57-84)
Current location: University of
Iowa Museum of Art, Iowa City

Paracas, Juan Pablo, Ica Valley,
Peru
Spout-and-Bridge Vessel
Clay, pigment
H. 8 1/8 in. (20.6 cm)
Provenance: acquired from
Sawyer (RW 57-87)
Current location: Metropolitan
Museum of Art, New York
Ill.: Lapiner 1976, no. 143

Paracas, Hacienda Florite, Nazca
Valley, Peru
Bowl
Clay, pigment
Diam. 8 3/4 in. (22.2 cm)
Provenance: acquired from
Sawyer (RW 57-88)
Current location: Metropolitan
Museum of Art, New York
Ill.: MPA 1969a, no. 479

Paracas, Peru
Bowl
Clay, pigment
H. 3 1/4 in. (8.3 cm)
Provenance: acquired from
Sawyer (RW 57-89)
Current location: National
Museum of the American Indian,
Washington, D.C.
Ill.: Menzel, Rowe, and Dawson
1964, pl. 6

Paracas, Juan Pablo, Ica Valley,
Peru
Bowl
Clay, pigment
H. approx. 5 in. (12.7 cm)
Provenance: acquired from
Sawyer (RW 57-92)
Current location unknown

Paracas Ocucaje, Ica Valley, Peru
Jar
Clay, pigment
H. 17 in. (43.2 cm)
Provenance: acquired by exchange
from the Textile Museum,
Washington, D.C. (RW 60-190)
Current location: Field Museum
of Natural History, Chicago
Ill.: MPA 1960b, pl. 13

Paracas II, Chiquerillo, Ica Valley,
Peru
Whistling Bottle
Clay, pigment
H. 6 1/4 in. (15.9 cm)
Provenance: acquired from Soldi
(RW 58-125)
Current location: Field Museum
of Natural History, Chicago
Ill.: Willey 1971, fig. 351

Paracas V, Juan Pablo, Ica Valley,
Peru
Vessel
Clay, pigment
H. 5 in. (12.7 cm)
Provenance: acquired from
Sawyer (RW 58-118)
Current location: National
Museum of the American Indian,
Washington, D.C.
Ill.: Lapiner 1976, no. 142

Paracas VI, Juan Pablo, Ica Valley,
Peru
Bowl
Clay, pigment
Diam. 7 in. (17.8 cm)
Provenance: acquired from
Sawyer (RW 58-128)
Current location unknown
Pub.: MPA 1960b, cat. no. 91

Paracas VII, Juan Pablo,
Ica Valley, Peru
Spout-and-Bridge Vessel
Clay, pigment
Diam. 6 1/2 in. (16.5 cm)
Provenance: acquired from
Sawyer (RW 57-96)
Current location unknown
Pub.: MPA 1960b, cat. no. 88

Paracas IX, Juan Pablo, Ica Valley,
Peru
Bowl
Clay, pigment
Diam. approx. 5 in. (12.7 cm)
Provenance: acquired from
Sawyer (RW 58-108)
Current location unknown

Paracas IX, Juan Pablo, Ica Valley,
Peru
Bowl
Clay, pigment
Provenance: acquired from
Sawyer (RW 58-138)
Current location unknown

Paracas X, Juan Pablo, Ica Valley,
Peru
Bowl
Clay, pigment
Diam. 6 1/2 in. (16.5 cm)
Provenance: acquired from
Sawyer (RW 58-109)
Current location: National
Museum of the American Indian,
Washington, D.C.
Pub.: MPA 1960b, cat. no. 93

Paracas X, Juan Pablo, Ica Valley,
Peru
Bowl
Clay, pigment
Diam. 5 in. (12.7 cm)
Provenance: acquired from
Sawyer (RW 58-110)
Current location: National
Museum of the American Indian,
Washington, D.C.
Ill.: Dockstader 1967, pl. 97

Paracas, Ocucaje, Ica Valley, Peru
Figure
Clay, pigment
H. 6 1/2 in. (16.5 cm)
Provenance: acquired from Soldi
(RW 58-124)
Current location: Field Museum
of Natural History, Chicago
Ill.: MPA 1960b, cat. no. 95, pl. 23

Paracas, Peru
Shoulder Poncho, Cushma
Cotton, wool
L. 21 3/4 in. (55.2 cm)
Provenance: Ex-coll. Ratton (Paris)
Current location: Textile
Museum, Washington, D.C.
Ill.: D'Harcourt 1962, pl. 111

Moche III, Peru
Stirrup-Spouted Bottle
Clay, pigment
H. 9 5/16 in. (23.5 cm)
Provenance: RW 59-164
Current location: University of
Iowa Museum of Art, Iowa City

Moche, Peru
Vessel in the Form of a Human
Figure
Clay
H. 8 1/4 in. (21 cm)
Provenance: acquired from
Mathias Komor
Current location: Art Institute
of Chicago

Moche, Peru
Stirrup-Spouted Vessel in the
Form of a Kneeling Person
Clay
H. 7 in. (17.8 cm)
Provenance: acquired from Soldi
Current location: private
collection

Moche, Peru
Stirrup-Spouted Vessel with
Feline Decoration
Clay
H. 10 in. (25.4 cm)
Current location: private
collection

Moche, Peru
Mask
Copper, gilt
H. 7 1/2 in. (19.1 cm)
Provenance: acquired from
Mrs. Warwalram Von Schoeler
(RW 57-68)
Current location: Metropolitan
Museum of Art, New York
Ill.: Powell 1959, 65

Tiahuanaco, Bolivia
Vessel, Kero
Clay, slip
H. 6 5/8 in. (16.5 cm)
Provenance: acquired from
Sawyer (RW 57-75)
Current location: Textile
Museum, Washington, D.C.
Ill.: Lapiner 1976, fig. 865

Native America

Aleut, Tigalda Island,
Aleutian Islands, Alaska
Burial Mask
Wood
H. 15 1/2 in. (39.4 cm)
Provenance: collected by Harley
Stamp ca. 1885; ex-coll. Museum
of the American Indian/Heye
Foundation, New York;
RW 59-175
Current location: Metropolitan
Museum of Art, New York
Ill.: MPA 1960b, cat. no. 58, pl. 11

Inuit, Bering Sea, Alaska
Kanag Handle
Walrus ivory or bone
L. 8 in. (20.3 cm)
Provenance: ex-coll. Museum
of the American Indian/Heye
Foundation, New York;
RW 59-182
Current location: Metropolitan
Museum of Art, New York
Ill.: MPA 1960b, cat. no. 60

Inuit, Point Barrow, Alaska
Hunting Charm
Ivory
L. 6 1/4 in. (15.9 cm)
Provenance: ex-coll. Museum
of the American Indian/Heye
Foundation, New York;
RW 59-178
Current location: Metropolitan
Museum of Art, New York
Ill.: Mathiassen 1929, 42

Inuit, Alaska
Atl-atl Tip in the Form of a Sea
Otter
Ivory
H. 3 1/4 in. (8.3 cm)
Provenance: collected by Curtiss;
ex-coll. Peabody Museum of
Archaeology and Ethnology,
Cambridge, Massachusetts;
RW 59-148
Current location unknown
Pub.: MPA 1960b, cat. no. 63

Inuit, Alaska
Armor Slat
Bone
L. 8 1/2 in. (21.6 cm)
Provenance: acquired from Kelley
Rollings (RW 82-289)
Current location: private
collection

Inuit, Alaska
Container
Walrus ivory
H. 3 3/4 in. (9.5 cm)
Provenance: ex-coll. Museum
of the American Indian/Heye
Foundation, New York;
RW 59-174
Current location unknown
Pub.: MPA 1960b, cat. no. 61

Tlingit, Northwest Coast
Rattle
Wood, pigment, fiber
L. 15 in. (38.1 cm)
Provenance: ex-coll. Robert Hull
Fleming Museum, Burlington,
Vermont; acquired from Klejman
Current location: Menil Col-
lection, Houston
Ill.: Holm 1975, pl. 85

Tlingit, Northwest Coast
Small Model of an Oil Dish in
the Form of a Bear
Wood
H. approx. 2 in. (5.1 cm)
Provenance: ex-coll. Robert Hull
Fleming Museum, Burlington,
Vermont; acquired from Klejman
Current location: private
collection

Tlingit, Northwest Coast
Soul Catcher
Bone
L. 8 1/8 in.
Provenance: ex-coll. Harry
Beasley; acquired from Klejman
(RW 64-251)
Current location: private
collection
Ill.: Wardwell 1968b, fig. 2

Tlingit, Northwest Coast
Shaman Charm
Whale tooth
L. 3 15/16 in. (10 cm)
Provenance: ex-coll. Harry
Beasley; acquired from Simpson
(RW 65-272)
Current location: private
collection
Ill.: Emmonds [i.e., Emmons] and
Miles 1939, pl. XXI, fig. 4

Haida, Northwest Coast
Pipe in the Form of an Eagle
Wood, shell
L. 4 in. (10.2 cm)
Provenance: ex-coll. Museum
of the American Indian/Heye
Foundation, New York
Current location: private
collection

Haida, British Columbia, Canada
Oil Dish in the Form of a Bear
Wood
L. 6 5/8 in. (17.4 cm)
Current location: private
collection

Haida, Queen Charlotte Island
Oil Dish
Wood, shell
L. 11 1/2 in. (29.2 cm)
Provenance: collected by Thomas
Crosby ca. 1875; ex-coll. Museum
of the American Indian/Heye
Foundation, New York;
RW 59-173
Current location: private
collection
Ill.: AIC 1964, cat. no. 125

Chumash, St. Nicolas Island,
California
Figure of a Killer Whale
Stone
L. 8 1/2 in. (21.6 cm)
Provenance: ex-coll. Museum
of the American Indian/Heye
Foundation, New York;
RW 59-179
Current location unknown
Ill.: Coe 1977, cat. no. 559

Iroquois, Eastern Woodlands,
United States
Mask
Wood, pigment, hair
H. approx. 10 in. (25.4 cm)
Provenance: ex-coll. Museum
of the American Indian/Heye
Foundation, New York
Current location: private
collection

Caddoan, Yell County, Arkansas
Bottle
Clay
H. 8 3/4 in. (22.2 cm)
Provenance: ex-coll. Museum
of the American Indian/Heye
Foundation, New York;
RW 59-181
Current location: Metropolitan
Museum of Art, New York
Pub.: MPA 1960b, cat. no. 67

Zuni, New Mexico
Figure of War God
Wood, paint
H. 29 3/4 in. (75.6 cm)
Provenance: RW 60-191
Current location: Metropolitan
Museum of Art, New York
Ill.: MPA 1960b, pl. 12

Wapishana (?), Guyana
Club
Wood
L. 20 in. (50.8 cm)
Provenance: ex-coll. Museum
of the American Indian/Heye
Foundation, New York
Current location: private
collection

Wapishana/Macana(?), Guyana
War Club
Wood, stone
L. 14 1/8 in. (35.9 cm)
Provenance: collected before
1850; ex-coll. Museum of the
American Indian/Heye Foun-
dation, New York
Current location: University of
Iowa Museum of Art, Iowa City

Mundurucu, Rio Tapajos, Brazil
Head
Human head with tattoo, hair,
feathers, fiber, beeswax, peccary
teeth
H. 11 1/2 in. (29.2 cm)
Provenance: collected ca. 1880;
ex-coll. Museum of the American
Indian/Heye Foundation, New
York; RW 59-176
Current location: Musée de
Marseille
Pub.: MPA 1960b, cat. no. 105

List of Exhibition Abbreviations

AFA 1980: *African Furniture and Household Objects*. Organized by the American Federation of Arts. Indianapolis Museum of Art, April 9-May 25, 1980; Nelson Gallery-Atkins Museum (Kansas City), July 3-August 3, 1980; M. H. de Young Memorial Museum (San Francisco), September 21-November 9, 1980; Brooks Memorial Art Gallery (Memphis), March 1-April 19, 1981; Brooklyn Museum, June 20-September 7, 1981.

AIC 1957a: *African Sculpture from the Collection of Mr. and Mrs. Raymond Wielgus*. Art Institute of Chicago, April 13-June 16.

AIC 1957b: *Animal Sculpture in Pre-Columbian Art*. Art Institute of Chicago, September 8, 1957-February 2, 1958.

AIC 1958: *Oceanic Art, a Loan Exhibition*. Art Institute of Chicago. March-June 1.

AIC 1963: *Chicago Collectors*. Art Institute of Chicago, September 20-October 27.

AIC 1964: *Yakutat South: Indian Art of the Northwest Coast*. Art Institute of Chicago, March 13-April 2.

AIC 1967: *The Sculpture of Polynesia*. Art Institute of Chicago, November 17-December 31, 1967; Museum of Primitive Art (New York), February 14-May 14, 1968.

AIC 1971: *Art of the Sepik River*. Art Institute of Chicago, October 16-November 28.

AIC 1977: *The Native American Heritage: A Survey of North American Indian Art*. Art Institute of Chicago, July 16-October 20.

Allen 1956: *African Negro Sculpture*. Allen Memorial Art Museum, Oberlin College, February 6-March 6.

AMNH 1961: *Art and Life in Old Peru*. American Museum of Natural History (New York), September 25, 1961-January 14, 1962.

AMNH 1965: *Faces and Figures: Pacific Island Art from the Collection of Jay C. Leff*. American Museum of Natural History (New York), January 27-May.

Arts Club 1966: *The Raymond and Laura Wielgus Collection*. Arts Club of Chicago, September 26-November 2.

Arts Council 1960: *The Epstein Collection of Tribal and Exotic Sculpture*. Arts Council of Great Britain (London), February 23-March 26.

Arts Décoratifs 1954: *Chefs-d'oeuvre de la curiosité du monde: 2e exposition internationale de la Confédération Internationale des Négociants en Oeuvres d'Art*. Musée des Arts Décoratifs (Paris), June 10-September 30.

Berlin 1964: *Afrika: 100 Stämme-100 Meisterwerke/Afrique: 100 Tribus-100 Chefs-d'oeuvre*. Sponsored by the Festival of Berlin and the Congrès pour la Liberté de la Culture (Paris). Höchschule für Bildende Künste (Berlin), September 12-October 4; Musée des Art Décoratifs, Palais du Louvre, Pavillon de Marsan (Paris), October 28-November 30.

Brooklyn 1954: *Masterpieces of African Art*. Brooklyn Museum, October 10, 1954-January 2, 1955.

Brooklyn 1959: *Ancient Art of the Americas*. Brooklyn Museum, December 1, 1959-January 3, 1960.

Brussels 1958: *Kunst in Kongo: Exposition Universelle et Internationale* (Brussels), April 17-October 19.

Brussels 1992: *Tresors du nouveau monde*. Musées Royaux d'Art et d'Histoire (Brussels), September 15-December 27.

Cannes 1957: *Première exposition international rétrospective des arts d'Afrique et d'Océanie*. Palais Miramar (Cannes), July 6-September 29.

Dapper 1992: *Vision d'Océanie*. Musée Dapper (Paris), October 22, 1992-March 15, 1993.

De Young 1993: *Teotihuacan: City of the Gods*. Fine Arts Museums of San Francisco, M.H. de Young Memorial Museum, May 26-October 31.

Frumkin 1960: *Art of the Sudan*. Allan Frumkin Gallery (Chicago), February 5-March 12.

Guggenheim 1968: *Mastercraftsmen of Ancient Peru*. Solomon R. Guggenheim Museum (New York), June 16-November 3.

Guimet 1959: *Le Masque*. Musée Guimet (Paris), December 1959-May 1960.

IEF 1970: *African Sculpture*. Organized by the International Exhibitions Foundation. National Gallery of Art (Washington, D.C.), January 28-March 1; William Rockhill Nelson Gallery of Art (Kansas City), March 19-April 29; Brooklyn Museum, May 16-June 21.

Iowa 1956: *African Sculpture*. State University of Iowa, School of Fine Arts (Iowa City), June 12-July 31.

Iowa 1959: *Nigerian Art*. State University of Iowa, School of Fine Arts (Iowa City), summer.

IUAM 1989a: *Gifts to the Art Museum, 1985-89*. Indiana University Art Museum (Bloomington), June 13-September 10.

IUAM 1989b: *Power, Leadership, and Conflict: Political Themes as Expressed in the Visual Arts*. Indiana University Art Museum (Bloomington), October 10-December 24.

IUAM 1990: *Treasures from Polynesia: Selections from the Raymond and Laura Wielgus Collection*. Indiana University Art Museum (Bloomington), 1990.

IUAM 1992: *A Golden Year: Gifts in Honor of the Indiana University Art Museum's 50th Anniversary*. Indiana University Art Museum (Bloomington), January 29-April 26.

IUAM 1993: *Affinities of Form: The Raymond and Laura Wielgus Collection of the Arts of Africa, Oceania, and the Americas*. Indiana University Art Museum (Bloomington), October 1, 1993-February 27, 1994.

Layton 1957: *African Sculpture: Collection of Mr. and Mrs. Raymond Wielgus*. Layton School of Art (Milwaukee), January 3-February 9.

Leleu 1952: *Chefs-d'oeuvre de l'Afrique noire*. Leleu (Paris), June 12-29.

London 1948: *40,000 Years of Modern Art*. Institute of Contemporary Arts (London), December 20, 1948-January 29, 1949.

London 1949: *Traditional Art of the British Colonies*. Royal Anthropological Institute (London), June 21-July 20.

London 1951: *Traditional Sculpture from the Colonies*. Imperial Institute (London), May 25-September 30.

London 1953: *The Webster Plass Collection of African Art*. British Museum (London), October 10-December 31.

Los Angeles 1964: *Gold Before Columbus*. Los Angeles County Museum, March 19-May 15.

Lowie 1967: *African Arts*. Robert H. Lowie Museum of Anthropology, University of California (Berkeley), April 6-October 22.

Malines 1956: *Art primitif: Collection J. Van der Straete*. De Zalm (Malines), October 6-November 11.

MFA 1968: *The Gold of Ancient America*. Museum of Fine Arts (Boston), December 5, 1968-January 12, 1969; Art Institute of Chicago, February 1-March 9, 1969; Virginia Museum (Richmond), March 24-April 20, 1969.

MMA 1969a: *Art of Oceania, Africa and the Americas from the Museum of Primitive Art*. Metropolitan Museum of Art (New York), May 10-September 1.

MMA 1969b: *Masterpieces of Fifty Centuries*. Metropolitan Museum of Art (New York), October 18, 1969-January 15, 1970.

MMA 1970: *Before Cortés: Sculpture of Middle America*. Metropolitan Museum of Art (New York), September 30, 1970-January 3, 1971.

MMA 1990: *New Guinea Bone Carvings*. Metropolitan Museum of Art (New York), November 15, 1990-November 25, 1991.

MOMA 1984: *"Primitivism" in 20th Century Art: Affinity of the Tribal and the Modern*. Museum of Modern Art (New York), September 27, 1984-January 15, 1985; Detroit Institute of Arts, February 25-May 19, 1985; Dallas Museum of Art, June 23-September 1, 1985.

MPA 1960a: *Antelopes and Queens: Bambara Sculpture from the Western Sudan*. Museum of Primitive Art (New York), February 17-May 8.

MPA 1960b: *The Raymond Wielgus Collection*. Museum of Primitive Art (New York), November 23, 1960-February 5, 1961.

MPA 1961: *Art Styles of the Papuan Gulf*. Museum of Primitive Art (New York), February 14-May 5.

MPA 1962: *Gods with Fangs: Chavin Civilization of Peru*. Museum of Primitive Art (New York), February 21-May 6.

MPA 1963: *Senufo Sculpture from West Africa*. Museum of Primitive Art (New York), February 20-May 5; Art Institute of Chicago, July 12-August 11; Baltimore Museum of Art, September 17-October 27.

MPA 1964: *Masterpieces from the Americas*. Museum of Primitive Art (New York), May 20-November 11.

MPA 1965: *The Jaguar's Children: Pre-Classic Central Mexico*. Museum of Primitive Art (New York), February 17-May 9.

MPA 1974: *Rituals of Euphoria (Coca in South America)*. Museum of Primitive Art (New York), March 6-September 8.

Munich 1961: *Nigeria: 2000 Jahre Plastik*. Städtische Galerie (Munich), September 29, 1961-January 7, 1962; Kunsthalle (Basel), January 20-February 18, 1962.

New York 1939: Belgian Congo exhibition in Belgian Pavilion, World's Fair (New York), April 20-October 31.

NGA 1979: *The Art of the Pacific Islands*. National Gallery of Art (Washington, D.C.), July 1-October 14.

NMAA 1987: *African Art in the Cycle of Life*. National Museum of African Art (Washington, D.C.), September 28, 1987-March 20, 1988.

Olive 1948: *Océanie*. Galerie Andrée Olive (Paris), summer.

Pennsylvania 1956: *African Tribal Sculpture*. University of Pennsylvania, University Museum (Philadelphia), April-September.

Pigalle 1930: *Art africain, Art océanien*. Galerie Pigalle (Paris), March 15-April 30.

Princeton 1995: *The Olmec World: Ritual and Rulership*. Princeton University, Art Museum, December 16, 1995-February 25, 1996; Museum of Fine Arts (Houston), April 14-June 9, 1996.

Reattu 1954: *Art Afrique noire*. Musée Reattu (Arles), April 10-September 30.

San Diego 1973: *Dimensions of Polynesia*. Fine Arts Gallery of San Diego, October 7-November 25.

Toledo 1959: *The African Image*. Toledo Museum of Art, February 1-22.

Tucson 1975: *Tucson Collects*. Tucson Museum of Art, May 1-June 22.

Tucson 1976: *Tucson Collects II*. Tucson Museum of Art, May 1-June 20.

UCLA 1978: *Moche Art of Peru*. University of California, Frederick S. Wight Gallery (Los Angeles), October 10-November 26, 1978; Heard Museum of Anthropology and Primitive Art (Phoenix), January 12-March 3, 1979; Denver Art Museum, April 13-May 27, 1979.

Volney 1955: *Les Arts africains*. Cercle Volney (Paris), June-July.

Bibliography

African Arts. 1973. "The Raymond Wielgus Collection." 6, no. 2 (Winter): 50-55.

African Folktales and Sculpture. 1952. Folktales selected, edited, and with an introduction by Paul Radin. Sculpture selected and with an introduction by James Johnson Sweeney. Bollingen Series, 32. New York: Pantheon Books.

AIC — see Art Institute of Chicago.

Allan Frumkin Gallery. [1959]. *Art of the Sudan*. Exhibition catalogue. Essay by Roy Sieber. Chicago.

Allen Memorial Art Museum, Oberlin College. 1955/56. "Exhibition of African Art." *Allen Memorial Art Museum Bulletin* 13, no. 2: 63-155.

American Museum of Natural History, New York. 1965. *Faces and Figures: Pacific Island Art from the Collection of Jay C. Leff*. (Exhibition brochure.) New York.

Anton, Ferdinand. 1959. *Peru: Indianerkunst aus Präkolumbisher Zeit*. Munich: R. Piper.

———. 1962. *Alt-Peru und seine Kunst*. Leipzig: E.A. Seemann.

———. 1972. *The Art of Ancient Peru*. Translated by Mary Whittall. Rev. ed. London: Thames and Hudson.

———. 1973. *Women in Pre-Columbian America*. Translated by Marianne Herzfeld. Revised by George A. Shepperson. New York: Abner Schram.

———, and Frederick J. Dockstader. 1968. *Pre-Columbian Art and Later Indian Tribal Arts*. New York: Harry N. Abrams.

Apollo. 1982. "Indiana University Art Museum." N.s., 116, no. 249 (November): 333.

Armstrong, Robert Plant. 1981. *The Powers of Presence: Consciousness, Myth, and Affecting Presence*. Philadelphia: University of Pennsylvania Press.

Art Institute of Chicago. 1957a. *African Art: Collection of Mr. and Mrs. Raymond Wielgus*. Catalogue entries by Raymond Wielgus. Exhibition catalogue. Chicago.

———. 1957b. *Animal Sculpture in Pre-Columbian Art*. Catalogue by Alan Sawyer. Exhibition catalogue. Chicago.

———. 1957c. "Animal Sculpture in Pre-Columbian Art." *The Art Institute of Chicago Quarterly* 51, no. 3: 86-87.

———. 1958. "The Primitive Arts Department Features Oceanic Art"; "Exhibitions." *The Art Institute of Chicago Quarterly* 52, no. 2: 35-37.

———. 1960. *Primitive Art from Chicago Collections*. Exhibition catalogue. Chicago.

———. 1963. *Chicago Collectors*. Exhibition catalogue. Chicago.

———. 1965. *Primitive Art in the Collections of the Art Institute of Chicago*. Chicago.

———. 1971. *Calendar of the Art Institute of Chicago* 65, no. 4: 2-3.

Art News. 1960. "The Wielgus Collection." 59, no. 8: 14.

Arts Club of Chicago. 1966. *Raymond and Laura Wielgus Collection*. Exhibition catalogue. Text by Allen Wardwell. Chicago.

Arts Council of Great Britain. 1960. *The Epstein Collection of Tribal and Exotic Sculpture*. Exhibition catalogue. London.

Arts Magazine. 1960. "Nationwide Exhibitions: The Wielgus Collection at the Museum of Primitive Art." 35 (December): 22-23.

Balandier, Georges. 1966. *Ambiguous Africa: Cultures in Collision*. Translated by Helen Weaver. New York: Pantheon Books.

Barrow, Terence. 1973. *Art and Life in Polynesia*. Rutland, Vermont: Charles E. Tuttle.

Bascom, William R. 1967. *African Arts: An Exhibition at the Robert H. Lowie Museum of Anthropology of the University of California*. Exhibition catalogue. Berkeley: University of California.

———. 1973. *African Art in Cultural Perspective: An Introduction*. New York: W.W. Norton.

Beasley, Harry G. [1928] 1980. *Pacific Island Records: Fish Hooks*. London: Seeley, Service; reprint ed., London: John Hewett.

———. 1935. "Notes and Queries: Weaving-Peg, Turuturu." *The Journal of the Polynesian Society* 44, no. 1 (March): 65, pl. opp. 64.

Bennett, Wendell C., and Junius B. Bird. 1964. *Andean Culture History*. 2nd ed. New York: American Museum of Science Books and Anthropological History Press.

Benson, Elisabeth P. 1974. *A Man and a Feline in Mochica Art*. Studies in Pre-Columbian Art and Archaeology, 14. Washington, D.C.: Dumbarton Oaks.

Berrin, Kathleen, and Esther Pasztory, eds. 1993. *Teotihuacan: Art from the City of the Gods*. Exhibition catalogue. New York: Thames and Hudson.

Bierhorst, John. 1988. *The Mythology of South America*. New York: William Morrow.

Bird, Junius B. 1962. *Art and Life in Old Peru: An Exhibition*. Exhibition catalogue. New York: American Museum of Natural History.

Bolz, Ingeborg. 1966. "Zur Kunst in Gabon." In *Beiträge zur afrikanischen Kunst*, 85-221. Edited by Willy Fröhlich. Ethnologica, n.s., 3. Cologne: Brill.

Boos, Frank H. 1966. *The Ceramic Sculptures of Ancient Oaxaca*. South Brunswick, N.J.: A.S. Barnes.

Bounoure, Vincent. 1992. *Vision d'Océanie*. Exhibition catalogue. Paris: Musée Dapper.

Brussels. Exposition universelle et internationale. [1958]. *Art in the Congo*. Translated and edited by Jozef Kadijk. Exhibition catalogue. Antwerp: n.p.

Burland, Cottie Arthur. 1965. *North American Indian Mythology*. London: Hamlyn.

Burlington Magazine. 1954. "Notable Works of Art on the Market." 96, no. 616 (July): betw. pp. 229 and 233.

Butler, Joseph T. 1970. "The American Way with Art." *Connoisseur* 175, no. 700 (June): 158-63.

Cannes. Palais Miramar. 1957. *Arts d'Afrique et d'Océanie: Premier exposition retrospective internationale*. Exhibition catalogue. Cannes: Palais Miramar.

Carnegie Institute, Pittsburgh. 1960. *Exotic Art from Ancient and Primitive Civilizations: Collection of Jay C. Leff*. Exhibition catalogue. Pittsburgh: Carnegie Institute, Department of Fine Arts.

Chefs-d'oeuvre de l'Afrique noire: Exposition chez Leleu. [1952]. Exhibition catalogue. [Paris]: J. Leleu.

Chicago Daily Sun-Times. 1957. "Africa's Art." April 12: 32.

————. 1958a. "Art out of This World." March 25: 25.

————. 1958b. "Chicago-Owned Art Aids Oceanic Show." March 31: 26.

Chicago Sun-Times. 1958. "Exhibit 50 Examples of Oceanic Art." Column by Frank Holland. March 30: sec. 3, p. 8.

————. 1966. "Social Chicago: Accent on Primitive." Column by Kay Rutherford. September 27: 36.

Chicago Tribune. 1957. "Front Views and Profiles: Past Perfect." Column by Lucy Key Miller. May 14: pt. 3, p. 1.

————. 1958. "The Wonderful World of Art: It's a Short Step from Modern to Primitive." Column by Edith Weigle. April 13: pt. 7, p. 2.

————. 1970. "People at Home: Primitive Art Dominates Modern High Rise." Column by June Hill. June 20: sec. 1A, p. 1.

Christian Science Monitor. 1961. "Of Quipus, Gold, and Featherwork." Article by Dorothy Adlow. October 16: sec. C, p. 1.

Christie's (New York). 1994. *Important Tribal Art* (Auction May 5). New York.

Cincinnati Art Museum. 1970. *Sculpture Collection of the Cincinnati Art Museum*. Cincinnati.

Coe, Michael D. 1965. *The Jaguar's Children: Pre-Classic Central Mexico*. Exhibition catalogue. New York: Museum of Primitive Art.

Coe, Ralph T. 1977. *Sacred Circles: Two Thousand Years of North American Indian Art*. Exhibition catalogue. Kansas City: Nelson Gallery Foundation. (First published in 1976 by the Arts Council of Great Britain. The 1977 edition contains an addendum of objects for the Kansas City venue.)

Collier, Donald. 1967. "Pre-Columbian Mexican Art." *Field Museum Bulletin* 38, no. 10 (October): 9.

Covarrubias, Miguel. 1957. *Indian Art of Mexico and Central America*. New York: Alfred A. Knopf.

Cranbrook Institute of Science. 1951. "Andean and Mexican Additions." *Cranbrook Institute of Science Newsletter* 20, no. 7 (March): cover.

Dagas, Esther A., ed. 1993. *Drums: The Heartbeat of Africa*. Montreal: Galerie Amrad African Art Publications.

Daily Iowan. 1956. "Antelope Dance?" June 6: 3.

Darish, Patricia J. 1987. "African Art at the Indiana University Art Museum." *African Arts* 20, no. 3 (May): 30-41.

Delataille, L. and E., eds. 1992. *Tresors du nouveau monde*. Exhibition catalogue. Brussels: Musées Royaux d'Art et d'Histoire.

D'Harcourt, Raoul. 1934. *Les Textiles anciens du Pérou et leurs techniques*. Paris: Les Editions d'Art et d'Histoire.

————. 1962. *Textiles of Ancient Peru and Their Techniques*. Translated by Sadie Brown. Rev. ed. Seattle: University of Washington Press.

Dictionary of Black African Civilization. 1974. Edited by Georges Balandier and Jacques Maquet. Translated by Lady (Mariska Caroline) Peck, Bettina Wadia, and Peninah Neimark. New York: Leon Amiel.

Disselhoff, Hans Dietrich. 1966. *Leben im alten Peru*. Munich: Callwey. (Translated by Alisa Jaffa and published as *Daily Life in Ancient Peru* [New York: McGraw-Hill, 1967].)

Dockstader, Frederick J. 1967. *Indian Art in South America*. Greenwich, Conn.: New York Graphic Society.

Donnan, Christopher P. 1978. *Moche Art of Peru*. Exhibition catalogue. Los Angeles: UCLA Museum of Cultural History.

Dräyer, Walter, and Andreas Lommel. 1962. *Nigeria: 2000 Jahre afrikanischer Plastik*. Exhibition catalogue. Munich: Piper.

Easby, Dudley Tate, Jr., and Elizabeth Kennedy Easby. 1962. "Zapotec Get Together." *Archaeology* 15 (June): 94-98.

Easby, Elizabeth Kennedy. 1968. *Pre-Columbian Jade from Costa Rica*. Exhibition catalogue. New York: André Emmerich.

————, and John F. Scott. 1970. *Before Cortés: Sculpture of Middle America*. Exhibition catalogue. New York: Metropolitan Museum of Art.

Elisofon, Eliot. 1958. *The Sculpture of Africa*. Text by William B. Fagg. New York: Praeger.

Emmerich, André. 1959. "Savages Never Carved These Stones." *American Heritage* 10, no. 2 (February): 46-57.

Emmonds [i.e., Emmons], George Thornton, and G.P.L. Miles. 1939. "Shamanistic Charms." *Ethnologia Cranmorensis* 4: 31-35.

Fagg, William B. 1953. *The Webster Plass Collection of African Art*. Exhibition catalogue. London: British Museum.

————. 1961. *Nigeria: 2000 Jahre Plastik*. Exhibition catalogue. Munich: Städtische Galerie. (A slightly abridged version was published by Basel Kunsthalle in 1962.)

————. 1963. *Nigerian Images: The Splendor of African Sculpture*. New York: Praeger.

————. 1964. *Afrique: Cent tribus-Cent chefs-d'oeuvre*. Exhibition catalogue. Paris: Congrès pour la Liberté de la Culture. (Also published as *Afrika: 100 Stämme-100 Meisterwerke/Africa: 100 Tribes-100 Masterpieces*.)

————. 1965. *Tribes and Forms in African Art*. New York: Tudor Publishing Company.

————. 1969. *African Sculpture*. Exhibition catalogue. Washington, D.C.: International Exhibition Foundation.

————, and Margaret Plass. 1964. *An African Sculpture: Anthology*. New York: Dutton Vista.

Feder, Norman. 1982. *American Indian Art*. New York: Harrison House/Harry N. Abrams.

Fine Arts Gallery of San Diego. 1973. *Dimensions of Polynesia*. Edited by Jehanne Teilhet. Exhibition catalogue. San Diego.

Fraser, Douglas. 1959. "Torres Straits Sculpture: A Study in Oceanic Primitive Art." Ph.D. dissertation. Columbia University. (Published in 1978 [New York: Garland Press].)

Fröhlich, Willy. 1966. *Beitrage zur afrikanischen Kunst*. Cologne: Brill.

Galerie Andrée Olive, Paris. 1948. *Océanie*. Foreword by André Breton. Introduction and catalogue by F.-H. Lem. Exhibition catalogue. Paris: Andrée Olive.

Galerie Pigalle, Paris. 1930. *Exposition d'art africain et d'art océanien*. Exhibition catalogue. Paris.

Gathercole, Peter, Adrienne L. Kaeppler, and Douglas Newton. 1979. *The Art of the Pacific Islands*. Exhibition catalogue. Washington, D.C.: National Gallery of Art.

Gazette des Beaux-Arts. 1977. "Autres acquisitions ou dons récents: Etats-Unis." Ser. 6, no. 89 (March): 90.

Gifford, Philip C. 1974. "The Iconology of the Uli Figure of Central New Ireland." Ph.D. dissertation. Columbia University.

Gillon, Werner. 1984. *A Short History of African Art*. New York: Viking Penguin and Facts on File.

Goldwater, Robert. 1960. See Museum of Primitive Art. 1960a.

———. 1964. See Museum of Primitive Art. 1964b.

Groth-Kimball, Irmgard. 1954. *Art of Ancient Mexico*. Text by Franz Feuchtwanger. London: Thames and Hudson.

Greub, Suzanne, ed. 1985. *Authority and Ornament: The Art of the Sepik River, Papua New Guinea*. Exhibition catalogue. Basel: Tribal Art Centre.

Guiart, Jean. 1963. *The Arts of the South Pacific*. Translated by Anthony Christie. New York: Golden Press. (Also published the same year as *Océanie* [Paris: Gallimard] and as *Ozeanien* [Munich: C.H. Beck].)

Hausenstein, Wilhelm. 1923. *Barbaren und Klassiker: Ein Buch von der Bildnerei exotischer Völker*. Munich: R. Piper.

Herald-Times. 1990a. "'Treasures from Polynesia' on Exhibit at IU Art Museum." (Bloomington, Indiana) March 2: sec. D, p. 6.

———. 1990b. "IU Art Gallery Named for Donors: Wielguses 'Visit' Their Collection." (Bloomington, Indiana) April 10: sec. D, pp. 1, 3.

Holm, Bill, and Bill Reid. 1975. *Form and Freedom: A Dialogue on Northwest Coast Indian Art*. Houston: Institute for the Arts, Rice University.

Horizon. 1962. 4, no. 4 (March): frontis.

Horn, Miriam. 1987. "Peering into a People's Soul: Two New Museums at the Smithsonian." *U.S. News and World Report* 103, no. 14 (October 5): 67-68.

Hôtel Drouot, Paris. [1931] 1972/73. *Sculptures d'Afrique, d'Amerique, d'Océanie: Collection André Breton et Paul Eluard*. Paris: Hôtel Drouot; reprint ed., New York: Hacker Art Books, as the second part of a volume that also includes *Sculptures nègres* by Paul Guillaume.

Hubbard, Guy. 1992. "Classroom Use of this Month's Clip and Save Print: Pendant, Hei-Tiki, Maori, New Zealand." *Arts and Activities* 112, no. 1 (October): 64-66.

———. 1993a. "Classroom Use of this Month's Clip and Save Print: Polychrome Vase, Eighth Century." *Arts and Activities* 113, no. 4 (May): 48-50.

———. 1993b. "Classroom Use of this Month's Clip and Save Print: Cycladic Idol, Greece, and Standing Figure, lupinga lua luimpe, Zaire." *Arts and Activities* 113, no. 5 (June/Summer): 62-66.

Huet, Michel. 1963. *Afrique africaine*. Text by Léopold Sédar Senghor et. al. Lausanne: Clairefontaine.

Indianapolis Star. 1985. "Indiana University Art Museum Opens Impressive New Installation." Column by Steve Mannheimer. November 24: sec. E, p. 21.

Indiana University Art Museum, Bloomington. 1977. "Recent Acquisitions." *Bulletin* 1, no. 1 (Fall): 61, 71.

———. 1978. "Recent Acquisitions." *Bulletin* 1, no. 2: 115, 131-32.

———. 1979. "Recent Acquisitions." *Bulletin* 2, no. 1: 57, 59, 69-70.

———. 1980. *Guide to the Collections*. Bloomington.

———. 1985. *Art of Africa, Oceania, and the Americas*. (Gallery opening brochure.) Bloomington.

———. 1986. *African, Pacific, and Pre-Columbian Art in the Indiana University Art Museum*. Essays by Roy Sieber, Douglas Newton, and Michael D. Coe. Bloomington: In Association with Indiana University Press.

———. [1989a]. *Art Insight: Gods, Spirits, and Myths in the Art of Ancient America*. (Gallery brochure.) Text by Diane Pelrine. Bloomington.

———. [1989b]. *Art Insight: Oceania: In Praise of Ancestors and Other Spirits*. (Gallery brochure.) Text by Diane Pelrine. Bloomington.

———. [1989c]. *Art Insight: Prestige and Leadership Arts in Sub-Saharan Africa*. (Gallery brochure.) Text by Diane Pelrine. Bloomington.

———. [1990a]. *Naming Ceremony: The Raymond and Laura Wielgus Gallery of the Arts of Africa, Oceania, and the Americas*. (Brochure.) Bloomington.

———. 1990b. *Treasures from Polynesia: Selections from the Raymond and Laura Wielgus Collection*. (Gallery brochure.) Text by Teri Sowell. Bloomington.

———. [1991]. *Indiana University Art Museum*. (Brochure.) Bloomington.

———. [1992]. *A Sacred Flute Figure from Papua New Guinea*. (Gallery brochure.) Text by Teri Sowell. Bloomington.

IUAM — see Indiana University Art Museum.

IU Newspaper. 1990. "Art Gallery Named for Donors." Column by Richard Gilbert. April 6: 2, 10.

Jones, Julie. 1974. *Rituals of Euphoria: Coca in South America*. Exhibition catalogue. New York: Museum of Primitive Art.

Joralemon, Peter David. 1971. *A Study of Olmec Iconography*. Studies in Pre-Columbian Art and Archaeology, 7. Washington, D.C.: Dumbarton Oaks.

———. 1981. "The Old Woman and the Child: Themes in the Iconography of Preclassic Mesoamerica." In *The Olmec and Their Neighbors*, 163-80. Edited by Elizabeth P. Benson. Washington, D.C.: Dumbarton Oaks.

Kaeppler, Adrienne L., Christian Kaufmann, and Douglas Newton. 1993. *L'Art océanien*. Paris: Editions Citadelles et Mazenod.

Kan, Michael. 1970. *African Sculpture*. Exhibition catalogue. Brooklyn: Brooklyn Museum.

Kerchache, Jacques, Jean-Louis Paudrat, and Lucien Stéphan. 1988. *L'Art africain*. Paris: Editions Citadelles.

Krämer, Augustin F. 1925. *Die Málanggane von Tombára*. Munich: G. Müller.

Lapiner, Alan. 1976. *Pre-Columbian Art of South America*. New York: Harry N. Abrams.

Layton School of Art, Milwaukee. 1957. *African Sculpture: Collection of Mr. and Mrs. Raymond Wielgus*. Introduction by Allan Frumkin. Catalogue by Raymond Wielgus. Exhibition catalogue. Milwaukee.

Leiris, Michel, and Jacqueline Delange. 1967. *Afrique noire: La Création plastique*. Paris: Gallimard. (Translated by Michael Ross and published as *African Art* [New York: Golden Press, 1968].)

Leloup, Hélène. 1988. "Dogon Figure Style." *African Arts* 22, no. 1 (November): 44-51.

———. 1994. *Dogon Statuary*. Translated by Brunhilde Biebuyck. Strasbourg: Daniele Amez.

Los Angeles County Museum. 1964. *Gold Before Columbus*. Introduction by Ralph C. Altman. Text by Peter T. Furst. Exhibition catalogue. Los Angeles.

Lothrop, Samuel Kirkland. 1937. *Coclé: An Archaeological Study of Central Panama, Part 1*. Memoirs of the Peabody Museum of Archaeology and Ethnology, 7. Cambridge, Mass.: Peabody Museum.

Mack, Charles W. 1982. *Polynesian Art at Auction 1965-1980*. Northboro, Mass.: Mack-Nasser Publishing.

Maggs Bros. Booksellers. N.d. *Voyages and Travels*. Vol. 4, pt. 9, *Australia and the Pacific*. Catalogue no. 856. London: Maggs Bros. Booksellers.

Malines. 1956. *Art primitif: Collection J. Van der Straete*. Introduction by Henri Lavachery. Exhibition catalogue. Malines: Ville de Malines.

Mason, J. Alden. 1931-39. *Archaeology of Santa Marta, Colombia: The Tairona Culture*. 3 vols. Field Museum of Natural History Anthropological Series, vol. 20, nos. 1-3. Chicago: Field Museum of Natural History.

Mathiassen, Therkel. 1929. "Some Specimens from the Bering Sea Culture." *Indian Notes* 6, no. 1 (January): 33-56.

Maurer, Evan M. 1977. *The Native American Heritage: A Survey of North American Indian Art*. Exhibition catalogue. Chicago: Art Institute of Chicago.

McCarthy, Frederick D. 1961. "The Malanggan Mask/Le Masque mélanésien." *Le Théâtre dans le monde/World Theatre* 10, no. 1 (Spring): 21-30.

McNaughton, Patrick R. 1987. "Nyamakalaw: The Mande Bards and Blacksmiths." *Word and Image* 3, no. 3 (July-September): 271-88.

———, and Diane Pelrine. 1995. "African Art." In *Africa*, 223-56. Edited by Phyllis M. Martin and Patrick O'Meara. 3rd ed. Bloomington: Indiana University Press.

Menzel, Dorothy, John H. Rowe, and Lawrence E. Dawson. 1964. *The Paracas Pottery of Ica: A Study in Style and Time*. University of California Publications in American Archaeology and Ethnology, 50. Berkeley: University of California Press.

Metropolitan Museum of Art. 1970. *Masterpieces of Fifty Centuries*. Exhibition catalogue. New York: E.P. Dutton.

———. 1987. *The Pacific Islands, Africa, and the Americas*. Introductions by Douglas Newton, Julie Jones, and Kate Ezra. New York: Metropolitan Museum of Art.

Milwaukee Journal. 1957. "The World of Art: African Sculpture at Layton School." Column by Frank Getlein. January 6: sec. 5, p. 6.

Milwaukee Sentinel. 1957. "A Funerary Figure." January 6: sec. D, p. 4.

MMA — see Metropolitan Museum of Art.

MPA — see Museum of Primitive Art.

Munro, Eleanor C. 1956. "Which Way to See African Sculpture?" *Art News* 55 (May): 26-28, 62.

Musée Dapper. 1994. *Dogon*. Exhibition catalogue. Paris.

Musée des Arts Décoratifs, Paris. 1954. *Chefs-d'oeuvre de la curiosité du monde: 2e exposition internationale de la Confédération Internationale des Négociants en Oeuvres d'Art*. Exhibition catalogue. Paris.

Musée Guimet, Paris. 1959. *Le Masque*. Exhibition catalogue. Paris: Editions des Musées Nationaux.

———. 1965. *Masques*. Paris: Olivier Perrin.

Musée Reattu, Arles. 1954. *Art Afrique noire*. Arts et civilisations. Arles.

Museum of Primitive Art, New York. 1960a. *Bambara Sculpture from the Western Sudan*. Introduction by Robert Goldwater. Exhibition catalogue. New York.

———. 1960b. *The Raymond Wielgus Collection*. Foreword by Robert Goldwater. Introduction by Raymond Wielgus. Exhibition catalogue. New York.

———. 1964a. *Sculpture from Peru Selected from the Collection of the Museum of Primitive Art*. Exhibition catalogue. New York.

———. 1964b. *Senufo Sculpture from West Africa*. Text by Robert Goldwater. Exhibition catalogue. New York.

———. 1969a. *Art of Oceania, Africa and the Americas from the Museum of Primitive Art: An Exhibition at the Metropolitan Museum of Art*. Exhibition catalogue. New York: Metropolitan Museum of Art.

———. 1969b. *The Herbert Baker Collection*. Exhibition catalogue. New York.

———. 1973. *Robert Goldwater: A Memorial Exhibition*. Exhibition catalogue. New York.

New Bulletin (Algeria). 1969. 3 (May 1): 8.

Newton, Douglas. 1961. *Art Styles of the Papuan Gulf*. Exhibition catalogue. New York: Museum of Primitive Art.

New York Times. 1959a. "Art: Brooklyn Museum: Display of Ancient Sculpture, Pottery and Metal Work of Americas Opens." Column by John Canaday. December 1: 46.

———. 1959b. "Before Columbus: Two Exhibitions Examine the Past from Contrasting Points of View." Column by John Canaday. December 6: sec. 10, p. 19.

———. 1960. "Around the Galleries." November 27: sec. 10, p. 11.

Oldman, William. 1946. *Skilled Handwork of the Maori: Being the Oldman Collection of Maori Artifacts Illustrated and Described*. 2nd ed. Wellington, New Zealand: Polynesian Society.

Oliver, Douglas L. 1974. *Ancient Tahitian Society*. Vol. 1: *Ethnography*. Honolulu: University Press of Hawaii.

The Olmec World: Ritual and Rulership. 1995. Essays by Michael D. Coe et al. Exhibition catalogue. Princeton: Art Museum, Princeton University.

Parke-Bernet Galleries, New York. 1970. *Eskimo and American Indian Art: Various Owners Including Jay C. Leff* (Auction January 31; sale 2979). New York.

Paulme, Denise. 1956. *Les Sculptures de l'Afrique noire*. Paris: Presses Universitaires de France. (Translated by Michael Ross and published as *African Sculpture* [New York: Viking Press, 1962].)

Pelrine, Diane M. 1993. *Affinities of Form: The Raymond and Laura Wielgus Collection of the Arts of Africa, Oceania and the Americas*. Exhibition brochure. Bloomington: Indiana University Art Museum.

Plass, Margaret. 1956. *African Tribal Sculpture*. Philadelphia: University Museum, University of Pennsylvania.

Portier, André, and François Poncetton. 1922. *Décoration océanien*. Paris: A. Calavas.

Portland Museum of Art. 1971. *Tribal Art of West Africa*. Exhibition catalogue. Portland, Maine.

Povey, John F. 1982. "First Word." *African Arts* 15, no. 2 (February): 1-3, 6.

Powell, Jane P. 1959. *Ancient Art of the Americas*. Brooklyn: Brooklyn Museum.

Primitive Art. 1979. Text by Ferdinand Anton, Frederick J. Dockstader, Margaret Trowell, and Hans Nevermann. New York: Harry N. Abrams.

Rautenstrauch-Joest-Museum, Cologne. 1959. *Schätze aus Peru: Von Chavin bis zu den Inka*. Exhibition catalogue. Recklinghausen: Aurel Bongers.

Robbins, Warren M., and Nancy Ingram Nooter. 1989. *African Art in American Collections*. Washington, D.C.: Smithsonian Institution Press.

Rockefeller, Nelson A. 1978. *Masterpieces of Primitive Art: The Nelson A. Rockefeller Collection*. Text by Douglas Newton. New York: Knopf.

Rosenzweig, Miriam E. 1990. "Art Under New Management." *Indiana Alumni Magazine* 52, no. 6 (July-August): 16-19.

Rousseau, Madeleine. 1951. *L'Art océanien: Sa présence*. Collection Le Musée Vivant, 38. Paris: Association Populaire des Amis des Musées.

————, and Cheikh Anta Diop. 1948. *Evidence de la culture nègre*. Collection Le Musée Vivant, special number (November).

Rowe, John Howland. 1962. *Chavín Art: An Inquiry into Its Form and Meaning*. Exhibition catalogue. New York: Museum of Primitive Art.

Royal Anthropological Institute, London. 1949. *Traditional Art of the British Colonies*. Exhibition catalogue. London: Royal Anthropological Institute.

Rubin, William, ed. 1984. *"Primitivism" in 20th Century Art: Affinity of the Tribal and the Modern*. 2 vols. New York: Museum of Modern Art.

Sautier, Albert. 1930. "Exhibition of African and Oceanic Art at the Pigalle Gallery." *Formes* 3 (March): 12-13.

Sawyer, Alan Reed. 1961. "Paracas and Nazca Iconography." In *Essays in Pre-Columbian Art and Archaeology*, 269-98. Edited by Samuel K. Lothrop. Cambridge, Mass.: Harvard University Press.

————. 1966. *Ancient Peruvian Ceramics: The Nathan Cummings Collection*. Exhibition catalogue. New York: Metropolitan Museum of Art.

————. 1968. *Mastercraftsmen of Ancient Peru*. Exhibition catalogue. New York: Solomon R. Guggenheim Foundation.

Schmidt, E.W. 1929. "Die Schildtypen vom Kaiserin-Augusta-Fluss und eine Kritik der Deutung ihrer Gesichtsornamente." *Baessler-Archiv* 13: 136-77.

Schmitz, Carl A. 1971. *Oceanic Art: Myth, Man and Image in the South Seas*. New York: Harry N. Abrams.

Segy, Ladislas. 1951. "Bakuba Cups: An Essay on Style Classification." *Midwest Journal* 4, no. 1: 26-49.

————. 1952. *African Sculpture Speaks*. New York: A.A. Wyn.

————. 1953. "African Names and Sculpture." *Acta Tropica* 10, no. 4: 289-309.

————. 1958. *African Sculpture*. New York: Dover.

Sieber, Roy. 1956. *African Sculpture (18th Annual Fine Arts Festival, School of Fine Arts, State University of Iowa, June 12-July 31)*. Exhibition catalogue. Iowa City: State University of Iowa.

————. 1980. *African Furniture and Household Objects*. Exhibition catalogue. Bloomington: Indiana University Press in Association with the American Federation of Arts.

————, and Roslyn Adele Walker. 1987. *African Art in the Cycle of Life*. Exhibition catalogue. Washington, D.C.: Smithsonian Institution Press.

Siroto, Leon. 1968. "The Face of the Bwiiti." *African Arts* 1, no. 3 (Spring): 22-27, 86-89, 96.

Sotheby and Co., London. 1956. *Catalogue of Important African Art, The Property of Mrs. Webster Plass and Antiquities, the Property of Sir Edward Harrison and the Property of Mrs. R. Barge* (Auction November 19). London.

————. 1967. *Primitive Art* (Auction November 20). London.

Sotheby's, New York. 1987. *Pre-Columbian Art* (Auction November 18; sale 5635). New York.

Speyer, A. James. 1957. "Art News from Chicago." *Art News* 56, no. 4 (Summer): 66, 81.

Steward, Julian Haynes, ed. [1948] 1963. *Handbook of South American Indians*. Vol. 4, *The Circum-Caribbean Tribes*. Smithsonian Institution, Bureau of American Ethnology Bulletin 143; reprint ed., New York: Cooper Square Publishers.

Tannous, David. 1980. "Artifacts into Art: An Oceanic Extravaganza." *Art in America* 68, no. 1: 93-97.

Textile Museum, Washington, D.C. 1969. "Some Recent Acquisitions to the Textile Museum's Collections." *Textile Museum Journal* 2, no. 4 (December): 45-48.

Think. 1957. "Sculptural Arts of Tribal Africa." 23, no. 4 (June): 17-19.

Time. 1960. "Collector's Primitive." December 5: 72.

————. 1970. "African Images, Power and Presences." February 2: 44-47.

Toledo Blade. 1957. "African Art Work." June 10: Peach sec., p. 1.

Toledo Museum of Art. 1959. *The African Image: A New Selection of Tribal Art*. Introduction and catalogue by Margaret Plass. Toledo.

Trowell, Kathleen Margaret, and Hans Nevermann. 1968. *African and Oceanic Art*. New York: Harry N. Abrams.

University of Kansas Museum of Art. 1957. *Art of the Aztec Empire*. Exhibition catalogue. Lawrence.

University Prints. [1970]. *African Art*. Ser. N, sec. 1. Cambridge.

Valluet, Christine. 1991. "Uli: La Grande Cérémonie." *Primitifs* 6 (September-October): 36-50.

Verly, Robert. 1959. "Vu du Kasai: L'Art africain et son devenir." *Problèmes d'Afrique centrale* 44: 145-51.

Waite, Deborah. 1983. *Art of the Solomon Islands from the Collection of the Barbier-Müller Museum*. Geneva: Barbier-Müller Museum.

Wardwell, Allen. 1964. *Yakutat South: Indian Art of the Northwest Coast*. Exhibition catalogue. Chicago: Art Institute of Chicago.

————. 1967a. "Polynesia: The Indwelling Power." *Art News* 66, no. 7: 38-39.

————. 1967b. *The Sculpture of Polynesia*. Exhibition catalogue. Chicago: Art Institute of Chicago.

————. 1968a. *The Gold of Ancient America*. Exhibition catalogue. Greenwich, Connecticut: New York Graphic Society.

————. 1968b. "Small Scale Carvings from the Northwest Coast." *Auction* 2, no. 1 (September): 13-15.

————. 1971. *Art of the Sepik River*. Exhibition catalogue. Chicago: Art Institute of Chicago.

————. 1986. "Guns in Black Tie: Raymond Wielgus Sees Pistols As Sculptures." *Connoisseur* (August): 94-97.

————. 1995. *Tangible Visions: Northwest Coast Indian Shamanism and Its Art*. New York: Monacelli Press.

Willett, Frank. [1971] 1991. *African Art, An Introduction*. London: Thames and Hudson; reprint ed., New York: Thames and Hudson.

Willey, Gordon Randolph. 1971. *An Introduction to American Archaeology*. Vol. 2, *South America*. Englewood Cliffs, New Jersey: Prentice-Hall.

Wuthenau, Alexander von. 1975. *Unexpected Faces in Ancient America 1500 B.C.-A.D. 1500: The Historical Testimony of Pre-Columbian Artists*. New York: Crown Publishers.

Zahan, Dominique. 1980. *Antilopes du soleil: Arts et rites agraires d'Afrique noire*. Vienna: Edition A. Schendl.

Zimmerman, Enid. 1990. "Questions About Multiculture and Art Education or 'I'll Never Forget the Day M'Dlawi Stumbled on the Work of the Post-Impressionists.'" *Art Education* 43, no. 6: 8-24.

Index of Peoples and Places

Numbers refer to catalogue entries